THE LOST C
IS KNOWN AROUND THE WORLD

"An adventurer cuts loose...a cut above most of its genre."
—The Oakland Tribune

"One long tale of quest and adventure, of chance meetings and inevitable partings, meals relished and hotels endured, camel caravans caught and buses missed–spun through with his eclectic gleanings from obscure works of archaeology, history and explorers' diaries. Also woven throughout the books, in a crazy-quilt jumble of innocent awe and hard bitten savvy, are reflections on the people and places he encountered...
...There is a disarming casualness and a kind of festive, footloose fancy to his tales that are utterly beguiling."
–The San Francisco Chronicle

"...a tonic...experiences in exotic places the rest of us think only Indiana Jones visits...it will whet your appetite and leave you chomping at the bit."
—The Missoulian

"...an offbeat travel guide that is fun to read even if you don't have plans to duplicate author David Hatcher Childress' remarkable journey. A thoughtful young man, Childress tells a good story and his book is lively and interesting."
—The Washington Post

"Explore for lost treasure, stone monuments forgotten in jungles...and hair-raising terrain from the safety of your armchair."
—Bookwatch

"A fascinating series of books, written with humour, insight, depth and an astonishing knowledge of the ancient past."
—Richard Noone

The Lost Cities Series:
Lost Cities of Atlantis, Ancient Europe & the Mediterranean
Lost Cities of North & Central America
Lost Cities & Ancient Mysteries of South America
Lost Cities of Ancient Lemuria & the Pacific
Lost Cities & Ancient Mysteries of Africa & Arabia
Lost Cities of China, Central Asia & India

The Lost Science Series:
The Anti-Gravity Handbook
Anti-Gravity & the World Grid
Anti-Gravity & the Unified Field
The Free-Energy Device Handbook
The Energy Grid
The Bridge to Infinity
The Harmonic Conquest of Space
Vimana Aircraft of Ancient India & Atlantis
Ether Technology
The Fantastic Inventions of Nikola Tesla
Man-Made UFOs: 1944-1994

The Mystic Traveller Series:
In Secret Mongolia by Henning Haslund (1934)
Men & Gods In Mongolia by Henning Haslund (1935)
In Secret Tibet by Theodore Illion (1937)
Darkness Over Tibet by Theodore Illion (1938)
Danger My Ally by F.A. Mitchell-Hedges (1954)
Mystery Cities of the Maya by Thomas Gann (1925)
In Quest of Lost Worlds by Byron de Prorok (1937)

Write for our free catalog of exciting books and tapes.

A
HITCHHIKER'S GUIDE
TO ARMAGEDDON

David Hatcher Childress

Acknowledgements

Many thanks to all the authors who helped this author, including The Tragically Hip, Andrew Tomas, Jennifer Bolm, Nicholas Roerich, Roy Chapman Andrews, Harry Osoff, Herman Hegge, Maurits Einhoven, John Michell, William Corliss, and many others.

Many thanks for your contributions.

Dedication
To all scientist-philosophers everywhere
who continue to study, learn and grow.

A
HITCHHIKER'S GUIDE
TO ARMAGEDDON

ADVENTURES UNLIMITED PRESS
KEMPTON, ILLINOIS

A Hitchhiker's Guide To Armageddon
by David Hatcher Childress

ISBN 0-932813-84-4

Printed in the United States of America

First printing August 2001

Published by
Adventures Unlimited Press
One Adventure Place
Kempton, Illinois 60946 USA
auphq@frontiernet.net
www.adventuresunlimitedpress.com

Brief portions of this book first appeared in
World Explorer magazine

Table of

Contents

I wanted to change the world.
But I have found that the only thing
one can be sure of changing is oneself.

—*Aldous Leonard Huxley*

1.
The Pros & Cons of Hitchhiking— Previous Armageddons

*"The backward look behind the assurance of recorded history,
the backward half-look over the shoulder,
towards a primitive terror."*
—T.S. Eliot, *The Dry Salvages*

*Who controls the past controls the future;
who controls the present controls the past.*
—George Orwell, *1984*

You call this archaeology?
—Wendell Jones, Sr.

The light was blinding. It turned dark red and then orange. Then I opened my eyes. I saw flies buzzing around my face. It was another hot morning in the Middle East. I glanced up from my sleeping bag. I had spent that night in a park outside of Akko, an old crusader town in northern Israel.

Soon, the flies began to crawl over my face like army ants over a Brazilian farm. I pulled the sheet over my head and tried to get another 20 minutes of sleep.

Armageddon seemed far away then, back in 1978. Tension existed in the Middle East, but the omnipresent armed guards and gun-toting youths were not part of the overall Armageddon assault. That would come later. For now, things were relatively calm, and I was

merely a young college dropout who was travelling across Asia and Africa.

Have you ever wondered what it is like to be alone? To be totally alone, where no one knows who you are—or cares? One way to find out is to try hitchhiking in a foreign country, standing at a lonely crossroads in some remote junction miles from nowhere, with your thumb out, and maybe a sign with your destination on it. Suddenly you're no one, nobody, anybody. The man with no name, the man with any name. The man with no friends, and no enemies. A solitary man. A man standing on the road, waiting for ride.

I had hitchhiked from the Golan Heights, the former Syrian territory now occupied by Israel, and had made my way along the Lebanese border to this spot near the ancient castle of Akko. I had gotten several lifts to this point, one in an old truck full of watermelons. It was late when the watermelon truck dropped me off at the crossroads north of Haifa. An orchard nearby had plenty of trees and secluded spots to sleep for the night. I didn't have a tent, but it didn't seem like it would rain that evening.

That night I had dreamed of lost cities in the deserts and continents rising from the ocean. I dreamed of angry warriors laying waste to whole cities. I dreamed of Armageddon and its aftermath.

I had thought about Armageddon sometimes before. I had heard of it, mainly through television and movies, and the occasional book that I saw in bookstores such as *The Late, Great Planet Earth* by Hal Lindsey. Lindsey, a fundamentalist Christian, believed that God had created the earth some six or seven thousand years ago, and that Armageddon was imminent. This massive conflagration, started by the Communists, would ultimately involve most of the world. The destruction wrought by this World War III would be considerable, literally the end of the world according to Lindsey.

I had always been interested in history, ancient civilizations, mysteries of the past, and unusual topics in general. Prophecy, and the general area of "precognition" and psychic predictions intrigued me a great deal. The topic of Armageddon piqued my interest, though my view of the universe was much broader than Reverend Lindsey's.

The prophecies of the end times found in the writings of the Bible, Nostradamus, Mother Shipton and others fascinated me. These predictions indicated that a terrible world war is to be fought that will involve the Middle East. It has been suggested that this war was World War II, which did involve some fighting in the Middle East; it embroiled most of the world, and its images of destructive power

are still very much with us today. Still, it seemed to me that Armageddon, and the subsequent building of the New Jerusalem (according to the Biblical *Revelation*) was an event yet to come. Others thought so, too.

However, as I brushed the flies away from my head and sat up in my sleeping bag, it occurred to me that the Armageddon of my dream could be looming on the horizon: the Egyptian president Anwar Sadat had just been assassinated—by officers in his own army, no less.

A few days later, after hitchhiking to Jerusalem, and then on to Gaza, I was in Egypt. I was at the Great Pyramid, sitting on a block of stone. The dusty, noisy streets of Cairo and the Giza suburb lay below me. I gazed to the southwest and could see two more giant pyramids. Soldiers mounted on camels, with their automatic rifles slung across their laps, rode about in the distance.

The sun blazed down on me as I clutched my ticket for the Great Pyramid. Like hundreds of other tourists on this January day in 1978, I would climb up the face of the pyramid and enter into it. As I sat at the base of the Great Pyramid, I wondered again about Armageddon, and how the concept had originated.

§§§

The First Recorded Armageddon

The New Kingdom period of ancient Egypt was an exciting time. This was a time of great prosperity and, economically at least, Egypt was perhaps at its peak. It had begun expanding into Asia Minor, and the age saw great ocean voyages such as Queen Hatshepsut's voyage to the fabled land of Punt, thought to be in East Africa, or possibly as far south as Mozambique or Zimbabwe.

At the time Tuthmosis III (who had reigned as coregent with Queen Hatshepsut since 1504 BC) ascended to the throne on Hatshepsut's death in 1482 BC, four decades had passed without a major Egyptian military campaign in western Asia. Now the situation changed completely. The King of Qadesh, a strong fortified city on the River Orontes in northern Syria, led a Syrio-Hittite-Canaanite confederacy in a general rebellion against Egypt.

In response, Tuthmosis III, as yet a young man and often called "the Napoleon of Egypt," marched into western Asia to regain the territories between the Nile and Euphrates that had been conquered forty years earlier by his ancestor Ahmose.

Over the next 20 years Tuthmosis III led a total of 17 campaigns in

western Asia, at the end of which he had earned the reputation of being the mightiest of all the kings of the ancient world. The account of these various wars, copied from the daily records of the scribe who accompanied the army on its campaigns, can be found in the *Annals,* a 223-line document carved into the walls of the corridor surrounding the granite holy of holies Tuthmosis III built at Karnak.

The account begins with his departure at the head of his troops from the fortified border city of Zarw.[1,2] According to Ahmed Osman in his book *The House of the Messiah,* after ten days Tuthmosis arrived in Gaza, where he celebrated the start of his new year with festivals in honor of his 'father,' Amun, whose image he carried inside an ark made of wood and metal, at the head of the marching army. He stayed there for the night before pushing on northward toward central Canaan where he paused in a town called Yehem to the south of a mountainous ridge he had to cross in order to reach Megiddo, the city where the Qadesh enemy had gathered. Here he was faced with a choice of three routes. The shortest, called the Aruna Road, was narrow and dangerous, and he therefore summoned a Council of War, in which he said to his officers: "That vile enemy of Qadesh... has gathered to himself the princes of all lands who were loyal to Egypt... And he says (so they say): 'I shall stand to fight against His Majesty here in Megiddo.' Tell me what is in your hearts."[2]

In answer to the question of which road to take for the approach to Megiddo, his officers replied: "How can one go on this road which is so narrow? It is reported that the enemy stand outside and are numerous. Will not horse have to go behind horse, and soldiers and people likewise? Shall our own vanguard be fighting while the rear stands here in Aruna [the starting point of the narrow road] and does not fight?"[2]

However, in the light of fresh reports brought in by messengers, Tuthmosis III decided that he would make his way to Megiddo by the unappealing—but, to his enemies, unexpected—narrow road.

To this choice his officers replied: "Thy father Amun prosper thy counsel... The servant will follow his master."[2]

And so the scene was set for the first recorded battle of Armageddon—a battle between the Egyptian army and the combined army of Qadesh.

In his assault upon Megiddo, Tuthmosis III marched at the head of his troops down the narrow mountainous road from Aruna, with the image of Amun pointing the way. When he eventually emerged into the valley southeast of Megiddo, he could see that the enemy

forces had been divided. Having apparently expected him to take one of the two broader roads available to him, one group had been stationed at Taanach to the south and the other nearer to Megiddo. But, as a result of his unexpected choice of the central route, Tuthmosis and his troops appeared on the scene between them.

On the advice of his officers, the king encamped for two days while he waited for the rear echelon of his army to arrive. Then, having divided his army into separate units, he attacked. Says the *Annals*: "His Majesty set forth in a chariot of fine gold, adorned with his accoutrements of combat, like Horus, the Mighty of Arm, a lord of action like Montu, the Theban, while his father Amun made strong his arm. The southern wing of His Majesty's army was at a hill south of Kina, and the northern was to the north-west of Megiddo, while His Majesty was in their centre, Armin being the protection of his person..."[2]

The Egyptian forces prevailed in the ensuing battle and the local kings opposed to Tuthmosis fled to the sanctuary of the Megiddo fortress, where, as the gates of the city had been shut, they were hauled to safety by citizens who let down 'garments to hoist them up.' The account of the battle complains that the enemy had "abandoned their horses and their chariots of gold and silver" and "if only His Majesty's army had not given up their hearts to capturing the possessions of the enemy, they would [have captured] Megiddo at this time."[2]

Instead, they had to lay siege to the city for seven months, the occupants having surrounded it with a protective ditch and fence: "They measured [this] city, which was corralled with a moat and enclosed with fresh timbers of all their pleasant trees." However, the king was not with them: "His Majesty himself was in a fortress east of this town."[2]

A stele from Gebel Barakal in Nubia describes the ultimate surrender of the city at the end of this protracted campaign: "Then that enemy and the princes who were with him sent out to My Majesty, with all their children carrying abundant tribute, gold and silver, all their horses which were with them, their great chariots of gold and silver, as well as those which were painted, and their coats of mail, their bows, their arrows and all their weapons of warfare. It was these with which they had come from afar to fight against My Majesty, and now they were bringing them as tribute to My Majesty, standing on their walls, giving praise to My Majesty, seeking that the breath of life might be given to them."[4]

On the fall of Megiddo, most of the city-states situated between

the Jordan and the sea, as well as some northern Syrian cities, including Hamath (north of Qadesh), recognized the suzerainty of Egypt. Their lords, bringing presents with them, came to Tuthmosis III's camp to pay homage to him.

The attack upon Megiddo, followed by the protracted siege and the final assault on the city, was the start of a long and successful military career for the king. After the capture of Megiddo, he proceeded to south Lebanon, where he captured three cities by the River Litani before returning to Egypt.

It was not until his sixth campaign that he was finally to vanquish his persistent enemy, Qadesh in northern Syria, which had survived the defeat of its allies at Megiddo and continued to instigate rebellion against Egypt. This powerful enemy, a Hittite confederacy which would later break up into countries like Mittani and city-states like Byblos, is one of history's great mysteries.

Three years after laying siege to Qadesh and capturing it, Tuthmosis III crossed the Euphrates as part of the continuing campaign to restore his empire between the Nile and the Euphrates, and defeated the King of Mittani.

According to the Egyptologist Maspero: "He entered the country (Mitanni) by the fords of Carchemish (between Syria to the west, Mesopotamia to the east and the Hittite land of Anagol in the north), near the spot where his grandfather, Tuthmosis I, had erected his stele a century previously. He placed another beside this ... to mark the point to which he had extended his empire."[3]

Yet, although he had now succeeded in reestablishing the empire stretching from the Nile to the Euphrates that his grandfather had created originally, Tuthmosis III looked back on the battle of Megiddo as the most important military campaign of his life. That is why in all his military inscriptions, not only those carved on the walls of the temple at Karnak, he gives more details about that first military campaign than the others.

It was a theme he returned to in the granite stele at Gebel Barakal, near the fourth cataract in Nubia, that he erected in his Year 47, when his days of battle were over, to give a summary of his achievements during his reign: "I repeat further to you hear, O people! He (the god) entrusted to me the foreign countries of Retenu (Canaan/Syria) on the first campaign when they had come to engage with My Majesty, being millions and hundred-thousands of men, the individuals of every foreign country, waiting in their chariots—three hundred and thirty princes, every one of them having his (own) army."[2]

And so ended the first battle of Armageddon, a decisive battle between Egypt in the west and the Syrian-Lebanese foes of the Hittite confederacy. So important was this battle in ancient times that it was well remembered by all the people of the ancient Middle East, and the fall of the fortress of Megiddo was a turning point in the history of the region.

§§§

The Fortress of Megiddo

Whether this was the first major battle between nations at the fortress of Megiddo, we have no way of knowing. But we do know that it was not the last! During the neo-Atonist reign of Israel by Solomon, Megiddo was a major fortress that protected the northern passes. It was originally a Philistine city until conquered by the Hebrews.

Believed to have been founded in the 4th millennium BC, if not earlier, the city controlled an important route linking Syria and Mesopotamia with the Jordan valley, Jerusalem, Gaza, and Egypt. Its commanding location made the city the scene of many early battles, and from its name the word Armageddon is apparently derived. The military importance of Megiddo and its long history as an international battleground is aptly reflected in the "Apocalypse of John" (*Revelation* 16:14-16) in which Armageddon (Har Megiddon, the Mount of Megiddo) is designated as the site where, at the end of days, all the kings of the world will fight the ultimate battle against the forces of God.

In 609 the Judean king Josiah was defeated at Megiddo by the Pharaoh Necho II. Josiah was the king of Judah from 641-609 BC and during his reign an old copy of *The Book of the Law* (apparently *Deuteronomy*) was found in a secret location in the Temple at Jerusalem. Josiah had it read publicly and led a reform movement to concentrate worship at Jerusalem, much as Mohammed was to do at Mecca. Later, Josiah died at the hands of the victorious Egyptian army at Armageddon II.

In modern times Megiddo was the scene in 1918 of the defeat of Turkish forces by the British under General E. H. Allenby (1861-1936). Today, the town is situated at the southern edge of the Plain of Esdraelon 29 km (18 miles) southeast of Haifa.

Armageddon is the Greek transliteration of a Hebrew word. The term may mean "the mountain of Megiddo," referring to Mount

Carmel overlooking the plain of Megiddo. Mount Carmel, a short, rocky mountain ridge covered with gardens and villas, is also important in Biblical history and is considered sacred to Christians, Jews, Muslims, and Bahai. Different readings of the underlying Hebrew or Aramaic produce "city of Megiddo," "fortress of Megiddo," or "land of Megiddo." Other interpretations eliminate Megiddo entirely, in favor of "the mount of assembly" or "his fruitful mountain," and may refer to Mount Zion in Jerusalem.

That Armageddon may refer to Mount Zion in Jerusalem is an interesting theory, and certainly, the ancient city of Jerusalem is part of the scenario, lying only a short distance from Megiddo. It is implied that the battle of Armageddon is also a battle for Jerusalem.

§§§

The Establishment of Jerusalem

The battle of Armageddon has always been associated with the struggle for control of the physical city of Jerusalem, as well as the metaphysical "City of Peace" that is more a state of consciousness than an ancient city that needs to be controlled.

The metaphysical Jerusalem, or "City of Peace" existed in the past under the reign of enlightened Solomonic kings, and is to exist again in the "New Jerusalem" or "New City of Peace." This city has yet to come into existence according to prophecy, but may exist soon.

So we see that there are two Jerusalems: one that is an ancient city occupied by Hittites, Egyptians, Canaanites and Babylonians before the Israelis; and another one that is an idealized utopian city, where peace and prosperity rule, where freedom of religion and commerce are intrinsically part of the society.

This utopian city-state, called variously Jerusalem, the New Jerusalem, the City of Brotherly Love (Philadelphia), the New Atlantis, Zion, Dzyan, and other names, is the dream of a golden age of the past—and the future. This dream of a New Jerusalem is akin to the Rastafarians and their quest for "Zion." This is quite different from (but with similarities to) the quest for a Jewish state with a capital at Jerusalem. The Rastafarian's Zion is clearly some future utopia that is not yet established, and is not likely to be at the present-day location of Jerusalem.

But, in order to understand the modern—and ancient—concept of Armageddon, we must understand the history of Jerusalem and the Middle East and the various religious sects that have come and

gone.

The founding of Jerusalem begins in remote prehistory, apparently in a time before the Flood—a time that some historians call the time of Atlantis and the Land of Osiris in the Mediterranean basin. Massive cities of giant stone blocks were created throughout the area at this time, most of them now being underwater. Some have survived above water, such as the megaliths at Malta, Baalbek, and at the foundation of the temple at Jerusalem.

At the massive temple of Baalbek in the Beka Valley in eastern Lebanon, are giant stones known as ashlars. They are foundation blocks for a large wall on top of which is the temple. At Baalbek, these blocks weigh up to 2,000 tons, and are the largest cut-stone blocks in the world. A Roman temple to Jupiter was built on top of this huge wall about 100 BC.

At Jerusalem is a similar wall of huge ashlar stones, though they are not easily seen. In recent years, the Israelis have opened a tunnel along the base of the Temple Mount inside which these huge blocks can now be viewed.

Says the *Illustrated Dictionary & Concordance of the Bible*, "The earliest reference to Jerusalem is found in the Egyptian Execration (curse) Texts from the 19th century BC. The name itself is apparently of western Semitic (Canaanite) origin, composed of two elements, *yeru*, from a root meaning "to establish, raise up," and *shalem*, the name of a Canaanite god. The El Amarna Letters, an archive of the correspondence of Canaanite kings with their Egyptian masters (14th century BC), contain six letters of the ruler of Jerusalem. Little is known of Jerusalem's pre-conquest history."[9]

The Egyptians had, off and on, controlled the area around Jerusalem, and certainly areas along the coast, like Gaza. Shortly after the first battle of Armageddon in 1482 BC, the Egyptians endured a revolution that some historians say began in Mittani, the land of the Hittites—and the land of the famous queen Nefertiti.

Reincarnation and the Cult of Amun

Cairo was starting to get on my nerves after a few days, and back at my hotel, I realized that it was time to leave and visit the lost city of Akhetaton further south.

I took a share taxi from near the Giza railway station, and was shortly zipping along the west bank of the Nile, dodging camels, donkey carts and women with long robes, scarves and typically some

large jar on their heads. I was sandwiched in the back seat of the Mercedes with several other Egyptians, including a tall, swarthy man in robes and a turban. Behind him sat his wife and daughter. We arrived at at the agricultural Nile city of El Minya around noon. I looked around for a hotel, and found a cheap single at a hotel near the train station. That night I toured El Minya by horse drawn carriage, and then left for Tel El Amarna the next morning.

It was a forty-minute taxi ride to the ferry station on the Nile where one crossed the river to the small Arab village on the other side of Tel El Amarna. When finally at the site of the lost city of Akhetaton, I met a large, dark haired woman named Francis, who with her friend, Della, was visiting Egypt from Chicago.

As we walked around the site we talked about how the rise of the New Kingdom created a new prosperity for Egypt. Egypt became an empire with far-flung foreign influence. There is a great deal of evidence that the Egyptians were off exploring the whole world at this time, including Pacific islands and the Americas. From the ports on the Red Sea, ships went to Punt, to India, to Sumatra, and apparently even to Australia and beyond. The colonization of the Pacific by Egyptian-Libyan fleets most probably occurred at this time. There was a renaissance of building and art, and Egypt controlled large areas of North Africa and the Middle East. Egyptian culture had not been so advanced since the early days of the Old Kingdom.

Something was going to happen, though, during this period that was to shock Egypt greatly, and lead historians and philosophers to debate the subject for thousands of years afterward. Even though the Egyptians themselves went to great extremes to wipe this period of Egyptian history from the records, it is probably the best known period in all of Egypt's many thousands of years of history.

In the year 1353 B.C., the Pharaoh Amenhotep III (also called Amenophis III) died. His oldest son Amenhotep IV then became the Pharaoh by actually marrying his own mother, Tiy. However, Amenhotep IV's father had many wives. One of his wives was a young princess from Mittani, which was a small and little known kingdom in present day Syria. Mittani was settled by Aryans who had come out of Central Asia, and had strong ties with the ancient India of the Rama Empire, as well as the Aryan Vedic invaders of 3000 BC (who may have come out of the Altai Mountains of

Mongolia).

This Mittanian princess was the famous Nefertiti. Amenhotep IV also married Nefertiti, who was legally his step-mother, and she began having children by Akhenaton. They had a stream of daughters, and by the year 1360 BC, Amenhotep IV decided to change his name to Akhenaton, "Glory to Aton," and he and Nefertiti would build a new city on a plain where no city had ever been before. They chose the area at Tel El Amarna to build their city Akhetaton, "City of the Horizon of Aton," for several reasons. Firstly, it was in the geographical center of Egypt. Secondly, it was a fertile plain that was crescent-shaped, with cliffs coming close to the Nile on each end, which would make it easy to defend during a civil war in Egypt. Just such a civil war was brewing, and did in fact occur, though it was largely conducted in secret.

According to Barry Wynne, who wrote the 1972 book *Behind the Mask of Tutankhamun*,[4] Akhenaton became known as the heretic king because he suppressed the Amun priesthood that had long been the true rulers of Egypt. Akhenaton proclaimed that the many gods of Egypt were false and that there was only one god, and that God was Aton, the Sun! Like monastic utopianists, Akhenaton and Nefertiti liberated the people of Egypt (whether they knew it or not) from the thousand-year yoke of the Amun priesthood and the diabolical practices that they followed.

To this day, most Egyptologists do not understand what the battle between the Atonists and the Amun priests was really all about. Probably they will never understand it, because they do not understand the principles underlying the battle. The Dead Sea Scrolls taught that there is a cosmic battle between the "Sons of Light" and the "Sons of Darkness," and such was the battle appeared to be being fought on Egyptian soil during the end of the New Kingdom.

For a thousand years the Amun priests had ruled Egypt by their manipulation of the people through the worship of various gods and goddesses, most of them personified people, such as Osiris and Isis. The god of evil, Set, from which we get our word "Satan," was one of the many gods of Egypt. The religion of Set, like many religions today, was a religion of fear, where, if one gave generously to the temple, then nothing harmful would happen to the person (who was true and faithful).

According to Wynne, another insidious device that was foisted upon the Egyptian people was the cult of mummification, so well identified with ancient Egypt. Mummification was an extremely expensive and time-consuming process. It took 40 nights or more, and generally would cost the deceased's family their entire fortune. And of course, the richer the person (such as a Pharaoh) the more costly the mummification and accompanying ceremonies.

The Atonists abhorred mummification for several good reasons. They believed in reincarnation (as did many Egyptians, and certainly Mittanians like Nefertiti) and the cult of mummification was in direct opposition to their religious beliefs. Atonists believed that the body of a person must completely deteriorate (ashes to ashes, dust to dust) before a person can reincarnate again. This is why Hindus, Buddhists, Jains, Zoroastrians, Coptic Christians, etc., prefer to be cremated or dismembered upon death, so as not to leave any of the former physical body behind.

However, with mummification, the physical body did not deteriorate after death, and in fact, mummies that are thousands of years old have been shown to still have well-preserved tissue in them. In theory, it would be possible to clone or take the genetic codes out of the cells of mummies in Egypt. This, then, at least the Atonists believed, was the most diabolical part of the Amun priest's nefarious activities: the rendering of their victims so that would be unable to reincarnate again, and be trapped on the astral plane for eternity.

With the suppression of the Amun priests, Akhenaton and Nefertiti basked in the peace and quiet of their new capital city in the desert. Things were going well for awhile, until Nefertiti's mother-in-law began interfering with her marriage to Akhenaton. Tiy pointed out that Nefertiti had so far borne six daughters, but no males. Where was the heir to the throne?

Meanwhile, the Amun priests were not idle, and they took care to plot the destruction of Akhetaton, and the demise of those who had suppressed them. According to Philipp Vandenberg in his book, *Nefertiti*,[8] it was actually she who was the power behind the Atonist movement, and it was well known in Egypt that this was true. Nefertiti, as a Mittanian, would have been taught the ancient solar religion of Atlantis and the Rama Empire: a religion of reincarnation, karma, and of different planes of existence. Angels and Archangels

live on higher planes above us, they believe. Archangels are said to live on the sun. Similarly, the sun is the sustainer of all life, as evidenced in the famous "Hymn to Aton."

Akhenaton eventually became estranged from Nefertiti, who was relegated to her own palace at Akhetaton. This was divorce Egyptian-style, and Akhenaton married another woman, whose name has not come down to us. According to legend in Egypt, the Amun priests made a poison ring with which to kill Nefertiti. A messenger was told to take it to the Queen at Akhetaton. The messenger, however, became confused, and the poison ring was given to Akhenaton's new wife, rather than to Nefertiti, for whom it was meant. Akhenaton's new wife then died.

Whether this poisoned queen was the mother of Tutankhamun is debated by historians. At about this time, Smenkhare, Akhenaton's son or brother (no one is quite sure which) became co-regent with Akhenaton and married the oldest daughter of Akhenaton and Nefertiti, Meritaten. It was common in Egypt for brothers and sisters to marry and even for father and daughter or mother and son, as was the case with Akhenaton.

About the year 1348 BC, Vandenberg says that Akhenaton married his daughter Ankhesenpaten, who was only 12 years old at the time. This was probably to further establish the Akhenaton/Nefertiti royal line, because, at about the same time, Smenkhare died at about the age of twenty, probably poisoned by Amun priests. Akhenaton died at about the same time, probably also of poisoning. At some point here, possibly just before Akhenaton's death, probably upon the death of Smenkhare, Meketaten, second oldest daughter of Nefertiti and Akhenaton, apparently attacked the Karnak Temple in Thebes (modern-day Luxor), which was the stronghold of the Amun priests. She and her army were defeated and killed.

Ankhesenpaten then married the young Tutankhaten, who was later to change his name to Tutankhamun, which symbolized the defeat of Atonism, and the triumph of Amunism once again. Nefertiti lived alone in her palace, and Tutankhamun moved back to Thebes, where he too was poisoned at a young age. Legend has it that he was given a poisoned flower, which scratched his cheek. The general Horemheb then became Pharaoh, and asked Nefertiti to marry him. She refused. What happened to Nefertiti after that is not known,

though it is presumed that she lived a lonely life in a deserted city. Her dream of a glorious New Age city had lasted but a few short years. With her death, the Amun priests had the city completely destroyed, and monuments in Thebes and elsewhere with any reference to Akhenaton, Nefertiti or the Aton, were defaced, destroyed, or buried.

§§§

A History of the Hebrews

Shortly after the demise of the Atonists, the 18th Dynasty of Egypt, which had ushered in the New Kingdom, came to a close (1307 BC). The Hebrews had been slaves in Egypt since about 1500 BC. At the beginning of the 19th Dynasty, a man known as Moses appeared on the scene. In the well-known story, he was rescued from a reed raft in the reeds of the Nile by the Pharaoh's daughter, and was harbored by the royal family. In the famous Exodus from Egypt, circa 1280 BC, Moses took "his people" and escaped across the Red Sea. According to Ralph Ellis in *Jesus, Last of the Pharaohs*,[10] Moses had been steeped in the Atonist belief of the One God, being the Sun God, and took with him not only Hebrews (who were present in Egypt during the time of the Atonists), but other Egyptians who believed in the Atonist credo. After an alleged 40 years of wandering around Saudi Arabia and the Sinai Desert, Moses delivered them to the river Jordan, across which he told them was the promised land. He then expired, never to see Zion and the City of Peace himself. Meanwhile, back in Egypt, increasingly weaker Pharaohs presided over a land which continued on a downward spiral under the rule of the Amun priests until the Nubian kings took over in 945 BC.

But back in the Jordan valley, sons of the Pharaohs were setting up a whole new lineage, a line of Sun Kings, or Sons of the Sun. Saul, son of Kish from the tribe of Benjamin, was the first king of Israel, now established in the Jerusalem area after the defeat of Jericho. He probably reigned c.1020-1000 BC, although the exact dates and length of his reign are disputed. Several independent and conflicting stories about how Saul became king are contained in *I Samuel*, Chapters 9-12, but three points seem clear: (1) The desire for a king arose because the loosely organized tribal league could not meet the military threat posed by the Philistines; (2) Saul's military prowess and personal bravery made him a prime candidate; and (3) Samuel, the last

representative of the league, played a major role in the choice of Saul, although he opposed the development of the monarchy and sought to limit the new king's power.

The remainder of *I Samuel* presents Saul's reign, but with a pro-Davidic bias. Saul enjoyed considerable initial success and was responsible for the strength and cohesion of the Hebrew nation. He cleared the Philistines from the central hill country and extended his authority into Judah and northern Transjordan. Samuel soon broke with him, however, and the subsequent lack of religious support, together with Saul's growing envy and suspicion of David, his brilliant young commander, began to destroy Saul's judgment. He ignored the Philistine threat too long and met with disastrous defeat on Mount Gilboa. He killed himself rather than accept capture.

§§§

Some Philistines Were Said to Be Giants

The Philistines were one of a number of Sea Peoples who penetrated Egypt and Syro-Palestine coastal areas during 1225-1050 BC. Of Aegean origin, they settled on the southern coastal plain of Canaan, an area that became known as Philistia. The Sea Peoples raided eastward by land and sea, sacking Troy, toppling the Hittites, devastating Syro-Palestine, even—unsuccessfully—attacking the Nile Delta. They provide a link between the Homeric world and that known from late Egyptian records and early Biblical narratives. The Philistines rapidly adopted the Canaanite language and culture, while introducing tighter military and political organization and superior weaponry based on the use of iron, over which they had a local monopoly. The chief Philistine cities were Ashkelon, Ashdod, Ekron, Gath, and Gaza.

The military rulers of the Philistines extended their rule in Canaan, constantly warring with Israel. The Israelite king David, who had earlier been a Philistine vassal, finally defeated them, succeeding where Samson and Saul before him had failed. Distinctive Philistine artifacts in the Mycenaean tradition, such as the double-handled jug, have been found in archaeological excavations in Palestine (a name derived from Philistia).

The Philistines were said to be giants, however the first reference to giants is in *Genesis* 6:4 which is about the Nephilim, the famous "Giants in the Earth" which married the daughters of men; these were the famous "Sons of God."

Then, in *Genesis* 14:5 we are told of the Rephaim, also giants, who were defeated by the hero-king Chedorloamer and the allied kings of Ashteroth. Also mentioned are the Emims, who dwelt in the wilderness of Moab, "a people great, and many, and tall as the Anakims, which also were accounted giants as the Anakims." (*Deut.* 2:10)

British scholar C.J.S.Thompson mentions the Anakims in his 1930 book *The History and Lore of Freaks*. He says this race of giants dwelt at Hebron, and were the same giants who excited the wonder and alarm of the spies sent by Moses to Canaan. These giants are variously described as the sons of Anak or Anakim, and the descendants of Anak. They were "men of great stature" and according to *Numbers* 13:32, "And there we saw the giants, the sons of Anak which come of the giants; and we were in our own sight as grasshoppers, and so we were in their sight."[12]

In *Deuteronomy* 9:2 they are described as, "A people great and tall, the children of the Anakims, whom thou knowest and of whom thou hast heard say, 'Who can stand before the children of Anak?'"

The land of Ammon "also was accounted a land of giants; giants dwelt therein in old time; and the Ammonites called them Zamzumminms, a people great and many and tall as the Anakims." (*Genesis* 12:12)

Og, King of Bashan, was the last of the race of these giants we are told in the *Book of Joshua*. "All the Kingdom of Og in Bashan, which reigned in Ashtaroth and in Edrei, who remained of the remnant of the giants; for these did Moses smite and cast them out."

Says C.J.S. Thompson, "It is probable that Og, whose story survived in many Eastern legends, was about nine feet in height, although in some accounts he is said to have been taller, and according to the *Targum*, he was 'several miles' in height."[12]

The Bible relates the familiar tales of how giants joined the Philistines and fought against the Hebrews in *II Samuel* (21:15-22) and that "there was a battle in Gath, where was a man of great stature, that had on every hand six fingers, and on every foot six toes, four and twenty in number, and he also was born a giant. And when he defied Israel, Jonathan the son of Shimeah the brother of David slew him."

Goliath, whom David slew with his slingshot, may also have had six fingers and toes and was said to stand six cubits and a span in

height. This is about nine feet, nine inches, a considerable height by any standards. His coat of mail weighed 5,000 shekels of brass, computed to be about 208 pounds.

The Jewish-Roman historian Josephus mentions two pillars, one of stone and one of very hard brick, that were placed by giant men to stand as a monument to their architectural wisdom in the event of a cataclysmic flood such as those in legends. These giants were known as the children of Seth (identified by British author H.T. Wilkins as "giants of the kingdom of Thoth, or Taut of Atlantis..."[11]) and they had erected the two pillars so that one might survive the flood.

Says Josephus, "Now, these pillars remain in the land of Siriad to this day... Noah quitted the land of Seth for fear that his family might be annihilated by the giants. Their span of life had been reduced to 120 years... and Jah turned dry land into sea to destroy the earth... The food of the antediluvians was fitted to maintain a long life, and they observed the stars over the period of the Great Year, that is 600 years... Ephorus and Nicolaus say that the antediluvians had a span of life of 1,000 years. As late as the days of Joshua, son of Nun, there were still giants of Hebron, who had bodies so large and faces so entirely different from other men, that they were surprising to the sight and terrible to the hearing. The bones of these giant men are still shown to this day."[11]

Josephus is affirming to us what the ancient traditions tell: that in antiquity, men in general were larger than the man of today, and they were longer lived. As we read in the *Bible*:

My spirit shall not always strive with man,
for that he also is flesh:
yet his days shall be
a hundred and twenty years.
—Genesis 6:3

The Reign of David, King Solomon & the Glory of Jerusalem

David, was the second and probably the most famous king of Israel (1002-962 BC). His long career, beginning with his tortuous climb to power, is described in *I Samuel* Chapters 16-31, *II Samuel*, and *I Kings* Chapters 1-2. David entered the service of Saul, Israel's first king, but Saul's jealousy finally forced him to flee. He sought refuge first as a bandit leader, then as a Philistine mercenary. After

Saul's death, David returned to Hebron where he was appointed king over Judah and, several years later, following a long civil war with Saul's heir, over Israel.

David consolidated his power in Jerusalem, which he made the political and religious capital of his kingdom. Although the Old Testament records that David was not permitted by God to build a temple, God promised David an "eternal dynasty in Jerusalem." This promise, the religious ideology of Atonist Egypt and David's successful imperial expansion were the sources of Israel's later hope for a messiah. The latter part of David's reign was marred by family problems and numerous revolts, two of them led by his own sons. The Bible portrays these evils as the bitter fruit of his adulterous affair with Bathsheba. David was forgiven, however, and the son that succeeded him was Bathsheba's child, Solomon.

David was also an accomplished musician. Late tradition credits him with organizing the temple choirs, and attributes many of the Psalms to him. Today, the symbol of Ireland is the harp of David, the musical instrument played by the king—a symbol which adorns popular beers and stouts from Ireland to this day.

The son and successor of King David, Solomon, was the third king of Israel, reigning from about 972 BC until his death in 922. David's son by Bathsheba, Solomon was unexpectedly elevated to the throne after his half-brother Adonijah had attempted unsuccessfully to seize the kingship. The young Solomon quickly mastered the situation, ruthlessly eliminating all potential threats to his rule.

His reign was marked by foreign alliances, especially with Egypt and the Phoenicians, and by military strength, and was thus untroubled by major wars or internal revolts, leaving him free to pursue other interests. Solomon fully exploited the economic possibilities of his empire and used the resulting wealth to support vast building projects, the most famous being the Temple in Jerusalem. He was also an author and a patron of literature, although many of the writings attributed to him—for example, the books of *Proverbs*, *Ecclesiastes*, and the *Song of Solomon*—are sometimes said to have been written by some later author. Solomon's success in so many spheres contributed to his legendary reputation for wisdom, but his reign ended with simmering resentment over taxes and religious disputes fostered by his marriages, often to foreign women who were of other religions. The worship of Baal, Isis, and Krishna were all practiced at the time.

Jerusalem under Attack

Nebuchadnezzar II, the most important of the Chaldean, or Neo-Babylonian, kings, reigned from 605 to 562 BC. Although he is called Nebuchadnezzar in the Old Testament, his Babylonian name was Nabu-kudur-usur; modern historians often refer to him as Nebuchadrezzar.

His father, Nabopolassar, was founder of the Chaldean dynasty in Babylonia. An Assyrian-appointed governor of Babylon, he revolted in 626, joined the Medes, and destroyed the Assyrian capital of Nineveh in 612. After driving the last Assyrians into northwestern Mesopotamia, Nabopolassar left military operations in the hands of his son. Nebuchadnezzar dispersed the Assyrians, pushed their Egyptian allies out of Syria, and was about to invade Egypt itself when he received news of his father's death. He returned to Babylon to take the throne.

The Jewish Kingdom of Judah was positioned between two great powers—Egypt and Babylonia. It was unable to remain either independent or neutral; if it joined one side, it would be attacked by the other. In 597 and again in 586 when the kingdom attempted to establish independence, Jerusalem was besieged and captured by Nebuchadnezzar. The second time he destroyed the city and carried off the Jews into their long Babylonian Captivity.

In Babylonia, but most conspicuously in Babylon itself, Nebuchadnezzar engaged in numerous building projects. Babylon was fortified, many temples were constructed, and a great step-pyramid, or ziggurat, the so-called Hanging Gardens, was erected. The last was later numbered among the Seven Wonders of the Ancient World. Bizarrely, Saddam Hussein, the military dictator of Iraq, is said to believe himself to be the reincarnation of the famous Babylonian king.

Events of the last years of Nebuchadnezzar are obscure. Old, even senile, he was perhaps dethroned by his own son. The Biblical book of *Daniel*, in which the king figures prominently, describes him as eating grass and undergoing a physical transformation in his final days. The Dead Sea Scrolls, however, suggest that it was not Nebuchadnezzar, but the last Chaldean king, Nabonidus (r. 556-539), who was afflicted by some such ailment.

The Babylonian Captivity is the name given to the period between 586 and 538 BC when the Jews of the Kingdom of Judah lived in exile in Babylonia. After Nebuchadnezzar II captured Jerusalem and destroyed the first temple in 586, he deported the Judeans to various

Babylonian cities (*Jer.* 52:28-32). When Cyrus the Great conquered Babylonia in 538, he permitted the Jews to return to their homeland.

Jerusalem Restored

Cyrus, 599-530 BC, founded the Achaemenid Persian empire and ruled it from 549 to 530 BC. His father was Cambyses I, a prince in Persis, modern Fars province. His mother, according to Herodotus, was the daughter of Astyages, king of the Medes, who ruled the Persians. Cyrus revolted against his overlord and defeated him, after which the Achaemenid empire was founded. Cyrus first conquered the Iranians who opposed him; it is interesting to note that the current Iranian monarchy traces its history back to him, and proudly celebrated their 2,500th anniversary in 1971. Cyrus the Great then marched against Croesus, king of Lydia (in present-day Turkey). Cyrus defeated him and captured his capital, Sardis. After consolidating his rule over Ionian Greek cities on the coast of the Aegean Sea, he turned to Babylonia.

The conquest of the great and ancient city of Babylon in 539 BC made Cyrus the ruler of a vast domain from the Mediterranean Sea to the borders of India, including Palestine and Jerusalem. According to the *Illustrated Dictionary & Concordance of the Bible*, "Persian policy differed greatly from the Babylonian and Assyrian policy of deportation and brute subjection , and actually encouraged the exiled Israelites to return to their homeland and rebuild the Temple. Cyrus' famous decree (538 B.C.) giving freedom to return to Israel and rebuild the Temple, is recounted in the first chapter of the Book of Ezra. ... The opposition of various parties overcome, the rebuilding of the temple was finally completed in 515/6 B.C., though it was of modest proportions."[9]

The Persian kings ruled over a vast empire extending from the Aegean Sea to the Indus River from 549 to 330 BC. This was the first world empire of antiquity, and many civil institutions first appeared under the Achaemenids' rule. Universal law (the king's law), the postal system, coinage, and other institutions were used, and Zoroastrianism became widespread in this period. The rebuilding of Jerusalem under king Zerubbabel with Nehemiah's guidance brought the city back to prominence, and the city flourished during the rule of the Persians. The first leader was Cyrus the Great, but Darius I, was the real architect of the empire; Darius III, its last monarch, was defeated and succeeded by Alexander the Great.

The *Illustrated Dictionary & Concordance of the Bible* says: "[With]

the conquest of Palestine by Alexander the Great, ...Jerusalem came within the Hellenistic orbit. An attempt was made by the Syrian rulers to establish a parallel Hellenized city on its western ridge. When Antiochus IV Epiphanes attempted to impose Hellenism by force and desecrate the Temple, the revolt led by Judas Maccabee began."[9]

The Maccabees and the Second Temple

The Maccabees were a family of village priests from Modein near Jerusalem who, in 168 BC, instigated an uprising to defend Judaism against both the Seleucids, the Hellenistic rulers of Syrio-Palestine, and Jews who had become Greek assimilationists or Hellenists. The name is derived from the epithet Maccabeus ("hammerer" or "extinguisher") bestowed on the most famous member of the family, Judas. The uprising began when the aged Mattathias killed an apostate Jew who was about to offer sacrifice to Zeus on an altar set up by the Seleucid King Antiochus IV Epiphanes in the Temple precincts at Jerusalem. Mattathias's five sons carried on the uprising, three of them successively in leadership roles: Judas, Jonathan, and Simon.

Assisted by the Hasideans and an army of 6,000, Judas won several victories over Syrian armies and, in 164 BC, occupied the Temple in Jerusalem, building a new altar and fortifying the area. This remarkable event continues to be celebrated as the Festival of Chanukah or Rededication (sometimes also called the Festival of Lights).

Antiochus Epiphanes died in 163 BC, and the Hasideans, satisfied with the victory of the faith, withdrew from further fighting. The struggle nevertheless continued as Judas and his brothers sought political as well as religious liberty. Judas fell in battle in 161 BC, but his brother Jonathan became high priest in 151 BC and captured Ashkelon and Gaza. Simon, the last of the brothers, subdued Acre and was appointed hereditary high priest in 140 BC. Finally, in 139 BC, Judean ambassadors to Rome brought back a senatorial decree recognizing the independence of the Jewish state and commending the Jewish people to the friendship of all kingdoms in the East within the Roman sphere of power.

Simon was murdered in 135 BC, but his son John Hyrcanus consolidated the gains of his father and uncles. The family ruled until 63 BC when Jerusalem was taken by the Roman general Pompey.

The Maccabees, whose determination saved Judaism from extinction, ruled Judea for a century. Their story is told in the Apocryphal books of *I* and *II Maccabees*. It was the Maccabees who rededicated the ancient Temple of Solomon and, apparently, the Ark of the Cov-

enant may have been returned to the temple during this period, though it may have been taken to Ireland by this time (see chapter 8).

Bar Kochba, also known as Simeon ben Koseva, was the leader of the Jewish rebellion against Rome, in AD 132-35. Although most contemporary scholars considered a revolt futile, Rabbi Akiba ben Joseph saw in Simeon "the Son of the Star" (Bar Kochba) and supported the uprising. The rebels avoided open battles, fighting instead from underground fortifications. Jerusalem was conquered. Emperor Hadrian recalled Severus from Britain to oppose Bar Kochba. After a lengthy and heroic defense, the rebellion failed. Fifty fortresses and a thousand villages were destroyed; Jerusalem was renamed Aelia Capitolina (Hadrian's name was Aelius); and a temple to Jupiter was built on the ruins of Solomon's Temple. Bar Kochba died in battle.

This temple to Jupiter, formerly the Second Temple, was then turned into a Moslem mosque at the death of Mohammed in 632 AD. Mohammed died in Jerusalem, or the Roman Aelia Capitolina in that year, and it is believed by Muslims that the footprint of Mohammed is embedded in a stone inside a shrine known as the "Dome of the Rock."

Today, the government of Israel is in control of Jerusalem and the site of this ancient temple—although Jews are officially forbidden to go there, except for the western wall of the temple, known as the Wailing Wall. And Armageddon is scheduled to begin after the Temple is rebuilt a third time, something which the Israelis may have already done: a virtual temple was created at the site in April of 2001, as we will see in a later chapter.

It it obvious, even from this cursory overview, that the land historically known as Palestine has been fractured, divided, sought after and ruled by many tribes and nations throughout its history. The fact that it is currently in dispute is hardly surprising. Watershed events in the history of Christians, Muslims, Jews and others have occurred here. All the physical and metaphysical properties that make this region so important to so many people seem to be valid. The prophecies that predict that this is the place where the kings of the world will gather to fight the ultimate war would seem to be on target—and that's just plain scary.

Bibliography

1. *The Traveler's Key to Ancient Egypt*, John Anthony West, 1985, Alfred Knopf,

New York.

2. *The House of the Messiah,* Ahmed Osman, 1994, Harper-Collins, London.
3. *The Struggle of Nations,* Gaston Maspero, 1896, London.
4. *Behind the Mask of Tutanhkamun,* Barry Wynne, 1972, Souvenir Press, London.
5. *The Curse of the Pharaohs,* Philipp Vandenberg, 1975, J.B. Lippincott Co. Philadelphia, PA.
6. *Secrets of the Great Pyramid*, Peter Tompkins, 1971, Harper & Row, New York.
7. *Egypt Before the Pharaohs*, Michael A. Hoffman, 1979, Alfred Knopf, New York.
8. *Nefertiti*, Philipp Vandenberg, 1978, Hodder and Stoughton, London.
9. *Illustrated Dictionary & Concordance of the Bible*, Geoffrey Wigoder (gen. ed.), 1986, GG The Jerusalem Publishing House Ltd., Jerusalem.
10. *Jesus, Last of the Pharaohs*, Ralph Ellis, 2000, Edfu Books, London
11. *Secret Cities of Old South America*, H.T. Wilkins, 1952, Adventures Unlimited Press, Kempton, IL.
12. *The History and Lore of Freaks*, C.J.S. Thompson, 1930, 1996, Senate, London.

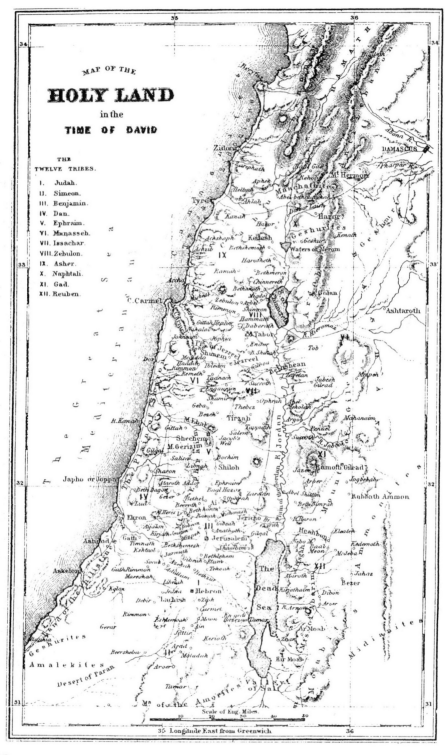

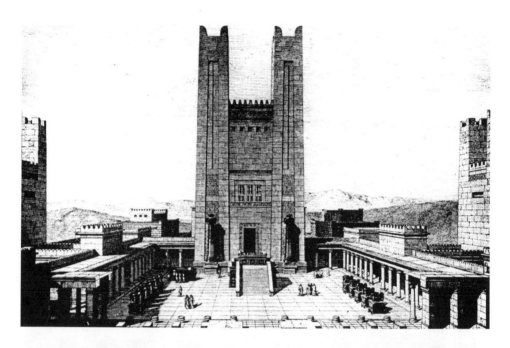

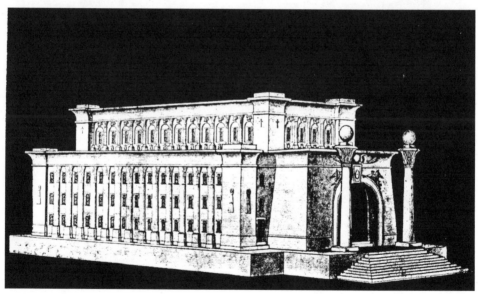

The First Temple at Jerusalem, as restored by the archeologists Mordon (top) and Frisbee (bottom). Notice the Egyptian-looking feel to it.

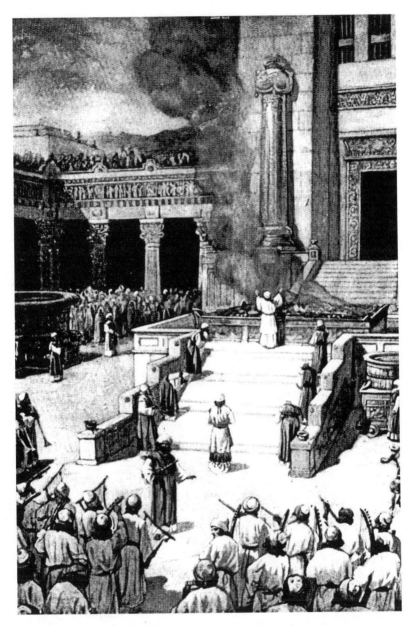

Solomon dedicates the Temple in this old print.

The Second Temple at Jerusalem, or Temple of Zerubbabel, as restored by the archeologist Chipiez. It too looked like an Egyptian temple.

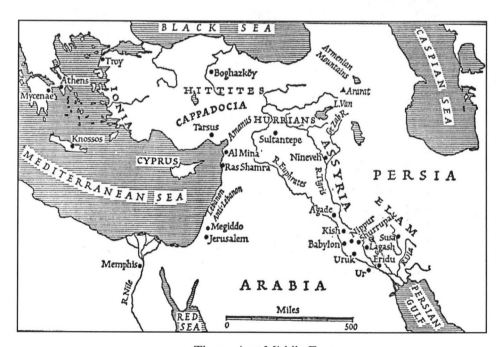

The ancient Middle East.

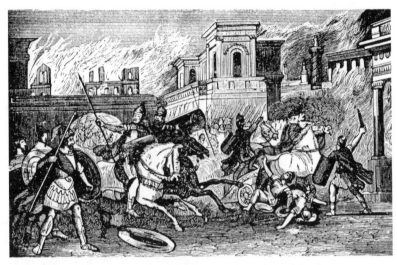

Babylon destroys the First Temple in this old print.

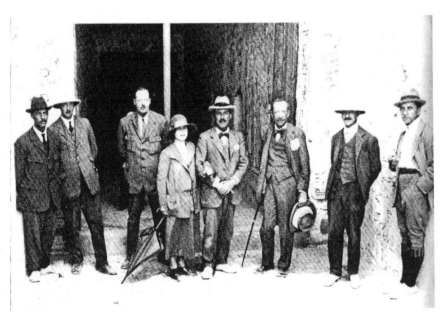

The excavation team of the tomb of Tutankhamun: (From left to right) Arthur Mace, Carter's secretary Richard Bethell, his assistant A.R. Callender, Carnarvon's daughter Evelyn and Howard Carter, Lord Carnarvon, Alfred Lucas and the expedition photographer Harry Burton.

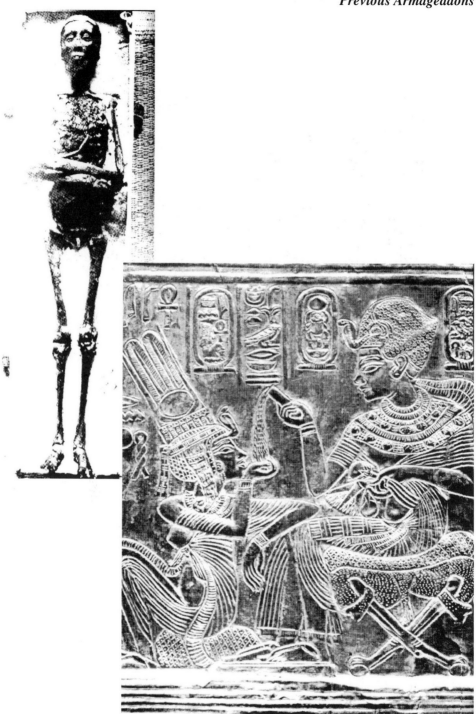

Top: The bare mummy of Tutankhamun. Bottom: Tutankhamun pours perfume to to the outstretched hand of his wife Ankhesenpaten in this gold relief from his tomb.

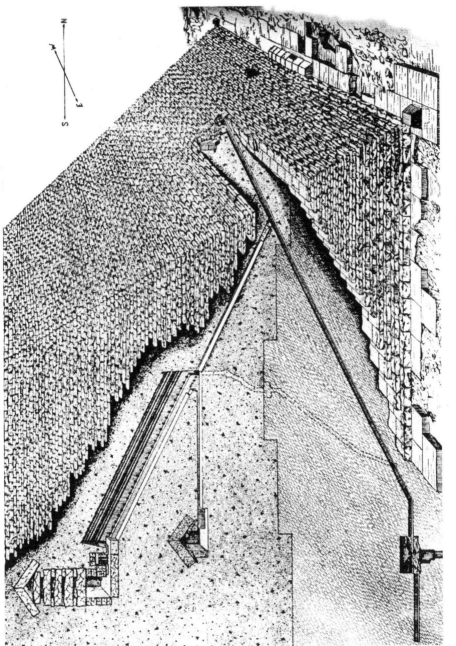

The passages in the interior of the Great Pyramid.

2.
Beneath the Andes— Inside the Tunnels of South America

Let him that would move the world,
first move himself.
—Socrates

It is only when we forget all our learning that we begin to know.
–Henry David Thoreau (1817-1862)

My interest in South America was considerable. Of all the continents that I had traveled through, South America was the most mysterious, the most adventurous, the most dangerous. After my early journeys to South America starting in 1983, I had written my third lost cities book, *Lost Cities and Ancient Mysteries of South America,* published in 1986. But I returned almost every year from 1986 to 1992, and again in 1999. What I was to find during these trips bordered on the incredible: an ancient tunnel system beneath the Andes, what appeared to be an underwater UFO entrance, and vestiges of lost cities.

I look back at those times in wonder. During those years I hitchhiked in trucks over the Cordillera Blanca from Huaraz to the strange underground ruins of Chavin. I visited Samaipata again in Bolivia, and made a number of trips around Cuzco, including expeditions to Paititi, and another lost city east of Cuzco known as Yanantin Orco, or the Black City. A witness told a guide and myself on one expedition that Yanantin Orco was on a high ridge east of the Urubamba River. He said that the city was larger than Machu Picchu and built out of large stones. Sadly, we were never

able to reach this lost city, though we mounted several expeditions during the years of 1988 through 1990. One day I plan to return to mount another search.

On these trips I visited Chile, Easter Island, Argentina, Brazil and Paraguay as well. These journeys have taken me to jungle ruins, lonely villages, and tunnels inside the earth. Although it seems incredible, there is a great deal of evidence to show that a network of ancient tunnels exists throughout much of South America. Legends abound on this tunnel system, and I can state that I have even been inside some of the tunnels on this strangest of continents.

The Gold of the Incas

Legends of tunnels in South America surfaced almost immediately after the conquest when the Spaniards discovered that the Incas had hidden much of their treasure—sacred relics of pure gold—either beneath the Inca capital of Cuzco or in a secret city known as Paititi. Either way, legend had it that a tunnel system was used.

The history of the conquest of the Inca empire by the Spanish is one of the most bizarre and incredible stories of history. That Francisco Pizarro with only 183 men could conquer a sophisticated empire of several million people is a feat that has never been equaled, and probably never will be!

Pizarro made his first expedition down the Pacific Coast from Panama in 1527, attracted by rumors of gold and other treasure. A Greek of his company went alone from the ship into an Inca village on the coast, and was taken to be a returning god by the natives. They brought him to a temple filled with more gold than he had seen in his life. Returning to the ship, he told Pizarro about the fabulous wealth he had seen. Satisfied that the rumors were true, Pizarro returned to Panama and then to Spain to prepare another expedition. He set out again in 1531, landed on a lonely beach in Ecuador and began marching inland. He was entering the newly united Inca empire, which had just recovered from a civil war. The people of Peru, Bolivia, and rest of the Inca empire were not all true Incas, but largely Quechua and Aymara Indians. Incas were the ruling elite, of a different race, who believed themselves descended from "Manco Capac," a red-haired,

bearded messenger from God.

After taking the town of Tumbez and putting quite of few of the people to death, the Spanish conquistadors continued their march south. At Cajamarca, they were received by Inca royalty with great pomp, splendor, and gifts. The ruler of the Incas (whose correct title is "the Inca") was impressed by reports of their beards and white skin, believing them to fulfill a prophecy about the return of Viracocha, the legendary bearded prophet from a far-away land who had visited the South American peoples many hundreds of years before. American Indians have no facial hair, though the first Incas are said to have had reddish-brown hair and beards, like Viracocha. Therefore, the Inca Atahualpa believed that the Spanish were Incas themselves, Sons of the Sun, gods in their own right, just as he was a god.

The conquistadors remained in Cajamarca for a time, while Atahualpa sent them gifts. The local people, who did not keep horses, assumed that because the Conquistador's horses constantly chewed on their bits, these were the horses' fodder. The Incas would put bars of gold and silver in the horses' feeding troughs, saying, "Eat this, it is much better than iron." The Spaniards found this quite amusing, and encouraged the Indians to keep bringing gold and silver for the horses to eat!

Finally, Atahualpa himself came to the Spaniards from his nearby palace. During this audience inside the walls of Cajamarca, Atahualpa had with him no less than 30,000 men, all under strict command not to harm the Spaniards, even if they themselves were attacked. This prohibition proved to be their downfall. The conquistadors kept many of their men in hiding, ready to attack, as Pizarro and his generals with the Dominican friar Vincente de Valverde had their audience with Atahualpa in the town square.

The Inca welcomed them as Viracocha Incas and fellow Sons of the Sun. Then the friar Valverde addressed the Inca, telling him about the one true faith, and the most powerful men on earth, the Pope and King Charles of Spain. After a long speech translated by the Indian Felipe, the Inca asked the source of the friar's material, who responded by handing the Inca a Bible. The Inca placed it to his ear. Hearing nothing, he threw it to the ground.

This rather unpious gesture from Atahualpa was just what the

conquistadors were waiting for. The Spaniards attacked in full force, many from hiding, and began a slaughter of the Inca guard. They killed thousands it was claimed, many of whom were trying to escape. Not one conquistador was hurt, with the exception of Francisco Pizarro himself, who was wounded by one of his own men as he reached for Atahualpa.

And so was Atahualpa kidnaped by a mere 160 gold-crazed conquistadors (some of the original 183 had died of disease and in earlier battles). To secure his freedom, Atahualpa offered to give the Spaniards gold in exchange for his release. Sensing that they still did not realize the fabulous wealth at his command, Atahualpa stood up in the room in which he was imprisoned and reached as high as he could; he offered to fill the room with gold to that height in return for his release. The Spaniards agreed.

Complicating the story at this point were several intrigues. First, there was a great rivalry between Francisco Pizarro, his brother Ferdinand, and Don Diego de Almagro. Indeed, Francisco Pizarro and de Almagro were bitter enemies. Second, Atahualpa was still at odds with his brother Huascar, who by many accounts was the legitimate heir to the Inca throne. It had been the civil war between the two brothers that had weakened the Inca empire just prior to the arrival of the Spanish. While he was still in captivity, Atahualpa ordered Huascar arrested, believing him to be plotting a takeover of the empire. Both Atahualpa and Huascar now took a rather fatalistic attitude to the events taking place, as their father had predicted such a conflict before his death.

Third, most of the subjects of the Inca empire were not Incas, who spoke Quechua, but common Indians of entirely different races and cultural heritages. Few were loyal to the Incas, and many of them eventually sided with the Spanish. Finally, again from captivity, Atahualpa ordered his brother Huascar killed, thinking this would save the empire from him, believing that the Spaniards may not release him even after the ransom was paid. All of these factors together set the stage for the fall of the greatest civilization extant in the Western Hemisphere at the time.

It took some time for the gold to reach Cajamarca, as it had to be brought from Quito, Cuzco, and other cities that were hundreds of miles away. While the ransom was being gathered,

Pizarro sent some of the conquistadors as emissaries to Quito and Cuzco to ensure that Atahualpa had not ordered an assault on Cajamarca. When they returned, they reported that fabulous wealth was to be found in these cities. The Incas did not use gold, silver, and precious stones for currency as Europeans and other cultures did. Instead, they were valued for decoration, and used extensively for religious objects, furnishings, and even utensils. Many buildings had interior gold-lined walls, and exterior gold rain gutters and plumbing. Therefore, when the Inca was ransomed for a room full of gold, to the Incas it was as if they were paying with pots and pans, old plumbing, and rain gutters!

These were sent gladly, though religious objects and those with aesthetic value were not. The ransom paid has been estimated to have been 600-650 tons of gold and jewels and 384 million "pesos de oro," the equivalent of $500,000,000 in 1940. Given the rise in the price of gold since then, today that ransom would be worth almost five billion dollars.

Not surprisingly, once the ransom was paid, Atahualpa was not released. The Indian interpreter, Felipe, had fallen in love with one of Atahualpa's wives, and he was keen to see that the Inca king did not survive. He spread the rumor that Atahualpa was raising an army to storm Cajamarca. This being the only excuse the Spaniards needed to execute the Inca, he was condemned to death. Spaniards who had befriended Atahualpa advised him to convert to Christianity before his execution, which would allow the Dominical fathers to strangle him as a Christian rather than burn him at the stake as a heretic. He complied, was baptized, then strangled. This was done even though more gold was on its way, as part of a second ransom, worth much more than the first.

Meanwhile, three Spanish emissaries came back from Cuzco, the Inca capital, with even more treasure, looted from the Sun Temple. They brought an immense cargo of gold and silver vessels loaded on the backs of 200 staggering, sweating Indians. And the second ransom train of 11,000 llamas was on its way to Pizarro's camp. Loaded with gold, it had been sent by Atahualpa's queen from Cuzco. But when they heard of the Inca's assassination, the Indians drove the llamas off the road and buried the 100 pounds of gold that each animal carried.

Sir Clements Markham, who had a particularly keen knowledge of Peru, believed that the gold was hidden in the mountains behind Azangaro. The Cordillera de Azangaro is a wild sierra little known to foreigners, the name in Quechua meaning, "place farthest away." It is believed that this was the easternmost point in the Andean cordilleras which the old Inca empire dominated. This area east of Cuzco, Pisac and Machu Picchu is thought to contain a lost city called Paititi (Paikikin, originally in Quechua). Legends maintain that portions of the lost treasure of the Incas was sent to this mountain jungle city, including the 14 gold-clad mummies of the previous Inca kings.

Other versions of the story of the lost treasure say that many gold artifacts was hidden in a system of tunnels that is said to go stretch through much of the central Andes, with an underground vault called the Garden of the Sun somewhere near Cuzco.

One fantastic story involves the subterranean chamber known as "The Garden of the Sun." Sarmiento, a Spanish historian (1532-1589), wrote that this subterranean garden was located near the Temple of the Sun. "They had a garden in which the lumps of earth were pieces of fine gold. These were cleverly sown with maize—the stalks, leaves and ears of which were all of gold. They were so well planted that nothing would disturb them. Besides all this, they had more than twenty sheep with their young. The shepherds who guarded the sheep were armed with slings and staves made of gold. There were large numbers of jars of gold and silver pots, vases, and every kind of vessel."[2]

Shortly after the conquest of Peru, Cieza de Leon, part Inca and part Spanish, wrote, "If all the gold that is buried in Peru... were collected, it would be impossible to coin it, so great the quantity; and yet the Spaniards of the conquest got very little, compared with what remains. The Indians said, 'The treasure is so concealed that even we, ourselves, know not the hiding place!'

"If, when the Spaniards entered Cuzco they had not committed other tricks, and had not so soon executed their cruelty in putting Atahualpa to death, I know not how many great ships would have been required to bring such treasures to old Spain as is now lost in the bowels of the earth and will remain so because those who buried it are now dead." [2, 3]

What Cieza de Leon did not say was that, although the Indians as a whole did not know where this treasure lay, there were a few among them who did know and closely guarded the secret.

After seeing the fineness of the treasures in Atahualpa's first ransom, Pizarro had demanded that he be shown the source of this fabulous wealth before he would release the Inca. He had heard that the Incas possessed a secret and inexhaustible mine or depository, which lay in a vast, subterranean tunnel running many miles underground. Here was supposedly kept the accumulated riches of the country.

However, legend has it that Atahualpa's queen consulted the Black Mirror at the Temple of the Sun, a sort of magic mirror similar to that in the story of Snow White. In it she saw the fate of her husband, whether she paid the ransom or not. She realized that her husband and the empire were doomed and that she must certainly not reveal the secret of the tunnels or wealth to the gold-crazed conquistadors.

The horrified queen ordered that the entrance to the great tunnel be closed under the direction of the priests and magicians. A large door into a rocky wall of a cliff gorge near Cuzco, it was sealed by filling its depths with huge masses of rock. Then the disguised entrance was hidden under green grass and bushes, so that not the slightest sign of any fissure was perceptible to the eye.

Conquistadors, adventurers, treasure hunters, and historians have all wondered about and pursued this legend. What incredible treasure did the Incas seal into these tunnels? And as to the tunnels themselves, when and how were they made, and where do they go?

§§§

Inside the Andes

Researchers like Harold Wilkins believed that the tunnels run from the central Andes around Cuzco for hundreds of miles north and south through the mountains, as far as Chile and Ecuador. Wilkins believed that there were other spurs of these tunnels that ran to the east, coming out at the lost city of Paititi in the high

jungle somewhere. Another spur was said to run to the west, down to the coastal desert of Peru. This spur of the tunnel system could have come out near Lima, the area of the ancient Inca city of Pachacamac, or near Pisac and the Candlestick of the Andes, which is further south along the coast.

Wilkins believed, as did apparently Madame Blavatsky (founder of The Theosophical Society), that a spur of the ancient tunnel system came out in the Atacama Desert near to Arica and the current border between Chile and Peru, which is further south still. Madame Blavatsky related the story, retold by Wilkins, of the ancient treasure and tunnel system. [2, 3]

Sometime around the year 1844, a Catholic priest was called to absolve a dying Quechua Indian. Whispering quietly to the priest, the old Indian told an amazing story about a labyrinth and a series of tunnels built long before the days of the Inca emperors of the Sun. It was told under the inviolable seal of the confessional, and could not be divulged by the priest under pain of death. This story would probably never have been told, except that the priest, while traveling to Lima, met with a "sinister Italian." The priest let out a hint of great treasure, and was later supposedly hypnotized by the Italian to get him tell the story!

"I will reveal to thee what no White man, be he Spaniard, or American, or English, knows," the dying Indian had said to the priest. He then told of the queen's closing of the tunnels when the Inca Atahualpa was being held captive by Pizarro. The priest added under hypnosis that the Peruvian government, in about 1830, had heard rumors of these tunnels and sent an expedition out to find and explore them. They were unsuccessful.[2]

In another similar story, the Father Pedro del Sancho tells in his *Relacion* that in the early period of the conquest of Peru, another dying Indian made a confession. Father del Sancho wrote, "...my informant was a subject of the Incan emperor. He was held in high esteem by those in power at Cuzco. He had been a chieftain of his tribe and made a yearly pilgrimage to Cuzco to worship his idolistic gods. It was a custom of the Incas to conquer a tribe or nation and take their idols to Cuzco. Those who wished to worship their ancient idols were forced to travel to the Incan capital. They brought gifts to their heathen idols. They were also

expected to pay homage to the Incan emperor during these journeys."

Del Sancho continues, "These treasures were placed in ancient tunnels that were in the land when the Incas arrived. Also placed in these subterranean repositories were artifacts and statues deemed sacred to the Incas. When the hoard had been placed in the tunnels, there was a ceremony conducted by the high priest. Following these rites, the entrance to the tunnels was sealed in such a manner that one could walk within a few feet and never be aware of the entrance.

"...My informant said that the entrance lay in his land, the territory which he ruled. It was under his direction and by his subjects that the openings were sealed. All who were in attendance were sworn to silence under the penalty of death. Although I requested more information on the exact location of the entrance, my informant refused to divulge more than what has been written down here."

Another interesting story of the tunnels around Cuzco and the incredible treasure they contain involves Carlos Inca, a descendant of an Inca emperor, who had married a Spanish lady, Dona Maria Esquivel. His Castilian wife thought that he was not ambitious enough, and that he did not keep her in the style she deemed befitting her rank, or his descent.

Poor Carlos was plagued night and day by his wife's nagging, until late one night, he blindfolded her and led her out into the patio of the hacienda. Under the cold light of the stars, when all around were asleep and no unseen eye was on the watch, he began to lead her by the shoulders. Although he was exposing himself to many risks including torture and death at the hands of the Quechuas, he proceeded to reveal his secret. He twirled her around three times, then, assuming her disoriented, led her down some steps into a concealed vault in or under Sacsayhuaman Fortress. When he removed her blinds, her tongue was finally silenced. She stood on the dusty, stone floor of an ancient vault, cluttered with gold and silver ingots, exquisite jewelry, and temple ornaments. Around the walls were life-size statues of long-dead Inca kings. Only the golden Disk of the Sun, which the old Incas treasured most, was missing.

Carlos Inca was supposedly one of the custodians of the secret hiding place of Inca treasure that eluded the Spanish and other treasure seekers for centuries. The U.S. Commissioner to Peru in 1870 commented on this episode: "All I can say is if that secret chamber which she had entered has not been found and despoiled, it has not been for want of digging... Three-hundred years have not sufficed to eradicate the notion that enormous treasures are concealed within the fortress of Cuzco. Nor have three-hundred years of excavation, more or less constant, entirely discouraged the searchers for tapadas, or treasure mounds."[1, 2, 3]

There certainly appears to be some repetition and borrowing between some of these stories. Yet most historians and archaeologists believe that they are based on some fact. That tunnels and lost treasure exist, there seems to be no doubt. But the real questions are, Where are they?, and, Who made them?

We may be about to find out, as a team of investigators from Spain has recently recieved permission to use ground penetrating radar (GPR) to explore for tunnels beneath the Temple of the Sun in Cuzco. The press conference, held on March 23, 2001 at the prestigious Casa de América in Madrid, in conjunction with the Peruvian Embassy in Spain, said that the Bohic Ruz Explorer Society of Spain "will open one of the greatest mysteries of our time,"—namely the opening of these ancient tunnels, long sealed off by the early Peruvian government.

"We have found important structures and evidence of galleries constructed underneath the Koricancha. These discoveries will capture the imagination of the world and has the potential to rival the finding of King Tut's Tomb in Egypt," said Anselm Pi Rambla, President of the Bohic Ruz Explorer Society.

News reports from Madrid quoted Rambla as saying, "Many investigators over the past 400 years have reported the existence of these subterranean galleries in the area of Sacsayhuaman that are connected to the Inca Temple of the Sun by a two-kilometer tunnel. These tunnels run throughout the city of Cusco and legends say that the lost gold of the Incas are hidden in these tunnels."

The Bohic Ruz Explorer Society was to begin their GPR search in the near future, though it was not specified when. With the

constant unrest in Peru, it is difficult to say when the tunnels beneath Cuzco will be entered and mapped. Perhaps portions of the lost treasure of the Incas will be discovered. Now, that would be a find!

<div align="center">§§§</div>

The Tunnels Beneath the Fortress of Sacsayhuaman

Above Cuzco is the awesome stone fortress of Sacsayhuaman. It contains tunnel entrances that are sealed and the visitor can walk a short distance inside some of the tunnels, but they are ultimately blocked after 20 or 30 feet.

All over Sacsayhuaman gigantic blocks of stone, some weighing more than 200 tons (400 thousand pounds) are fitted together perfectly. The enormous stone blocks are cut, faced, and fitted so well that even today one cannot slip the blade of a knife, or even a piece of paper between them. No mortar is used, and no two blocks are alike. Yet they fit perfectly, and it has been said by some engineers that no modern builder with the aid of tools of the finest steel could produce results more accurate.

Each individual stone had to have been planned well in advance; a 20-ton stone, let alone one weighing 80 to 200 tons, cannot just be dropped casually into position with any hope of attaining that kind of accuracy! The stones are locked and dovetailed into position, making them earthquake-proof. Indeed, after many devastating earthquakes in the Andes over the last few hundred years, the blocks are still perfectly fitted, while the Spanish Cathedral in Cuzco has been leveled twice.

Though this fantastic fortress was supposedly built just a few hundred years ago by the Incas, they leave no record of having built it, nor does it figure in any of their legends. How is it that the Incas, who reportedly had no knowledge of higher mathematics, no written language, no iron tools, and did not even use the wheel, are credited with having built this cyclopean complex of walls and buildings? Frankly, one must literally grope for an explanation, and it is not an easy one.

When the Spaniards first arrived in Cuzco and saw these structures, they thought that they had been built by the devil himself,

because of their enormity. Indeed, nowhere else can you see such large blocks placed together so intricately. I have traveled all over the world searching for ancient mysteries and lost cities, but I had never in my life seen anything like this! Some historians have stated that the fortress was built a few hundred years before the Spanish invasion, but, the Incas could not recall exactly how or when it was built!

The Spanish dismantled as much of Sacsayhuaman as they could. When Cuzco was first conquered, Sacsayhuaman had three round towers at the top of the fortress, behind three concentric megalithic walls. These were taken apart stone by stone, and the stones used to build new structures for the Spanish.

Sacsayhuaman was also equipped with a subterranean network of aqueducts. Water was brought down from the mountains into a valley, then had to ascend a hill before reaching Sacsayhuaman. This indicates that the engineers who built the intricate system knew that water rises to its own level.

Garcilaso de la Vega, who wrote just after the conquest, said this about the tunnels beneath Sacsayhuaman: "An underground network of passages, which was as vast as the towers themselves, connected them with one another. This was composed of a quantity of streets and alleyways which ran in every direction, and so many doors, all of them identical, that the most experienced men dared not venture into this labyrinth without a guide, consisting of a long thread tied to the first door, which unwound as they advanced. I often went up to the fortress with boys of my own age, when I was a child, and we did not dare to go farther than the sunlight itself, we were so afraid of getting lost, after all that the Indians had told us on the subject…the roofs of these underground passages were composed of large flat stones resting on rafters jutting out from the walls."[2, 3]

There are indeed tunnels that one may enter at Sacsayhuaman and nearby Qenqo. If one walks behind the Inca's stone seat inside the fortress toward Qenqo, one will find all sorts of bizarre stone cuttings, upside-down staircases, and seemingly sensless rock carving on a grand scale. There are also tunnel entrances in this area. Various rock-cut tunnels lead down into the earth, and at least one goes to another part of the mountain area of Qenqo.

All of these tunnels are blocked at some point and this area of Sacsayhuaman is still being excavated by Peruvian archaeologists. The area is very fascinating, but it seems quite clear that one cannot penetrate into the tunnels beneath Cuzco from these now-blocked tunnel entrances.

The old chroniclers say the tunnels were connected with the Coricancha, a name given to the Sun Temple and its surrounds in old Cuzco.

The Coricancha was originally larger than it is today and contained many ancient temples, including the Temples of the Sun and the Moon, and all of these buildings were believed to be connected with Sacsayhuaman by underground tunnels. The place where these tunnels started was known as the Chincana, or "the place where one gets lost." This entrance was known up until the mid-1800s, when it was walled up.

In his book *Jungle Paths and Inca Ruins*, Dr. William Montgomery McGovern states: "Near this fortress [Sacsayhuaman] are several strange caverns reaching far into the earth. Here altars to the Gods of the Deep were carved out of the living rock, and the many bones scattered about tell of the sacrifices which were offered up here. The end of one of these caverns, Chincana, has never been found. It is supposed to communicate by a long underground passage with the Temple of the Sun in the heart of Cuzco. In this cavern is supposed, and with good reason, to be hidden a large part of the golden treasure of the Inca Emperors which was stored away lest it fall into the hands of the Spaniards. But the cavern is so huge, so complicated, and its passages are so manifold, that its secret has never been discovered.

"One man, indeed, is said to have found his way underground to the Sun Temple, and when he emerged, to have had two golden bars in his hand. But his mind had been affected by days of blind wandering in the subterranean caves, and he died almost immediately afterwards. Since that time many have gone into the cavern—never to return again. Only a month or two before my arrival the disappearance of three prominent people in this Inca cave caused the Prefect of the Province of Cuzco to wall in the mouth of the cavern, so that the secret and the treasures of the Incas seem likely to remain forever undiscovered."[1, 2, 3]

Another story, which may well be derived from the same source, tells of a treasure hunter who went into the tunnels and wandered through the maze for several days. One morning, about a week after the adventurer had vanished, a priest was conducting mass in the church of Santo Domingo. The priest and his congregation were astonished to hear sudden, sharp rappings from beneath the church's stone floor. Several worshipers crossed themselves and murmured about the devil. The priest quieted his congregation, then directed the removal of a large stone slab from the floor (this was the converted Temple of the Sun!). The group was surprised to see the treasure hunter emerge with a bar of gold in each hand.

Even the Peruvian government got into the act of exploring these Cuzco tunnels, ostensibly for scientific purposes. The Peruvian *Seria Documental del Peru* describes an expedition undertaken by staff from Lima University in 1923. Accompanied by experienced speleologists, the party penetrated the trapezoid-shaped tunnels starting from an entrance at Cuzco.

They took measurements of the subterranean aperture and advanced in the direction of the coast. After a few days, members of the expedition at the entrance of the tunnel lost contact with the explorers inside, and no communication came for twelve days. Then a solitary explorer returned to the entrance, starving. His reports of an underground labyrinth of tunnels and deadly obstacles would make an Indiana Jones movie seem tame by comparison. His tale was so incredible that his colleagues declared him mad. To prevent further loss of life in the tunnels, the police dynamited the entrance.[1,2,3]

More recently, the big Lima earthquake of 1972 brought to light a tunnel system beneath that coastal city. The important pyramid center of Pachacamac lies on the southern edge of Lima, and other ancient mud-brick pyramids still exist in areas of Peru's largest city. During salvage operations, workers found long passages no one had ever known existed, although the subsequent systematic examination of Lima's foundations led to the astonishing discovery that large parts of the city were undercut by tunnels, all leading into the mountains. But their terminal points could no longer be ascertained because they had collapsed during the course of

the centuries. Did the Cuzco tunnels explored in 1923 lead to the Lima area?

§§§

A Tunnel in Eastern Bolivia

With several old friends from the World Explorers Club, including Carl Hart, Steve Yenouskas, Larry Frego and Raul Fernandez, I journeyed to Peru and Bolivia to discover what we could of the tunnels in South America. After a week in Peru, we set off one day from Cuzco for Tiahuanaco. Once there, we camped for a night near the ruins. Tiahuanaco had few visitors at that time, and the museum was shut for years in a long remodelling process. When I returned in 1999 I was amazed to see that the museum was one of the best and most bizarre museums in South America, especially its large collection of elongated skulls.

The WEX crew returned to La Paz for a night and then continued by bus to the strange hilltop city of Samaipata in the mountain jungles of eastern Bolivia. I had visited Samaipata by myself in the mid-80s, and wrote about the strange "fort" in my book *Lost Cities & Ancient Mysteries of South America*. At the time, I was the 153rd person to visit the site since it had been opened to the public in 1974.

Erich von Daniken had visited the site in the early 70s and had described it as a "rocket launching pad" for alien visitors. The site itself was bizarre enough: high on the summit of the mountain was a large outcrop of rock that had been cut into various rooms, channels, pools, chairs, petroglyphs and odd, crisscross grooves.

The whole place was extremely ancient and worn, and apparently there had once been walls and buildings that were now long gone. A large jaguar was carved into the solid rock at the western end of the "fort." Was Samaipata a cult center for the jaguar? Was it a mining city? Or possibly a remote fort on the eastern edge of the mountain highlands, watching over the lower valleys to the east? No archaeologist has so far come up with an answer to Samaipata, including who built the "city" and when. On a *National Geographic* map of archaeological sites in South America

that I carried with me, Samaipata was not even listed.

The strangest part of Samaipata was a feature that was hidden in the jungle about a 100 meters south of the main fort, a tunnel into the ground that was called by the locals the *Camino de la Chinchana,* or the "Path of the Subterranean."

The *Camino de la Chinchana* was a tunnel that began as a two-meter opening to a pit that went straight down for about 6 meters. Once one had made the first descent down to the floor of the pit, something that would take a rope or a ladder, then one would find himself standing in a tunnel that was high enough and wide enough for a man to stand without stooping. This tunnel then descended downhill from the fort, apparently going in a north-west direction.

According to the caretaker of Samaipata, the tunnel had been explored once by Bolivian archaeologists who had entered the pit with a rope and had advanced some 100 meters or more into the tunnel. The air became stale and a small cave-in had blocked a portion of the tunnel. Without proper breathing gear, the team was unable to advance any further into the earth.

The tunnel was clearly man-made, and at least around the entrance, it was dug out of dirt, rather than cut out of solid rock. I asked the caretaker of Samaipata where this tunnel was supposed to go. He pointed to the north, across the valley, to a mountain about 15 kilometers away. This mountain looked something like the back molar in a row of teeth.

"There," he said, pointing to the mountain, "there to *La Muela el Diablo,* is where the archaeologists say that the tunnel goes. On that mountain is supposed to be another city, just as here."

Using my dictionary, I translated *La Muela el Diablo* as "The Devil's Dimple." This tunnel was said to run from the top of the mountain of Samaipata down to the valley, beneath a river, and then up to a mountain on the other side.

In 1990 Carl, Steve, Raul and I made a brief search of the area around the Devil's Dimple but could not find evidence of any lost city or of a tunnel entrance. It was a cursory exploration that proved or disproved little. Still the fact remained that the entrance to a bizarre man-made tunnel, one that was apparently thousands of years old, existed at the weird ruins of Samaipata.

Was it the entrance to a lost mine used thousands of years ago? Was it a spur of the legendary tunnels near Cuzco? The thought that one might be able to enter into a vast labyrinth of tunnels beneath the Andes by entering the *Camino de la Chinchana* was an exciting thought. The entrance still exists at Samaipata, waiting for a bold adventurer with the right equipment to discover its secrets. But for myself and Carl, we were to continue on to Brazil and the even more intriguing tunnel entrance at Sao Tomé das Lettres near Sao Paulo.

§§§

The Tunnel Beneath Sao Tomé das Lettres

Our WEX team had to split up, with Steve and Raul returning to Peru and the U.S., while Carl and I headed down to Corumba, the Bolivian bordertown with Brazil. From there we took a bus through the Matto Grosso to Sao Paulo, the largest city in South America.

In Sao Paulo Carl and I visited my Brazilian publisher and various Brazilian friends. I had received a letter from a Brazilian woman who had read the Portuguese version of my book *Lost Cities & Ancient Mysteries of South America* and had written me a letter concerning the opening to a tunnel system at the resort mountain town of Sao Tomé das Lettres. Her name was Marli and she worked at one of the many banks in Sao Paulo.

Carl and I met with Marli one night for dinner and she told us about the town and the tunnel entrance. Sao Tomé das Lettres is Portuguese for "Saint Thomas of the Letters" and is the rather long name of a small town north of Sao Paulo that, like Samaipata in Bolivia, is on the top of a mountain. Sao Tomé das Lettres is in fact a well-known tourist town in Sao Paulo state, though I had never heard of it. Being on top of a mountain, it had good views, was cooler than Sao Paulo, and offered hiking trails, good restaurants and an artist colony for atmosphere. It also had the entrance to a man-made tunnel system, a feature well known to visitors of the small town.

Carl and I suggested to Marli that the three of us take a trip to Sao Tomé das Lettres and see the entrance to the tunnel system.

She agreed to accompany the two of us as our guide and inter-preter. We left the next day, taking a bus for some four or five hours out of Sao Paulo, heading on a major highway toward the city of Belo Horizonte in the state of Minas Gerais.

Soon the bus turned off the main road and headed up a nar-row paved road for some distant, low mountains. Eventually the road wound its way to the top of one of the mountains and we found ourselves in Sao Tomé das Lettres.

Carl, Marli and I grabbed our luggage from beneath the bus and stood on the cobblestone street at the lower edge of town. There were many quaint houses, all made of well carved stone with tile roofs and small windows. I noticed that stonework and even stacks of stone slate, was everywhere. Sao Tomé das Lettres was not only a tourist town, it was also a mountaintop quarry.

We walked up the main street and found a small hotel to spend the night, leaving our packs and other luggage in the hotel. By now it was late afternoon and we had only time to walk about town and familiarize ourselves with this pleasant area.

Later, Marli took us to a local restaurant where a crowd of young people had gathered to hear the local restaurant owner talk about the mysteries of Sao Tomé das Lettres. He was a large man, in his 50s, who spoke in Portuguese to the 20 or so people gathered in his restaurant.

The crowd listened intently as the man spoke and occasion-ally I asked Marli what he was saying.

"He is talking about the tunnel that is at the northern edge of town," said Marli, whispering to me. "He says that the tunnel is open as far as anyone has ever walked through it. At no place is the tunnel blocked. The tunnel is man-made, but no one knows who built it or where it goes.

"The Brazilian army went into the tunnel one time to find out where it ends. After travelling for four days through the tunnel the team of Army explorers eventually came to a large room deep underground. This room had four openings to four tunnels, each going in a different direction. They had arrived in the room by one of the tunnels.

"They stayed in the room for sometime, using it as their base and attempted to explore each of the other three tunnels, but af-

ter following each for some time, turned back to the large room. Eventually they returned to the surface, here at Sao Tomé das Lettres."

The man continued talking about the tunnel. Apparently he gave this lecture every night at his restaurant.

"Now he is saying," continued Marli, "that there is a man here in town who claims to know the tunnel and claims that he has been many weeks inside the tunnel. This man claims that the tunnel goes all the way to Peru, to Machu Picchu in the Andes. This man claims that he went completely under South America, across Brazil and to Machu Picchu. Isn't that amazing!"

I raised an eyebrow and looked at Carl. He nodded to me at the fantastic nature of the story. "Does this restaurant owner say that he has been through the tunnel to Peru?" asked Carl.

"No," said Marli, "it is not this man, it is another man. I don't know who this other man is. But now he is telling another story, this time it is about himself. He says that he was walking early in the morning on the north side of town, near to the tunnel entrance. On this morning, he suddenly met a strange man walking in the area of the tunnel. This man was very tall, about seven feet, and dressed strangely, like the Indians of the Andes in Peru and Bolivia. The man did not talk to him, but walked away. Later, the restaurant owner tried to find this man, but no one knew about him or knew who he was. The restaurant owner thinks that he came from the tunnel!"

As we left the restaurant, Carl, Marli and I were quite stunned. It all seemed so incredible. "Well, Marli," I said, "tomorrow we must see this tunnel and explore it!"

The next morning after breakfast, we checked our flashlights, put water and snacks into our daypacks, and set off up the cobblestone streets of Sao Tomé das Lettres to the north side of town.

It didn't take long to find the tunnel entrance; already four or five young people were gathered around the entrance looking into the wide cavern.

The entrance was quite large. It was a wide mouth of a cave with a mound of dirt creating a small hill over the entrance. The cavern entrance faced to the west and immediately began running down hill, into the earth. The tunnel/cavern would have to

go downhill, as we were essentially on top of a mountain.

With our flashlights in hand, we entered the cavern. Within a few meters, the cavern entrance narrowed into a tunnel which was about three meters (9 feet) high and two meters wide. The tunnel was dug out of dirt, and was not cut out of solid rock, as some tunnels are.

The tunnel headed downward at a steady slope, but it was not too steep. A small channel, made by running water moving through this part of the tunnel (and perhaps by the visitors walking through it) was in the middle of the floor, sort of a small "trail" worn into the floor. At no point was it ever necessary to duck, stoop or crawl in this tunnel. Quite the opposite, it was quite wide and high, even for the tallest man to walk through, even someone who was, say, seven feet tall!

I was amazed at this ancient feat of engineering. We were descending down into the earth in a wide, gradually slopping tunnel that was dug into a red, clay-type dirt. It was not the smooth, laser-cut rock walls that Erich von Daniken had claimed to have seen in Ecuador in his book *Gold of the Gods,* but it was just as incredible.

It wouldn't have taken some space-age device to make this tunnel, just simple tools; yet, it was clearly a colossal undertaking. Why would anyone build such a tunnel? Was it an ancient mine that went deep into the earth, searching for an elusive vein of gold or merely red clay for the long gone ceramic kilns? Was it an elaborate escape tunnel used in the horrific wars that were said to have been fought in South America—and around the world—in the distant past? Or was it some bizarre subterranean road that linked up with other tunnels in the Andes and ultimately could be used to journey safely to such places as Machu Picchu, Cuzco or the Atacama Desert? Maybe a combination of all three.

Marli, Carl and I continued walking through the tunnel for a kilometer or so. Other visitors to Sao Tomé das Lettres followed us into the subterranean system. The tunnel was not perfectly straight, but wound left and right and occasionally dropped down a few feet and continued on. It was perfectly dry and the air was fresh and quite breathable.

Eventually, after an hour or so, we came to a spot in the tunnel

where it suddenly dropped down about a meter and a half. It was not a great obstacle and we could see the tunnel continuing downward, but it was a convenient place to stop. We rested at this spot and then decided to go back to the surface. We had no intention of continuing for several days to the fabled room of four doors deep beneath Brazil.

We talked about the bizarre tunnel. It was real, there was no doubt about that. It was man-made as well, as the tunnel was perfectly uniform and contained no fissures or faults of any kind. Did it really go to Machu Picchu and the Andes? It seemed incredible, but we could not discount this story. Not yet anyway.

§§§

Cuzco, June 1999

I returned to Peru with a group from the World Explorers Club in June of 1999. It was a group expedition, with me as the leader. It had been a few years since I had been back, and I was eager to see Cuzco, Machu Picchu and the Andes again.

The group visited the many ancient sites in the Sacred Yucan Valley, including the towns of Pisac, Calca, Yucay, Urubamba and Ollantaytambo. We spent the night in Ollantaytambo and visited the massive Sun Temple (so-called) on a steep ridge just above the ancient city. Ollantaytambo is one of only three towns in Peru with ancient buildings that were inhabited in the past and are still inhabited today. Cuzco is another of these towns, and the third is the remote Choqiconcha.

Choqiconcha is in a valley east of Pisac, and is inaccessible by vehicle. A dirt road does wind over the mountains to the valley however, going within a few miles of the town. I had visited Choqiconcha with the World Explorers Club in 1988 on one of the Yanantin Orco-Paititi expeditions.

It is said that the lost treasure of Paititi was taken out of Cuzco at the time of Atahualpa's execution by Pizzaro and sent to Choqiconcha for safekeeping while the Inca empire was restructured out of chaos. Atahualpa had just finished a civil war with his brother Huascar, headquarted in Quito. Quito is also an ancient city, probably pre-Inca, but no ancient buildings are still inhabited.

Legend says that part of Atahualpa's treasure was kept in the

main square of Choqiconcha, with a guard tower at each corner of the square. For one year or more, the treasure was kept at this remote town while the Spanish took over Cuzco and installed their hand-picked governors. Then, after this time at Choqiconcha, the treasure was moved to an even remoter location, the lost city of *Paikikin*, or Paititi. This ancient city, presumed to be in the mountain jungle east of Chociconcha, Pisac and Machu Picchu has been sought for hundreds of years—but never found.

When the conquistadors under Pizarro had executed Atahualpa and marched on Cuzco in late 1533, they installed a "puppet Inca" as ruler of Peru and the Inca empire, the native prince Manco. Two years later, Manco Inca led the rebellion of 1536 against the Spaniards. He recaptured Cuzco, and even threatened to take the new Spanish city of Lima, meanwhile setting up his new headquarters at the heavily fortified Calca, in the Yucay Valley north of Cuzco. Later realizing that this was too close to Cuzco, he moved to Ollantaytambo.

Still later, after a successful defense against the Spanish at Ollantaytambo, Manco Inca made an attempt to relocate his army again, this time to the still-lost city of Urocoto. Urocoto is believed to lie far to the southeast, in the forests east of Lake Titicaca, where the secret monastery of the Andes is also rumored to be located. Manco Inca never made it to Urocoto, though, and instead retreated over an Inca road which ran from Ollantaytambo to the northwest, through the Panticolla Pass, and emerged at the Urubamba River near the present-day town of Chaullay.

Manco's force crossed the bridge at Chaullay and followed the road westward along the Vitcos River, entering the Vilcabamba region. They then made their headquarters at Vitcos. Today the Vitcos River is called the Vilcabamba River.

Feeling secure from the pursuing Spaniards at Vitcos, the Incas failed to destroy the bridge at Chaullay. This allowed the conquistador Rodrigo Orgonez to pursue Manco right to Vitcos. But the Inca army escaped from Vitcos, retreating further into the interior of the Vilcabamba region. Meanwhile, Manco's half-brother, Paullu, had been proclaimed the new puppet Inca by the Spanish. Paullu Inca supported the Spanish in their pursuit of his renegade half-brother, and even led an army of native auxiliaries into battle against Manco's army.

The Spaniards pursued the Incas no further into the mountainous jungles of the Vilcabamba region that year. Manco set up a capital in an area known as the Espiritu Pampa, calling the city Vilcabamba. Here they built palaces, temples, stone dwellings, canals, bridges, fountains, and squares. Unfortunately, this capital did not remain a peaceful refuge for long. In April 1539, a force of conquistadors led by Gonzalo Pizarro reached Vitcos, then pressed on for Vilcabamba. Manco Inca's force attacked them 14 miles (22 kilometers) from the new capital, hurling boulders down on the invaders at a spot known as Chuquillusca. But Gonzalo's men climbed up higher, out-flanked Manco, and defeated the Inca army. Manco himself escaped only by swimming across the Concevidayoc River and hiding in the deep forests. Manco's wife and many Inca nobles were captured and taken back to Cuzco by the Spanish invading force, after they had first gone on to briefly occupy Vilcabamba.

Manco returned to Vilcabamba to reorganize the Inca state after the Spaniards left. He conducted raids on Spanish-held towns, and even started to seek refuge in Quito, but turned back after he learned that the route was overrun with hostile tribes and armed Spaniards.

Meanwhile, in 1541 the Spanish fought among themselves for control over Peru, and Diego de Almagro lost his bid to gain control. He was executed, but later followers of Almagro assassinated Francisco Pizarro, thus ending the long and bitter feud. In 1542, seven members of the now-defeated Almagro faction sought refuge at Vilcabamba. The Inca welcomed them to his capital, hoping they would instruct his army in the use of European weapons. However, hoping to gain pardon from the Spaniards, they stabbed Manco while he was playing the Inca game quoits, which is similar to horseshoes. They were, in turn, killed by the Incas.

Manco's son Sayri-Tupac then became the ruling Inca. He was left alone until 1548, when the Spanish once again turned their attentions to Vilcabamba, determined to subdue every last bit of Inca power. Negotiations for Sayri-Tupac to leave Vilcabamba began, and in 1557 the Inca emerged to accept an estate in the Sacred Valley.

Ollantaytambo—Survivor of an Early Armageddon?

Ollantaytambo is the last town in the Sacred Valley before it becomes a narrow gorge going down to the eastern jungles. On my previous trips to Peru I had not had a chance to explore this town sufficiently, which has some of the strangest megaliths in the world. With the 1999 World Explorers group, I examined the evidence of a civilization of master builders who had inhabited the area before the Incas.

Ollantaytambo has the foundations of an ancient bridge of megalithic proportions. Walls of very large boulders are to be found from the river up to the hilltop fortress (the "Sun Temple") above the town. Here one sees terracing and steep steps coming to a massive wall, perfectly fitted together of extremely well-cut blocks of granite. Blotches of orange lichen extend over much of the stones, indicating a great age.

Most impressive at Ollantaytambo are the six large stones that face the river. The largest is about 13 feet (4 meters) high, 7 feet (2.1 meters) wide, and about 6 feet (1.8 meters) thick, and weighs over 50 tons (45,500 kg). Made from red porphyry, a very hard type of rock, many of their surfaces are very finely polished. Other blocks scattered about weigh more than twice this.

The stones were apparently quarried across the river, which is 200 feet below the fortress, about 3,000 feet up a steep slope. A 250-ton stone from this quarry lies at the bottom of the river. Another lies along the road coming up to the fortress. Some giant blocks, hewn into giant rectangles, are to be found at the cliff-face quarry.

On the fourth giant stone from the left is a stepped motif, identical to those found at Tiahuanaco in Bolivia, but not found elsewhere in the Cuzco area. Tiahuanaco-style pottery is also found in the area. Even more unusual is a stone in which a "keyway" has been carefully cut into the stone to hold a metal clamp, presumably to hold two colossal blocks together as earthquake protection. This stoneworking technique is found at Puma Punku in Tiahuanco and nowhere else (to date) in South America. This signature technique is, however, found at many other megalithic sites around the world.

The keystone cuts on some of the largest blocks, now scattered

at the summit of the Sun Temple above Ollantaytambo, indicate that the builders were the same as at Tiahuanaco where keystone cuts are also used. Similarly, the giant blocks are in some places perfectly fitted, but in others they are scattered about or separated from the other massive blocks. In some cases, a crude stone rubble filler is placed between the collossal stones.

According to mainstream archeologists, this massive stone edifice, with its gigantic blocks scattered about the site and stone rubble filled in between, was exactly like this at the time of the Spanish conquest. They believe the rather preposterous idea that the way we see the site is the same way that it was intended by its Inca occupiers—the huge walls were never finished and the railway-car-size blocks were left where they are found today, weighing from 50 to 70 tons each. Keystone cuts can be seen on some of the blocks, but there are no corresponding keystone cuts on other blocks—in fact, there is no other block. It never made it to the site.

The significance of the lack of corresponding keystone cuts for the giant blocks of Ollantaytambo is entirely lost on the mainstream archeologists of today, Peruvian and foreign. They ignore obvious inconsistencies in the whole architectural scheme and ascribe all the building to one period of time: that of the early Inca civilization from the 4th century AD on up to 1000 AD.

While the Incas used Ollantaytambo as a fort to guard the entrance to Cuzco from up the Urubamba Valley (or down the Urubamba Valley, as was to be the case as the Incas retreated), it appears that Ollantaytambo, like Sacsayhuaman, was already in place before the arrival of the Incas. It would appear that the building is from the same time as Tiahuanaco, as evidenced by the megalithic style, motifs, and keystone cuts. The simple stone rubble filler between some of the large blocks is probably Inca construction from the ascribed period, but the massive granite blocks with keystone cuts must come from an earlier period. There is certainly evidence that Ollantaytambo is as old as Tiahuanaco, and some scholars place that ancient city to 15000 BC. Are the scattered 250-ton blocks at these sites evidence of some past earth-shaking event—some ancient Armageddon or cataclysmic earthquake?

§§§

Fun at the Sun Festival

Our WEX group continued on to the town of Aguas Calientes and then to Machu Picchu. I had not visited this fantastically beautiful megalithic city on top of a mountain for some years, and it was great to see it again. I often think that it would be great if everyone could see Machu Picchu, the Giza Pyramids, the Mexican pyramids and the Easter Island statues in their lifetime—foremost among many other spectacular ancient sites.

Back in Cuzco, we attended the Inti Raymi sun festival, held every year on June 24. It used to be held on the summer solstice at June 21, but the Spanish changed it to June 24. The sprawling Sacsayhuaman fortress was jam-packed with tourists and locals. Many had their guinea pig and potato picnics with them as they watched the reenactment of the ancient sun ceremonies. A huge stage had been set up where elaborately dressed Incan descendants reenacted the ceremonies devoted to the sun. Musicians played flutes and drums as male and female dancers interacted on stage.

It is an awesome sight to see thousands of people sitting amongst the gigantic walls of Sacsayhuaman, walls that are today unexplained, as no satisfactory construction technique has yet been put forward. This megalithic site is also ascribed to the Incas, which becomes all the more amazing when mainstream archeologists maintain that the Incas did not even have knowledge of the wheel. Yet they constructed such buildings as Sacsayhuaman?

Later that night, our group all went out to dinner. It was a great night of camaraderie and stories. As the night wore on, we left the restaurant and walked into Cuzco's main square, the Plaza de Armas. From here, some of our group went back to the hotel, about five blocks away down the main street, while the rest went out to a nightclub.

Soon we were watching a five-piece band in ponchos playing pan flutes, guitars, congas and more. We ordered drinks for all and fought to get a table in the crowded club. The annual Inti Raymi festival brought people from all over the world to this ancient city, and all the restaurants, nightclubs and hotels were packed.

As the night wore on, everyone headed back to the hotel, except me. I lingered at the nightclub talking to a Chilean guy who was planning to kayak around the world. With the music still

playing, and the nightclub still packed, I decided around 2:00 AM to head back for the hotel.

I stepped out onto the Plaza de Armas, and there was still quite a bit of activity. A number of people were standing around, and there were a few cars and taxis about the square, even a police car. It was only a few blocks to my hotel, and it was all downhill. So, I foolishly broke my own rule about taking a taxi late at night, something I had warned our group about when we first arrived, and decided to walk to the hotel.

I took off at a brisk pace along the shops and restaurants of the Plaza de Armas and then down the Avenida del Sol, the main street of Cuzco, which was still being walked by a few dozen people. Then I turned west on a side street to my hotel, two blocks away.

I strode purposely up the ancient cobblestone street to the first corner and crossed the street. Suddenly, I was attacked from behind by a man who grabbed me in a stranglehold around the neck. With a scream, I was dragged backward. From across the street I saw another figure running toward me. Quickly he grabbed me by my waist as I fell backward to the street. There were two of them, going to strangle and rob me. Were there three?

As I was carried backward by the man strangling me, I let out a sharp scream. At the same time I gripped the pepper spray pen that was in my right jacket pocket. Kicking forward at my second attacker who was coming down on top of me, I turned the pepper spray backward at the attacker who was choking me. With a determined push of the sprayer I let forth a full blast of the pepper oil mist and then turned it on the man in front of me.

With several pumps of the sprayer I sprayed the entire area around me. I heard the man in front of me whisper, "vamos," to his friend, and they suddenly released me and ran.

I quickly staggered to my feet and reeled away from the cloud of pepper spray that lingered. No one else seemed to be on the street.

I staggered forward in the direction of the hotel, and by keep my eyes largely closed, could see just enough to get myself to the corner and down the street where I knew my hotel was.

I staggered forth and found a steel garage door shutter, used for security by many businesses in Cuzco and Peru, which I thought was the hotel. I began pounding on the steel shutter to alert the night watchman to let me into the hotel.

I pounded and pounded for several minutes on the door, my eyes stinging from the pepper spray and my adrenalin and heart pounding away. A car suddenly stopped and asked if he could help me. I told him I was trying to get inside my hotel.

"Your hotel is down here," he called, and pointed a few doors down. By then, other people were on the street looking at me, and I could barely see through the tears and swelling of my eyes. I had not sprayed myself, but had only come into contact with the peripheral cloud. I imagined that the effect on the attackers whom I had sprayed full-face must have been truly devastating!

The night watchman of my hotel helped me into the building, and when he saw me clutching my eyes and forehead, he thought I had been struck and cut somewhere. I told him in Spanish that robbers had attacked me and handed him my room key.

He led me upstairs and opened my room for me. I staggered in and closed the door. Tearing off my shirt and glasses, I lunged into the bathroom and turned on the shower. Within moments I had stripped off my clothes and shoes and was drenching myself with the warm water. I washed myself carefully with my eyes closed, and allowed the shower head to wash my face for several minutes.

Finally, I dried myself off and opened my eyes. They didn't sting anymore, but were still a bit fuzzy and watery. I felt better all around when suddenly there was a knock on the door. The watchman was there with some clean towels and a jar of iodine.

I was wrapped in a towel and combing my hair when I came to the door. He was shocked when he saw me, and said that he thought I had been cut in the forehead the way I held my hand over eyes.

I informed him that I was fine, and had used pepper spray against some robbers which had affected my eyes as well as theirs. I handed him a tip of a few dollars and thanked him again. His eyes wide in wonder he backed away as I shut the door.

Carefully, I locked the door and made sure the windows were bolted. Then I fell back on the bed and lay back on the pillow. It had been an exciting evening. Too exciting.

On our last night, at Norton Rat's Pub on the Plaza de Armas in Cuzco, I got to thinking about the mysteries of South America. Was this a land that had survived the last Armageddon? Maybe a land caught in time. Indeed, it seems that South America lives in a world of its own, different from the rest of the planet.

Bibliography

1. *Lost Cities & Ancient Mysteries of South America,* David Hatcher Childress, 1985, Adventures Unlimited Press, Kempton, IL.
2. *Mysteries of Ancient South America,* Harold Wilkins, 1949, Adventures Unlimited Press, Kempton.
3. *Secret Cities of Old South America,* Harold Wilkins, 1952, Adventures Unlimited Press, Kempton.

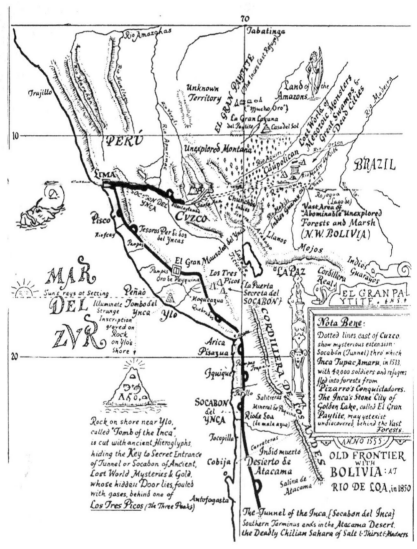

Harold Wilkins' 1947 map of the tunnel system in South America.

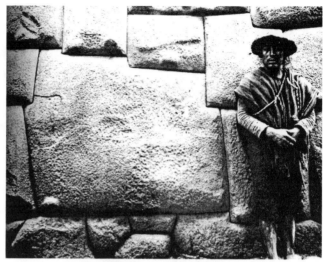

An old photo of a wall in Cuzco.

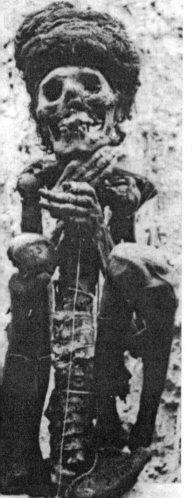

Fourteen former Inca emperors were mummified and placed, sitting on their thrones, in the Temple of the Sun. These mummies were said to have been taken into a tunnel system beneath Cuzco, and then ultimately to a lost city called Paititi.

The Sun Disk from the temple in Cuzco is thought to be either in the tunnels beneath the city or in the lost city of Paititi.

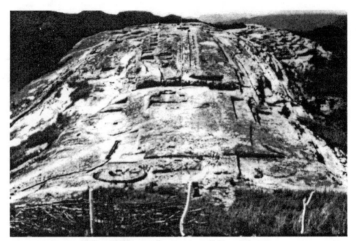

The hill top fortress of Samaipata.

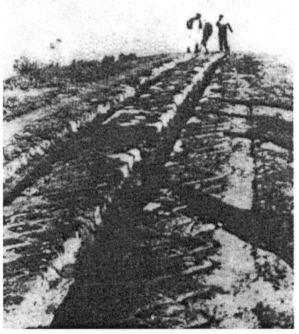

The strange grooves at Samaipata.

Massive walls at Ollantaytambo.

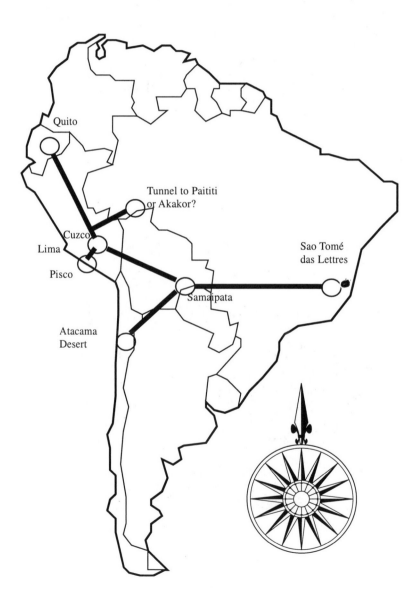

A map of the possible tunnel system in South America.

A cargo cult model of an airplane from the 1961 film *Mondo Cane*.

3.
I Was A
Cargo Cult God—
Me Versus the Volcano

*The greatest thing in this world is not so much
where we are, but in what direction we are moving.*
—Oliver Wendell Holmes

*And he dwelleth in desolate cities,
and in houses which no man inhabits,
which are ready to become heaps.*
—Book of Job, 15:28

My life as a cargo cult god was brief, but exciting. In some ways, being deified was the high point of a long and varied career as an archeologist and explorer. My latest adventure had sent me into previously unknown territory—the remote Papua New Guinea island known as New Hanover—an island famous, as it turns out, for a bizarre cargo cult.

What is a cargo cult? According to experts on the subject (usually anthropologists who have done field research in Melanesia) cargo cults develop when primitive societies are exposed to the overpowering material wealth of the outside industrialized world. This happened on a large scale during World War II, when Allied soldiers fighting the Japanese were stationed on remote islands throughout the Pacific. The native population observed the Allied supply ships, planes and helicopters dropping off cargo boxes full of food, medicine and clothing for the soldiers' continued well-being. Not understanding exactly where the foreigners' plentiful supplies came from, the natives believed they were miraculous gifts sent from the spirit world. They built makeshift piers and

airstrips and performed magical rites to summon the well-stocked foreign ships and planes. The practice continues, and the faithful still expect the Allies to arrive soon, bringing with them lots of canned food, radios and motorcycles.

Some cargo cults centered around American soldiers stationed on remote Melanesian islands during World War II. These generous Americans would share their rations, giving clothing and tinned food to locals. These welcomed gifts were sometimes believed to be gifts from the natives' dead ancestors. The people believed their benificent dead were using these messenger gods to send the "cargo" from the other side. The name given to these messenger gods was John Frum, originating from the common phrase "I am John from… [town or state of residence]."

The "John Frum" cult became synonymous with cargo cults in the Solomon Islands and the New Hebrides (now Vanuatu) immediately after the war. Other cargo cults are associated with other personas. In April 1984, the *Los Angeles Times* published a human interest piece headlined "They Wanted to Buy Lyndon Johnson." The article told the story of a strange group of Pacific Islanders who raised $1,000 "to send to President Johnson to persuade him to come and be their munificent leader." This strange group was the population of New Hanover, and we'll cover the story in more detail later.

The *Los Angeles Times* juxtaposed two photographs in its report. The lead photograph shows a group of "natives of New Hanover" dancing with feathers, face paint, and drums. These dancers, in fact, appear to come from the New Guinea highlands, several hundred miles distant across the Bismarck Sea from New Hanover. Nevertheless, the dancers' eyes seem to stare downward at a second photograph below, a headshot of President Johnson in suit and tie.

The Birth of the Cargo Cult

Anthropologist Lamont Lindstrom traced the first time "cargo cult" occurred in print. It was in a short article that appeared in the November 1945 issue of the colonial news magazine *Pacific Islands Monthly*. This article, contributed by Norris Mervyn Bird, was entitled "Is There Danger of a Post-war Flare-up Among New Guinea Natives?" Mr. Bird, who was described as "an old Territories resident," who had lived before the war in Rabaul, said in his own words:

Stemming directly from religious teaching of equality, and its resulting sense of injustice, is what is generally known as "Vailala Madness," or "Cargo Cult." Various explanations of the "Madness" have been advanced, but the late F.E. Williams, anthropologist to the Papuan Government, after extensive study, gave as his conclusion that the main cause was "ill-digested" religious teaching. This "Madness" is not confined to any one area, but is found among tribes whose dialects and customs differ widely. In all cases the "Madness" takes the same form: A native, infected with the disorder, states that he has been visited by a relative long dead, who stated that a great number of ships loaded with "cargo" had been sent by the ancestor of the native for the benefit of the natives of a particular village or area. But the white man, being very cunning, knows how to intercept these ships and takes the "cargo" for his own use. We have seen grave harm to the native population arising from the "Vailala Madness," where livestock has been destroyed, and gardens neglected in the expectation of the magic cargo arriving. The natives infected by the "Madness" sank into indolence and apathy regarding common hygiene, with dire effect on the health of the community. How much more dangerous, then, will the "Madness" be when a military aspect is superimposed on the religious? Imagine the position, with some thousands of natives armed and trained in the use of modern weapons... It is folly to say: "It cannot happen here, to us." It CAN, and may, happen here, to us. It is ridiculous to think that the discipline instilled with the military training would make such an uprising impossible.

Those of us who witnessed the "strike" in Rabaul in 1928 do not wish to see another such—certainly not with thousands of natives armed with modern weapons. What would the result be if the "Vailala Madness" took hold of the regiments of black soldiers now being trained in New Guinea? By his very nature the New Guinea native is peculiarly susceptible to these "cults." ...The very fact that he is being trained as a soldier, and is expected to fight alongside the white man, and the fact that he is accepted as an equal in barracks by the whites, but is not accepted as equal by society in general, will aggravate the condition and render him

still more susceptible to these cults… His discipline and training will be discarded at a moment's notice and he will emerge, as he is, a primitive savage with all a primitive savage's instincts. The New Guinea native is not unreliable. He is worse—he is unpredictable. The result of an organized uprising of these armed savages could be the massacre of Europeans in these islands, together with a host of natives.

Mr. Bird's initial target was the missionaries. These do-gooders had unwisely filled Islanders' heads with visions of Christian equality, and with what result? The unpredictable savages may become crazed, infected with the disorder called "Vailala Madness" or "Cargo Cult." Madness was the most common prewar label for Melanesian social movements, until it was superseded by cargo cult in 1945.

Mr. Bird's accusation of missionary bumbling was not new. Missionaries had encountered such charges before the war as well. The missionaries quickly fought back in the pages of succeeding issues of *Pacific Islands Monthly*. In January 1946, Anglican missionary S.R.M. Gill denied that either the missionaries or military servicemen were responsible for sparking cargo cults. He countered with the suggestion that Islanders who were most susceptible to cults were those who had been dragooned into military or plantation labor service, rather than those who volunteered to join the Papua and New Guinea native infantry brigades.[1]

Five months later, American Lutheran missionary R. Inselmann more bluntly charged the planter community with responsibility for cargo cults. He submitted a letter of protest to the magazine which published it under the headline "'Cargo Cult' Not Caused by Missions." In the letter Inselmann offers the opinion that cargo cults were not all bad. He said, "Cargo believers could transform themselves into native geniuses of the Melanesian philosophy of life. Genuine science and technology have developed from apparently crazy beliefs. Genuine Melanesian scientists can come from the cargo believers."[1]

Says anthropologist Lamont Lindstrom in his book *Cargo Cult*, "This nationalist paean to cargoism evokes cultural authenticity, genuineness, resistance, and adaptation as well as personal initiative and self-confidence. Cargo culture is honorable and authentic; cargo sentiments are adaptive and resistant; and cargo mentality is nothing but natural philosophy. Melanesians, who are

now citizens of the new nation, should both take pride in and profit from their genuine cargo-cult culture."[1]

§§§

My Arrival in New Guinea

In November of 1994 I arrived in New Guinea from Queensland in northern Australia. My goal was to visit the remote island of New Hanover off the northern tip of New Ireland. At the time, I knew nothing of the cargo cult that flourished on the island. My goal was to explore the place and find the strange ruins that were said to be on the island.

The year before, while giving a slideshow-lecture tour around eastern Australia for *Nexus* magazine, I had been contacted by an Australian forestry worker who had seen me on a local television program. The forestry worker, a Mr. Tony Gordon, informed me by telephone that he had worked for years on New Ireland for a huge Malaysian logging company that had concessions on New Ireland, New Britain and New Hanover.

Gordon told me that rumors abounded about strange ruins and legends on New Hanover, a mountainous island without roads. He told me that there was a pyramid somewhere in the center of the island. He also said that there was supposed to be a sphinx, or part of one, somewhere on the island, and the remains of an ancient city.

Naturally, all of this sparked my interest, and I was determined to visit the island. I had never been to New Guinea and this island nation of strange tribes, cargo cults and weird ruins appealed to me. Little did I know I would become a god. Nor did I realize just how strange and dangerous New Guinea was to the visitor.

I arrived at the airport in the capital of Port Moresby in the mid-afternoon. Gathering my luggage, I looked around. It was a small airport with only two luggage bays. I was waved through customs by men in blue uniforms and tight frizzy hair, closely cropped to the scalp. They paid little attention to me, a blonde haired tourist with a black backpack, tennis shoes, jeans and a t-shirt. Their eyes were on others, expats returning with their families, native New Guinea city dwellers who now were businessmen. Within a few steps I was outside the main door.

In the tropical, humid afternoon I stood around for a few minutes, getting my bearings. "Hey, mate," said a fuzzy-haired taxi

driver, "need a taxi?"

"Yes," I answered. "I'm going to the Salvation Army Hostel. Do you know it?"

"I know it well," he answered, attempting to take my luggage away from me. "It's on the way into town."

I held firm to my luggage. "How much is the taxi fare?"

"Only 15 kina," he said, pulling on my backpack.

Feeling the need to bargain, even though I had no idea of the price and the distance involved, I countered with a decisive, "Ten kina."

"Okay, okay, mate. You're a hard bargainer. Ten kina. You got it," he said quickly, pulling on my bag again. I let it go and followed him to a rusting, purple Holden in the parking lot. A sign saying "taxi" was glued to the inside of the windshield and a pair of dice hung from the rearview mirror. He put my pack in the back seat, instead of the trunk, and then opened the passenger door. I swung into the seat with my day pack and valuables in my lap. In a moment we were off.

We drove downhill past small stores with corrugated tin roofs and iron bars in front of the windows. Women, children and men were camped along the road, with large clusters around the frequent bus stop shelters. Eventually we started passing modern gas stations, and a few tall buildings, six or seven stories high, could be seen in the distance. Suddenly the taxi pulled up to the gate of a compound surrounded by barbed wire.

"What is this, the prison?" I asked the taxi driver.

"The prison?" he laughed. "No, this is the Salvation Army Hostel!"

"The Salvation Army?" I stammered as he opened the rear door and grabbed my backpack. "This fortress is the Salvation Army?"

"Yeah, mate," he said, pocketing the 10 kina I handed him.

The guard at the gate gave me a friendly nod and pointed the way to the office. Once I was checked in and had a private room with a shared shower and toilet, I learned that every business, hotel and apartment complex had armed guards and usually fences of barbed wire. I also learned that everything closed at dusk or just before, and that few people walked the streets at night because of the ever-present danger of what are termed "rascals."

"Rascals" is a cute sounding name for not-so-cute gangs of tribesmen and city-bound warriors who wander the streets at night in small groups. They were deadly, and would rob someone on

the street, or break into their house, for the simplest of possessions. Robbery with these gangs could mean death—usually by being severly beaten or hacked to death.

These gangs would even block roads with logs and, when drivers came to a stop, attempt to seize the vehicle and its occupants. The expat community in Port Moresby lived in virtual fortresses complete with armed guards, and women carried pistols in their purses. Their everyday life was one of constant danger and struggle. There was no nightlife in Port Moresby, and I was warned to be inside the Salvation Army compound every night by dusk or risk being robbed, mugged or even killed.

Over lunch at the yacht club in Port Moresby the next day, I met a couple of Australian and New Zealand expats who were engineers with a large construction firm in New Guinea. Over a couple of South Pacific Lagers at the bar they told me about life in New Guinea.

"It's a case of traditional values and violence colliding head-on with the modern world," said Robert, a Kiwi who had a house in Auckland but spent most of his time in New Guinea. "Out in the bush they have a system of paybacks and customary tribal raiding. It is part of their traditional system of raiding other villages, and their love of warfare and fighting. Ambushing someone and killing them is acceptable behavior for them. It's normal."

"What is the payback system?" I asked, finishing my beer.

"The payback system is a virtually endless series of retributions between families and tribes. If someone is killed in a robbery or a raid, the family is bound to kill someone from the other family or tribe. This often becomes a vicious cycle that only ends after a number of people have been murdered, often in their beds. The payback system is one that pervades the culture of the entire nation."

He suddenly pulled out a blue semi-automatic pistol and laid it on the bar. "I always carry this pistol," he said. "One time, in the highlands, I was driving in my Landrover toward Lae when I came to a log across the road. It was late afternoon. As I came to a halt, two guys with axes suddenly attacked me in the car. I shot and killed one and the other one ran away. I moved the log and drove into Lae where the construction company was located.

"Later, I learned that a brother of the man I had killed worked for the construction company as a day laborer and was planning a payback on me. This was essentially an ambush on me or a raid

on my home late at night."

"Wow," I said, beginning another beer. "What did you do?"

"I had the brother brought into my office where I got out this pistol and showed it to him. I then took the clip out of the pistol and took each bullet out one by one. With each bullet, I would hold it up to him and tell him: this bullet is for you; this bullet is for your oldest brother; this bullet is for your youngest brother; etc., etc.

"I then loaded the pistol again and set it on my desk. 'Any questions?' I asked him. He never gave me any problems after that, but it's the way you have to deal with these blokes—they're tough, and violence is their way of life."

"Is it as dangerous in the small villages in the highlands?" I asked.

"Not really. The main dangers are near the main towns where the city people and expats live, plus there are shops and things to steal. They try to keep people from coming to the city by not building roads. There are only a few miles of roads around Port Moresby. You can't even drive to the second largest city in the country."

"Really," I said, "you mean there aren't roads connecting the various parts of the country?"

"Yeah, they keep the capital isolated from the rest of the country, and areas of the northern coast and Sepik River are cut off from the rest of the country as well. If all those highlanders could walk down a road to Port Moresby, there would be a lot more trouble here than there is already. I'm quite serious; this is a dangerous country!"

He gave me a warning about not going out at night, one that I was to hear several times daily. During those days in Port Moresby, I went to bed early and read a lot. In the end, I was glad for the barbed wire and night watchmen that the Salvation Army used.

After a few days in Port Moresby visiting the national museum and seeing what little the small capital had to offer, I caught an internal flight to Rabaul on the island of New Britain, a large island just east of the main island of New Guinea.

New Guinea is the largest island in the world aside from Greenland (Australia is considered a continent) and the mountainous main island has many other islands, large and small, associated with it. The largest of these other islands is New Britain, and to the north and east of it is another long and thin island named

New Ireland.

Rabaul is the third largest city in New Guinea, after Port Moresby and Lae. Rabaul is located in the northern part of the island, on the Gazelle Peninsula, and situated in a beautiful harbor among a cluster of volcanoes.

My first stop, after checking in at a small home-run guesthouse called Teddy's, was to visit the yacht club where I could get information on the rumored sphinx and pyramid of New Hanover.

The Rabaul Yacht Club, open to anyone, was a pleasant meandering bar that sat along the old harbor. There was an indoor bar due to the frequent rains, complete with some old billiard tables. There was also the attractive outdoor bar, complete with bamboo. It was the classic tiki bar in a picturesque south sea bay—and they had cold beer to boot! So, clutching my South Pacific Lager, I hung out at the bar and eventually got talking to a pilot named Ian who knew some of the people around New Ireland and New Hanover.

Ian told me to look up a Welshman who had the only shop on New Hanover at the small jetty of Taskul, the government village on the east side. "Arthur Williams is his name. Another bloke to look up is Shane Jenkinson, the owner of the Kavieng Hotel. He knows everybody."

"Have you heard about a lost pyramid or a sphinx on New Hanover?" I asked him.

"No, can't say as I have. It is a remote island. There is a logging company in Kavieng that is logging the island that I know of. Dominance Resources. They have an office in Kavieng." Ian tossed back the rest of his beer and slammed the bottle down on the bar. "Good luck on your quest for the lost pyramid! You'll need it. That's a cargo cult island."

"Thanks," I nodded. And with that, Ian left for his hotel down the street. For myself, I began to wonder for the first time, what was this cargo cult on New Hanover?

Rabaul was a major Japanese base during WWII. The Japanese actually built tunnels into the many cliffs and mountains around Rabaul, thus creating an almost impenetrable underground world on the outskirts of the city. The Americans, Australians and Brits bombed the hell out of it anyway, and sank hundreds of ships in the harbor. The tunnel rats held out for awhile after the base had been taken by Allied troops. There was was literally bitter hand-to-hand fighting in these tunnels, some large enough to drive a

tank through.

These battles may have been the origin of some of the bizarre tales of underground battles that were described in letters to the editor of *Amazing Stories* during the late forties. In those pages, imaginative writers (Richard Shaver and others), or intelligence agents for that matter (such as Fred Crisman), wrote of battles with deros and teros in underground caverns.

I was told that rock singer for the group Van Halen, David Lee Roth, had come to Rabaul to check out the tunnels and caves. Being an avid spelunker, Roth had heard of the miles of tunnels around Rabaul and had made a special trip here to visit them. I spent part of one day investigating the beginning of one of the tunnels, a well known entrance near the east side of town. With my small flashlight I delved a few hundred feet into the side of the mountain, marveling at the extensive fortification work that was involved in these underground defenses.

It was amusing to ponder what sort of conjectures about these tunnels might be made in a few hundred years if their origin was lost in the collapse of civilization and history in this area. They were bizarre enough to have fostered all sorts of strange legends, including a mythology that they were entrances to the hollow earth.

§§§

The Road to Kavieng

From Rabaul, looking east, one can see the long thin island of New Ireland. I had considered jumping a tramp steamer to reach the island, but then discovered that there was a twice weekly flight to a small town called Namatanai just opposite Rabaul. I procured a ticket for a flight the next day, and made the 20 minute trip in a small 12-seater prop plane.

Namatanai is a village with a store, some houses, and a tavern/hotel. I went to the store for some information and discovered that the daily bus to Kavieng in the far north of the island would be coming along in an hour or so.

The bus, a rusting old custom-outfitted school bus with wooden seats, had simple windows that could be opened or closed if one gave it considerable effort. I struggled to get my window down and get a breeze going past my seat as best as possible. It was a three-hour trip, past some destroyed Japanese tanks at one point,

but otherwise through pleasant countryside with green villages and small children who came to wave at the passing bus.

As the bus headed for Kavieng, the main town of New Ireland, I read up on the island in my guide book. New Ireland is the center for the curious art of shark calling. Shark callers can be found in such villages as Kontu and Tabar where certain men have the ability to "call up" sharks. The unfortunate shark swims up to the caller's boat where it is netted, speared, or even just plain grabbed if it is small enough.

A variant on shark calling is the "shark propeller," a noose that is hung with half coconut shells which make a rattling noise to attract sharks. A rope attached to the noose is connected to a wooden propeller which is spun around to tighten the noose around the head of the shark, which is then brought thrashing aboard the canoe. It is advisable to keep one's arms and legs away from the thrashing shark.

Many of the children, and adults of New Ireland have red hair. They weren't albinos either, but genuinely had red, frizzy hair. I wondered if that was why the island was named New Ireland, because of all the red hair. The cause is not European mixture during WWII, either, I was told, but is an ancient trait of the people. Some natives on New Britain and New Hanover have red hair as well.

Where did the natives of New Ireland and the islands east of New Guinea come from? They are not the same people as the inhabitants of the New Guinea Highland. The settlement of the Pacific remains a mystery to this day. The vastness of the ocean as well as a lack of concern by historians has made tracing the origin of the island populations difficult at best. While anthropologists agree that there are at least three races in the Pacific region (Micronesian, Polynesian, and Melanesian), they have not agreed on where they came from or when the Pacific was settled. The islands east of New Guinea up until the eastern Fijian islands are considered Melanesian islands. Tonga and all islands to the east are considered Polynesian, including New Zealand, Easter Island and Hawaii.

It was generally assumed that the settlement of the Pacific occurred fairly recently, and many ruins were thought to be only a few hundred years old. Evidence now suggests that man

may have ventured out into the Pacific over 30,000 years ago. New discoveries in partially submerged caves in New Ireland are proving that man reached this area tens of thousands of years ago. Conservative geologists claim that they could not have walked, but must have come by boat.

In his book *The Fragile South Pacific*[2] Andrew Mitchell says, "Until recently archaeologists who worked in the Bismarcks and the Solomons were unable to find any evidence of occupation by man older than 4,500 years. This seems odd, for man appears to have been in mainland New Guinea for at least 40,000 years; indeed some believe that agriculture originated in the highlands of New Guinea, so old are the cultures that have been discovered there. What took man so long to reach these nearest major islands? ...In 1985, Jim Allen and Chris Gosden from La Trobe University in Melbourne, excavated Matenkupkum cave in New Ireland and found human artifacts 33,000 years old deep in the earth deposits. These finds are set to revolutionize theories about the movement of man into the Pacific."

In an article in the prestigious journal *New Scientist* ("Pacific Islanders were the First Farmers," *New Scientist*, Dec. 12, 1992, page 14) author Leigh Dayton relates that archaeologist J. Golson, formerly of the Australian National University, has found ditches and crude fields in New Guinea. The implication is that humans were tending plants here between 7,000 and 10,000 years ago.

The article also reports that on Buka Island in the Solomons, while excavating Kilu cave, archaeologists M. Spriggs and S. Wickler unearthed small flake tools with surfaces displaying starch grains and other plant residues. Evidently, these tools were used for processing taro. Further, the starch grains resembled those of cultivated rather than wild taro. The date for the find was an astonishing 28,000 years before present! The article points out that a site at Wadi Kubbaniya, Egypt has been dated at 17,000 to 18,000 years old by G. Hillman of the Institute of Archaeology, London. This site also had grinding stones and tuber remains, but the Solomon Island discovery was 10,000 years older!

Therefore, recent evidence suggests that New Ireland was first inhabited by 30000 BC, an astonishingly ancient date, one that has rocked the archeological status quo of the South Pacific. Certain archeologists now maintain that agriculture and civilization

started in the vicinity of the South Pacific, rather than in Asia or Africa. Mainstream history textbooks have yet to incorporate this "fact," however.

A recent book that backs up this hypothesis is *Eden in the East*[4] by Stephen Oppenheimer, a medical doctor who worked for many years in Indonesia. Oppenheimer's hypothesis is that there is a drowned continent in Southeast Asia. The submergence of the large continental shelf around Southeast Asia, including all of Indonesia and New Guinea, occurred in the last Ice Age. He maintains that rice growing and other agricultural activity began in this drowned continent. He further theorizes that the real location of the legendary continent of Atlantis was the former continent of Southeast Asia. Sumerian legends of a land before the flood, called Dilman, may also point to the area around Indonesia.

Kavieng is a small town, but has all the services that a traveller/explorer needs. It has several hotels, a number of shops, a handful of taverns and pubs, and a bustling marketplace. The bus let me off right in front of the Kavieng Hotel, an old establishment with a restaurant and bar. I had been advised to stay here, as the old expats that would have information on New Hanover would be drinking at the bar in the evening. The manager, Shane Jenkinson, was also said to be a helpful character who could get me the contacts I would need for a trip to the island.

The Strange Gods of New Hanover

My first stop that evening was the Kavieng Club, a few yards down the main street from the hotel. This turned out to be a rambling old colonial club with ceiling fans and wicker chairs. A large bar of dark polished wood was at the far end of the room. In another room were enormous antique snooker tables with various locals and expats eagerly playing some nightly tournament. Dart boards were evident, too, and a number of people were playing darts.

All in all, it was a pleasant and spacious club, and open to anyone who was properly dressed; this meant a shirt, pants, and some sort of shoe or sandal. Although the atmosphere was casual, one got the feeling he might see Somerset Maugham and his south sea buddies sitting in the corner in one of the wicker chair groupings.

It was at the Kavieng Club that I heard the first of the strange tales of New Hanover. I met with Shane Jenkinson, the tall, blond, owner of the hotel next door, and over a few beers he began to tell

me a few things about the island.

"It's a strange island, New Hanover," Shane said. "I've been out there a few times, and I've done quite a bit of fishing and scuba diving around the island. That's where they have that weird religion."

"You mean the cargo cult? Have you heard about a pyramid and a sphinx on the island?" I asked.

"Well, not really. I heard that there was some sort of 'city' with walls on the high ridges of a mountain. That mountain looks like a person's head, they say. On the southern part of the island is the Lavangai Catholic Mission. Maybe they have a pyramid or something. They're the cargo cult, or part of it."

"Really, a Catholic cargo cult? A city on top of a mountain?"

"Who knows?" stated Shane, downing his beer.

He then told me a strange story: "One time we were out scuba diving on the southern part of the island, near the mountain that supposedly has a face on it. This is the part of the reef where they throw the bodies of the dead. They say that sometimes the water goes dark because of spirits.

"On this one dive, I was with a tourist, and suddenly we got separated. I looked around for her, but I couldn't see her anywhere. Then, suddenly, the water got completely black, like a thick cloud was hiding the sun. I was starting to panic, looking for the tourist. Then I saw this light somewhere farther down in the water. Thinking it might be her, I swam toward it. It was weird, and very dark. Eventually I surfaced, and found the woman back on board the boat waiting for me. My boat captain looked frightened and asked me what happened. When I told them, he said that this was a magic spot where the spirits dwelt."

"That is a strange story," I said, swishing beer in my mouth. "The water went completely dark? What was the light?"

Shane looked down at the floor and shook his head. "I don't know, mate. I just don't know. I'm starting to believe in magic myself."

"I know what you mean, Shane," I comforted him. "They say that the difference between fact and fiction is that fiction has to make sense."

"Ha, ha," laughed Shane. "I'll drink to that!" And he did.

The next day I did some research and contacted a few government offices. At the library I discovered more about mysterious New Hanover island.

§§§

The New Hanover Sun Cult

One book that the library had was the 1965 book *Assignment New Guinea*[3] by Keith Willey. In one chapter, Willey discusses New Hanover, the Johnson Cargo Cult and the mysterious ruins that are said to be on the island. Says Willey:

> On a clear day the outline of New Hanover can be seen from the wharf in Kavieng as a darker blue against the sky. It is separated from New Ireland by twenty miles of ocean, dotted with atolls and humped outcrops of coral. New Hanover extends over several hundred square miles and is dominated by two mountains, The Mother and The Child, both regarded by the natives as sacred.
>
> The island's past is clouded in mystery, with evidence of a race of sun worshipers who flourished there for centuries, then sailed off in a fleet of canoes, never to return. Undoubtedly a scientific expedition should be sent to the area without delay; for obelisks, carved figures, and what appear to be sacrificial altars found on New Hanover and elsewhere through the Bismark Archipelago in recent years could add up to the greatest archaeological discovery made in the Pacific since the statues on Easter Island.
>
> Some weeks before my arrival a government malaria specialist, J. Sheridan, announced that high on The Mother's slopes he had seen a number of obelisks. These were carved in curious patterns, with lines, fish, and birdlike heads facing the rising sun. I talked with Richard Theodore Hermann who runs Meteinge and Metekabil plantations on New Hanover, and who had discovered these relics some years earlier. He is a German who has lived in the New Guinea islands for thirty-five years and was one of the few prewar white residents to survive the Japanese occupation.
>
> "Natives on New Hanover still spoke with respect of the 'men belong time before'," he said. He believed these were a race with a superior culture who had disappeared generations ago. "Either they migrated elsewhere in canoes, or they may have been wiped out in an epidemic; perhaps by malaria, which destroyed the Maya civilization in Central

America," he said.

On the slopes of The Mother he had found a number of basalt obelisks, apparently of volcanic origin, which he believed could provide a link with temples built by sun worshipers in Europe, Egypt, Central and South America, and other widely scattered areas. He had seen similar remains in Germany where people were sacrificed every spring, centuries ago; and believed the New Hanover discovery could be a clue to some early form of humanity which had spread throughout the world. The obelisks, huge, domed boulders, long as a normal room and half as high, were carved with the faces of birds, outlines of fish, and lines and whorls, all pointing east at the rising sun. One had an altar, perhaps for human sacrifice; with runnels where the blood could pour out onto the ground.

Sheridan's announcement brought reports of finds made over the years in other parts of the territory. The Director of Native Affairs, J. K. McCarthy, said that on Tingwon Island, twenty miles west of New Hanover, the natives told legends of a strange people who had visited them centuries before, then sailed away and perished at sea. Their bodies were resurrected and returned to existence as upright stones. Such relics had been found in the area, including one carved like a wheel, although the wheel was unknown there. Another legend told of a cave in the mountains of New Hanover where the strangers had stored huge amounts of cargo before going off in their canoes.

Jack West of Lae, who has lived in New Guinea since the early 1920s, said that in 1946 he found carved boulders on an island off the coast of New Britain. A very old obelisk seven or eight feet high faced the rising sun, while surrounding it were smaller stones, half-buried, and carved with primitive designs. The setting was similar to another group of stones he had seen on an island of the Schouten Group, off Wewak, when he was there many years before as a labor recruiter.

A Rabaul expert speculated that the temple on New Hanover may be linked with the Ingiat cult which is centered in the Duke of York Islands, east of Rabaul, but has adherents among the Tolais of New Britain.

Ingiat priests claim the ability to turn into fish, birds, or

reptiles; and to work spells that can kill from a distance.

Willey also mentions other mysterious stone ruins or standing stones on islands near New Hanover: "On New Ireland itself I met a planter, Peter Murray, who had found a ring of boulders 'like Stonehenge,' on Unea, main island of the Vitu group, about eighty miles north-west of the New Britain post of Talasca. He said: 'The stones are rectangular, each about eleven feet long, and carved with circles and squiggly lines like hieroglyphics. Two old men, Uva and Umbelevi, guided me to where they are positioned on top of a 2,500 foot peak known as Kambu. The stones are not volcanic; obviously they have been quarried elsewhere and taken up the mountain by some means. They are so ancient that the natives do not even have legends about them.'

"Names of some natural features in the Vitus are not unlike those on New Hanover, though the islands are two hundred miles apart. Unea and nearby atolls have the villages of Penata, Penata Botong, and Penata Genata Taravi. New Hanover has Penatkin and similar names; yet the people have no record of contact and their languages are quite different. The obelisks could have some connection with stone mortars and pestles found all over New Guinea. In many villages are boulders deeply carved to form basins, circular hollows which are symmetrical and polished. A few of the blocks have twin depressions, with traces of carved designs. Often pestles found with these mortars are shaped like a bird's head. No one knows where the implements came from, who used them, or why. Certainly no native now living in New Guinea could have made them. Some experts see this as evidence that people of a higher culture, possibly equipped with iron tools, once flourished in the islands.

"Everywhere the relics are venerated by the natives, who speak of them as the work of 'men belong time before,' of whom they know nothing."[3]

The Island Where LBJ is a God

Incredibly, the cargo cult in New Hanover has been largely centered around former American President Lyndon Baines Johnson. Johnson, or LBJ as he is commonly known, is not the only figure in the New Hanover cargo cult—others include John Frum (who started the cult, accidentally), Jesus Christ, and several legendary personalities of the Natinei Clan.

Like most cargo cults, the one on New Hanover started with all the fracas of World War II, what with the Japanese taking control of the islands around New Guinea, including Guadacanal in the Solomon Islands.

In order to counter the massive Japanese naval base at Rabaul, the Americans built a huge naval base on Manus Island, the northernmost island in all of New Guinea. Untold millions were spent on the base and at times as many as 600 Allied ships were anchored at Seeadler Harbor. Then suddenly the war ended, and within a year the Americans pulled out and scrapped everything. The sudden wealth and industrial growth came to a complete halt, and the natives returned to their former easygoing ways.

The Americans had a smaller naval base at the island of Emirau in the St. Matthias Group of islands just to the west of New Hanover. During the war this naval base had a larger population than the entire St. Matthias island group put together. Once the Americans left Emirau, the natives also returned to their previous life of isolated existence.

The cargo cult of New Hanover began in the early 1960s and continues to this day. As New Guinea was getting ready for independence from Australia in 1964, a small group of Americans, working for the Army Corps of Engineers, was building a dock on New Hanover. These generous soldiers would often give clothes and canned food to the natives who lived off fish and coconuts.

Impressed by the affluence and generosity of these soldiers, as the independence voting was to begin in New Guinea, the locals of New Hanover asked the soldiers who their president was. They reasoned that if they elected the same president as the soldiers had, they would gain a similar prosperity—cargo, if you will.

The soldiers told the natives that their president was Lyndon Baines Johnson. So, when the first House of Assembly elections were held, the New Hanover voters decided, quite reasonably, that if New Guinea and New Hanover were a democracy and they could vote for whomever they chose, they might as well vote for Lyndon Baines Johnson.

Despite being told repeatedly that they could not elect Johnson as their assemblyman, New Hanover voters went "all the way with LBJ." Later, when Johnson showed no sign of taking up the cause for the island, the people took more direct action. They refused to pay their taxes (at the time, one kina per person per year)

and instead put the money into a fund to "buy" LBJ. This amounted to a few thousand kina—the equivalent of several thousand dollars, a relatively large sum for the island—but this failed to bring Johnson, who was apparently oblivious to the islander's needs.

Things got worse for the islanders, unfortunately. They were branded a cargo cult, but worse, the government of New Guinea decided to punish them for not paying their taxes and sent police and army personnel to the island to force them to pay. The natives continued to refuse, supported by the local Lavangai Catholic Mission, known as the TIA (Tutukuval Isukal Association) who curiously backed the demands for LBJ, a "god," to come to the island.

At one point, the islanders expected LBJ to arrive at a mountaintop as a returning god. Because of the Catholic mission's confused teachings, the islanders at some point mixed Jesus Christ in with their beliefs, expecting both Johnson and Jesus to arrive at the island and bestow wealth (cargo) on the islanders.

Neither event happened and the army and police arrested many of the males and turned them into a chain-gang of prisoners who were forced into labor on the island as a penalty for not paying their taxes. This continued for a brief time and then the prisoners were released. Eventually, the people reluctantly paid their taxes.

The cargo cult flared up again in the early 1980s, slightly modernized with the inclusion of a helicopter to convey the "gods" to New Hanover. Papua New Guinea's main newspaper, the *Papua New Guinea Post-Courier* gave broad coverage of events that took place during August 1983 on New Hanover. Lyndon Johnson never arrived, but islanders were waiting still. Said the article:

HANOVER AWAITS CHRIST

Hundreds of people are pouring onto the island of New Hanover off New Ireland for "the return of Jesus Christ" on Friday.

Supporters of the Tutukuval Isukal Association are expecting to receive K200 million on that day, according to people in Kavieng, the main town of New Ireland.

The people of New Hanover are best remembered for their support of the bizarre activities of the Johnson cult in the 1960s.

Thousands of people on the island dropped all normal

activities to await the arrival on a mountain top of the then US President, Lyndon Johnson.

They expected President Johnson to rule over them and bestow all of the wealth of the United States on their island.

Later investigations found the mass indoctrination of villages stemmed from distortions of conversations with US Army surveyors who spent a short time on the mountain top preparing for the establishment of communications equipment.

In later years, activities of the cult followers were steered into business ventures within the operations of the TIA [Tutukuval Isukal Association].

Their leader Mr. Walla Gukguk served a term in Parliament as the Member for Kavieng.

Mr. Gukguk was removed from his seat late last year for failure to attend meetings of Parliament.

The MV Danlo has been sailing between Kavieng and Taskul since Monday taking people for Friday's "celebrations."

The boat has been travelling fully loaded, and many disappointed followers have been left at Kavieng.

Details of the proposed celebrations could not be confirmed yesterday, but officials in Kavieng expect Taskul to host the occasion.

The cult's quasi-religious aspects have often been linked to the strong influence on the island of the Catholic Church, but members of the church maintain that any involvement by priests has only been to assist the TIA member[s] to start their business ventures.

"AUSSIES GO HOME"

The Tutukuval Isukal Association of New Hanover, New Ireland, is pressing for the removal of all Australians from PNG for having "ignored requests for presidential government for New Hanover people."

Hundreds of association members have been gathering at Kuligei village to celebrate their "hamamas day" [happy day] and to await the arrival of former American President Lyndon Johnson.

They expect the late Mr. Johnson or a US representative to arrive in a helicopter on Mount Pativung on Friday to

declare for New Hanover people a "matanitu" or government base[d] on the US presidential system.

In a special meeting this week, leaders of the association unanimously agreed to press Mr. Johnson for the removal of all Australians, because the Australian government had ignored their request.

The New Ireland Provincial Government is playing a "low key" with the celebration at Kuligei village.

"We do not want to interfere with their program, although we fear there would be some trouble if Mr. Johnson or whoever the Americans decide to send do not arrive to meet the people," [a] provincial government spokesman said. *(End of article)*

In the same issue of the *Courier* was this editorial:

EDITORIAL: HAPPY EVENT ON HANOVER

What can one say about the multitude assembled atop a mountain on New Hanover Island except that it seems highly unlikely that either Lyndon Baines Johnson or Jesus Christ will arrive there today by helicopter.

To many people no doubt the vision of the Tutukuval cultists awaiting the event—and it seems K200 million—will be weird. But the cargo cult has its place in contemporary Papua New Guinea mythology. It is not an embarrassment.

The difficulty with cargo cults is that many of them mask political objectives which, in our overburdened democracy, ought logically to find a place in some official forum. Some of the expectations expressed by cultists are not too far removed from ideas raised in supposedly sober debate in many assemblies.

But whether political or not in their basis, essentially harmless ideas such as those expressed on New Hanover this week do very little damage to the national psyche—and might even boost our tourist image.

Let's hope the weather stays fine for the celebrations at Kuligei village today. Apinun! *(End of Editorial)*

The next week, the paper ran the following story:

MISSION FAILED: CULTISTS LEFT

Devoted cult followers deserted New Hanover Island by the hundreds during the weekend after being "stood up" by Christ.

But the followers have been urged to retain their faith and continue worshiping because Christ had merely postponed his visit until September 1985.

The followers left New Hanover as early as Thursday after the leader of the Tutukuval Isukal Association, Mr. Walla Gukguk, announced that Christ would not arrive to meet them on Mount Pativung as planned.

A provincial government spokesman in Kavieng said food shortages and accommodation problems forced many to leave the island early.

"The only real ceremony which took place on Mount Pativung was the unsuccessful transfiguration of Mr. Gukguk, who could not disappear into the clouds as expected by his followers.

"Mr. Gukguk was to have been picked up by some UFO or a cloud to go to heaven but this did not eventuate.

"His promise to heal the sick and give sight to the blind also did not eventuate," the spokesman said. *(End of Article)*

Five years later, in 1988, the American tabloid *Weekly World News* advertised on the its cover the story "Headhunter tribe thinks that former prez LBJ is a big-eared god!" Inside, the article itself is titled "Wacky tribe thinks ex-prez LBJ is a god! Savages worship Johnson and his flop-eared mutts." It reads, in part:

A Stone Age tribe of cave dwellers in the rugged and remote Bismarck Mountains of central Papua New Guinea worships a former U.S. president as a god-king, reports the stunned leader of a recent anthropological expedition to the area. A fading and wrinkled color photograph of Lyndon B. Johnson hangs garlanded with flowers in the mammoth, cathedral-like cave of the primitive tribe's high priest, said Dr. Ulrich Ritterfeldt of the University of Utrecht in Holland. "It's absolutely mind-boggling," he told newsmen in the coastal city of Madang.

Through a combination of sign language and pidgin English, the high priest, Ken Ma, told us the tribe has been venerating LBJ as its 'holy, wise and generous' deity for

about 20 years," Ritterfeldt said. ...The high priest told the anthropologists that an ancient tribal legend predicted that a pale-faced god with large, protruding ears and his long-eared hounds would descend from heaven—from nearby Mt. Wilhelm, which towers above the clouds at 14,793 feet—to shower blessings on the simple savages and help them form a great society.

As I looked out over the water to New Hanover in the distance, I had to laugh at the comic-book aspects of these stories: Stone Age headhunters, savages, primitives, wacky tribes, and the big-eared god-king LBJ and his floppy beagle dogs. The *Weekly World News* version of the Johnson cult rehashes journalism's self-indulgent motif of America as cargo god: President LBJ brings the goods. There is also the implied equation of Johnson's Great Society with cargo cults: free stuff from the government.

§§§

The Mysteries of New Hanover

The next morning I met with Arthur Williams, the only foreigner who lived on New Hanover. Arthur was a Welshman who had come to New Guinea as a policeman in the 1970s to work for the British Colonial Office. After some time in various parts of New Guinea he ended up in Kavieng and married a woman from New Hanover. When his first wife ran away, he married her younger sister. Sometime in the mid 1980s he moved to the small village of Taskul opposite Kavieng on the eastern shore of New Hanover.

I had been told that Arthur made the two hour trip from New Hanover to Kavieng twice a week for supplies, and that I could probably go to New Hanover with him in his boat. I met up with him at the local Burns-Phillip store, the largest chain of stores in New Guinea, much like a large trading store.

"Excuse me, are you Arthur Williams?" I asked the tall man near a large stack of Australian goods.

He turned, several cans of Ox and Palm brand corned beef in his hand. "Yes," he said simply.

"My name is David Hatcher Childress, and I am trying to get to New Hanover. I was wondering if I could get a ride with you in your boat? Some of your friends recommended that I contact you."

He looked at me for a moment and smiled, "I'd be happy to give you a ride to New Hanover. I'd welcome the company. Meet me at the dock at three o'clock."

By 3:30 we were in his small aluminum boat, powered by a Yamaha outboard engine, crossing the ocean channel between New Ireland and New Hanover. The mountainous interior of New Hanover hung behind low clouds that encircled the remote island. It had no roads, no cars, no electricity. It had mysterious megalithic ruins. The inhabitants supposedly worshipped Lyndon Johnson. What place could be stranger?

It was just becoming dusk as we came to the small concrete dock at the government administrative village of Taskul. Several men, wearing shorts and t-shirts, but no shoes, were waiting at the dock. Arthur waved at them and threw them the rope.

They stared at me, the first tourist to ever visit New Hanover, with my wavy blond hair and gold-rim spectacles both covered with salt spray. "This is our visitor," Arthur announced. "His name is David and he will be staying with me."

Everyone smiled and I was led to Arthur's island home, a set of corrugated tin buildings, which was right next to the dock. One of the buildings was his store, the only store on the island. His house was next to the water. The village consisted of a few other buildings, including a government school and a one-man police station.

Arthur showed me to a storeroom that was behind the store, and told me I could stay there. There was a small cot in the middle of the room and some tins of kerosene. I pulled out my sleeping bag and tossed it onto the cot.

"David, come meet my family," said Arthur. He introduced me to Linda, his young wife and to their two daughters who were three and four. They were two lively gals who giggled and jumped about the room. Linda was in the small kitchen most of the time, and Arthur had the only television set and video deck on the island. On the occasional evenings when he started his generator, the girls could watch their video tapes, which included several Disney cartoon movies like *The Little Mermaid.*

That evening Arthur opened up his store for a few hours, and several people stopped by to shop. I explored the small general store, picking out my dinner for the night and checking for various supplies. I wanted to support my host as best I could. I offered to pay for my room, but Arthur told me that buying my

supplies at his store would be enough.

I learned that night about some of the legends of the island. The real name of the island is Lavongai, Charles Lamangau, the Provincial Economist, told me. The capital was at Rina-i-atukul, a place nearby.

"Are there large stone walls there?" I asked him.

"No, but there is a small lake there. It is the source of the Luan River. This is the place where the two brothers came from."

"What two brothers?"

"Natinei Kalus and Natinei Pis. They had yellow hair, like you."

"What?" I stammered. "Who were these guys?"

"They were gods," said Charles. "The first man was formed in the big pool from a sudden burst of foam splashing an island in the middle of the pool. A baby was created though that eruption of foam and the island: the first man of New Hanover, Natinei Kalus, or 'boy of the foams.' His brother was Natinei Pis, or 'boy of the sand.' Together they married their sisters and began the 12 tribes of the island and the process of the division of the land. They had supernatural powers. Gods, or people with supernatural powers are called pukpuks. The pukpuks can be good or bad.

"It was the two brothers who moved the big volcanic stones to kill the bad pukpuks. The bad pukpuks had turned into a gigantic bird that was eating the people. The two brothers fought the gigantic bird with the big rocks. Then the gigantic bird was cooked in a supernatural oven called a Mu-Mu." With that Charles stopped and looked at a kerosene lantern that Arthur had hanging outside of his shop. This was all history to him, not legends.

"So there was a giant bird that ate people? Like a pterodactyl?" I asked. I wondered if this giant bird was an aircraft of some sort.

"A giant bird that eats people," Charles said. "On the west side of the island there is another story of two giant birds called 'manolus' who fought with a giant octopus. A tree was even pulled down. The people in Nusalava village will show where the giant birds started their journey to Noipus where they were defeated by the octopus. A dragon-snake monster also lives in this area.

"Also, there is a rock in the north that looks like a ship, so people believe it is Noah's Ark. There is a lake high in the mountains near Metemulai village. It has fish from the ocean. There is also coral rock in that high region. There is also a secret cave in the mountains called Valval. It has cut stones inside. There are many

carved stones, many with a fish. New Hanover has many mysteries."

The next morning over a breakfast of some eggs and rice, I asked Arthur about the sphinx and pyramid that were rumored to exist. I had neglected to ask Charles about these things.

"Well, I don't know about a pyramid, but it sounds like what you're looking for may be on top of Mount Suilava on the southwest side of the island. It is supposed to be this mountain with strange walls and looks like the profile of a man. I've never been there actually."

As I researched this over the next day, I discovered that Mt. Suilava was called Mt. Suilou on my map, a bad photocopy I had gotten from a government office in Kavieng. It was the highest mountain on the island, faced the ocean on the southern coast and was said to contain giant ruins.

During my visits to Charles Lamangau and his office, I got more information on Mt. Suilava, the most famous mountain on the island. Stories varied from person to person, but I heard that there were several different faces on the mountains, and that the obelisks and giant walls were to be found here. It was near the Metakavil plantation, a coconut farm along the southern coast.

"There is a village near there," said Charles. "The name is Metasiven. From there you can see Mount Suilava." He looked at me very seriously, "I will find a guide for you."

That night, Charles told me more about the mysteries of the island. "There was a famous magician from this island," he said, "Tata Marok, a man with a magic stone. Also there were dwarves who lived here before the current people came."

"Dwarves?" I asked. The Hawaiians and Micronesians have tales of dwarves and "little people" called Menehunes that are said to have come before the current population, and are sometimes credited with enigmatic stone works.

"Yes, the Makan Ketket, the dwarves who lived here before the current people came," said Charles. "They tried to dam the Metamulai River on the west side of the island by thowing rocks in the river to block it, working during the night.

"They made it about halfway across the river and then people saw them working and they stopped. Today you can see the portion of the dam along the Metamulai. According to the legends, they wanted to make the western peninsula into an island by cutting it off from the rest of the island with this dam."

That night I looked up at the moon that was waxing in the sky. Lamangai, or New Hanover, was a strange island indeed. It had mystery, but I did not feel that there was danger here. I felt relaxed and enjoyed the people I had met. Although in Port Moresby it was unquestionably dangerous, here on New Hanover, I felt I was among a peaceful and friendly population, isolated from the rest of the world.

With an expedition being formed to the village of Metasiven for me, I looked up at the moon again and wondered: What had brought me to this place? Why was I here? What would I find? Where would I go after this? My head swam with possibilities. Who was I?

My Life as a Cargo Cult God

The next day there was more excitment around the dock than usual. Charles and Arthur were welcoming a tall man with a large floppy hat. He wore a worn yellow coat that stood out against his dark skin. In his teeth he clenched a corn cob pipe. He was keen and intelligent, and was the government malaria officer for the island.

"David, this is Steven," Arthur said to me. "He will be taking you to the village of Metasiven."

"Hello, Steven," I said, extending my hand. "Pleased to meet you."

"Pleased to meet you," he said, shaking my hand and holding his pipe in his mouth. "Are you ready for the journey? Do you have provisions? We will need extra cans of gas."

I then made arrangements to pay Steven for his boat, and paid for all the gas we would need. Otherwise, his services were free. He had business at the Mt. Suilava area and was curious about the mountain himself.

We boarded his aluminum outboard, which now held about 12 people, and he started the motor. It was just after lunch, and we would be cruising along the entire southern side of the island to reach the remote village of Metasiven.

I sat up front on the only cushion on the boat. Steven, pipe clenched firmly in his teeth, explained to me that I was the "big man," meaning that I was paying for everything and was the boss, so to speak. Naturally, I considered him the boss, but it was clear that everyone looked at me in wonder.

These people were "grass roots" folks, said Steven, who had

been to a missionary school in Rabaul for some years. The others looked up to him as an authority, and he explained to me that he would like to end some of the superstitions that the natives believed.

We stopped briefly at Ungat, the site of the Lavongai Catholic Mission where the Johnson cargo cult had been largely centered. A few people turned up at the shore where we unloaded a man with the unusual disease of elephantitis in his leg. We set off again to another village further west along the coast, Metemana, where a woman and her children got off the boat.

It was early afternoon when we reached the village of Metasiven. The entire village came to the shore to watch us unload the boat. Steven, puffing up large clouds of tobacco, told the villagers that I had come to climb Mt. Suilava and see the giant walls high on the mountain. I took some photos of the village and then was told to leave my pack in a room in the only two-story building in the village.

Within an hour Steven and I were off with our guide, a school teacher named Darius, who told me he was 26. He spoke good English and was an eager companion. As the village crowded around, it was clear that this was the most exciting thing to have happened there for some years.

Along with several other "grass roots" characters, we began walking north along a trail into the interior of the island. The mountain could be seen in the distance. This was a preliminary trip to reach the base of the mountain and climb to the second, lower peak.

For the first hour, we walked along well-worn trails up into the back hills near the mountain. We passed some isolated huts and finally came to a point where the last huts could be found in a high but flat spot. Here we found some bushhunters who would guide us deeper into the forest.

With "bushknives," or machetes, we headed up a small trail past a taro patch and then into thick jungle, walking a barely discernable trail through the ferns, thorny palms and trees. It was steep going, up muddy hillsides and over streams. I kept telling them that I wanted to find the great stones and walls that the Germans had been talking about.

The bushmen took us up the lesser peak, Mt. Suilik, a steep peak that ran into the towering cliffs of Suilava. We had clawed and hacked our way up the hillside and were now near the top of

Mt. Suilik. It was getting late though, and I feared that it would be dark soon—dark before we could get back to the village.

As we stood looking at the virtually sheer cliff walls of the mountain and the jungle covering portions of it, Steven took a puff of his pipe and blew some smoke. "We can make it to the top, up those cliffs," he said. Then he added thoughtfully, "But I am afraid you will die." I looked at him and at the towering cliffs. This was not a reassuring thought.

As the "big man" I decided we should go back to the village since it was getting late and my death was imminent. It was then that I was told that our guide—a bushman named Yaphet who hunted wild pigs with spears and a sharp bush knife—was something of an unpredictable maniac who had killed one man and hacked the arm off another. He was apparently a murderer who was literally hiding out in the forest. No wonder Steven had mused that I might die up on the mountain.

We headed back to the village, walking in the twilight and arriving just as it got dark. Huge fruit bats flew in the trees overhead and the children came to the edge of the village to watch us return.

I washed up and changed my shirt, and over a dinner of taro, rice and fish we discussed our going around to the other side, where our guide had said there were large rocks, one on top of the other.

Over dinner I was also told of the legends that surrounded the mountain. I was told that it was the mountain of the gods, and that the natives were afraid to go to the top of the mountain. They believed that if they went to the summit, the sky would go dark.

I was also told that a legend of a returning god surrounded the mountain. I was shown an article by Steven that appeard in the Dec. 1, 1989 *Weekend Magazine* that stated the Johnson Cult had re-emerged on New Hanover with "the revelation that TIA—the 'cultic-socio-economic association,'" believed that a "mythical culture hero," named Kiukiuvat or Natinei Pis, "would return to herald a transformation of the island into a socio-economic, egalitarian state."

The brief article also said that every few years, at a certain time (not mentioned) the people of this cult climb a "magic mountain" and wait for Kiukiuvat, one of the legendary brothers with yellow hair, to return.

"The people are very excited," said Steven, puffing on his pipe

by the fire after dinner. "They think you are Kiukiuvat, the god they have waited for. They are afraid to climb the mountain, but they think that it is your destiny. They are afraid but they are also excited."

"Why are they afraid?" I asked him.

"They are superstitious," he said simply. "That is why I want to climb the mountain with you. To end their superstitions. I am an educated man and I am not superstitious. They are grass roots people."

As I drifted off to sleep that night, a mosquito coil burning in the corner of the room, I lay half in my sleeping bag on a woven mat and thought of the mountain, the Johnson cargo cult, my crazed bush guide Yaphet, and my sudden status as a returning god, Natinei Pis or Kiukiuvat. Would I be marrying the chief's daughter in the morning? Steven somehow believed that my death was imminent. Was I one of those gods who was ritually sacrificed after deification to ensure a good harvest? Going all the way with LBJ...

At the Throne of the Mountain Gods

The next morning we were all up at dawn. Breakfast was coffee, biscuits and peanut butter. The children of the village watched in amazement while I taped up my feet with surgical tape to gain support on my arches for the steep climb up the mountain. Many of my grass roots bush guides didn't even wear shoes, but my left foot had started hurting from the day before. I was determined to protect myself from the thorns, rocks and muscle stress.

We headed out of the village, a party of 13 people plus myself. Steven and Darius walked up front with Yaphet, the crazed murderer, his bush knife hanging loosely in his hand. Various students from Darius' school joined us, and several bushmen and "grass roots" fellows, as Steven called them. We were a motley crew with torn shirts, bare feet in some cases, and a dangerous selection of knives and machetes.

We hiked upward, past the first low fields and huts and then onto a trail that went around the backside of Mt. Suilik, the peak we had climbed the afternoon before. We crossed a large landslide area and then continued upward into thick jungle, following a small path across the hills.

Then it was up into the thick jungle ridge of Mt. Suilava, the bushmen hacking out a thin trail that climbed steeply upward. It

rained lightly several times, turning our trail into slick mud and bush. It was tough going with sharp thorns and vines tearing at our arms and legs.

After several hours of this, we came to a high point on the ridge where the trail went back down to a saddle on the ridge. Here we cut a resting spot and had biscuits for lunch. The bushmen went on ahead, cutting a trail. I looked for the large wall of stones that I had been told was on the mountain, but so far I had not seen anything.

I waited, tired and wet, on a small ledge, a steep, mud and jungle ridge in front of me—on either side were cliffs—it would have been fatal to slip and fall over either side of the ridge.

Steven and Darius said that I had better wait here while they went on ahead with the bushmen and cut the trail up the steep jungle face. They said that I would die if I fell, and they wanted me to be safe. I let everyone go ahead and then after waiting for a bit, I scrambled after them up the steep mountain, grabbing roots and vines with my feet slipping in the mud. Suddenly, I made it to the top, where the trail leveled out for a bit through tall grass, and then went down and back up again.

Then I saw Steven and his grass roots boys. This was the top they said.

Steven looked at me and said, "You are the first European to make it to the top of the sacred mountain. This is a very important occasion!"

I smiled, catching my breath and looking around. The top was rounded and grassy with sheer cliffs on all sides except for the ridge we came up. Nice views of the ocean to the south could be had, but otherwise I could see no ruins or large stones. "Where are the big stones?" I asked.

I was informed that they were back down the hill the way we had come. The others had already headed back down the trail, sliding and climbing down the roots and vines. Steven, Darius and I headed down after them and stopped at one of the rock outcrops that we had passed before. Here the bushmen had cleared away much of the jungle with their machetes, exposing a stack of huge basalt stones.

They were black, roughly-hewn blocks that were enormous. At first glance they seemed to be natural, but upon closer look it was clear that they were stacked on top of each other. For a natural formation this seemed very odd. I could not see any way that

103

they could have been naturally stacked up in this way. However, it was a bit disappointing because I had hoped to see huge walls of perfectly fitted stone as I had often seen in South America and other places.

We continued to descend the mountain back to the main saddle where we had eaten our lunch. The bushmen had cleared much of the area revealing even more huge stacks of massive basalt stones. Some were very big, and they appeared to be piled up on what might have been a lookout post. Huge blocks were on top of each other, though the walls appeared to have been tumbled in an earthquake. Was it artificial, or just a bizarre natural formation? It was hard to say for sure. I took photographs and looked for inscriptions or carvings, but could find none.

Sitting down, I pulled out a bag of coconut cookies and shared them with the group. Steven and Darius showed me a large stone that was partly split. They told me that this was the special stone that made a loud bang whenever someone in the village died.

"Tradition," Steven told me, "says that this stone makes a loud noise if anyone has died, signaling to all around the area of a death." He lit his pipe, his floppy hat catching the smoke. "All the people know about this stone, but few have seen it. Now we know that it exists."

I looked at it in wonder. It seemed impossible what he was saying, but they clearly believed it to be true.

It was getting late, but it had stopped raining some time ago, and now the sun was shining. This was a good sign, everyone thought, but it was time to start back down. We slid down the trail for awhile but then took a shortcut down the steep, mud-covered southern side of the mountain. There was surprisingly little foliage, and lots of rocks scattered about. In the lower levels there were signs of terracing, or so it looked.

I had several bad falls along the way, one time landing flat on my back as my feet slipped out from under me. I was lucky that I did not fall on some freshly cut bamboo stick or small tree—which would probably have run me through.

Yaphet, the crazed murderer, was handy with a bush knife and cut me a staff to use. It came in handy, and I alternately grabbed the nearest tree or root on the steep slope, or leaned heavily on the staff. As we hit the mountainside trail again I was starting to limp a bit. I seemed to have pulled a muscle in my left leg near the knee. I was covered with scratches and scrapes while thorns were

embedded in my arms and legs.

It was starting to get late so we took a side trail through a low-land swamp that was a shortcut back to the village. Three grass roots boys helped me along and made sure that I found the trail through the swamp while the others went on ahead.

The boys cut sugar cane, giving me a stick as we neared town. In the end I was in a sad state—limping with my left leg, barely able to bend my knee.

It was almost sunset when we made it back to the village. I sat on the rough wooden step of the hut I was staying in and slowly took off my shoes and shirt—both covered in mud—my shirt torn by thorns. I washed up at the village pump, but I still found myself limping.

A large dinner of rice, sweet potatoes and corned beef was prepared and I stood by the fire, wondering about the day's events.

Suddenly an old man came up to me, his eyes wide. He grabbed my hand and began shaking it, saying something in the Lavongai language.

"He says that you have broken the spell on the mountain," said Steven. "The people here have always been afraid to climb that mountain. It is taboo. They believe that they would die if they climbed up there."

"They thought they would die if they went to the top of the mountain?" I said. This was the first time I was being told this part of the story.

"Yes, they believe that they will die and the sky will turn black—pitch black. Always the people have been afraid, but now they are not afraid anymore. We have been to the mountain and we have come back. You made this happen."

"Me? What did I do?" I asked.

"You are the big man," said Steven. "They think you are Natinei Pis, the yellow-haired one who will change the island and make it better."

I stared into the fire. The weird ruins, the taboo mountain, the rock that made a sound, and now I was a cargo cult god. If my leg hadn't hurt so much I might have felt like I had reached some pinnacle in my career as an explorer and archaeologist.

The next morning we loaded up Steven's boat and made ready to leave the village. The entire area turned out to see us off, maybe 80 people. They shook my hand and waved to me as we left.

"They want you to return soon to the village," Steven said to

me as he revved the engine to catch a wave away from shore. I waved to them and smiled. I would miss them and this jungle island. The people were good people, and certainly not dangerous. Even Yaphet, the crazed bushman, seemed helpful and trustworthy to me. If I was a god, then this was a village of gods.

Back at Arthur Williams' store in Taskul I bought a couple of warm beers from the shelf and relaxed on a bench. My knee still hurt and I was still limping. My arms were still scratched but I had removed all the thorns. I told Arthur about the whole adventure while he listened intently.

"I had heard about that murderer fellow," he said. "The police are still after him. You were lucky. Instead of being murdered, you became a cargo cult god. That's good luck!"

The next day he was going back to Kavieng in his boat and I went with him. As the dark forests of New Hanover receded into the distance, I wondered about the pyramid and the sphinx. Maybe Mt. Suilava was the sphinx. Was it the pyramid as well? Perhaps I would have to return one day.

Back in Kavieng, I checked into the Kavieng Hotel and sought out an airline ticket back to Port Moresby. I was told that the flights were full all the way to Port Moresby, but I could fly as far as Rabaul.

The next day I flew to Rabaul, but I took my backpack on the plane instead of checking it in. I then stayed on the plane instead of getting off at Rabaul, because I knew that the flight would continue on to Port Moresby.

I went to the toilet while the plane loaded, and then was lucky to find an empty seat just before takeoff. If the crew noticed anything, they didn't say anything to me. The plane took off and I looked at the green volcanoes around the Gazelle Peninsula of Rabaul.

I was relieved to have made it back to Port Moresby, where I once again checked into the Salvation Army Concentration Camp. To my shock, I read in the newspaper the next day that during the night the main volcano at Rabaul had erupted and destroyed both the city and the airport!

During the night, a French volcanology station had realized that there was going to be an eruption and the entire city of 20,000 people was evacuated during the wee hours. Lava and volcanic ash spewed from the volcano and covered the entire area. The sky went dark with volcanic ash for a hundred miles, including

around New Hanover.

Incredibly, the prophecy had been fulfilled of climbing the sacred mountain—the sky would go black, and it did. I was glad I had stayed on the plane and not gotten off at Rabaul like my ticket had said. My luck was holding out.

And that, more or less, is my brief life as a cargo cult god. One day, I must return to New Hanover. The last time I checked, I was still a god there.

Bibliography

1. *Cargo Cult: Strange Stories of Desire from Melanesia and Beyond,* Lamont Lindstrom, 1993, University of Hawaii Press, Honolulu.
2. *The Fragile South Pacific,* Andrew Mitchell, 1989, University of Texas Press, Austin.
3. *Assignment New Guinea,* Keith Willey, 1965, Jacaranda Press, Brisbane, Qld.
4. *Eden in the East,* Stephen Oppenheimer, 1998, Weidenfeld & Nicholson, London.

A John Frum t-shirt made in Vanuatu.

Weekly World News featuring the LBJ cargo cult.

Some of the rocks near the top of the mountain.

An American bomber in PNG, circa 1944.

Above: (Left) Yaphet: bush man, guide, murderer. (Middle) David Hatcher Childress: author, explorer, cargo cult god. (Right) Valus: bush man and grass roots character.

4.
You Can't Get There From Here— The Wonder Wall

Of Paradise I cannot speak properly,
for I have not been there,
and that I regret.
—Sir John Mandeville, *Travels*, 1356

Don't judge each day by the harvest you reap,
but by the seeds you plant.
—Robert Louis Stevenson

In a soldier's stance I aimed my hand
At the mongrel dogs who teach
Fearing not that I'd become my enemy
In the instant that I preach
My pathway led by confusion boats
Mutiny from stern to bow,
But I was so much older then,
I'm younger than that now.
—Bob Dylan, *My Back Pages*

The road was long and winding. The sun was setting over snow capped mountains in the distance. A cold wind blew over my pack and faded jeans. What day was it? Who was I? Where did I go from here?

I had spent the night beneath a bridge in my sleeping bag, trying to keep dry and out of reach of the wind and the rain. The year was 1984, and I had spent two months hitchhiking around New Zealand, and was now heading back to Auckland. I had only a few dollars in my pocket and was ready to leave, back to my modest home in the farmlands of Illinois.

That all seemed long ago when I stepped off the airplane 12 years later in Auckland to investigate the megalithic ruins known as the Kaimanawa Wall.

The Settlement of the Pacific

The settlement of the Pacific remains a mystery to this day. The vastness of the Pacific as well as the lack of concern by historians has made tracing the origin of the Polynesians, at best, difficult. While anthropologists agree that there are at least three races in the Pacific region, they have not agreed on where they came from or when the Pacific was settled.

Evidence now suggests that man may have ventured out into the Pacific over 30,000 years ago. New discoveries in partially submerged caves in New Ireland, a long narrow island east of New Guinea, are proving that man reached these islands tens of thousands of years ago.

In his book *The Fragile South Pacific*[2] Andrew Mitchell says, "Until recently archaeologists who worked in the Bismarcks and the Solomons were unable to find any evidence of occupation by man older than 4,500 years. This seems odd, for man appears to have been in mainland New Guinea for at least 40,000 years; indeed some believe that agriculture originated in the highlands of New Guinea, so old are the cultures that have been discovered there. What took man so long to reach these nearest major islands? ...In 1985, Jim Allen and Chris Gosden from La Trobe University in Melbourne, excavated Matenkupkum cave in New Ireland and found human artifacts 33,000 years old deep in the earth deposits. These finds are set to revolutionize theories about the movement of man into the Pacific."

According to Maori tradition, the first Maori to come to New Zealand was the warrior Kupe, a powerful man and a legendary navigator of Pacific. Kupe was fishing near his island home Hawai'iki, when a great storm arose and blew him far down to the south, where he sighted Aotearoa, "the land of the long white cloud." The legend says that Kupe eventually made the return voyage to his homeland, and told them of his discovery. Many researchers believe that this happened as late as 950 AD, but other theories place it much longer ago than that.

At one point, the ancient homeland of Hawai'iki got overpopulated, and a huge wave of migration set out for Aotearoa in ten great canoes, supposedly in the 14th century. The names of the canoes are still remembered in the stories, and their landing points, crews, and histories are also recalled. Even today, many Maoris still trace their history back to one of these ten canoes.[1, 3, 6]

It is generally accepted that Maoris are Polynesians, but the location of Hawai'iki is open to considerable interpretation. Most anthropologists who write about the Maori do not believe that Hawai'iki is the same as modern day Hawaii. Rather, accepted belief usually places Hawai'iki at either Tahiti or in the Marquesas Islands east of Tahiti.

Carbon dating in New Zealand places settlements there at least about the ninth century AD. In addition, according to tradition, New Zealand was already inhabited by another race of people before the Maoris, a group of people called the Moriori. The Moriori were driven out of New Zealand and then lived only on the remote Chatham Islands, which are more than 500 miles to the east of New Zealand. Early observers of New Zealand considered the Maoris and Morioris to be different ethnic groups, though today prevailing theory is that they were part of different waves of "Polynesian" migration, the Morioris being part of the earliest migratory waves. Today, with the discovery of the Kaimanawa Wall in the Taupo district of the North Island, there are indications of even earlier settlers in New Zealand than the Morioris.

Since archaeologists admit that islands nearby New Zealand such as Tonga, Fiji and New Caledonia were colonized at least 3,000 years ago, it seems that these same navigators would have reached New Zealand as well. Other islands such as New Ireland were colonized an incredible 33,000 years ago. The history of New Zealand, and many Pacific islands, would seem to need some radical revision.

§§§

Early Theories on the Polynesians

The origin of the Melanesians or of the Micronesians, while mysteries as well, has not occupied historians as much as the origin of the Polynesians. What were a race of "Caucasians" doing out in the middle of the Pacific when the western areas were either Mongoloid or Negroid types? The origin of the Polynesians perplexed early explorers in the Pacific from the very start. The Dutch Navigator Jacob Roggeveen said that the Polynesians were descended from Adam though "human understanding was powerless to comprehend by what means they could have been transported to the Pacific."[1] Such doubts also afflicted James Cook and his men.

Prior to the publication of Darwin's *The Origin of the Species*, it was generally believed (by Europeans anyway) that the races of man were descended from the sons of Noah, Shem, Japheth and Ham. Darker races were considered the sons of Ham, while lighter races, such as

American Indians and Polynesians, were considered the sons of Shem.

Early on, a Malaysian origin for the Polynesians was speculated. The second edition of pioneer anthropologist J.F. Blumenback's book *Natural Varieties of Mankind* (1781) added a fifth race to his originally speculated four of Caucasian, Asiatic, American and Ethiopian. This fifth race was Malaysian, which included the Polynesians.

With the arrival of missionaries in the Pacific came other theories, such as that the Maoris "had sprung from some dispersed Jews," thereby making them one of the lost tribes of Israel.[1] We now have the notion that Maoris, and Polynesians in general, are Semites. The *Book of Mormon* also follows this theory, stating that the Polynesians were descended from American Indian Semites who first landed in Hawaii in 58 BC after voyaging in Mexico and South America. Evidence shows, however, that Caucasian Polynesians reached Fiji and Tonga by 1000 BC or even earlier.

Thor Heyerdahl has sought to provide some evidence this hypothesis in a number of his expeditions. Heyerdahl is not a Mormon, but does believe that there was contact between Polynesia and the Americas. Heyerdahl has stated that voyagers in the Pacific came from both the shores of Asia and the Americas. Many critics of Heyerdahl believe that he advocates the American contact theory exclusively, which is wrong. Heyerdahl maintains that Polynesians came from western Asia (Egypt, Sumeria, India) and that the eastern islands of Polynesia such the Marquesas, Tahiti and Easter Island had extensive contact with the Americas. This is evidenced, he says, by the profusion of statues in eastern Polynesia, especially Tiki statues, which are also found in the ancient Americas. I agree with him.

Archaeologists admit that there is evidence that the Polynesians were in contact with North and South America, especially such islands or groups as the Marquesas, Rapa Nui and Hawaii. The sweet potato plant, or yam, is originally from South America and was known to have been cultivated on many Pacific islands before European discovery. The South American sweet potato was cultivated in ancient New Zealand and the Maoris called it Kumara, the same word used for the plant in South America. Kumara, curiously, is a common Sanskrit word and used in India to this day.

However, contact with the Americas does not necessarily mean that the Polynesians originated there, and the prevailing theory of the late 1800s and early 1900s was that the Polynesians were actually an Indo-European group who came to the Pacific via India. Linguistic evidence was usually cited, such as the detection of Sanskrit words in Polynesian vocabularies. In the days when racism was a common fact of life, one reason for such a theory was partly political: to prove that a fellowship existed between Maoris and Europeans. The main

contributor to this theory was Edward Tregear who wrote a book entitled *The Aryan Maori*, published in 1885.

A more important scholar who supported Aryan Maoris was John Macmillan Brown who had studied at Glasgow and Oxford before taking up the Chair of English, History, and Political Economy at Canterbury University College in 1874. Brown retired from his chair in 1895 and spent much of the remaining forty years of his life traveling the Pacific in pursuit of his intellectual hobbies, including the origin of the Maori. Brown settled in New Zealand and published his first book, *Maori and Polynesian* in 1907.

Brown believed that they had come by several routes from the Asian mainland. Some had come through Southeast Asia, having been driven on by a Mongol influx; others had come in a northern arc through Micronesia. This northern migration had passed over the Bering Strait into the Americas before doubling back to colonize eastern Pacific islands like Easter Island. The Polynesian language that eventually emerged was a combination of several primitive Aryan tongues. In *Maori and Polynesian*, Brown suggested that this amalgam was formed in Indonesia, but later he shifted his ground. In his 1920 thesis, *The Languages of the Pacific*, Brown argued that "the linguistic attitude" of the Polynesians faced "north towards Japanese and Ainu." What had induced Brown to change his mind was the discovery of Tocharish, a "primeval" Aryan language as Brown called it, in a manuscript found at Dunhuang in the Gobi Desert in 1911. This famous cache of ancient texts, some written in unknown languages that have never been deciphered, was to provide a gold mine for those scholars who took interest in them.[1]

Said Brown, "The main features of the Polynesian tongue... go back to the old stone age in Europe... We must conclude that the Aryan language started on its career from twenty to twenty-five thousand years ago, and that philological students of Latin and Greek and the modern European languages must study Polynesian in order to see the type from which these sprung."[1]

Brown went on become Chancellor of the University of New Zealand, and enthusiastically championed unorthodox theories on the origin of the Polynesians, even to the point of advocating a lost continent in the Pacific which a few years later was called "Mu" by Colonel James Churchward.

Brown had traveled widely throughout the Pacific, something most anthropologists and historians had not done, and was awed by the many megalithic remains he had seen. He believed that he could trace the footsteps of the Aryans into and through the Pacific from their megaliths. Brown claimed that the megalithic remains at Coworker and Atiamuri in New Zealand were evidence of Aryan occu-

pation.

Brown's magnum opus on the Pacific startled many people. His final book, *The Riddle of the Pacific*,[1] published in 1924, claimed that there was once a continent in the Pacific that was now mostly submerged. This continent, of which most Pacific islands were the last remnants, had been founded by megalith building Aryans from the Americas.

Here was the Chancellor of the University of New Zealand advocating a sunken civilization in the Pacific—and not without reason. Brown may have first become convinced of a lost Pacific continent when he was introduced to the ancient texts at Dunhuang. One of the ancient papers allegedly contained a fragment of a map which showed a sunken continent. Brown had also been to Easter Island where the local tradition has it that natives are from a sunken land called *Hiva*. He was convinced that an advanced culture once existed throughout the Pacific and that sudden cataclysms had submerged most of the land causing a collapse of the civilization.

Despite the fact that geologists of his time discounted any rapid geological change in the Pacific it is a fact that the flat-topped guyots throughout the Pacific must have been formed above the water. These wind-blown mesas, similar to those in the American southwest, need thousands of years of blowing sand to flatten their tops. Similarly, large atoll archipelagos such as the Tuamotus, Kiribati or the Ha'apai group of Tonga would become mini-continents if the ocean levels were dropped only a few hundred feet. Geologists state that ocean levels were at least 300 feet lower ten thousands years ago. This would all the isalnds much larger and many of the island archipelagos into some large land masses indeed.

Essentially, the question is not whether there was more land in the Pacific in the past, but whether these large island masses were inhabited at the time—approximately 10,000 years ago. Diffusionist archeologists like myself, who believe that civilizations existed prior to 8000 BC, believe that man was already voyaging in ships at this early time. This idea is gaining acceptance as more and more archeological finds are being dated to ever-earlier times. For instance, mainstream archeologists now accept that the island of New Ireland was inhabited 33,000 years ago! How did these people get there? Either the topology of the Pacific was vastly different back then, or they came in ocean-going boats.

The Pacific floor is very active geologically. Ninety percent of all volcanic activity occurs in the oceans. In 1993, scientists located the largest known concentration of active volcanoes on the sea floor in the South Pacific. This area, the size of New York State, is known as "the Ring of Fire" and is not far from New Zealand. It hosts 1,133

volcanic cones and sea mounts. Two or three could erupt at any moment. This alone could cause severe earthquakes and tidal waves around the Pacific.

From India to New Zealand—With Love

The time frame for an Indo-Aryan origin for Polynesians, including Maoris, was put forward by historian Stephenson Percy Smith, founder of The Polynesian Society, in 1891. Smith used notes he had gotten from a high Rarotongan priest named Te Ariki-tara-are to trace the Polynesians back to India, though he admitted that the Indian side of it was weak do to a lack of records in India. He created the following table for the Aryan migrations to the Pacific, still largely accepted by mainstream archeologists:

450 BC	India
65 BC	Java
450 AD	Fiji-Samoa
650 AD	Hawaii
675 AD	Marquesas
850 AD	Maku visits New Zealand
1150 AD	Toi visits New Zealand
1175 AD	Moriori move to Chatham Islands from mainland
1250-1325AD	Voyages to New Zealand of Maori forerunners.
1350 AD	New Zealand settled by "The Fleet" of ten canoes.

Today, evidence is showing that it is most likely that New Zealand was populated long before 850 A.D. Smith was unaware of the Lapita Pottery discoveries to come decades later proving that early settlers reached western Polynesia by at least 1200 BC, therefore his estimate of 450 BC was overly conservative as is his entire time table.

In the 1840s in the North Island of New Zealand, Reverend William Colenso was given a metal bell by local Maoris who had been using it as a cooking pot. Maoris were not known to work metals, and they claimed to have found it at the base of a tree. An inscription in archaic Tamil-Dravidian, from which the Tamil language of southern India is derived (it precedes Sanskrit) is on the bell. It reads: "Bell of the ship Muhamed Buks." The name "Muhamed" is an ancient name, used in ancient India and the Middle East (and still popular today). The bell is now kept at the Wellington Museum.[3] Because of this ancient bell, many early anthropologists believed that ancient Hindus commonly voyaged to New Zealand and other Pacific is-

lands, which is probably true, given the surviving remnant of the Hindu island of Bali.

At one point in prehistory, starting around 1500 BC, the Hindu-Nagas of India and Southeast Asia spread into the Indonesian archipelago creating a sophisticated island nation based on Hinduism, elaborate ritual and seafaring as far as the edge of New Guinea. The ancient Hindu maritime empire extended from Pakistan and Iraq to Java, Bali, Borneo and beyond. The Hindu island of Bali is all that remains of this great empire now, but formerly it may have ruled many islands in the Pacific.

Another theory cropped up at the turn of the century, this one classifying the Maoris and Polynesians as belonging to the Alpine section of the Caucasian race, and located their primeval home in the Atlas Mountains of North Africa. The late Barry Fell, founder of the Epigraphic Society, maintained that the Polynesians were North African sailors who worked as a hired navy for the Egyptian pharaohs.[11]

Elsdon Best, in his book *The Maori*, published in 1924, said that according to Maori traditions, they came from a western land called Uru and then migrated to Irihia which, he said later, was very like Vrihia, the Sanskrit name for India. Another famous anthropologist was New Zealander Peter Buck, half Maori, whose Maori name was Te Rangi Hiroa. He also accepted the Indian origin of his ancestors and wrote in his book *Vikings of the Pacific* in 1938: "...in remote ages the ancestors of the Polynesian people probably did live in some part of India." Then they worked eastwards through the river courses of Southeast Asia into Malaysia and Indonesia where the pressure of Mongoloid people "turned their gaze to the eastern horizon and embarked upon one of the greatest of all adventures."

§§§

The Kaimanawa Wall

In May, 1996, newspapers in New Zealand and around the world carried stories about the discovery of a seemingly man-made stone wall in the North Island. This section of stone wall, with its huge rectangular blocks, was quickly dubbed "The Kaimanawa Wall" because it was in the Kaimanawa Mountains immediately south of Lake Taupo, the North Island's largest lake. The wall had been known to locals for years and had been dubbed the "dinosaur's barbecue" by the hunters and Department of Conservation workers in the area. I had been sent a photo of the wall back in 1990 by Auckland resident Bruce Cathie who had visited the wall in the late 1980s.

But it was not until May of 1996 that South Island archaeologist

and author Barry Brailsford brought the wall to the attention of the national news media in New Zealand. At this same time, I was flown over from Australia by Auckland physician and historian Dr. Gary Cook to examine the wall. On May 7, 1996, I arrived at the wall with Barry Brailsford, Dr. Cook, a Swiss photographer Kapil Arn, and several other acquaintances. For several hours we examined the wall and the surrounding hillside before the news media was scheduled to arrive.

The wall is instantly remarkable. As one sees it from the nearby logging road, one is immediately amazed. A huge, sheer rock wall of large rectangular blocks is facing the road. It is about 8 meters long and 2 meters high (26 ft. x 6.5 ft.). Two rows of large rectangular blocks are clearly visible. A 20-meter-high mound (65 ft.) covered with trees, some of them very old, towers above the wall. The blocks seem to be a standard 1.8 meters long by 1.5 meters high (6 ft. x 5 ft.). The bottom block runs straight down to 1.7 meters (6 ft.) and beyond. The stone is a local ignimbrite, a soft volcanic stone made of compressed sand and ash. The nearest outcrop of such stone is about 5 km. away.

The blocks run for 25 m. (82 ft.) in a straight line from east to west and the wall faces due north. The wall consists of approximately 10 rectangular blocks that are seemingly cut and fitted together without mortar. The wall has been split by an earthquake which has caused a ragged crack through the several blocks. The wall is also pulling apart and sinking to the west. Because the wall is pulling apart, a second layer of blocks can be seen behind the first row of blocks. All the blocks, even those behind the first row, are perfectly rectangular with joints at right angles. The evidence seemed to point to the theory that the wall was man-made. I discussed certain questions about the wall with Department of Conservation workers who were present at the examination. It had been thought that the wall might have been part of a lumber mill that was operational around the turn of the century. I asked them how old the largest tree that was growing on the mound on top of the wall was. They replied that it must be over 100 years old, thereby canceling out the idea that the wall had been in use at any time this century.

Barry Brailsford showed me around the forest and demonstrated with a metal probe how there were several tiers of rock above the wall, now covered by the dense forest growth and dirt. The wall could possibly be part of a terraced pyramid, he suggested. Barry had gone through 20 years of normal academic life before becoming involved with the Wall and the subject of pre-Maori civilizations. He had been a Senior Lecturer at Christchurch Teacher's College and had written a number of books on the history of New Zealand in-

cluding *The Tattooed Land*[9] and *The Greenstone Trail.*[8] In 1990 Barry was honored with an MBE for his contribution to Maori scholarship and education.

In 1992 he was involved in the publication of *The Song of Waitaha* which chronicled the history of the Waitaha, a pre-Maori people whose descendants still live in areas of New Zealand today. Barry had previously been appointed spokesman for the Waitaha in 1988. One hundred and forty Waitaha descendants and their tribes arranged a formal appointment for Barry. It was done according to custom during a specially organized ceremonial meeting. In the meeting it was agreed that, as spokesman, Barry would write the Waitaha history from the oral tradition of tribal elders and keepers of the ancient wisdom, something never done before. According to Barry, the Waitahanui, or Waitaha as they are known, were two hundred tribes who lived in New Zealand over 2,000 years ago. Current historical dogma denies the Waitahas' existence and states that Maori settlers were the first, and arrived in New Zealand from Polynesia 700 to 800 years ago.

§§§

International Publicity and the Wonder Wall

While speaking at the Adventures Unlimited Bookstore/Cafe in Auckland on June 15, 1996, Barry Brailsford reiterated his belief that the wall was a man-made structure. He began his talk by mentioning the carbon dating of Polynesian rat bones recently on the South Island which indicated that the rat had arrived over 2,000 years ago, thereby proving that humans were already in New Zealand at the time when the wall may have been built. Said Barry to a crowd of about 50 people, "I would like to sit the disbelievers down with the elders. Then they would have a chance to hear these wisdom-keepers for themselves, or say that they are silly old men."

Barry continued by saying, "I went with the Waitaha elders to the wall one morning at 4 o'clock on a very special mission. It was to reclaim the spirit of the ancestors and lift the tapu so all our children could go there. They did not go to claim the wall for themselves, they claimed it for the nation."

Said Brailsford in his lecture at the World Explorers Club, "These were the Urukehu, People of the West. The names of the settlers with an Hu suffix, such as Turehu or Tuahu, are the red-haired or blonde-haired people who had hazel eyes. It is possible that some of the Waitaha were European and North African sailors such as Phoenicians and Libyans. The Pa Maori saw the end of the Waitaha,

but strands of the Waitaha are woven into today's Maori population."

Said Brailsford, "New Zealand was a very special land from which the greenstone came. New Zealand's ancient heritage comes from Asia, South America, Africa and Europe. The greenstone is the key to this land. It is called pounamu, our gift to the world. It was used as ballast in the oceangoing ships, the double-hulled waka ships. These ships had a very large sail and went to all parts of the world. Pounamu, the greenstone, is harder than steel and diamond saws are now used to cut the stone." Concluded Brailsford, "Black Elk, the great North American Indian chief, came to New Zealand to collect the ancient stones which he said his people had once used. The tiki, for example, that wonderful carving, is found on all the Pacific islands with the name of the God Tiki. You go to Europe or Sumeria and the translations for the same carving all say 'the god Tiki.' There are five different trails of the Pacific god Tiki being traced to different parts of the world. Furthermore, pottery shards found near a South Island lake were sent to the Canterbury museum. Thor Heyerdahl said that the shards were of Chilean origin.

"The wall is at a place where four to five tribal boundaries come together. It is a place of power made by the placement of stone, it ties the land to the stars. With its discovery, a door has been opened into the past that creates a very different vision from the one we have had before."

Barry expressed his disbelief that the wall could be a natural deposit, stating that it was incredible that this sort of rock could break into even cubes. Straight fractures are common, but standardized cubic crystals are unknown. Ignimbrite, of which the wall is made, is a crumbly stone made of compressed volcanic ash and sand.

"The question is," said Brailsford, "does volcanic ash cool and crystallize into geometrical shapes such as rectangles or hexagons? I maintain that ignimbrite does not crystallize into geometric forms, as basalt and granite do, for instance. Department of Conservation employees, led by Neville Ritchie, are claiming that ignimbrite does crystallize into geometric blocks. If it did crack when cooling, a few jagged cracks and splitting might be seen, but not uniform rectangular blocks."

Basalt is well known as a volcanic intrusion of molten igneous rock which cools and crystallizes into octagonal "logs" of dense rock. Such basalt "crystal" logs are extremely heavy, but can be used as building material. Curiously, an entire city in Micronesia, Nan Madol on Pohnpei Island, is built out of basalt crystals. The amazing complex is eleven square miles in size and uses an estimated 250 million tons of basalt to create 100 artificial islands and walls up to 15 meters

high. Basalt formations occur at the famous Giant's Causeway in Ireland and Mount Wellington outside of Hobart, Tasmania. Ignimbrite is not an igneous rock like basalt or granite; it is a soft stone of compressed ash and does not crystallize into perfectly rectangular blocks.

I asked Neville Ritchie live-on-air during a Radio Pacific interview if he could name any other sites in New Zealand (or anywhere in the world, for that matter) where such "crystallized ignimbrite" might be seen? His answer was a simple, "No." At about the same time, I was interviewed by the BBC for their All Night news program. The London interviewer expressed surprise that New Zealanders believed their history only went back 700 years and felt it was only natural that Pacific Islanders had reached New Zealand at a similar time when other Pacific Islands were settled, circa 1500 BC.

I pointed out in my radio, television and newspaper interviews that giant structures on Tonga were probably at least 3,000 years old, and that Lapita pottery in Tonga, Fiji and New Caledonia had proved that those islands were inhabited by atleast that time, nearly 2,300 years before the official settlement of New Zealand.

This seemed almost impossible, I told interviewers, as the Polynesians were excellant seafarers who colonized some of the remotest islands in the world, such as Easter Island and the Hawaiian Islands. Tonga is very near to New Zealand and it seems unlikely that no Tongan ships would have ventured to New Zealand. Voyages to the Northern Island of New Zealand could have begun about 1000 BC. Certainly, such voyages were happening at that time between Fiji, Tonga and New Caledonia.

Obstacles to Discovery

The controversy over the wall continues. Probes of the tree-covered hill immediately above the rock wall indicated that more stones could be found beneath the soft dirt. The pattern that could be discerned was one of a stepped pyramid with the exposed wall being part of the lowest tier. It was thought that some simple excavation around the wall might prove once and for all whether the wall was a freak natural formation or part of a larger man-made structure. However, before the area could be excavated by the Department of Conservation an injunction against any digging was made by various Maori groups who wanted to determine whether the wall was part of some sacred site for their tribe. Therefore, at least for some time, the wall will remain unexcavated and largely a mystery.

Various theories on the wall circulate including that it is a step pyramid similar to those on Tonga. As I have pointed out, Tonga is relatively close to New Zealand and it is known to have been settled

over 3,000 years ago, a long enough time in the past to have a connection with the New Zealand wall. Tonga has a number of large pyramidal structures that are also built out of megalithic blocks of stone.

Carbon dating of the Kaimanawa Wall is impossible because no bonding material has been used. So the controversy flourishes and the age-old mystery of the prehistory of the Pacific continues to be fueled by new evidence for ancient contact between Egypt, India, China, South America and Pacific Islands. Meanwhile, the ancient land of the Green Stone is slowly awakening to its own destiny, a destiny linked to an ancient past that is slowly being discovered.

*Let us not look back in anger
or forward in fear,
but around us in awareness.*
—James Thurber

§§§

Other Mysteries of the Western Pacific & Australia

In an article in the prestigious journal *New Scientist* that was entitled "Pacific Islanders were the First Farmers," (*New Scientist*, Dec. 12, 1992, page 14) author Leigh Dayton points out that archaeologist J. Golson, formerly of the Australian National University, has found ditches and crude fields in this area. The implication is that humans were tending plants here between 7,000 and 10,000 years ago.

The article further points out that on Buka Island in the Solomons, while excavating Kilu cave, archaeologists M. Spriggs and S. Wickler unearthed small flake tools with surfaces displaying starch grains and other plant residues. Evidently, these tools were used for processing taro. Further, the starch grains resembled those of cultivated rather than wild taro. The date for the find was an astonishing 28,000 years before present! The article points out that a site at Wadi Kubbaniya, Egypt has been dated at 17,000 to 18,000 years old by G. Hillman of the Institute of Archaeology, London. This site also had grinding stones and tuber remains, but the Solomon Island discovery was 10,000 years older! On top of all this is the underwater cave and human remains on New Ireland dated to 33,000 years before present.

When some of the more than 400 gravel hills on New Caledonia were excavated in the 1960s, they had cement columns of lime and shell matter that was carbon dated by Yale and the New Caledonia Museum as having been made before 5120 BC. and 10950 BC. These

intriguing cement columns can be found in the southern part of New Caledonia and on the Isle of Pines.[13]

Egyptians in the Pacific

The late Professor Barry Fell, a former Harvard Professor and native New Zealander, popularized the theory that the Pacific was settled in the second millennium BC by the Egyptians. He is well known for advocating Egyptian, Libyan, Celtic and Phoenician ancestry for American Indians, and applies his epigraphic (the study of ancient writing) research to Polynesians. Says Fell in his popular book *America B.C.*[11] after linking Libyan language to the Zuni Indians of Arizona and New Mexico, "These phonetic rules are of the same kind as another series I demonstrated in 1973, linking the Libyan language with that of Polynesia. The Polynesian people, like the Libyans themselves, are descended from the Anatolian Sea Peoples who invaded the Mediterranean around 1400 B.C. and, after attacking Egypt and suffering a series of defeats as the Egyptians record, eventually settled Libya. Later the Libyan seamen were employed by the Pharaohs in the Egyptian fleet, and still later the Libyan chiefs seized control of Egypt to establish the Libyan dynasties. Thereafter Libyan influence spread far and wide, especially in the Indo-Pacific region, where the Egyptians mined gold, as in Sumatra. During the Ptolemaic period (after Alexander the Great conquered Egypt) Libyan seamen in the service of the Greek Pharaohs explored widely, some of them settling parts of the Pacific."

According to Fell, "The foregoing inferences, based largely on linguistic studies, have forced us to discard the theory that traced the Polynesian settlements to supposed immigrants of uncertain origin in East Asia, for the early Polynesian inscriptions are essentially Libyan both as to the alphabet and the language. Linguists such as professor Linus Brunner in Europe and Dr. Reuel Lochore in New Zealand have found this new interpretation to be consistent with their own researches into the sources of the languages of Malaysia and Polynesia (see Brunner and Schafer's, *Malayo-Polynesian Vocabulary*, Auckland, 1976). It also explains the occurrence of Greek words in the Polynesian tongues. As Professor Brunner has pointed out, the Greek colonies in Libya used a dialect of Greek in which certain consonants replace those of Attic Greek, and it is in the Libyan form that the Greek words of Polynesia occur. The Anatolian elements in Polynesian have been the special study of Lochore, and these too are now seen to be consistent with a Libyan origin of the Polynesians, for we know from the ancient Egyptian records that Libya was settled by the Anatolian Sea Peoples."[11]

Therefore, what Fell is saying is that he believes that the

Polynesians were descended from Libyans in the service of Egypt, working as sailors to Egyptian gold mines in Sumatra, and even Australia and elsewhere. He also believes that many Melanesians are the descendants of Negro slaves used as workers in the gold mines. Fell even goes on to call the dialect used by the Zuni Indians of the American southwest as *Mauri script* and maintains that the Maoris may be related to the Zuni Indians and their "Mauri" language.

Phoenician and Libyan rock inscriptions have been discovered in Indonesia. A letter in the January 21, 1875 issue of the magazine *Nature* spoke of Phoenician script in Sumatra. Writes the author, J. Park Harrison: "In a short communication to the Anthropological Institute in December last (*Nature*, Vol. XI, p. 199), Phoenician characters were stated by me to be still in use in South Sumatra. As many of your readers may be glad to have more information of the subject, I write to say that the district above alluded to includes Rejang, Lemba, and Passamah, between the second and fifth parallels of south latitude. Several manuscripts, on bamboo, from this region are preserved in the library of the India Office; and a Rejang alphabet is given by Marsden in his *History of Sumatra*, third edition. Some of his characters, however, appear to have been incorrectly copied. About half the Refang letters are admitted by all the Oriental scholars to whom I have shown them to be Phoenician of the common type; others being similar to forms found in Spain and other Phoenician colonies. Most of the letters are *reversed*, a peculiarity which is explained by the fact that the Rejang writing, according to Marsden, is read from left to right, contrary to the practice of the Malays generally. The matter is of great interest, and, it is to be hoped, will be investigated by Phoenician scholars."

Over the many years of modern archaeological research a great deal of evidence for Phoenician and Egyptian mining operations in Sumatra, Australia and into the Pacific has accumulated. It is likely that the Egyptians, Phoenicians, Dravidians, Cambodians and Chinese all came into the area of Australia and the western Pacific.

Circa 1000 BC, King Solomon's Phoenician ships made a three year trip across the Indian Ocean to a land of gold called Ophir. The theory is this: by 4000 BC and probably much earlier, the Egyptians were sailing across the Indian Ocean to Sumatra, Australia and New Guinea. They mined gold and traded with Indonesians, explored Australia and exploited its vast resources as best they could, and continued across the Pacific in a joint Hindu-Egyptian colonization and commercialization of the Pacific and ultimately with the advanced cultures of North and South America. They became the "sons of the sun," and many of the Pacific islands took the name of "Ra" as part of their names, such as Ra-i-tea or Ra'itea in the Society Islands. "Ra"

means "the sun" in both ancient Egyptian and Polynesian.

One clear link between Australia and Egypt is that the people of the Torres Straits Islands, between New Guinea and Northern Queensland, use the curious practice of mummification of the dead. The Macleay Museum at Sydney University has a mummified corpse of a Darnley Islander (Torres Strait), prepared in a fashion that has been compared to that practiced in Egypt between 1090 and 945 BC.

It was reported in Australian newspapers circa 1990 that a team of marine archaeologists from the Queensland Museum had discovered extensive cave drawings on many of the Torres Straits Islands. Some of the cave drawings, on isolated Booby Island, were of a Macassan prau which is a unique vessel with telltale double rudders and triangular sails used by *beche de mer* (sea cucumber) fishermen out of the Indonesian island of Sulewesi. The archaeologists declared the Torres Islands the "crossroads of civilizations" and were quoted as saying, "Now it's a new ballgame in an archaeological sense."

In 1875 the Shevert Expedition found similarities in Darnley Island boats and ancient trans-Nile boats. The island boats were used to row corpses to sea and leave them on a coral reef. Egyptian practice was to ferry corpses across or down the Nile for desert burial.

Similarly, it was pointed out by Kenneth Gordon McIntyre in his book *The Secret Discovery of Australia* (Picador, 1977) that the name of the island of Mir in the Torres Strait was the same as the Egyptian word for pyramid, "mir." Another similarity between the Egyptians and the Torres Straits Islanders, as well as residents of the Solomon Islands, Fiji and Polynesia, was the use a a wooden headrest. This carved headrest was used to slightly elevate the head, while the subject slept on his back.

Curiously, on the island of Pohnpei the new capital of the Federated States of Micronesia, an ancient Egyptian word is important in the government. Pohnpei island is divided into five districts and the governor of a district is called a nan-marché in the language of Pohnpei. Similarly, in ancient Egypt, a district was known as a nome, and a district governor was known as a nome-marché. Here we have extremely similar words meaning the exact same thing in ancient Egyptian and modern Pohnpei dialect. A coincidence?

The Egyptians built their ships without nails, and a number of ancient ships, many without nails, have been found along the coasts of Australia. Two ships 40 feet long and 9 feet wide, built without nails, have been found near Perth, Western Australia. Another was found partially hidden underneath a sand dune at Wollongong, New South Wales.

On the Atherton Tablelands of Queensland in 1910, Mr. A. Henderson dug up a Ptolemy IV coin from the Ptolmaic period of

Egyptian history, 221-204 BC.

Other strange finds linking Eyptians to the South Pacific follows:

—At Ipswich, Queensland in 1965 workmen dug up a cache of hand-forged Egyptian bronze, copper and iron tools, pottery and coins dating back more than 2,000 years.

—At Rockhampton in 1966 an Egyptian calendar stone, gold scarabs, and gold coins were found. Also in Queensland, near Herberton, can be found rock paintings that apparently depict a two-stem papyrus, the swamp plant of ancient Egypt. A three-stem papyrus rock painting can be found near Mareeba.

—At the Gympie Museum (Queensland) can be found a three foot tall rock statue of a baboon holding a papyrus against his chest. It was discovered in the 1920s on a farm near Gympie, near what was said to be a terraced, pyramidical hill. The Egyptian god of science, Thoth, was typically depicted as a baboon. Baboons only live in Africa and parts of Arabia.

—In a sand dune at Austinmer, New South Wales in about 1930 a woman found a handmade silver necklace and bronze armband reported to be of ancient Egyptian origin. In the vicinity of Austinmer, gardeners and beachcombers have found gold figures, pottery fragments, scarab beetles and small Egyptian figures.

—In Western Australia, around 1914, halfway between Perth and Geraldton, 100 miles inland, Mr. H. E.Thomson found Egyptian lotus flowers growing on recently burned ground. The Curator for the Perth Botanical Gardens identified them as lotus plants foreign to Australia.

In the town of Geraldton in 1963, workmen excavating 28 feet below the sea bed brought up an Egyptian bronze plate from an ancient beach level.

—In the Sydney suburb of Ryde in 1969, a gardener dug up hand-forged fragments of iron pottery inscribed in the Egyptian style.

—In the Sydney suburbs of Fivedock and Campsie, gold coins and ancient Egyptian jewelry have been dug up.

—At Towradgi, a 2,000 year-old coin was found in a sand dune. Near Goulgburn, a farmer plowed up an Egyptian silver coin.

—Near Newcastle, a broken bronze sword, earthenware pottery fragments, and old copper coins have been dug up near remains of stone dwellings and a stone wharf. At Campbelltown, an image apparently of an Egyptian deity is cut into a cliff face.

—Halfway between Sydney and Newcastle, Egyptian-like hieroglyphics are cut into a rock face. These amazing hierglyphs, very Egyptian, are thought to be a hoax, but an ancient hoax with no one taking credit! Nearby, very old aboriginal rock art shows Egyptian-like figures.

—The anthropologist Elizabeth Gould Davis says in her book, *The First Sex* (G.P. Putnam's Sons, 1971), "In Australia was found a pendant amulet of greenstone, carved in the shape of the Celtic cross, an exact duplicate of an amulet found in Egypt at Tel el Amarna, the site of the ancient city where Nefertiti and the Pharaoh Akhenaten held court thirty-five hundred years ago."

—The French researchers Luis Pauwels and Jacques Bergier say in their book, *Eternal Man* (Souvenirr Press, 1972), "In 1963 a strange and disconcerting piece of information came to us from Australia. A pile of Egyptian coins that had been buried for about 4,000 years was found in terrain sheltered by rocks. The readers who gave us this information referred to some rather obscure reviews for there was no mention of this find in any archaeological publication. However, the widely-read Soviet review Tekhnika Molodezi which devotes a regular column to unexplained facts with comments on them by experts took up this matter. It even published photographs of the excavated coins."

§§§

Early Chinese and other Voyages
There is also the very clear possibility of early Chinese, Arab, Greek and even Mayan and Incan voyages into the Pacific. In his book *Millennia of Discoveries*,[31] historian Alexander Adams maintains that the Greeks made voyages into Indonesia and the Pacific. Says Adams, "In the fourth century BC, energetic King Philip II reorganized Macedonia and established it as a capable military power that would dominate the Greek policies of the future. His son, Alexander the Great, by destroying Thebes broke up Greek resistance for many years. The brief but illustrious career of Alexander put his name in history books forever. In eleven short years he demolished the giant Persian empire and Macedonian and Greek soldiers marched to the borders of India.

"After his death in 323 B.C., the Hellenistic Age began. Rapid Hellenization of the Near East allowed Greeks to settle there in big numbers and exploit trade with East Africa, India, and the faraway China.

"The Macedonian fleet explored the Indus River and the southern coasts of modern Iran, Pakistan, Oman, and the gulf states. Understanding the principle of the monsoon—tropical winds in the Arabian Sea—allowed Greeks to sail directly from the Red Sea across the Arabian Sea to India. The need to follow the coasts of Arabia disappeared.

"The Macedonian dynasty of Ptolemies ruled Egypt from 323 to 30 BC. Relying on the knowledge of the ancient Egyptians, the Ptolemies monopolized the Red Sea trade and became primary suppliers of pearls, gold, ivory, slaves, and papyrus to the Greek markets.

"Greek fleets left Egypt and followed the African coast to the African horn and rounded it, sailing down south along the East African coast. These journeys took them all the way down to modern Mozambique and Tanzania, where they traded with the Sabean communities. What was the extent of the Greek travels? Either most of the ancient Minoan and Mycenaen heritage was totally forgotten by the fourth century B.C. or some of it was never known to the Greeks. But their own travels established them as pioneers in their own right.

"Modern Hawaiian and Polynesian contain some Greek words, suggesting that certain Greeks sailed way past India to the Pacific. Greek coins have been found in Java and in southeast Asia."[14]

In his book *Lost City of Stone*[10] historian Bill S. Ballinger theorizes that a fleet of Greek ships ventured out into the Pacific after the death of Alexander the Great and ended up founding a dynasty on the remote Micronesian island of Pohnpei. They built the gigantic ruins of Nan Madol on the southeast corner of Pohnpei, and explored much of the Pacific with their large Greek ships, based out of Nan Madol, Ballinger's "Lost City of Stone."

Similarly, Chinese voyages into the Pacific have been the subject of a number of Chinese books which mention the long journeys across the Pacific. According to archaeologist Henriette Mertz in her book *Pale Ink*[12] the Chinese made several voyages across the Pacific which were recorded in well-known Chinese books such as the 2250 BC book known as *Classic of Mountains and Seas* and the book *Fu Sang* written by a Buddhist missionary about 400 AD. 'East of the Eastern ocean lie the shores of *Fusang*. If, after landing there, one travels East for 1,000 li he will come to another ocean, blue in color, huge and without limit.'[12]

This other ocean is apparently the Caribbean, an ocean that is deep blue in color. Chinese expeditions arrived in California, journeyed across the deserts to the Gulf of Mexico, and even visited the Grand Canyon.

Many Chinese expeditions were sent into the Pacific, such as an expedition in 219 BC which never returned to China. Some Chinese sailors and expeditions may have settled on Pacific Islands in Micronesia and Polynesia, perhaps eventually intermarrying with Polynesians in Samoa, Tonga and Tahiti. Some Chinese ships had five decks for passengers plus cargo space and some of the first-class cabins were equipped with bathrooms and running water.

Egyptian explorers, early Hindu and Chinese voyages, similar Mayan expeditions and the mystery of the Polynesians are the subjects of ongoing investigation. As archaeological discovery and dating techniques become more and more sophisticated, a further vindication of these theories may come about. Meanwhile, Pacific Archaeology continues to struggle against the early archaeological prejudices that influenced it such as the erroneous dating of many the megaliths.

The Land of Giant Birds & the Tuatara

Ancient Polynesia was a strange land of giant birds taller than men, weird dinosaur-lizards called the Tuatara, vast forests, giant bats, and all manner of weird sea life. Ancient Polynesia spanned many large and small islands but the great southern island of New Zealand was Polynesia's great frontier with its vast mountains and forests.

New Zealand boasts many unique animals including the most bizarre of all, the tuatara *(Sphenodon punctatus)*, the sole survivor of the order of Rhynchocephalia, a lizard which paleontologists say predates the dinosaurs. The tuatara is a unique animal on the face of the earth, and exists in its own "order." The tuatara is a large olive-green lizard, some 2 feet, 3 inches long, which still has a vestige of a third eye on the top of its skull. This is called the pineal eye and is found in the higher vertebrates in the shape of the epiphysis or pituitary gland.

That this relic, "older than the dinosaurs," still exists in New Zealand is perhaps evidence of an ancient continent in the Pacific. Indeed, to explain some of the animals in New Zealand, certain geological concepts of continental drift and vanished continents were formulated.

More intriguing still is the moa, one of the largest birds that ever existed. One interesting theory about the dinosaurs that has gained increasing popularity over the years is that dinosaurs, like birds, were warm blooded. In this theory, birds are then the natural descendants of the dinosaurs. In other words, dinosaurs did not become extinct, they evolved into birds. The first birds can be found in New Zealand— the kiwi for instance. It has hairy feathers and vestiges of wings. The kiwi is also the only bird with its nostrils at the end of its beak. The moa, however, had no vestige of wings at all. There is no sign of a collarbone by which a vertebrate's front legs are almost invariably connected to the thorax. It is the truest of bipeds, and its feathers are so primitive that they seem more like hairs. Insects have hairs, and some mammals have both scales and hair, such as pangolins and armadillos.

Some moas were twelve feet tall and lumbered around the forests of New Zealand like small dinosaurs. Others were only the size of a small turkey. Moas dwelt in the forests by the hundreds, and the first Polynesians to arrive called them simply "moa," their word for common fowl. Yet by the time the first European explorers arrived, the moa was practically, if not entirely, extinct. Only the nocturnal kiwi still thrived. Curiously, a flightless megapode bird called the *Megapodius pritchardii* lives on the island of Niuafo'ou in far northern Tonga. This bird is similar to the kiwi or the dodo bird of Mauritius. Is it a last surviving megapode bird that once existed in other parts of Tonga? Ancient Tonga may have had large flightless birds just as New Guinea, Australia and New Zealand.

Says Andrew Mitchell in his book *The Fragile South Pacific,* "The distribution of megapodes in the Pacific is very odd. They are found in northern Australia's forests and scrublands, throughout much of South-east Asia, and in New Guinea. Aeons ago it seems that they progressed down the Solomon Islands land bridge with relative ease—one species reached the New Hebrides further to the west, now know as Vanuatu—and then they apparently vanished, only to reappear on one single island in the middle of the Pacific Ocean, the Island of Niuafo'ou in the Tongan group. The *Megapodius pritchardii* lives in splendid isolation surrounded on all sides by vast expanses of ocean."[2]

The question of why moas died out has led to a lot of arguments, ever since the first discovery of moa bones in the 1830s by a trader, Joel Polack, soon after the British anatomist Richard Owen had surmised that such a bird once existed. Mummified moa remains were discovered along with rock carvings, and some Maori chiefs still remember the moa hunting songs. But, what had created such a monster bird, and why was it that similar giant flightless birds, such as ostriches and rheas, also existed all over the world, and how did they get there? Did they evolve independently, or somehow together?

The generally accepted theory is also a controversial one. This theory is well summed up in the book, *No Moa* by Beverley McCulloch published by the Canterbury Museum in Christchurch. Ms. McCulloch says, "The islands of New Zealand are often regarded as Pacific Islands and part of Polynesia. Geologically, however, they are quite distinct from most of the islands of the Pacific. New Zealand is in fact a piece of a continent, like Australia or Africa, only a small portion of which emerges from the ocean."

All of the large, flightless birds known as megapodes belong to a group known as ratites. Yet to say that these birds lost their ability to fly over thousands (millions?) of years does not ring true. For one thing, the moa has not even the vestige of wings! Even seals and

whales still have vestiges of arms and feet. It appears that the moa never flew and was never meant to. Nor does its lack of wings explain why it became extinct; after all, Africa, Australia, New Guinea and South America are teeming with giant flightless birds, no better off in terms of wings than the moa. Why shouldn't they be extinct? After all, they were and are hunted by men as well.

The answer to that question would appear to be that moas, and the aepyornis or elephant bird of Madagascar, became extinct (if they are) because they were ultimately trapped on relatively small islands (compared to continents, anyway) where they had a limited space in which to run from pursuers.

Perhaps moas are the best example of dinosaurs turned into birds. Lumbering along on huge, powerful legs, they merely stepped on animals that gave them a hard time; after all, they weren't bothering anybody. Then along came man with his spears and arrows, and suddenly moas couldn't kick and stomp those that would do them in.

Then there is the tuatara, last ancestor of some bizarre, primitive reptile. Where are his relatives? Lost beneath the Pacific Ocean or deep-frozen under a mile of ice in Antarctica in the last poleshift?

§§§

The Politically Correct Pacific

What I did not realize at the time of all the publicity surrounding the Kaimanawa Wall was that I was walking on some very sensitive ground. I did not realize that the subject of ancient Tongans coming to New Zealand before the current Maoris was a powder keg of history and politics that was ready to explode, and I was suddenly caught in the middle of the controversy.

As it was explained to me by Barry, Gary and others, New Zealand was currently in the throes of dividing up the country among the Maoris, who felt that New Zealand had been stolen from them by the British settlers, and the European and Pacific Island immigrants who thought that New Zealand should be a multi-ethnic society where everyone had the same rights as everyone else, including land and fishing rights.

With a sizeable Tongan/Samoan immigrant community in New Zealand, and a British settler backlash against the rising pro-Maori legislation in the country such as exclusive fishing rights for Maoris, the idea that Tongans and other Pacific islanders had come to New Zealand before the Maoris was not politically correct.

Indeed, a female Maori journalist who had been assigned by an

airline magazine to do a story on our cafe/bookstore stormed out of the store after seeing some of the diffusionist books on sale, saying she would not do a story on our bookstore, and that archeologists like Brailsford was "messing everything up for the Maoris."

Indeed, the issue became so sensitive that I learned that there were now death threats, apparently from Maoris, against anyone who had anything to do with the discovery of the Kaimanawa Wall and the idea that it is a pre-Maori megalithic structure. Both Barry and Gary had taken security steps against these threats. I was told that I might be in danger as well.

I returned the U.S. where I completed a book that I was working on entitled *Ancient Tonga and the Lost City of Mu'a*.[6] With the publication of that book I flew back to New Zealand to give a presentation at the Adventures Unlimited Bookstore Cafe and to promote the book in Tonga, Rarotonga and New Zealand.

One woman who attended my lecture and slide show was named Janice, a blonde divorcee of average height and build. She bought a copy of *Ancient Tonga and the Lost City of Mu'a* and had me autograph it for her. She gave me her business card and told me that she was a "headhunter" who helped place people in special occupations. Curiously, her office was in the same building as the New Zealand Intelligence Service. I paid little attention to this, and was happy that she wanted a copy of my book.

Over the next week Janice came several times into the bookstore/cafe, and introduced me to her teenage daughter one afternoon. She told me that she also knew Barry Brailsford and was very interested in all our research on the Kaimanawa Wall and other New Zealand antiquities.

Meanwhile, Gary Cook told me that he had been warned by a friend that the New Zealand government had considered eliminating him as a troublemaker with all this Maori-upsetting Kaimanawa Wall stuff. He was given a scenario in which he would come home one evening to his house to find that it had been broken into. Upon looking through his house he would suddenly find that the intruders were still in his home and that he and his wife would suddenly be killed by these "robbers." This would all take place if he continued to promote the Kaimanawa Wall and pre-Maori contacts via his conferences, radio appearances and such.

"Wow," I said, putting down my cup of coffee. "I didn't realize that this was such a sensitive political issue."

"They've told me that the government is trying to appease the Maoris," said Gary. "Rumor has it that there are caches of arms at various spots on the North Island that certain revolution-inclined Maori groups want to use to make New Zealand a Maori-controlled

state. The government is trying to diffuse the situation as best they can. There is also a rivalry between the many Islander groups in New Zealand, especially between the Tongans, Samoans and Maoris. These islanders don't mix very well, and bar fights start between these groups all the time. If the Tongans are given credit for the Kaimanawa Wall, this could cause some political problems. Maybe the King of Tonga will claim New Zealand."

With that, Gary finished his coffee and announced that he had to leave. "Well, mate, I've got to be going. Watch out for yourself. Archeology can be a bit dangerous sometimes. Ask Indiana Jones."

I laughed and walked Gary to the door, and went back to my business.

A few days later Janice came into the bookstore/cafe in the early afternoon. This time she was with a companion, a tall, muscular man who was in his late fifties.

"David, I'd like you meet my friend, Peter," she announced. "Do you have a minute to have coffee with us?"

"Of course," I said, and joined them at a table near the door. We ordered coffee and Janice introduced me to Peter.

"Peter is a professional diver," Janice said. "He's British, but he's lived here in Auckland for some years." I looked at him. He was balding, but was extremely well-built. He wore an expensive diving watch was on his left wrist, and he seemed to a pleasant, soft-spoken, and well-educated person.

We chatted for a few minutes and then Janice asked me if I would like to go yachting with her and Peter on the Sunday coming up. Sunday was my free day at the bookstore, which was closed on that one day a week.

Auckland is famous for its yachting, and the city is known as the "City of Sails." It would be fun to go yachting one day, and I thought for a moment and then agreed. My friend Harry was working in the bookstore, and had just made us coffee, so I said, "It would be fun to go yachting—can my friend Harry come with us too?"

This suggestion seemed to make them visibly nervous. "Him?" Janice stammered. "You want him to go yachting with us as well?" She looked at Peter, who said nothing in return.

"Well, he's an old friend, and we both have Sunday off," I said.

This suggestion of bringing a friend along seemed to suddenly confuse them, but eventually Janice said, "Well, I guess that would be okay. He can come along."

"What time do you want meet on Sunday?" I asked.

"We can meet at 10:00 in the morning," Janice said. "I'll call you and tell you where to meet us." And with that, Janice and Peter got up to leave. "See you then," she said.

I shook Peter's hand, his strong grip squeezing my hand. "Nice to meet you," he said.

"Yes, it was nice to meet you. See you Sunday." And so the two left.

Two days later, it was Sunday morning and Harry and I met early at the bookstore. Suddenly, at 8:30 that morning a storm blew in over Auckland and it rained heavily for an hour. The phone rang, and it was Janice.

"David, I'm sorry, but we'll have to cancel the yachting today," she said. "Hopefully we'll do it some other time."

I told her that was fine and hung up. Harry and I began planning a new day for ourselves, one that included a number of chores around the bookstore. Later that day, ironically, it cleared up, and was bright and sunny, though in Auckland, one never knew what the weather would be from hour to hour. "If you don't like the weather," people often said, "just wait an hour."

I forgot about the incident, or the muscular professional diver Peter, and some months went by. I continued on to Nepal on one of my round-the-world trips, and back to North America.

Then one day, back in Auckland, I was working around the bookstore and someone mentioned how an older Maori woman had come into the bookstore and harranged an American in the store, and babbled for five minutes about the American CIA and then pointed to the building just down the street from the bookstore. Though it held a post office and a bank, it was well-known for having the offices of the New Zealand Secret Service. She made some derogatory remarks about the New Zealand Secret Service and then our manager hustled her out of the store.

We all laughed about it for a moment at Cafe 223 next door, but then it brought back memories of the aborted yacht trip, and Janice's diver friend. Like a freight train, it hit me that I had been targeted to be eliminated. I had become a problem to the New Zealand government, having been on the BBC and all, promoting pre-Maori contact in the islands. This was becoming a problem, and I was to go on a yachting trip where an unfortunate accident would take place.

After a few bottles of wine, would I have fallen overboard, then held under by Peter? He was a strong man, silent, and sure of himself. Any struggle against him would have been very difficult—and out at sea, would I have swum back to shore from far out in the Auckland Bay? The whole scenario sent shivers down my spine.

"Whoa, David, you look like you've seen a ghost," said Kurt, the owner of Cafe 223.

"I think I just met James Bond," I said, wiping my brow. "I need another drink." After a quick shot of tequila I slammed the glass

down and took a deep gulp of beer.

"James Bond? You mean the Roger Moore or one of those new guys?" asked the store manager, Denise.

"No, not the actor, the real life James Bond, with a license to kill," I said. "I mean, the guy's name wasn't James Bond, just that he had the same job as Bond, fixing difficult problems." I then told them all my revelatory suspicions that the New Zealand government was trying to kill me. It seemed incredible, but all the pieces of the puzzle seemed to fit.

"Wow, so all this fuss about the Kaimanawa Wall really has the New Zealand government worried?" asked Denise. "I guess the government wants to keep the Maoris happy, and publicity about pre-Maori discoveries of New Zealand is too controversial for them."

I shook my head and looked at my half empty, er, half full, beer. Had I escaped death out of sheer luck of the weather? They had clearly not wanted Harry to go on the trip, but only myself. Would two of us have had to drown? It was a sickening thought.

"Well, you're not politically correct with all your discoveries," said Kurt. "You discover some giant wall out in the forests, and suddenly, people are trying to kill you. Hey, maybe you are the real-life Indiana Jones. People are always trying to kill him too. Do you carry a whip?"

We all laughed at that. Maybe being the real-life Indiana Jones wasn't such a great deal after all—you get dragged under trucks, people try to kill you, you're buried alive in ancient tombs, stuff like that.

After a few more shots of tequila and a few more beers, it didn't seem to matter anymore. What if I wasn't politically correct in all my archeological discoveries? What if James Bond was trying to kill me? Tomorrow was another day—and that was that.

Bibliography

1. *Riddle of the Pacific,* John Macmillan Brown, 1924, London. Reprinted by Adventures Unlimited Press, 1996.
2. *The Fragile South Pacific,* Andrew Mitchell, 1989, University of Texas Press, Austin.
3. *The Secret Land,* Gary Cook, 2000, Stoneprint Press, Hamilton, New Zealand.
4. *Eden in the East,* Stephen Oppenheimer, 1998, Weidenfeld & Nicholson, London.
5. Celtic New Zealand,
6. *Ancient Tonga and the Lost City of Mu'a,* David Hatcher Childress, 1997, Adventures Unlimited Press.
7. *Song of the Stone,* Barry Brailsford, 1994, Stoneprint Press, Hamilton, New Zealand.
8. *Greenstone Trails,* Barry Brailsford, 1984, 1996, Stoneprint Press, Hamilton, New Zealand.

9. *The Tattooed Land,* Barry Brailsford, 1997, Stoneprint Press, Hamilton, New Zealand.
10. *Lost City of Stone,* Bill S. Ballinger, 1976, Ballentine Books, New York.
11. *America B.C.*, Barry Fell, 1976, Simon and Schuster, New York.
12. *Pale Ink,* Henriette Mertz, 1962, Henry Regnery, Chicago.
13. *Lost Cities of Ancient Lemuria & the Pacific,* David Hatcher Childress, 1988, Adventures Unlimited Press.
14. *Millennia of Discoveries,* Alexander Adams, 1994, Vantage Press, New York.

Top: Barry Brailsford and the author begin their examination of the Kaimanawa Wall. Bottom: The author pauses for a minute with the New Zealand press.

Top: Barry Brailsford meatures the wall. Bottom: Close-up of some of the perfectly rectangular blocks.

Top and bottom: The author studies the Kaimanawa Wall.

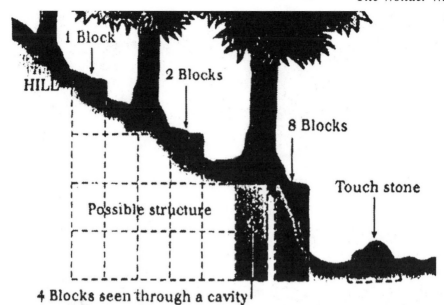

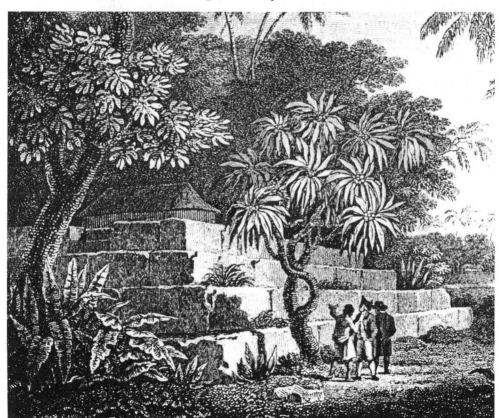

Top: Barry Brailsford's drawing of the possible pyramid inside the hill where the Kaimanawa Wall is located. Bottom: A Tongan pyramid at Mu'a drawn in 1797.

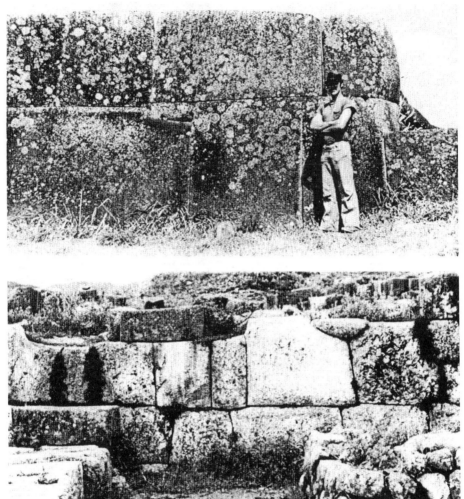

Top: The wall of Vinapu on Easter Island. Bottom: Similar masonry found at the Sacsayhuaman fortress at Cuzco, Peru.

Kaimanawa Wall•

5.
Lawyers, Guns & Money: Sucked Down by the Octopus

The nature of the universe is such that ends can never justify the means.
On the contrary, the means always determine the end.
—Aldous Huxley (1894-1963)

It is dangerous to be right when the government is wrong.
—Voltaire (1694-1778)

Show me a hero and I will write you a tragedy.
—F. Scott Fitzgerald (1896-1940)

Knowing others is intelligence;
knowing yourself is true wisdom.
Mastering others is strength;
mastering yourself is true power.
—Lao-Tzu, philosopher
(6th century BC)

Life for me lurched forward as the second half of the 90s rolled on. I had been inside the tunnels of South America; I was a cargo cult god on a remote island; New Zealand intelligence had a contract out on me for my termination with prejudice—and now, I was involved in the Kennedy assassination and being sucked down by what is often known as "the Octopus."

It all started when a friend and fellow author, Kenn Thomas,

came to Adventures Unlimited with a samizdat (unpublished) manuscript known as "The Torbitt Document," named after a Texas lawyer who penned it using the pseudonym "William Torbitt." Kenn suggested that Adventures Unlimited publish The Torbitt Document with commentary and accompanying documents, newspaper clippings and photos under the name *NASA, Nazis & JFK: The Torbitt Document and the Kennedy Assassination.*[1]

After some months of research, the book was published, and we became targets for the Octopus, that multi-armed hydra of government and private entities which is an alleged amalgamation of covert operatives from various intelligence agencies, including the CIA, arms dealers, drug dealers, assassins, shadow corporations, and corrupt banks dedicated to preserving the status quo in which they hold all the power. Only lawyers, guns and money were going to get us out the problems that came out of that book.

As I started getting into lawsuits over such things as the Kennedy assassination and UFOs, I realized that if you had lawyers, guns and money, you could basically get what you wanted. Money is probably the most important element, since money can always buy lawyers and hired guns.

You start amassing lawyers, guns and money, and eventually you can be a local warlord or national heavy hitter. The only thing that can stop you is someone with more lawyers, guns and money than you have. The stakes can get extremely high. These arsenals can amount to an entire country's printed currency and army, often a foreign-born army of paid mercenaries. In the real world of politics—local, national, and international—it is better to have other people carry your guns for you. Today's global powerhouses like the USA, Britain, Russia and China all started out with someone else's money and lawyers—the two of which were used for purchasing guns. Along with arms dealing, the international drug trade often figures into the whole volatile mix, often in a deadly way.

Entire governments, and their armies, have been bought and sold. This was a bit beyond my budget, but when the shit started hitting the fan, and the bullets were flying beyond the grassy knoll, I decided that I would fight back with whatever resources I could muster. I just hoped to stay out of harm's way. Could it be that JFK, even with the enormous family and political resources at his disposal, just went too deep into the murky world of lawyers, guns and money?

§§§

The Torbitt Document

New Orleans District Attorney Jim Garrison once said, "President Kennedy was murdered by elements of the industrial warfare complex working in concert with individuals in the United States Government. At the time of his murder, President Kennedy was working to end the Cold War. The annual income of the defense industry was well over twenty billion dollars a year, and there were forces in that industry and in the U.S. Government which opposed the ending of the Cold War."[6]

The Torbitt Document expounded upon this theme. Officially entitled "Nomenclature of an Assassination Cabal," it began circulating among conspiracy researchers in 1970 in the form of a photocopied manuscript. It was a damning exposé of J. Edgar Hoover, Lyndon Johnson, John Connally and Werner von Braun, among many others, for their role in the assassination of President John F. Kennedy. Adventures Unlimited's first published edition of the Torbitt Document emphasized what the manuscript says about the links between "Operation Paperclip" Nazi scientists working for NASA, the Defense Industrial Security Command (DISC), the assassination of JFK, and the secret Nevada air base known as Area 51.

•The Torbitt Document reveals the roles in the assassination played by NASA and the munitions police of the little-known Defense Industrial Security Command (DISC), an organization headed by Werner von Braun. This shadowy organization allegedly was a secret hit-team for the aerospace industry, part of NASA, and included ex-Nazis. Some of the DISC teams may have been the origin for "Men In Black" stories.

•The Torbitt Document tells how the assassination was carried out by J. Edgar Hoover's elite Division Five. The FBI's Division Five investigated the JFK, RFK and Martin Luther King assassinations, finding only evidence for "lone-nut" assassins.

•The Torbitt Document tells how the Las Vegas mob and the shadow corporate entities set up in Switzerland called Permindex and Centro-Mondiale Commerciale were involved in the JFK affair, and how the FBI cooperated with the Mafia to create the crime and later cover it up.

•The Torbitt Document links the same "assassination cabal" to the failed 1962 assassination attempt on French President

Charles DeGaulle. Torbitt tells how DeGaulle traced the attempt from right-wing French Algerians to Permindex in Switzerland and NATO headquarters in Brussels.

Other damning accusations in the Torbitt Document assert that Lyndon Johnson, John Connally, Clay Shaw, Werner von Braun and British Intelligence were tied to the JFK assassination plot, and that the "assassination cabal" planned to blame anti-Castro groups, or Castro himself, if the "lone-nut" explanation failed.

Indeed, the Torbitt Document paints a dark picture of NASA, the military industrial complex, and their connections to Mercury, Nevada and the Area 51 complex which headquarters the "secret space program" there.

The FBI and the CIA

There seems to be no doubt that the CIA played an important role in the planning and subsequent cover-up of JFK's murder. However, the role played by the CIA may have been overestimated, while the roles of the FBI and the military industrial complex in the assassination may have been long underestimated.

Consider this: How could the many murders, bits of evidence, and glaring inconsistencies have been kept from the public for such a long time without the full cooperation of the FBI's investigative team? Could it be that it was the FBI's Division Five that not only investigated the assassinations of JFK, RFK and Martin Luther King, but planned these assassinations as well? When the FBI or CIA investigate their own criminal activities, does it seem surprising that they can find no evidence of such activities? Despite the fact that nearly all Americans are aware that both the FBI and the CIA have been involved in "extra-legal" activities, the FBI and CIA have continued to deny any wrongdoing. It's like the boy holding a can of spray paint behind his back when the handwriting is on the wall, and insisting that "he didn't do it" and doesn't know who did!

Consider this: The head of the FBI's Division Five at the time of the assassination was William Sullivan. Sullivan was one of Hoover's top aides and personally handled the FBI investigations into the assassinations of JFK, RFK and MLK. He found no wrongdoing on the part of any government agency and firmly announced that each assassination was the doing of a lone-nut assassin. Sullivan was also deeply involved in the infamous COINTELPRO Operation which Hoover used to infiltrate and smear the political

left.

In 1975, Sullivan was called before a Congressional committee investigating Lee Harvey Oswald. When asked whether he had seen anything in the files to indicate a relationship between Oswald and the CIA, Sullivan replied, "No... I think there may be something on that, but you asked me if I had seen anything. I don't recall having seen anything like that, but I think there is something on that point... It rings a bell in my head."

Amidst continuing suspicion and speculation about the three high-profile deaths, an official Assassinations Committee was established in 1977. In that year, the Assassinations Committee was to question William Sullivan to be more specific about the source of that bell in his head. But before he could testify, he was shot to death on a November dawn, the apparent victim of a "hunting accident." The man who shot Sullivan said, "I thought he was a deer."

Sullivan, like many witnesses, never testified before the Congressional Assassinations Committee. If he did not perjure himself, he might have told them some very interesting things. What little we can piece together of Sullivan's activities for Division Five of the FBI are damning evidence that he was part of a massive cover-up, at the very least. Sullivan was in Washington D.C. the day of the JFK assassination. By 6:00 P.M. of that day, Sullivan was in charge of investigating the internal security aspects of the incident, and the background of Oswald.

H.R. Haldeman, President Nixon's chief of staff who went down with the Watergate scandal, wrote in his book *The Ends of Power* about the Watergate tapes: "In all of those Nixon references to the Bay of Pigs, [Nixon] was actually referring to the Kennedy assassination... The CIA literally erased any connection between Kennedy's assassination and the CIA... in fact, Counter Intelligence Chief James Angleton of the CIA called Bill Sullivan of the FBI and rehearsed the questions and answers they would give to the Warren Commission investigators."[6]

Enter the Mafia

Another FBI agent, Dallas resident James P. Hosty Jr., was the agent in charge of Oswald's case at the time of the assassination. According to the Warren Commission, on November 6, 1963, Oswald wrote a note to Hosty, which Hosty later ripped up and flushed down the toilet, under the orders of FBI office chief J.

Gordon Shanklin.

On the 1988 British television documentary *The Men Who Killed Kennedy*, Hosty said, "I feel there was, based on what I know now, a benign cover-up. [The government] was concerned about Oswald's connections to the Soviet Union and to Castro. They were fearful that, if the public were to find this out, they would become so incensed that it could possibly have led to an atomic war."

Hosty also said in that documentary that he was told by an FBI counterintelligence agent, not long after the assassination, that he was to halt all FBI investigations of Oswald and all cooperation with the Dallas Police Department regarding Oswald's background. Hosty said, "I have since determined that those orders came directly from Assistant Director William Sullivan, who was in charge of foreign counterintelligence and direct liaison to the National Security Council."

As "William Torbitt" will remind us over and over again, William Sullivan was also head of Division Five.

Another key FBI officer involved in the cover-up was New Orleans senior agent Regis Kennedy. It was Regis Kennedy who gave David Ferrie, the New Orleans pilot, private detective and Oswald acquaintance, his much-needed alibi of being in a courtroom with crime boss Carlos Marcello, a meeting supposedly witnessed by the FBI agent. Ferrie's death sentence was when New Orleans District Attorney Jim Garrison subpoenaed him as a witness in Clay Shaw trial. He was murdered before he could testify.

Says British author Anthony Summers in his bestselling book *Conspiracy: Who Killed President Kennedy?*, "His [Regis Kennedy's] attitude to organized crime was wholly inconsistent with his post. When David Ferrie needed an alibi after the assassination, it was Regis Kennedy who lined up with Carlos Marcello himself, and with Marcello's lawyer, to provide the inconsistent alibi. If Regis Kennedy did see Ferrie that fateful noontime, it was right to say so. However, this FBI officer's attitude to the Mafia, and to Marcello in particular, seems indefensible. Contrary to all other authorities, he insisted to the Assassinations Committee that Marcello was indeed a mere 'tomato salesman and real estate investor.' Regis Kennedy declared blithely that he 'did not believe Marcello was a significant organized-crime figure' and singled out the 1963 period as one of Marcello's innocent years. A report by the chief counsel of the Assassinations Committee found that the FBI's 'lim-

ited work on the Marcello case may have been attributable to a disturbing attitude on the part of the senior agent who supervised the case, Regis Kennedy.' Regis Kennedy directed much of the New Orleans inquiry after the assassination and was one of those assigned to investigate the original allegation that Marcello had uttered threats against the President's life."[6]

Regis Kennedy refused to testify before the New Orleans grand jury investigation into the assassination, citing "executive privilege." The "executive privilege" was from LBJ, who gave Kennedy permission not to testify. Regis Kennedy was identified by Beverly Oliver as one of two men who took from her the Super-8 movie film she had taken of the assassination. This valuable movie footage of the assassination may be more important than the Zapruder footage, but it seems we will never know, as the film was never seen again—probably turned over to William Sullivan and Division Five.

Other FBI agents that are curiously involved in the JFK assassination and its aftermath (and the Mafia) include Robert Maheu, a former FBI agent who became the CIA emissary first charged with recruiting the Mafia to kill Castro. He is also quite familiar to readers of "The Gemstone File,"[4] another samizdat manuscript circulated among conspiracy theorists having to do with the ability of lawyers, guns and (particularly) money to rule the world. Maheu controlled the entire Howard Hughes empire after Hughes was "kidnapped" in 1958.

§§§

What Does NASA Stand For, Anyway?

The list of FBI misdeeds and suspicious characters is a long and familiar one, but it is the other side of the Torbitt Document that is more carefully hidden by the conspirators: the role of NASA, DISC, and Permindex in Switzerland.

One of the most curious episodes in the JFK "thing" was the experience of Canadian businessman Richard Giesbrecht, who overheard David Ferrie discussing his role in the assassination with another man at the Winnipeg Airport on February 13, 1964. Giesbrecht overheard Ferrie talking several times about a package coming from Nevada. Later, the other man mentioned Mercury as the location where various contacts of one sort or another had taken place. Mercury, Nevada is not known to most Ameri-

cans, but it should be: it is part of NASA and is where the astronauts were trained for the Apollo moon missions.

Giesbrecht reported his information to FBI agent Merryl Nelson, whom he contacted through the U.S. consulate in Winnipeg. Giesbrecht said that the FBI agent at first told him, "This looks like the break we've been waiting for"—only to tell him a few months later to forget the whole thing. FBI agent Nelson is supposed to have said to Giesbrecht, "It's too big. We can't protect you in Canada."

Giesbrecht told the Canadian press that he believed that the FBI was ignoring his evidence and went to Jim Garrison in New Orleans. Garrison confirmed that Ferrie had been in Winnipeg that day. Garrison, however, may not have realized that Giesbrecht's greatest clue was the reference to Mercury, Nevada.

Take a look at the James Bond film *Diamonds Are Forever*, released in 1971. In one sequence, James Bond, while on assignment in Las Vegas, sneaks into a secret facility in the Nevada desert outside of Las Vegas. This facility is obviously Mercury. Once inside the facility, Bond pretends to be a worker in a lab coat and walks into a room where a German engineer is in charge. The man is clearly meant to be Werner von Braun. After witnessing the faking of the Apollo moon missions on the equivalent of an elaborate Hollywood set inside the facility, Bond steals the "lunar rover" and escapes into the desert. Does *Diamonds Are Forever* mirror the truth about NASA being part of a secret conspiracy?

With Operation Paperclip, the importing of many German scientists into the United States at the end of WWII, the aerospace and rocket industry of Nazi Germany became the American space program.[1, 7] But, while Werner von Braun saw his own pet rocket projects come to fruition, did he know of the secret anti-gravity projects (also based on German technological advancements during WW II), the crashed flying saucers, the secret mind-control and genetic research possibly being conducted at Mercury? He must have. With concepts like Alternative 3, involving underground bases full of genetically created "aliens" and secret trips to the Moon and Mars coming to the fore, today's informed public cannot help but wonder, "What is NASA?"

The Nazi connection to NASA, and their apparent use of special agents, and even hitmen with DISC, commanded by von Braun, makes us wonder who is really in control of the government? The Swiss connection to Permindex, with Clay Shaw as

one of the board of directors, also hints of a Nazi connection. Did the famous "Men In Black" get paid from Swiss bank accounts and carry NASA-DISC identification cards?

Perhaps the greatest secret of the JFK assassination is the role played by von Braun, DISC and NASA. Rocket technology is heavily dependent on mass volumes of petrol fuels being burned away at launch. Perhaps the Kennedy space program and the von Braun/military industrial complex space program (commonly known as NASA) just didn't mesh. Kennedy may have imagined the development of electric spacecraft, magnetic spacecraft, gyro spacecraft and other alternative propulsion means to conquer "the last frontier," which were simply not acceptable alternatives to the oil companies and their defense department associates.

Standard Oil and the Nazis

The power of the oil companies and their ability to control lawyers, guns and money in their relentless pursuit of furthering a military/industrial complex favorable to them is well-established, and is highlighted in the history of WW II.

William Teagle was a giant of a man, standing 6'3" tall and weighing over 260 pounds. Teagle had risen quickly through the ranks of John D. Rockefeller's Chase Manhattan, and later moved on to Standard Oil. There he avoided scandal after scandal of price fixing schemes. Teagle enjoyed Cuban cigars and Nazi politics, and was a major contributor to the Nazi party along with Royal Dutch Shell. Teagle also established early relations with I.G. Farben.

I.G. Farben was the German industrial giant who had become rich in the 1930s by arming the Nazi war machine, and would soon become Teagle's business partner. Teagle's business interests with I.G. Farben caused him to visit Berlin frequently. It was at this time he hired Ivy Lee, the father of public relations, to help him gain information regarding the United States government's reaction to the Nazi military build up.

When Hitler came to power, Teagle made sure that Standard Oil maintained its ties with Germany. Goering's planes could not fly without the lead additive tetraethyl, so Standard, DuPont and General Motors made sure that he had it. In fact, during the Battle of Britain, Great Britain actually had to pay royalty rights to Standard through the French while Goering's planes bombed London. Because of the bad publicity, Teagle turned Germany's ac-

count over to his Paris office, and made sure their tankers were using Nazi crews.

Before the United States entered the war, Standard Oil shipped their oil tankers with supplies bound for Germany through Vichy, North Africa. An example of this can be found in an incident where British ships seized an oil tanker headed for Casablanca. Cordell Hull, American Secretary of State, demanded that the vessel be released and when it was, the ship went on to Africa, soon followed by six additional freighters. Summer Welles, a State Department official, accused Standard refueling stations in Mexico and South America with supplying the Nazis. In Nicaragua, Standard was caught delivering Nazi propaganda to the natives.

The list of complicity goes on and on. On June 15, 1943 Cordell obtained an astonishing list of oil sales showing Standard subsidiary firms shipping fuel to Aruba which was then sent on to Fascist Spain and from there to Germany. Standard then sued the United States government for seizing synthetic rubber patents and using them to aid the Nazis who were developing different synthetic products.

Judge Charles E. Wyzanski gave his verdict, which reflected that he had decided against Standard. The final word came when Standard appealed the case. Judge Charles Clark words were quite harsh: "Standard Oil can be considered a national enemy in view of its relationship with I.G. Farben after the United States and Germany had become active enemies." Oil companies have no loyalty, or apparent morals. Profits are what count, and oil companies make higher profits today than ever before.

On top of all this, the grandfather of current U.S. President George W. Bush, Prescott Bush, was involved in arranging the illegal sale of tetraethyl lead to the Nazis. It was reported in a 1992 article in the *Village Voice* that Brown Brothers Harriman was the Wall Street investment firm that "arranged for a loan of tetraethyl lead to the Nazi Luftwaffe" in 1938. A senior managing partner of the firm was Prescott Bush. A number of books have directly accused Prescott Bush of masterminding the sales of huge shipments of specialized fuel to the Nazis.[3]

§§§

What If They Gave a War, and Nobody Came?
World War II was in many ways an oil war and an energy war.

The Axis Powers—Germany, Italy, and Japan—did not have oil fields of their own and desperately needed large oil reserves to fuel, literally, their own headlong rush into the modern machine age. In each of these countries, the military industrial complex was powering their post-Depression economies, and oil reserves were essential to further growth.

The Germans took the Ukraine with its large oil fields, as well as Norway, a major oil producer. The Japanese took the oil fields of Manchuria, and the Italians took the oil fields of Libya, the highest grade of crude oil in the world.

But eventually, even after Prescott Bush, grandfather of the current U.S. President, sold specialized high-grade aviation fuel to the Axis, the Germans, quite literally, ran out of gas. At the Battle of the Bulge, the last big battle of WWII, the Germans had lost their fuel supply lines and were forced to abandon their newly built Panzer tanks. Germany had lost the war at the fuel pump.

What if they gave a war and nobody came? Consider this:

1. The first German serviceman killed in the war was killed by the Japanese (China, 1937); the first American serviceman killed was killed by the Russians (Finland 1940); the highest-ranking American killed was Lt. Gen. Lesley McNair, killed by the U.S. Army Air Corps. So much for allies.

2. The youngest U.S. serviceman was 12 year old Calvin Graham, USN. He was wounded and given a Dishonorable Discharge for lying about his age. (His benefits were later restored by act of Congress)

3. At the time of Pearl Harbor the top U.S. Navy command was called CINCUS (pronounced "sink us"); the shoulder patch of the U.S. Army's 45th Infantry division was the Swastika; and Hitler's private train was named "Amerika." All three were soon changed for PR purposes.

4. More U.S. servicemen died in the Air Corps than the Marine Corps. While completing the required 30 missions, your chance of being killed was 71%.

5. Generally speaking, there was no such thing as an "average" fighter pilot. You were either an ace or a target. For instance, Japanese ace Hiroyoshi Nishizawa shot down over 80 planes. He died while a passenger on a cargo plane.

6. It was a common practice on fighter planes to load every 5th round with a tracer round to aid in aiming. Tracer rounds send out fiery dummy bullets that allow you see where your fire

is hitting, especially at night. This was a mistake. Tracers had different ballistics so (at long range) if your tracers were hitting the target, 80% of your rounds were missing. Worse yet, tracers instantly told your enemy he was under fire and from which direction. Worst of all was the practice of loading a string of tracers at the end of the belt to tell you that you were out of ammo—this was definitely not something you wanted to tell the enemy. Units that stopped using tracers saw their success rate nearly double and their loss rate go down.

7. When allied armies reached the Rhine, the first thing men did was pee in it. This was pretty universal from the lowest private to Winston Churchill (who made a big show of it) and Gen. Patton (who had himself photographed in the act).

8. German Me-264 bombers were capable of bombing New York City but it wasn't considered worth the effort.

9. German submarine U-120 was sunk by a malfunctioning toilet.

10. Among the first "Germans" captured at Normandy were several Koreans. They had been forced to fight for the Japanese Army until they were captured by the Russians, and forced to fight for the Russian Army until they were captured by the Germans, and forced to fight for the German Army until they were captured by the U.S. Army.

11. Following a massive naval bombardment, 35,000 U.S. and Canadian troops stormed ashore at Kiska. 21 troops were killed in the firefight. It would have been worse if there had been any Japanese on the island.

When you are part of the military industrial complex, no matter what is happening in a war, as long as your own factories aren't being bombed, everything is okay. Business is booming, new orders are coming in every day, and the purse strings of the nation are open to your accountants. But, once your factories are being bombed, and worker productivity is affected on top of damage to the manufacturing facilities, then the war is simply getting out of hand, and peace should be made.

Fortunately, or unfortunately, countries like Vietnam, Cuba, Colombia, Somalia, and Korea (at the time of the recent wars waged on them), didn't have large manufacturing facilities, so their weapons were entirely supplied from other countries, usually Russia, China, or the U.S.

A Brief Aside into the History of the Early Opium Trade

The drug trade is an old one, and, as aforementioned, is often related to the use of lawyers, guns and money for political gain. It goes directly to ruling kings, warlords, and the world's most powerful people. In many cases, the people involved are so powerful, the reading public would be incredulous of any stories of these people being involved in the drug trade and the billions of dollars that it generates.

The Opium Trade began in 1500, when Portuguese merchants first introduced the practice of smoking opium. Opium in its early days was used as a painkiller and for recreation. The Chinese believed that smoking opium was barbaric and soon banned its use. It was, however, imported to England by Queen Elizabeth's trading company. It was distributed throughout England by the crown, making the historic queen of England the first renowned drug dealer, which is how the empire acquired most of its fortune. In the 1600s, the drug was introduced to the people of Persia.

The Dutch then introduced the blending of tobacco and opium in their quest to gain a foothold in the emerging drug trade. However, the British East India Company cut them off quickly by controlling the growing process in Bengal to assume control of the trade. The Chinese tried to stop importation, as the drug epidemic soon reached staggering proportions, but by that time the British had achieved a monopoly on the drug. In India, growers were forbidden to sell opium to anyone other than the British East India Company, giving the British government a free hand on the drug commission.

While the Chinese sought to ban the drug, the crown sought other avenues of distribution and soon opium was being grown for importation into the United States and Europe. Some Americans, like John Cushing, invested heavily in the trade. In fact, one of the most famous families of America, the Astors of New York, bought tons of the drug which was then sent to England for sale. This is one of the ways they acquired their fortune and, in effect, became a part of the drug cartel. Considering today's laws, maybe we should confiscate their property which was, in part, gained through the sale of opium.

The Chinese tried to fight back, but the drug lords, under the guise of the British government, soon declared war on China and the Opium Wars began. By 1841, the Chinese were defeated and

were forced to pay a large indemnity to the crown and surrender possession of the city of Hong Kong to the British. Now, the British sought to increase their markets and their profits and by the end of the second Opium War in 1856, the Chinese were forced to legalize opium while the addiction rates in China skyrocketed.

Efforts were begun at this time to limit its use. The effects of opium were so devastating that laws were soon passed in the United States and Britain to regulate its use and to prohibit importation. Finally, after 150 years of failed attempts to rid its country of the drug, the Chinese were successful in forcing the British to stop the importation of opium to China. However, the damage was already done, and many lives were wrecked by the British search for wealth. The monarchy of England stands today as a beneficiary of the drug trade. The profits were enormous for the crown and today hardly anyone remembers them as the drug traders they were.

§§§

Sucked Under by the Octopus

As noted above, the information in The Torbitt Document was republished by Adventures Unlimited Press with additional commentary by myself and veteran parapolitical writer Kenn Thomas in 1996. Two years later, registered letters were received by myself and Kenn. A person mentioned in the book apparently took exception to being named one of the conspirators, or "assassination cabal" as Torbitt liked to term it, and was suing us for defamation of character.

Suddenly, as Kenn put it, we were being "sucked down by the Octopus." The plaintiff, an old friend of Oswald's from New Orleans, who knew David Ferrie as well, was still alive and had a lawyer who joined him in large lawsuits concerning his occasional mention in JFK assassination books.

Never had I believed that I would become personally entangled with actual participants of the assassination and its cover up. Court cases are frowned upon by the secret powers behind the scenes. Remember, when William Sullivan of Division Five was subpoenaed to testify before the Assassinations Committee, he was killed by an "accidental" shotgun blast.

Now Kenn and I were being forced to journey to New Orleans— Jim Garrison territory—Lee Harvey Oswald territory—David

Ferrie territory—for what might be another big JFK trial. Could we prove that the plaintiff was indeed part of the assassination cabal? Publishers in general, if they have to go to court, prefer to get as much publicity as possible. As P.T. Barnum had once said, "It doesn't matter what they say about you, as long as they spell your name right." Maybe we could get Oliver Stone to testify on our behalf. We could drag up a few of the survivors of that special op, including E. Howard Hunt and Gordon Liddy. Marina Oswald was still alive. Maybe she had a few secrets to get off her chest.

Damon Runyon, Jr. had supposedly been murdered because of his association with the bizarre conspiracy book *Were We Controlled?* Shortly after Kenn and I had done *NASA, Nazis & JFK*, we republished *Were We Controlled?* within the book *Mind Control, Oswald & JFK.*[2]

The thesis of *Were We Controlled?*, written under the pseudonym of Lincoln Lawrence, was that mind control was far more advanced, even in 1961, than ever believed by an incredulous public. In fact, according to Lawrence, a device known as RHIC-EDOM could completely erase a person's short term memory and give the mind subliminal messages and programing, including instructions to perform an assassination.

Lawrence theorized that Oswald was under some form of mind control, and had possibly received an implant at a hospital in Russia. Lawrence explained that RHIC was the acronym for Radio Hypnotic Intercerebral Control, and EDOM was shorthand for Electronic Dissolution Of Memory. Together the two devices could cause a person to have missing time, or other blank spots in their memory; new memories or programming could be put into their brains without them knowing it.

On top of this, if the person had an implant, they could be in an almost constant mind control process. This, Lawrence surmised, was what was going on with Oswald. Oswald, who acted very strangely at times—he didn't drive a car, but took a wild test drive just prior to the assassination—may have had a radio receiver implant in his head, and was essentially a RHIC-EDOM victim.

Incredibly, RHIC-EDOM, or at least the EDOM part of the device, could be a small battery-powered device worn as part of a person's clothing. That person could then simply touch another person, as in a handshake, and the victim was instantly hypnotized and would experience missing time. This, according to some researchers, is what happens during some UFO abduction sce-

narios.

UFOs were to come up in another lawsuit, this one involving a 48-year-old manuscript from the UCLA Library entitled *Flying Saucers—Fact or Fiction?* by a student named DeWayne B. Johnson. This manuscript of early flying saucers sightings was a valuable find Kenn thought, and he began further research into the microfilm archives of the *Los Angeles Times* and other papers to find the original articles that Johnson had mentioned.

Kenn showed me the original newspaper reports from the late 1940s, and I was surprised at the wealth of sightings, including formations of flying saucers, around Los Angeles and the American Southwest. Entire formations of saucers flew over Farmington, New Mexico during daylight, while others flew over Lubbock, Texas at night. Indeed, there was a sudden rash of UFO sightings in those early years, especially around Los Angeles and parts of New Mexico. Did NASA know about this?

"We're being sucked down by the Octopus," Kenn exclaimed one day while we were sitting at the bar at the World Explorers Club in Kempton.

"The Octopus?" I asked. "Do you really think that they are involved?"

"Don't you see," Kenn said, *"Were We Controlled?* was the first book to ever mention the Octopus, except for maybe Ian Fleming and the James Bond books. Now with *NASA, Nazis & JFK* and *Mind Control, Oswald & JFK,* the Octopus is screwing with us. They'll take us to court, and then as we're walking up the courthouse steps, an assassin will cut us down. Just like Larry Flynt."

My head was reeling, and it wasn't just from the tequila. "Wait a second, I don't think Layton is part of the Octopus, he's just a cranky old man. That is probably just a coincidence, but certainly the Octopus, whoever they are, must know about us and our books."

"Yeah, with the Octopus book I did with Jim Keith—now he's dead—I felt like I was a marked man. Now I'm getting divorced. My life is falling apart. I'm practically living in my car. And now Ron, my other publisher, is dead, too! He went out to a restaurant and later died. They never did explain it."

"Well, Kenn, when you're walking to your car on a dark night in the rain, and you look back and see a man in a trench coat and black hat following you, you can think of the Octopus and all the trouble you've caused." I smiled and leaned against the bar. The

orange lava lamp glowed warmly, and the many wooden masks and posters glowed in the neon-lava light.

"Ha, ha. It's funny to you, because you're not on the street. I barely have a job. I suppose it could be worse. Look at Danny Casolaro or Jim Keith. Grist for the Octopus."

On top of all that, the movie *Men In Black* had been released by Hollywood. One of the early scenes has Tommy Lee Jones arriving at a Mexican border patrol illegal immigrant bust. When an Immigration officer asks Jones who he is, Jones shows him an identity card and says, "Division Six."

"Division Six!" said Kenn, on another trip to Kempton. "That has to be from our book, *NASA, Nazis & JFK*. That is the only book that mentions Division Five, from which the parody is taken."

I agreed with Kenn, "Sure, you must be right. Wow, that's great that Hollywood is reading our books. I suppose the Octopus is, too."

Kenn took aim at a striped ball on the pool table at the World Explorers Club and let fly. "We've got to fight. We can't let them win."

I took a slug of beer and looked up at a mask from New Guinea. Wild boar ivory decorated the nose of the leather mask. The thought of battling the Octopus was a mammoth undertaking, it seemed. What good could a few guerrilla publishers and authors do against the Military Industrial Complex—the oil companies—the debt bankers—the intelligence organizations and their smuggling empires? What could one person do?

"Now they have another television show about us, as well. *The Lone Gunmen*. Those guys are obviously us and friends. Keith is gone,—we're next." He was referring to the mysterious death of our friend Jim Keith, author of *Mind-Control, World-Control*.[8]

"Well, being the Lone Gunmen of the *X-Files* television show isn't so bad. At least we're not the FBI agents. Do you suppose that Fox and Mulder might actually work for Division Five? That would be scary." With that I took another shot of tequila.

"I guess being the real-life lone gunmen is better than being the real-life X-Files. I always avoided that hype. Anyway, I thought you were the real-life Indiana Jones?"

We laughed and I looked at the papers from the court. "I wonder if we should fly down on a private plane to the New Orleans court case."

"You know about *The Gemstone File*," said Kenn. "It's too dan-

gerous. They'd probably blow up the plane. Don't be another JFK, Jr."

§§§

The Pen is Mightier than the Sword

Perhaps by just keeping to our guns, publishing steadily, and meeting these lawsuits head to head, we could fight the Octopus. One of my heroes was Benjamin Franklin, who coined the phrase: *The Pen is Mightier Than the Sword*. It was Franklin who convinced the French to intervene on behalf of the United States during the Revolutionary War.

In the '90s, the past looks back at us larger than life. The manipulation of all aspects of our lives becomes more and more apparent, and the theories that Oswald and the other high-profile assassins were implanted and controlled as 'mind-control' victims no longer seems so impossible. Information and the access to it was the most important thing looming on the event horizon, as I saw it. By publishing as much material as possible on suppressed topics such as mind control, free energy, anti-gravity, Tesla technology, and such, we could perhaps change the world. Indeed, we already had, at least in a small way.

Kenn and I took on our court case, and hired some good New Orleans lawyers to fight for us. Our strategy in the case was not to try to prove that the person suing us had anything to actually do with Kennedy assassination—that would be impossible and probably dangerous. Rather, since it had been several years since the book had been published, we argued that the statute of limitations had expired after one year, and he should have sued us sooner. This was a much simpler defense than opening up the entire JFK investigation again!

Our lawyers told us that this was a good tactic and that we were correct as far as the law was concerned. They also mentioned that the person suing us was well-known for lawsuits against publishers, and apparently made his living doing this. Having found this out, we were even more determined to fight the case in court. And we were relieved by the notion that we had perhaps not incurred the wrath of the Octopus, just a tiny sucker on the tip of one tentacle.

Time dragged on, and we often forgot about the case. Then one day, our lawyers gave us a call. The judge had thrown the

whole case out of court and even kept it from ever being appealed to a higher court.

This was great news to us, and everything was over, except the screaming, yelling, and paying the bills. It all cost a pretty penny, but in the end, I suppose it was all worth it. There were the shysters, the con artists, the pimps, the prostitutes, the assassins, the drug dealers, the lawyers, and the late night deals made in New Orleans strip clubs. There would be bad times too, but they were still around the corner...

Bibliography

1. *NASA, NAZIS, & JFK,* Kenn Thomas and William Torbitt, 1996, Adventures Unlimited Press, Kempton, IL.
2. *Mind Control, Oswald & JFK,* Kenn Thomas and Lincoln Lawrence, 1997, Adventures Unlimited Press, Kempton, IL.
3. *It's A Conspiracy,* Michael Litchfield, 1992, Earthworks Press, Berkeley, CA.
4. *Inside the Gemstone File,* Kenn Thomas and David Hatcher Childress, 1999, Adventures Unlimited Press, Kempton, IL.
5. *Tentacles of the Octopus,* Kenn Thomas, 2001, Adventures Unlimited Press, Kempton, IL.
6. *Conspiracy*, Anthony Summers, 1980, Marlowe & Company, New York. Also published as *Not In Your Lifetime* in 1998.
7. *Man-Made UFOs: 1944-1994,* Robert Vesco and David Childress, 1994, Adventures Unlimited Press, Kempton, IL.
8. *Mind-Control, World-Control,* Jim Keith, 1996, Adventures Unlimited Press, Kempton, IL.

6.

The Lost City
of the Kalahari

A half-buried ruin—a huge wreck of stones
On a lone and desolate spot;
A temple—or tomb for human bones
Left by man to decay and rot.
—Farini the Great

Write the bad things that are done to you in the sand,
but write the good things that happen to you on a piece of marble.
—Arabian wisdom

The Search for the Lost City of the Kalahari

The red sand of the Kalahari blew across the bone dry road. Up in the distance was a formation of huge stone blocks, stacked on top of each other in row after row. I put the binoculars down and yelled across the hood of our 4x4 Toyota that this must be the lost city that we had sought for so long.

The wind suddenly rose up and whipped around the truck. With a slamming of doors and a grinding of the gears, we were off to the megalithic city that lay in small valley below...

I had heard the strange tales of lost cities in the Kalahari, and naturally, I wanted to investigate them. Both Namibia and Botswana are still unexplored to a large extent, and all kinds of ancient mysteries are said to be present.

My most recent journey to the Kalahari started at the WEX club-

house in Holland, where the European manager of WEX, Herman Hegge, had organized our tickets to Capetown.

We headed for Capetown from Amsterdam in late November of 1999. We were picked up by another old Dutch friend of ours, Maurits Einhoven. Maurits was born in Holland, but his mother was South African. After a career in the construction and lumber industries, Maurits retired to Capetown to explore his family roots. Herman and I were happy to see him as we stepped out of the Customs section of the airport.

Maurits was dressed in khaki shorts and bush shirt. He was well tanned and smiling as he greeted us at the airport. In minutes we were whisked away down the maze of highways out to the suburban home he had bought a few years earlier. Herman and I were suitably impressed by the ranch style home, complete with swimming pool and brie (barbecue) pit.

Maurits showed Herman and I our rooms, and soon we were quaffing beers and laughing about old times. Having worked in the construction industry for years, Maurits had done much of the renovation of the house himself, and was proud of the French doors he had installed in the living room.

"So what about this lost city in the Kalahari?" he asked.

"I relate some of the story in my book *Lost Cities and Ancient Mysteries of Africa and Arabia*," I said. "It's supposed to be a ruined city of megalithic blocks, built in the form of a cross. Some say it is a real city, some say it is a natural rock formation… some say that it is all just a myth."

"There must be something out there," said Herman.

"A lost city in the Kalahari is very intriguing," said Maurits thoughtfully. He pulled out several maps of Southern Africa, and began to pour over them. "We'll need a four wheel drive vehicle and supplies. This should be quite an adventure! Where did the story originate?"

Such a question required a fresh beer, naturally, and then I duly leaned back in my leather chair to tell them how I had first heard of the lost city, or more correctly, the several lost cities rumored to be in the Kalahari.

§§§

Hitchhiking across Namibia and Botswana in 1979

I had first heard of the lost city of the Kalahari when I had spent some time in Capetown back in the late 1970s working in a sporting goods shop selling camping equipment. After six months of living in Capetown, I had hitched a ride with some friends up the coast to Namibia and then had crossed the Kalahari through Botswana to the Okavango swamps, and then on to Zimbabwe and Zambia. It was during that journey that I began collecting details about the lost city—and other strange structures—of the Kalahari.

I left Capetown one day and decided to head up north into the Kalahari and Namib deserts. It took me several days to hitchhike to the capital of Namibia, Windhoek, from Capetown. There I researched at the library and planned some short trips around Namibia.

After some time along the Skeleton Coast of Namibia—a remote, desolate coast of wrecked ships and miles upon miles of desert—I headed from Namibia into Botswana and the Kalahari Desert. This journey would take me to the eastern Namibian town of Gobabis, from which I would attempt to cross the Kalahari to the town of Ghanzi on one of the few roads through the Kalahari.

After waiting with others looking for a ride at a small village just over the border from Namibia, it was only one and a half days before the first truck came along. When we saw it, we all ran out onto the rutty tracks, and waved and jumped up and down like mad. You can bet he stopped. There was no way he was not going to give us a ride! Happily, all those waiting at the village, twelve of us, climbed in the back of this empty cattle truck and headed for Ghanzi, deep in the Kalahari.

At one point, we chased three ostriches down the road for five minutes, their tail feathers up, their mighty haunches bulging as they sprinted down the dirt tracks east toward our destination: the central Kalahari town and commercial center of Ghanzi.

I sat on the porch of Ghanzi's main spot of interest, the Oasis Store, for several days. It was a general store in the traditional sense of selling everything the Bushman could ever want. At the same time, it seemed to be the social center of the entire Kalahari Desert. All kinds of people would come and go—in particular thin,

wrinkled Khoi Khoi, in to buy some supplies, what little they needed and could afford.

I sat with them on the porch of the Oasis Hotel and drank cans of Lion Lager beer. Sometimes a Tswana, in cowboy hat, wool jacket, and boots, would join us. They were the cattle ranchers of the Kalahari. Usually they spoke better English than the Khoi Khoi, and after a few beers would tell about the lost cities and old mines in the desert, about which there are a number of legends. One grizzled, wrinkled old rancher even talked about a lost continent, Lemuria, and how the people had fled to all parts of the world, even South Africa. But that "was a long time ago."

It was here in Ghanzi that I began learning about the strange legends of ancient ruins in the Kalahari.

§§§

The Legend of the Lost City of the Kalahari

The Bushmen and Hottentots (now called Khoi Khoi) had many legends and tales of lost cities in the Kalahari. These cities were not built by them, but by the *ancients*.[1,2,3] In the *Sunday Times* of Johannesburg for March 15, 1931 and included by A.J. Clement, in his book *The Kalahari and its Lost City*,[2] it is said that a Mr. T. H. Howard met with a Mr. A. A. Anderson near the Nossob River in the Kalahari during the summer of 1873-4. Anderson told Howard that he had seen ruins of a lost city "up north," but that he had not approached the spot, for his Khoi Khoi had warned him that the Ovambos would kill anybody who actually entered the city. The building of the city had never been completed, and it was still possible to unearth tools from the debris.

Other newspaper articles at the time told similar popular reports of lost cities and the expeditions that searched for them. A Mr. R. Craill said that "stories more strongly authenticated than those told in the past pointed to the possible existence of mysterious ruins in the desert. Khoi Khoi told tales of the existence of strongly fortified walls, now crumbling into the sand, which had been seen in the Kalahari, and several pieces of stone carving stated to have come the 'lost city' were actually produced."[2]

These mysterious ruins were apparently to be found in differ-

ent parts of the Kalahari, even north near the Caprivi Strip and Ovamboland (as in the first report). Dr. Gustav Prelude, a well-known historian, reported that a party of Khoi Khoi in the Kalahari who had camped near his expedition had told him of a terrible drought and of large ruins somewhere to the north, and expressed their willingness to lead him there once the rains had fallen. The Khoi Khoi also claimed that precious stones had been found in the desert farther north.[2]

The *Kimberley Diamond Fields Advertiser* newspaper carried a story on August 24, 1949 about an expedition into the Kalahari led by a Dr. van Zyl in search of a lost city. Dr. van Zyl was prompted to search for the city because of a Khoi Khoi legend about a ruined city—one of a chain of forts said to have been built between Zimbabwe and the coast by past civilizations in order to safeguard the transport of gold and silver. A Dr. G. C. Coetzee, who had been a member of the expedition, said, "Nomadics swear to having seen the city, but searches have all proved vain. The heavy sand moves with the wind and landmarks disappear after every sandstorm."[2]

In 1956 an expedition left Natal which included the well-known South African author Alan Patton (author of *Cry the Beloved Country*) and a Major D.C. Flower. They had heard encouraging news from a man in Gobabis, who claimed that Khoi Khoi had told him of ruins between the Toanakha Hills and Mount Aha. Other Khoi Khoi rumors reported in the press were of ruins between Kang and Kaotwe, as well as between a place called Na Na (Nxau Nxau) and the Caprivi Strip. In the Nxau Nxau district an explorer named Dr. Haldeman was told by a Khoi Khoi that his father knew where there were some ruins. Dr. Haldeman went with the Khoi Khoi to a place called Donkey, but when they arrived the Khoi Khoi's father refused to guide them to the site. The father claimed that he was the sole survivor of nine Khoi Khoi who had seen the ruins.

Hottentots, relatives of the Khoi Khoi, but living a more settled lifestyle, told a Dr. W. M. Borcherds about a lost city along the course of a dry tributary which joined the Nossob River somewhere between Kwang Pan and Rooikop. The ruins were supposed to be close to a fairly high sand dune and a "large kaal (bare) pan."

A French explorer named Francois Balsan who crossed the Kalahari in 1948 told of a Hottentot living at Lehututu in the Central Kalahari who was supposed to have knowledge of the whereabouts of a lost city. Balsan had employed this Hottentot as a guide three years earlier on a previous expedition to Bechuanaland (Botswana, as it was called before independence); on this occasion Balsan thought he had trekked to within 35 miles of the lost city.

After Balsan's expedition failed to find the fabled lost city, the Johannesburg *Star* said, "South Africans resent this skepticism about the fairies at the bottom of their garden... Rider Haggard himself, a court official in his day and an honest South African has shown that the drier parts of the sub-continent abound in hidden cities and lost treasure. But you will never find them if you cross the desert by motor-car....The least the country can do for the lost city of Kalahari is to proclaim it a national monument, 'whereabouts at present unknown.'" (10 October, 1951)[2]

In 1958 a solo expedition in search of one of the lost cities, and a fabled diamond deposit, ended in tragedy in the Kalahari Gemsbok National Park. At a camp known as Kwang, a German geologist, H. Schwabe, left his car and began walking to the lost city and nearby diamond mine that he was told were just up the dry river bed. Days later, the warden from Twee Rivieren, Joep le Riche, found him with his bones picked clean by hyenas and vultures.

It is thought that some 50 expeditions have searched for various lost cities, the last led by an elderly woman in 1986.

I was to learn, however, that the city, as generally described, was much farther south, near the border of Botswana and the Northern Cape Province. The only way to go was along a dirt track that went northeast to Maun and the Okavango Swamps.

The Lost Lake of the Kalahari

Botswana is a semiarid, gently undulating plateau, with an average elevation of 900 m (3,000 feet), that rises to low hills in the extreme east. Tsodilo Hill (1,805 m / 5,922 feet), in the northwestern corner of Botswana, is the highest point in the country. The most important river is the Okavango, which brings large quanti-

ties of water from the highlands of Angola to the dry lands of Botswana; this river has no outlet to the sea, however, and flows into a huge, basinlike depression in the northern part of the plateau about 145 km (90 miles) from the Angola border, where its waters spread out to form the Okavango Swamp and ephemeral Ngami Lake.

Back in 1979, travel in the Kalahari was especially difficult for someone without his own vehicle, and after two days of hanging out in Ghanzi, I arranged a ride on a truck heading out to the town of Maun in the Okavango Swamps. An hour after leaving Ghanzi we were stuck in swamps around Lake Ngami, "the great lake of the unknown region."

For thousands of years this huge lake deep in the desert remained largely a myth to all but a few Khoi Khoi. These few Khoi Khoi hunters knew of the lake, telling of it in awe at their evening campfires in the desert: "a lake with waves that throw hippos ashore, roaring like thunder. A lake of many, many fish..."

Eventually the baYei hunters of the eastern Kalahari stumbled onto the lake and sent word back to their tribe—that was not until the 1750s. There was only one way to find the mythical lake of the unexplored southern desert of southern Africa, and that was to cross the Kalahari itself. It was on August 1, 1849 that the intrepid explorer, David Livingston, first set eyes on the lake. At that time, it was 240 kilometers wide. At times it completely dries up!

It certainly wasn't dried up the year I was there, in fact, it seemed to be covering a lot more than its usual boundaries. We were slipping and sliding all over the place, usually in several feet of water that was supposed to be the road. We had neither four wheel drive nor even good tires. Eventually we got stuck and there seemed no way out of the mud and water this time. "It is times like these," I reflected, "that I'm glad I'm hitchhiking. I can walk to Maun if I have to."

Fortunately, just then, a very large tractor came by and pulled us out. Then we were off again, around the back side of Lake Ngami, each tree quivering and trilling with thousands of Quelea finches. It was evening when we arrived in Maun, the center of the crocodile- and bird-infested swamps of the Okavango Delta.

The Okavango Swamp is a vast wetland in northern Botswana,

north of Lake Ngami. Occupying a depression that was once a prehistoric lake, the swamp covers about 10,000 square km (3,900 square miles). The swamp is fed by the 1,600-km-long (1,000 miles) Okavango River and a complex network of small channels. Today, it is a mecca for wildlife watchers and safari tourists.

From Maun I was on my way back to Zambia, where I would get a flight to the Seychelle Islands in the Indian Ocean, and ultimately, return to India and the Himalayas. Crossing Botswana was my last main sojourn in Africa back in 1979. I had vowed, though, that one day I would return to the Kalahari to find the legendary lost city.

§§§

Preparations for the Expedition

Maurits, Herman and I agreed that we would share the expenses of renting a double cab 4x4 pickup truck to use as our expedition vehicle. Maurits hauled out his old camping equipment, including tents, sleeping bags and folding shovels. We bought supplies of tuna fish, beans, rice, bread, cheese and other food.

Maurits introduced us to a South African friend he wanted to include in our expedition, a computer programmer named Maurits, but known as "Hooch." A young Afrikaaner recently out of the army, Hooch was a native Afrikaans speaker, and a survival expert. Both attributes could come in handy in the remote Kalahari. English was not well understood in the hinterlands of South Africa, Namibia, and Botswana.

We loaded the 4x4 with all manner of camping equipment, a mattress and a drink cooler, and then headed out of Capetown late one afternoon. We drove all night north through the inland mountains of the Cape Province. Our goal was the town of Upington, on the Orange River in the Northern Cape Province.

We arrived at dawn in Upington, Maurits and Hooch driving all through the night down the two lane paved strip that went through the heart of the Cape Province. I awoke in the back of the truck to see dawn glowing in the distance. Soon we were looking for a restaurant to serve us a hearty breakfast. After driving a few blocks around town, we found a suitable hotel and restaurant,

one with a breakfast buffet, in fact.

"Upington is a pleasant town," I said.

"This is a nice restaurant," said Maurits, pulling out one of his maps.

Over coffee, scrambled eggs and toast, we looked at the maps and discussed where to go next. A Kalahari campground known as Twee Rivieren at the entrance to the South African side of the park was about as close we could get to a dry river that went across the border into Botswana. Up this dry river was supposed to be the ruins of one of the lost cities. Yes, this was the same city that the German geologist, H. Schwabe was searching for when he was eaten by hyenas and vultures. But that was in 1958. Now it was 1999.

> *...the stars there have heart in plenty and are great hunters.*
> *She is asking them to take from her little child*
> *his little heart and to give him the heart of a hunter...*
> *Surely you must know that the stars are great hunters?*
> *Can't you hear them?*
> *Do listen to what they are crying!...*
> *You are not so deaf that you cannot hear them.*
> —Kalahari Bushman to Laurens Van der Post
> *The Heart of the Hunter*

The Kalahari and its People

Our decision was to try to go about 300 kilometers over the border of South Africa and into the Botswana section of the Kalahari Gemsbok National Park—a park that spans both countries. Botswana, a landlocked republic in southern Africa, is named for the Batswana (Tswana), the largest population group. The capital is Gaborone.

The Kalahari Desert, 260,000 square km (100,386 square miles) in area, covers the western two-thirds of Botswana and adjoining areas of eastern Namibia and South Africa's Cape Province. It is mostly a flat tableland (altitude 915-1,220 m/3,000-4,000 feet) that was once covered by an inland sea, and some say it isn't a desert at all. Much of the region is covered by sand, generally reddish brown in the south and grayish white in the north. Flora consists

of grasses and acacias typical of a steppe environment. Rainfall is light and erratic; summers are very hot, and winters are cool. The natural fauna includes giraffe, lion, impala, gemsbok, and wildebeest.

It is believed that the first white men to cross the Kalahari were David Livingstone and W. C. Oswell in 1849. Much of the Kalahari is still largely unknown, with construction of a road across the Kalahari to the coast of Namibia beginning only in 1993. Aerial surveys have attempted to map remoter areas. The lost cities in question would have been seen from time to time, but apparently they are "mistaken" for natural rock formations.

The original inhabitants of the Kalahari, according to the standard anthropological theory, were the mysterious San or Khoikhoi, a southern African people who have often been called Bushman or Hottentot. A seminomadic pastoral people who were also hunters and gatherers, the Khoikhoi once inhabited the southern part of Namibia and the northwestern, southern, and southeastern parts of South Africa. They speak a Khoisan language noted for the four clicks—dental, alveolar, cerebral, and lateral—occurring in many words.

In 1650, when contacted by Dutch settlers, the total Khoikhoi population was an estimated 35,000-50,000. The largest political unit was the tribe, varying in size from 500 to 2,500 people. Traditionally, each tribe consisted of a federation of clans united by the institution of chieftainship. Descent and residence were determined according to male ancestry. Each nuclear family occupied separate beehive-shaped huts. The Khoikhoi were monotheists and worshiped a celestial god. Their material culture was simple and adapted to their seminomadic life.[6]

The Tswana (also known as Bechuana or Batswana) are a Bantu-speaking people of the Sotho group of southern Africa. The Tswana are believed to have entered Botswana and subjugated the local Khoikhoi about the end of the 18th century and are thus very much latecomers to the area. The 19th century was marked by devastating invasions by Zulus and Boers. The Tswana, led by Khama III, chief of the Bamangwato tribe, asked for help against the Boers from the British, and in 1885 the British Protectorate of Bechuanaland was established.

The mystery of the origin of the Khoikhoi is still unsolved, and they are not racially classified as Negroes in the five major racial classifications, but are known anthropologically as Caucasians or sometimes Asians. Generally they are classed as whites, though another popular theory is that they are Asians or Mongoloids. Indeed, Khoi Khoi look a great deal like certain hill tribes in Laos, Vietnam, Thailand, Burma and China.

One view is that the Khoi Khoi are part of an Asian invasion of Eastern and Southern Africa. We must remember that Madagascar, an island just off Mozambique, was settled by Asians from Sumatra, Malaysia and Indonesia many thousands of years ago. In a migration that preceded the mass immigration of Europeans to North and South America by six or seven thousand years, so-called Stone Age people navigated an empty expanse of ocean that is twice as far as from Africa to Brazil.

This theory maintains that the last of this Indonesian invasion of southern Africa are now the Khoikhoi who roam in small numbers in their last refuge of the unpopulated waste of the Kalahari, where they track animals and follow the seasonal pans of water. At Mapungabwe in the Transvaal, excavations of skeletons at the site proved that the inhabitants were Khoikhoi or Hottentots.[1]

Does a lost Angor Wat exist in a dry river bed from a world thousands of years ago? Were the Kalahari and the Kali Yuga somehow related? What did the Khoikhoi have to do with the lost cities in the Kalahari, or were they megalithic stone cities that must predate even the arrival of the Khoi Khoi from Indonesia?

The Lost City of the Kalahari Gemsbok National Park

We arrived at the park just at sunset, my favorite time of the day. I don't think I will ever tire of sunsets, especially African ones—a flock of birds on the horizon, and the deep reds and oranges of the equatorial sun. The red sands of the Kalahari glowed in the orange dusk while we listened to the crackle of the fire at our feet.

We relaxed at the official Twee Rivieren campsite, renting a bungalow with two rooms, four beds, a shower and a small kitchen. We packed our drinks into the refrigerator and set about building a fire for that night's dinner. Firewood is scarce in the

Kalahari, but it can be bought at the camp store, plus we had brought some with us. Any good South African outback meal comes with boersvoers sausage, with plenty of beer to wash it down. It had been a dusty ride and the cold beer was like taking a throat shower.

The next morning we were up early. As we examined the maps from our campsite and bungalow, it was now clear that the area we trying to access was along the Nossob River which essentially defined the border between Botswana and South Africa. On one side was South Africa, with a road, campsites and even a few stores at Twee Rivieren and Nossob. The road conveniently ran right along the border.

Inconvenient, however, was the fact that the ruins were actually on the other side of the border, and there seemed to be no road on that side that corresponded with the one on the South African side. What should we do?

First, we drove to the Botswana border crossing about 15 kilometers from Twee Rivieren. At the border, it was confirmed that there were no roads going northwest along the Nossob River on the Botswana side. The road, rather, went to the northeast to Tshane in the central Kalahari. After some discussion, we decided to stay in South Africa, keep our bungalow for another day, and drive north along the border toward Nossob and Kwang.

We passed red sand dunes of the Kalahari with grazing herds of gemsbok and springbok. Zebras ran in the distance and occasional flocks of ostriches ran along beside us momentarily before speeding away from the dirt track road. Although this is a national park, it is a remote one, and we saw only a few other cars or trucks all day. Lions and giraffes were common in the park as well, but not really elephants or rhinos.

From Twee Rivieren there were two branches of the road, one to the northwest and the Mata Mata campground, and the other more directly north, passing through the campground of Nossob. It was this second route we were interested in, as it would take us to Kwang, where several expeditions to cities in Botswana had been launched.

From Twee Rivieren, the road went north along the dry Nossob River. Many spots on the map, like Kij Kij, were no more than a

crossroads, a trash barrel and a picnic table. Others were mere pull-offs from the road, and still others were little villages with a gas station and a store, such as Nossob.

North of Nossob and Kwang the road, and border, continued up to Grootbrak, Lijersdraai and Unie-end, where the borders of Namibia, Botswana and South Africa all come together. At this point the road ends (officially) and tourists turn back to Nossob and Twee Rivieren.

We drove up the one-lane, dirt track from Twee Rivieren to Kij Kij, Kransbrak, Kameelsleep, Cheleka and Nossob, and noticed that it would not be difficult to leave the road and drive north up a dry river bed to Botswana. The terrain consisted of low, flat hills and dry river beds flowing out of them into the wide, dry bed of the Nossob river. Periodic water holes could be found in the Nossob River bed, which flowed during the rainy season, which had ended a few months before.

At the campsite in Nossob, we got gas and cold drinks at the store. We asked about the lost city, and got curious looks. The store attendant inquired whether we were going to drive over the border.

"You can't go over there," she said. "There's no roads over there. It's against the law."

We denied any intention of driving over the border and headed back to the car. At Kwang, up the river 23 kilometers from Nossob, we checked out the terrain. The famous 1948 Simon Kooper Hottentot map from Dr. W.M. Borcherds shows the ruins of the lost city located up a dry river that connected with the Nossob somewhere between Rooi Kop and Kwang Pan. Both are north of the modern National Park campsite of Nossob, built in 1970s, which does not appear on the earlier maps.

According to modern route maps available free from the Park Service, the water hole known as Cubitje Quap was near to the area where the dry river joined the sometimes dry Nossob. Up this unnamed dry river was said to be the ruins of a lost city of colossal size. It became clear that we were quite near the ruins, but it seemed impossible to reach!

How could we cross the dry river and head north into Botswana without risking an international incident? Neither the Botswana

border police, nor the South African, would want to have to tell us that what we were doing was a serious infraction of national law. Both would require jail time for such an infraction. The South African side was especially active, with scores of rangers and police driving around in the their Land Rovers.

It seemed out of the question that we drive into that no man's land just a hundred meters ahead of us. An area that was still unexplored because it lay across an international border—a border which on one side had no roads. We stopped at the area where a dry river met the Nossob River, also dry. With our binoculars we scanned the flat red hills across the river. They were near, but impossible to reach. When other expeditions had gone many years ago, crossing the border at an unauthorized point was not forbidden. Now it was. Who might say what was to be found up those dry river beds?

§§§

Farini the Great and His Lost City

Another incredible tale of a lost city in the Kalahari is that told by Farini the Great. Born William Leonard Hunt in New York City, he became a showman, best known for tightrope walking across Niagara Falls. He changed his name to Gilarmi A. Farini and his show name was Farini the Great. Farini exhibited shows at Coney Island, and when a show did well, it was taken to London. One of the most popular London shows was entitled *Farini's African Pygmies or Dwarf Earthmen from the Interior of South Africa*. Essentially a tableaux of Bushman life in the Kalahari, it included six live Khoi Khoi. Farini was very interested in the Khoi Khoi and became even more so when they showed him diamonds they said had come from the Kalahari. Farini, his son Lulu, and a black South African showman named Gert Louw who had brought the Khoi Khoi to London, sailed from London to Capetown on January 7, 1895 and arrived on January 29. After meeting certain dignitaries in Capetown, in early February the party departed for the Northern Cape and the Kalahari. Six months later they returned to Capetown, claiming to have discovered a lost city of colossal proportions; they departed for London on July 22, 1895.

Back in London, Farini addressed the Royal Geographical Society and later the Berlin Geographical Society. His book, *Through the Kalahari*[3] was published at about the same time, and it contained photographs of the lost city taken by Farini's son Lulu. Farini even staged a *Lost City Exhibition* in London, which included photos of the city. These photos showed the city to be built of huge, massive stones stacked on top of each other, and of extremely ancient construction.[2, 3]

Farini described the megalithic city as a long line of stone laid out in the shape of an arc and resembling the Chinese Wall after an earthquake. The ruins were quite extensive, partly buried beneath the sand at some points, and fully exposed to view in others. They could be traced for nearly a mile, and consisted mainly of huge flat-sided stone. In some places the cement was in perfect condition and plainly visible between the various layers of the heaps. The top row of stones was weathered and abraded by the drifting sand. Some of the uppermost stones were grotesquely worn away on the underside so that they resembled a small center table supported by a short leg. In his Royal Geographical Society report he described the stones as "cyclopean."[2, 3]

Heaps of masonry, each about eighteen inches high, were spaced at intervals of about forty feet inside the wall. The heaps were shaped in the form of ovals or obtuse ellipses; they had flat bases and were hollowed out at the sides for about twelve inches from the edge. Some of them consisted of solid rock, while others were formed from one or more pieces of stone accurately fitted together. Where they had been protected from the sand the joints were perfect. Most of the heaps were more or less covered with sand, and it took his local guides almost a day to uncover the largest of them.

The following day, with no assistance from his guides, who apparently felt it was all a waste of time, Farini and his companions dug the sand away from the middle arc and exposed a pavement structure built of large stones. The pavement was about twenty feet wide, and so designed that the longer, outer stones were laid at right-angles to the inner ones. A similar pavement intersected it at right angles, and the whole structure resembled a Maltese Cross.

Farini visualized an altar, column or some other kind of monument at the intersection of the two pavements. The remains of the base, which were clearly visible at the junction of the pavements, consisted of loose pieces of fluted masonry. There were no inscriptions or markings of any kind. He concluded that the ruins were probably thousands of years old, and they must be of a city, a place of worship or the burial ground of a great nation. Lulu sketched the ruins and took several photographs.[3] Farini composed this poem for his lost city:

> A half-buried ruin—a huge wreck of stones
> On a lone and desolate spot;
> A temple—or tomb for human bones
> Left by man to decay and rot.
>
> Rude sculpted blocks from the red sand project,
> And shapeless uncouth stones appear,
> Some great man's ashes designed to protect,
> Buried many a thousand year.
>
> A relic, maybe, of a glorious past,
> A city once grand and sublime,
> Destroyed by earthquake, defaced by the blast,
> Swept away by the hand of time.[3]

In his book, *The Kalahari and its Lost City*, Clement does an exhaustive study of Farini's book, his route and the inconsistencies to be found in the publication (and there are many). Clement is to be commended for his research, though his final conclusions are to be questioned, as we shall shortly see. Farini's book caused a brief sensation at the time, and was published in both German and French. But then the whole business of a lost city in the Kalahari was generally forgotten until 1923 when the story was revived by Professor E. H. L. Schwartz of Rhodes University. Farini himself died at his ranch in Ontario in 1929. From the 1920s up through the 1950s, many expeditions set out in search of the incredible lost city, many using aircraft. No one was able to find it, largely due to Farini's wildly inaccurate maps to the spot. Many

began to feel that the whole thing was really just a natural lime-stone formation, yet Farini had photos of the city in his book, and no one had yet come up with a suitable natural formation that fit Farini's description. Clement also shows in his book that Farini almost certainly did not travel up to Lake Ngami afterward, as he claimed in his book. Clement believes that he turned back after discovering the city, and used details supplied by his secretary W. A. Healey who had visited Lake Ngami the year before collecting items, as well as Bushmen, for the London exhibit.

After pouring through Farini's book, Clement finally concluded that Farini's lost city must actually lie near the small town of Mier, now called Rietfontein. With partial sponsorship from the *Sunday Chronicle* newspaper, Clement set out with his 77-year old father, a reporter from the newspaper and a professional photographer, on Easter Monday of 1964. At Rietfontein they were shown an extremely unusual "rock formation" known to the locals as Eierdop Koppies (Eggshell Hills). Says Clement, "The unmistakable outline of a large, oval-shaped amphitheater, perhaps a third of a mile in length, was the predominant feature. In numerous places there was striking resemblance to a double wall built from large, glistening black rocks, and it was obvious that many of the individual boulders could easily be confused with square building blocks. There were several examples of flat slabs of rock perched precariously like table-tops on underlying boulders, and one of them—more impressive than the rest—closely matched the one appearing in Farini's illustration. One or two of the rocks showed a kind of fluting, several were encrusted with a mortar-like substance, and a few were shaped like a basin. To use the phraseology employed by Farini in his lecture before the Royal Geographical Society: 'The masonry was of a cyclopean character...'"[2]

Clement showed one of Farini's photos of his lost city to the oldest man in town who agreed that it seemed to show the same place. Clement, it seems, had genuinely rediscovered Farini's lost city—known all the time to local residents— but concluded that it was no city at all, merely a highly unusual natural rock formation of dolerite, a hard igneous rock. After showing his photos to a geologist, the geologist suggested that the "ruins" were the prod-

uct of the weathering of dolerite. In this case, magma intrusions forced their way in the form of sills or sheet along the bedding planes of sediments (some 180-190 million years ago guesses the geologist) forming the level planes or flat sheets of rock found at the site. As the magma cooled, it formed cracks and splits, making it seem as if the rock had been carefully cut and dressed, with pieces stacked up on top of each other. One of the components of dolerite is pyroxene, and over time a chemical reaction takes place in its decomposition that precipitates a brownish "desert varnish" and kind of cement.

Clement concludes his book by saying, "Like all legends, that of the Lost City will be a long time a-dying, and doubtless there will still be some who are disinclined to let the matter rest in spite of all the contrary evidence. And possibly this is just as well, for there is something rather sad about the destruction of a legend."[2]

I wonder if Clement wrote those words for me? Certainly, I am disinclined to accept his conclusions, and proof against them is given in his own book. Even before setting out, Clement was convinced that Farini's city was a natural formation. He could not conceive of a "cyclopean" structure in the Kalahari that was not natural. Says he, "The climatological history of the Kalahari does not appear to have undergone any marked change for several thousand years, and it is obvious that no settlement of the size indicated by Farini could exist without perennial rivers or lakes in the vicinity."(p.145) And, "...suitable conditions for the establishment of a 'city' cannot have existed along any of the river courses for tens of thousands of years. Furthermore, if the age of the Lost City is assessed in relation to Zimbabwe and the ancient ruins of Persia, it is impossible to conceive of any 'city' in the Kalahari having been built more than 15,000 years ago." (p.147-148)

It is painfully obvious that the "city" has nothing to do with Zimbabwe ruins, and his mention of ancient ruins in Persia seems totally beside the point, indicating that Clements, for all his excellent research on Farini, knows little about ancient history, and had probably never seen a cyclopean wall before. Cyclopean architecture, which can be found in Egypt, Turkey, Greece, Malta, Peru, Bolivia and other areas, is indeed an astonishing sight! To this very day the method for building such walls confounds ar-

chitects and engineers. Farini had traveled a great deal in Europe and the Mediterranean and had probably seen cyclopean walls in the Peloponnese in Greece or at Abydos or the Valley Temple of Chephren in Egypt. Farini was also a Mason, and, depending on his initiatory status within the Masons, had probably been exposed to the Masonic beliefs in Atlantis, cataclysms, Mystery Schools and such. His poem about the city indicates as much.

Other clues to the non-natural origin of the rocks can be found in photos taken both by Clement and Farini. The rocks are all neatly squared and the lines of "masonry" are parallel and at right angles. Some igneous formations such as basalt do indeed crystallize in regular patterns, but not like the dolerite rocks at Rietfontein. The final proof is Clement's own photo of one of the massive blocks with a series of four parallel, horizontal grooves on it. Clearly these are not natural! Even Clement admits that they could not be natural. In the photo caption he asks, "Are they natural, or were they made by Farini?"

I would venture to guess that they are neither. Farini's lost city is probably just as he believed it to be, a cyclopean structure from another era, destroyed in a cataclysmic shift of the earth's crust, possibly 15,000 years ago, but probably more recently, such as about 10,000 years ago. It has been suggested that a shift of the earth's crust about this time sent Africa moving to the south, causing a huge tidal wave to wash over all of Southern Africa. Any cities, such as Farini's, would have been destroyed and depopulated during such an event.

If the Kalahari was some sort of Atlantean colony 15,000 years ago or more, then I surmised that there must be other cyclopean ruins around that were also being mistaken for natural formations. And indeed there are. Clement mentions "massive stone blocks on Mr. Guy Braithwaite's farm, 'Gesond', in the Tuli Block of north-east Bechuanaland. Similar stone blocks are also present in the sandy bed of the Amacloutsie River. The so-called 'Solomon's Wall' is 'between fifty and one hundred feet high (imagine from three to five double-decker buses piled on top of each other), it is between ten and fifteen feet thick and dominates the countryside for a couple of miles... on the exposed faces of Solomon's Wall, chemical erosion has produced a network of lines

which give the appearance of building blocks. Some of these blocks are several feet square while others are only a matter of inches... The local Ngwato tribe claim that it was built by the 'old people,' and it is suggested that something similar to 'Solomon's Wall' may have been seen by Farini in the Kalahari."[2]

§§§

The Curse of the Lost City

The sun was setting over our campground, turning the red sands into a dark glow. We had our fire going and were watching a red fox sneak up on our camp, attracted by the smell of sausage and shishkebabs. We drank beer and talked about the events of the day.

"That woman at the store in Nossob seemed suspicious of us," said Maurits.

"If this is the right lost city," said Herman, "it seems very close to the border. It seems that someone would have found it already."

"Maybe they have," I suggested. "But their bodies are lying in the dust."

"The border probably isn't crossed that often by the South Africans," said Hooch. "I was in the army, and they are very strict concerning the borders."

"There seems to be a curse on this lost city," I said, throwing a piece of chicken toward the fox in the distant shadow,. "what with all these dead people and being so near the border—almost in some no-man's-land."

"We'll probably all be killed—that's bad luck," mused Maurits, finishing his beer.

"What about that guy Clements?" said Herman. "He had photos in his book of huge walls."

Studying Clements' book again, we realized that the lost city that he had found was not in the Kalahari Gemsbok National Park, but in another area to the west. Clement decided that Farini's city may actually lie near the small town of Mier, which is now called Rietfontein. He visited this lost city in 1965—and came back alive!

We looked over the maps once again, and soon discovered that Rietfontein was a remote town very near the Namibian border,

about 200 kilometers from the Kalahari Gemsbok National Park to the southwest. The main road into Namibia from the Northern Cape Province ran right through it.

Maurits jabbed a finger at a lonely town on the map, "There's our lost city, right there! If we get started right away we make it there by early afternoon."

"We won't be able to get onto the Botswana side of the border here, I don't think," said Herman. Hooch nodded in agreement.

"Okay, then," I said, pounding my empty enamel coffee cup on the concrete picnic table, "let's get going to Rietfontein."

Over a breakfast of fruit the next morning, we we packed up, paid our bungalow bill (sorry Beatles…) and exited the park gate heading south, away from the Botswana border. The red dirt of the Kalahari flew behind us as we sped down the wide dirt road back toward the main highway which was paved.

From a dusty crossroads, we began heading west toward the Namibian border on a narrow road that was sometimes paved, and sometimes a dirt road. This road went through some spectacular dry lake beds in a low basin and range type of geology, reminiscent of the dry lakes of Nevada and California. Zebras and gemsbok ran along the ridges to the north. The rugged hills and the red Kalahari sand spread out into the distance.

We passed one small store at a waterhole and ranch in the desert. Here we stopped and got cold drinks. A few Tswana ranchers were milling around the store and told us that Rietfontein was still some distance down the dirt road.

We continued an hour to Rietfontein, a small, dusty town of one-story concrete houses and a school. We found a store in the town, which happened to be right next to the police station. A number of people were milling around the shaded porch area of the store as we got out of the truck. I looked up the around—a dust devil was moving slowly towards us from up the street, throwing dirt onto the door of one of the gray homes.

By chance, the local policeman was standing outside the store, and Hooch spoke to him in Afrikaans. He would be happy to help us find the lost city, he told us. When we showed him the photos we had of the megalithic walls, he looked at them in surprise. Yes, he knew where these walls were, he said. They were just over

the border in Namibia.

"How far is the border?" we asked the policeman.

"Only about 10 kilometers," he told us "About 50 kilometers past the border is the town of Aroab. These rocks are between. Near to the border." The locals knew these walls as the Eierdop Koppies (Eggshell Hills).

We jumped back into the truck and drove the final 10 kilometers to the border, a small set of buildings along the road, out in the middle of the desert. No other buildings could be seen. We were quickly stamped out of South Africa in the first building and then walked into the second building for the Namibian formalities. A friendly Ovambo stood behind a counter to greet us. A photo of the current president, Sam Nujoma, was on the wall behind him.

The Megalithic Walls of Namibia

Namibia is vast, rugged, beautiful, varied and virgin. The Namib desert, said to be the oldest in the world, stretches for one thousand miles along the coast. The earliest known inhabitants of Namibia are the San/Khoikhoi, hunters and gatherers whose presence dates back some 11,000 years. In the mid-1400s, Bantu-speaking peoples from East Africa began migrating southwestward to Angola and northern Namibia. They were latecomers to the area, and by the early 1700s, they had pushed southward into the central Namibian plateau.

The first European to visit the area, the Portuguese explorer Diogo Cao, arrived at Cape Cross in 1485. Soon after, the Dutch East India Company began exploring the Namibian coast from its station at Table Bay. In 1773 the Cape government proclaimed Dutch sovereignty over Angra Pequina (Ludderitz), Halifax Island, and Walvis Bay. The Cape Colony and all its possessions were formally ceded to Britain in 1814.

By the early 1800s, British and German missionaries arrived in the interior. Namibia became a German colony (German South West Africa) in 1884, although the British had annexed Walvis Bay in 1878. The German settlers expropriated African lands and assigned Africans to reserves. Between 1904 and 1907, Herero and Nama rebellions against German land policies were brutally sup-

pressed. The Herero were reduced from 80,000 to 15,000, and the Nama from 20,000 to 9,000.

After World War II, in defiance of the international community, the South African government refused to hand over administration of Namibia to the United Nations. It ruled the territory directly for much of the period prior to independence and established a society based on separation of the races (apartheid). Nationalist resistance groups formed in the 1950s and 1960s, and in 1966 the South West African People's Organization (SWAPO) took up arms. The UN General Assembly formally terminated the South African mandate in 1966 and changed the name of the territory to Namibia in 1968. On March 21, 1990, Namibia became an independent nation, with SWAPO leader Sam Nujoma as executive president.

Sam Nujoma seemed a friendly enough fellow as he smiled down at me from his poster on the wall. After getting officially stamped into the country, we showed our photos from Clement's book to the Namibian border officers. They confirmed that these walls were down the down some kilometers. "Keep looking on the north side of the road," they told us.

With the border post receding behind us, and a cloud of red dust coming out the back end of the truck, I pulled out my harmonica and blew a few bars. The lost city seemed finally within reach.

Suddenly, as we came over hill we could see north up a wide, flat valley. In the valley, coming close to the road, was a massive pile of perfectly rectangular blocks of a colossal size.

"Hey, there it is!" I yelled from the back seat. Maurits slammed on the brakes and the truck skidded along the dirt road. We looked in amazement at the giant red boulders, most of them rectangular, stacked on top of each other to walls over 40 feet high. It was an incredible site.

"These must be the Eggshell Hills," said Herman.

Maurits pulled the truck down the road a hundred meters to a spot where a little-used side road went alongside the huge wall. He then drove off the road and approached the nearest of the stone walls. As the truck lurched to a halt, we all leapt out and rushed over to the stacked stones.

They had clearly been blown clean by the wind for thousands of years, and were neatly stacked on top of each other as one would expect megalithic construction to be. Many of the blocks were perfectly cut rectangles, with the corners softened by the thousands of years of exposure. Other blocks were more polygonal and rounded. Nearly all had flat surfaces.

With our cameras and binoculars in hand, we climbed over the rocks and searched the entire area. It was pile after pile of huge granite blocks, and it had the appearance of being part of a city—a very, very worn city, that was thousands, even tens of thousands, of years old. It seemed to be in several semi-circular walls, but no obvious architectural pattern, such as an enclosed plaza was found.

Sometimes when I looked at the walls, they seemed artificial. Other times, as I studied a certain section, they seemed natural. It was confusing, and certainly they could well have seemed to be ruins of a megalithic city to any early explorer. But were they?

I sat down on some of the blocks and took a deep gulp from my canteen. The sun was hot and I wiped my forehead with my bandana. Was this strange place just a natural formation, or was it the highly eroded remains of an ancient citadel?

One thing that puzzled me was that Clement had a curious photo in his book of one of the blocks with parallel grooves cut into it. Where was this block? I had to find it. To me it was the solution to the whole mystery.

We looked and looked, but we could not find the stone with the grooves in Clement's own photo of one of the massive blocks. This rectangular stone, with a series of four parallel, horizontal grooves on it, could not be found anywhere among the blocks. Yet it seemed like the same place.

Even Clement admits that the grooves could not be natural. In the photo caption he asks, "Are they natural, or were they made by Farini?"

But, where was this stone? We could not find it.

That night we camped at the lost city. We sat around our campfire and talked about this strange place. Was it an ancient city? Was it natural? Was this what Clement and Farini had found?

There seemed no clear answer to any of these questions. Where

was Clement's grooved stone? Were there other walls around here that were similar to these? As the moon began to rise, I leaned back on the roll of my sleeping bag and looked at the twinkling evening star—Venus. The desert was quiet, and only the crackling of the fire could be heard. What secrets did this lonely desert keep?

The Cataclysm in the Kalahari

According to various sources, a cataclysm occurred around 10000 BC. This might be called the cataclysm that destroyed Atlantis. Megalithic construction all over the world came to complete halt for thousands of years, and was then resurrected about 6000 BC. Was this city more than 10,000 years old?

In this theory, shortly after the sinking of Atlantis, the earth experienced another pole shift, causing the North Pole to be shifted from the Hudson Bay to where it is now. Much of Antarctica was ice free but now began to accumulate the awesome amount of ice it currently has. Today the lopsided ice cap in Antarctica is more than a mile thick and contains 90% of the fresh water in the world!

Southern Africa was completely depopulated at this time, as the African Plate slid in an essentially southward direction. A gigantic tidal wave washed over the entire southern portion of Africa, destroying all civilization. With a sudden tilt of the plate, parts of the ocean bottom, for instance around the Namib, were vaulted up, while the Triton Sea began to drain, eventually leaving only a few oases and Lake Chad. Only the vast swamps of Central Africa were left, and even those began to slowly drain. Giant saurians of the recent, but prehistoric, past slowly retreated to the remotest of swamps and river tributaries.

The Mediterranean, if it had not been flooded earlier at the time of the sinking of Atlantis, began flooding. The climate of Egypt changed, and in the end it was the only civilization left from ancient Osiris.

The ancient Rama Empire of India and Indonesia was gone, but small kingdoms in India and the Middle East survived the pole shift somewhat intact. In the wake of the devastation, a bold class of ancient seafarer, men who were scientists, architects and navigators, and who worshiped the sun—the amazing Atlantean

League—sailed the earth, exploring new worlds, colonizing far-flung areas, and remapping the earth. It was these people who later became the Phoenicians and Carthaginians.

Since much of Africa was depopulated by a giant wave in the last pole shift, it began to be slowly repopulated. Egyptians lived in the northeast corner, Ethiopian/Sabeans in East Africa, originally from Southern India. Negroes lived in Mexico, Cameroon and New Guinea, and Tuareg/Berbers in Morocco and the Tibesti Mountains of Algeria.

Asians probably began migrating across the Indian Ocean to Southern Africa about 5,000 BC, if not before. They populated Madagascar and the coastal area of Mozambique and inland to the high, mineral rich plateau of Zimbabwe. It was these people, Asians, along with Sabeans, who then began re-mining southern Africa, an area that had not been populated since before the last pole shift several thousand years before. Later, they built Zimbabwe and some of the other cities. The area was probably an international trading and manufacturing center, visited frequently by Phoenicians, Chinese, Persians, Indians, Arabs, and nearby Sabean traders who were just up the coast. Sabeans from Azania in East Africa then began encroaching in their territory and finally some disaster, either from within, such as a slave rebellion, or from without, such as an invasion, ended forever the Ma-Iti Empire.

The Asians, those that survived the slaughter, were forced to scatter and were pushed out of the Zimbabwe Highlands and High Veldt, into the desolate deserts of the Kalahari and Namib. Today, these people are the Bushmen and Hottentots. Madagascar remained the Asian stronghold. Later, the Zulu Wars in the early 1800s depopulated much of the country. The Portuguese and Dutch began to settle Southern Africa, and so history comes up to the present—a time of new cities and new populations.

And these walls in this remote portion of Namibia, were they a testament to an earlier time, when South Africa was part of the world before—a world of megalithic cities built before the flood? The dry rivers and lakes were here. The desert hadn't always been here. A small increase of rainfall would make the rivers run again. How long ago was it that the climate had changed here? Millions of years ago, or only ten thousand years ago? The question ech-

oed through my head on that starry evening in the desert. Had the Kalahari been inhabited in the distant past?

§§§

The Mystery of the Great Karas Berg Mountains

The next morning over hot coffee, we studied our maps, and determined that we should start heading back toward Capetown.

To our southwest was the town of Karasburg, the largest town in the southeastern portion of Namibia. We decided to head that way, on a lonely, little-traveled road. As the truck sped off down the dirt road, the massive blocks of stone behind us, I wondered about this desolate, weird place.

We were all still unsure about whether the lost city was natural or artificial, or a combination of both. This area was a small rocky spur of the Great Karas Berg, a mountain range to the southwest of us. We headed directly west to the small crossroads town of Aroab. After filling up the fuel tank, we headed south to Karasburg. Along the way we head through the Karas Mountains. Along here we were to see many odd granitic formations that looked similar to the lost city near the border.

As we drove south, we could see the towering cliffs of the numerous granite peaks of the Karas Berg. According to current geological theory, of a uniformitarian nature, these curious granitic formations are the result of the core of an ancient volcano being exposed to wind action for millions of years. The volcano is slowly worn down by winds into a flat mesa. After millions of more years, the flat mesa is worn into a core of crystallized granite.

This core of crystallized granite was exposed to the winds millions of years ago. Over this millions of years the mass of crystallized granite is cracked and weathered until it resembles artificial blocks of gigantic stones. These mountains of the Great Karas Berg are clearly natural, however. But, are the walls of the Eggshell Hills really natural, or are they artificial structures in an area of ancient granite mountains?

As we drove by, we saw the occasional low ranch house, perhaps inhabited by the descendent of one of the original German settlers. Otherwise, the area was quite beautiful, and quite unin-

habited. It seemed like quite a nice area, similar to Arizona, with its desert mountains. Tall mesas, and occasional walls of monolithic lava walls, were seen long the road. It was a strange landscape, one of towering cliffs and sweeping vistas of an ancient desert.

This strange mountain range that exists in southeastern Namibia poses a number of mysteries. The strange rock formations and flat topped mountains seem to have been inhabited once upon a time. Certainly, in a better climate, they would be ideal camps for villages, much like the Hopi mesas of northern Arizona today. There is no real reason why there couldn't have been people living in this area in prehistory—they had reached other areas far more remote than this! Indeed, it is curious that this area of the world is largely said to have been virtually unpopulated until about the year 1600 AD. This is an astonishingly recent date for an area that is so incredibly ancient.

Furthermore, there were the curious tales of living pteradons in the area. In the area to the southwest is the Fish River Canyon, which Namibians claim is an even more impressive sight that Arizona's Grand Canyon. To the northwest is Keetmanshoop, the site of an extraordinary series of events a number of years ago. Roy Mackal reports in his book *Searching for Hidden Animals*[5] that Dr. Courtenay-Latimer, one of the South African zoologists responsible for examining the coelacanth, investigated a strange sighting of a large "flying lizard" in the area of Keetmanshoop. Farms in the are usually quite extensive, as much as 100 square miles (160 square kilometers) large. The main livelihood is derived from a flowering plant named kana and colossal flocks of sheep. The natives of one particular farm around Keetmanshoop eventually left because the owner would not take seriously the allegation that there was a very large snake in the mountains where the sheep grazed and were shepherded. Having lost all of his hired help, the farmer sent his son of sixteen to tend the flocks of animals. When the boy did not return that evening, a party went into the mountains to search for him. They found him unconscious and brought him home. According to the attending doctor the boy was unable to speak for three days because of shock after he regained consciousness.

When questioned the boy related that he had been sitting under a shade tree quietly carving animals from pieces of soft wood when he heard a great roaring noise—like a strong current of wind. His immediate thought was that a "wind devil" (whirlwind) was responsible, since such air disturbances are common in this mountainous area. Looking up, he observed what appeared to be a huge snake hurling itself down from a mountain ridge. As the creature approached the sound was terrific, combined now with that of sheep scattering in all directions out of the creature's path. The creature landed, raising a cloud of dust and a smell he described like burned brass. At that point he apparently lost consciousness from shock and fright. The incident was investigated by police and farmers some of whom actually saw the creature disappear into a crevice in the mountain. Sticks of dynamite were fused and hurled into the crevice. After the detonations a low moaning sound was heard for a short while and then silence.[5]

Dr. Courtenay-Latimer arrived shortly afterward and studied photographs of the marks and tracks of the creature and theorized that it was possibly an injured python. Yet, Mackal does not buy this hypothesis, especially since the creature appeared to have wings and genuinely flew, in some form or another, creating an air disturbance with its wings. Was the dragon of the Great Karas Berg a living pterodactyl that had found an easy lunch with the nearby herd of sheep?

Other such flying monsters have been reported in parts of southern Africa such as the Kongamato of the Jiundu Swamps of western Zambia, a relatively near area to Namibia.[1, 4]

Another mystery of Namibia are the unusual rock paintings such as the famous "White Lady of the Brandenberg." In 1917, during a topographical mission, an engineer named Maak discovered on the side of Mount Brandenberg a painted shelter. Today it is known as Maak Shelter.

The paintings depict a procession of people, led by women. They are of Mediterranean type and their elegance and posture are similar to those of the figures depicted in Egyptian frescoes. "The figures have nothing common with the aborigines of southern Africa," says *Reader's Digest* in its book *The World's Last Mysteries*.[7] The procession is dominated by a woman, known as the

191

White Lady, dressed in skin-tight shorts like the Cretan bull-fighting girls, and carrying a lotus flower. She and her companions had bows, and their wrists are protected by gauntlets. They all wear boots and some have red hair and fair complexions.

Says *Reader's Digest*, "In Rhodesia [Zimbabwe] there are similar paintings. It would seem that travelers or invaders may have come from the north-east of Africa to the southern areas. In one of the decorated shelters archaeological material has been uncovered enabling the painting to be dated to about 5000 BC which was still in the age of prehistory in Egypt. However, the Egyptians are considered by some authorities to be a branch of the ancient Libyan peoples. Perhaps another branch emigrated southwards?"[7]

Indeed, it has long been surmised that Phoenicians may have attempted to colonize parts of southern Africa, and that such rock paintings of men in armor or white women as that at Maak Shelter were representations of Phoenician explorers or colonists. However, a date of 5000 BC throws such theories totally out the door! In mundane academic histories, mankind was hardly getting out of his cave in 5000 BC, much less having holidays in remote southern African deserts.

It seems clear that there was a time, once, when Namibia and Botswana enjoyed a different climate from that which they have now. This was a climate where forests once covered the land, where rivers flowed year-round, and where large herds of wild animals roamed, providing sufficient game for hunters. Today, the land is barren, waterless and uninhabited except for a few hardy, lone animals. If the dating of some of the cave paintings is correct, a mere seven thousand years ago Namibia was quite different. This would have been a similar time period to when the Sahara was part sea and part savanna. Further clues to the mysterious past of the area are to be found at the gigantic and mysterious "lost cities."

That night, in Karasburg, I stood outside next to the truck and looked into the cloudless sky. Tomorrow we would head back to Capetown. North, under the desert sky, lay the strange walls of the Eggshell Hills. Many stars twinkled in the sky—in another few hours a new day would begin. Many adventures lay behind

me. Many more lay ahead me, but on that starry night, it was only then and there that mattered.

Bibliography

1. *Lost Cities & Ancient Mysteries of Africa & Arabia,* David Hatcher Childress, 1989, Adventures Unlimited Press, Kempton, Illinois.
2. *The Kalahari and its Lost City*, A. J. Clement, 1967, Longmans, Capetown.
3. *Through the Kalahari*, G.A. Farini, 1896, Sampson, Low, Marston & Co., London.
4. *In Witch-Bound Africa*, Frank Melland, 1923, J.B. Lippincott Co., Philadelphia.
5. *Searching for Hidden Animals,* Roy Mackal, 1980, Doubleday & Co., Garden City, New York.
6. *Grolier Encyclopedia,* 1997 edition. Danbury, CT.s
7. *The World's Last Mysteries,* 1979, Reader's Digest Books, Pleasantville, NY.

The first map of Southern Africa, published in Lyons in 1535.

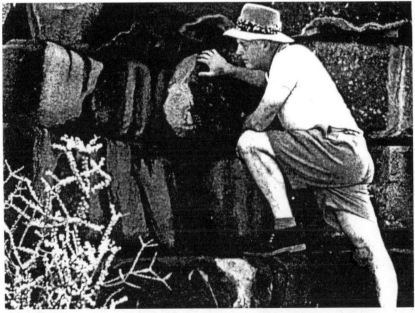

South African journalist A.J. Clement at the "lost city" in 1964.

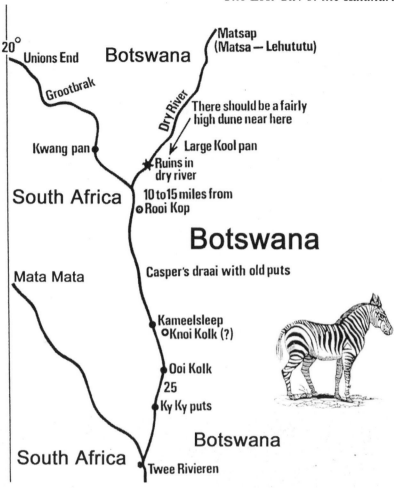

The famous 1948 Simon Kooper Hottentot map, redrawn.

The author climbs up one area of the "city." Photo by Herman Hegge.

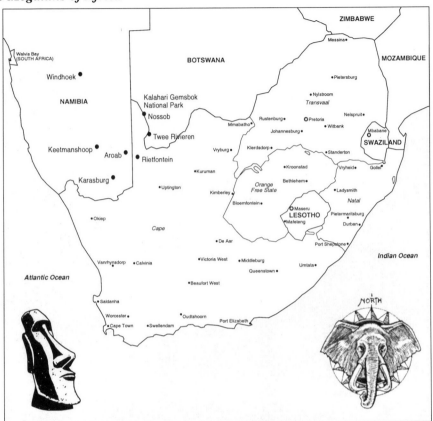

A.J. Clement's mysterious 1964 photo of parallel lines on one of the blocks.
Our expedition was unable to locate any such rock. Had it been removed?

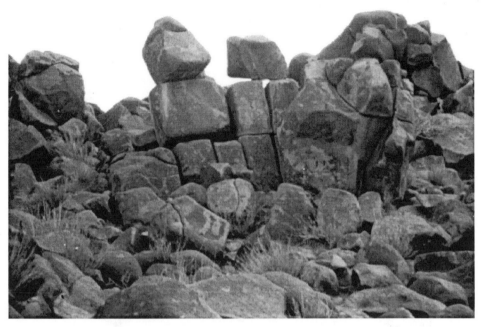

Curious square looking wall at the "city" in Namibia. 1999 photo.

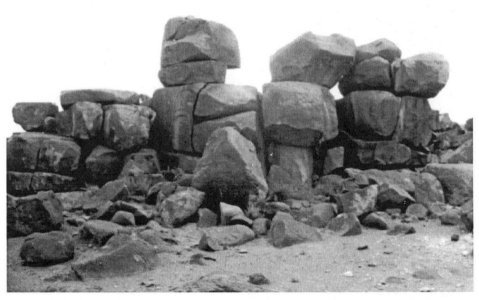

A man-made looking wall at the "city" in Namibia. Photo taken 1999 by the author.

7.

Across the
Gobi Desert—
A Phantom Power

When one has the feeling of dislike for evil,
when one feels tranquil,
one finds pleasure in listening to good teachings;
when one has these feelings and appreciates them,
one is free of fear.
—Buddha (BC 568-488)

Some say he bid the angels turn askance
The Poles of Earth twice ten degrees and more
From the Sun Axle; that with labour push'd
Oblique the Centric Globe to bring in change.
—John Milton, *Paradise Lost*, Verse X

For this they [scoffers] willingly are ignorant of,
that by the word of God the heavens were of old,
and the earth standing out of the water
and in the water: Whereby the world that then was,
being overflowed with water, perished.
—II Peter 3:5, 6

"**O**ver there!" I yelled at Jennifer as we ran down the platform look-
ing for our train to Ulan Bator. It was leaving from the Beijing Cen-
tral Station in less than five minutes, and we were in danger of miss-
ing it. We had spent precious time running through passenger wait-
ing rooms at the crowded station, in full pack, looking for the one
that served our track; then we realized that all foreigners had to re-

port to one waiting room, regardless of their destination. When we flew through that room to the exit, a smiling attendant looked at our tickets and pointed nebulously out to the maze of tracks.

I spotted a carriage that said Ulan Bator, Mongolia, on it, and was glad to have found the train. Now, if we could just find carriage number seven. A uniformed conductor showed us to our carriage, one which we shared with a Japanese tourist named Kimiko, and a Chinese-Russian language specialist from Beijing named Chun on his way to Moscow for translation work.

We settled into our bunks, got our snacks and drink bottles out, threw in a smattering of guide books, maps, and novels, and we had your standard tourist railway compartment.

There are three different trains that run between Beijing and Ulan Bator, the capital of Mongolia. It is said that the Russian and Chinese trains have the better service, and the Mongolian train the most basic. We were on the Chinese train, and it would be a two-day journey to Ulan Bator. It left the main station in Beijing early in the morning, and would reach the Mongolian-Chinese border about midnight, where we would have a stopover while the train's wheels were changed to fit the Russian gauge of track that ran through Mongolia. We were scheduled to arrive in Ulan Bator early the next evening.

We passed fields and grasslands with rugged hills behind them. A horsecart with a load of watermelons was being driven down a country road alongside the tracks. A freight train with two great, greasy black engines pulled up next to our train, and I waved at the engineer. He waved back. The sun reflected off pools of water and rivers as we passed, twinkling in glittery reds, yellows, and greens; at one moment, we crossed a section of the Great Wall. This was the life, I thought, grinning widely. I was enjoying the little nuances of the scenery and the glimpses of life on the farmlands and pastures of Inner Mongolia.

As the sun set over the dusty fields, I thought about the strange aura that the Gobi held. It was hard to put one's finger on it, really. There was no Mount Everest, or Great Wall, or Grand Canyon out there. Just a lot of desert and mountain. The growing orange of the sunset glowed in the distance and the train blew a long whistle.

Somewhere out there was a mystery, a mystery of phantom power— the invisible college—a secret organization of wise men and women. Some called them "the Watchers." Others called them "Masters," or "the Immortals." Legends placed these immortals, with their secret city, variously in Tibet, the Gobi Desert, or the Altai Himalaya

of western Mongolia. It was a fabulous quest, and as far as lost cities were concerned, the search for the phantom domain of the Immortals had moved to the top of my shopping list.

The Mysterious Gobi

Centuries ago, before that larger-than-life Mongol Chingis Khan created the largest empire the world has seen to date, the Chinese had some control over Mongolia. They called the area just beyond the Great Wall "Inner Mongolia" and the more distant part "Outer Mongolia." The Gobi Desert spanned areas of both Inner and Outer Mongolia.

The history of Mongolia is one of the least-known and strangest in the world. Even today, most of Mongolia remains unsurveyed and "wild." The government exercises as much control as it can over the more remote areas, though it is minimal, particularly since roads are scarce.

Mongolia is about one-third the size of the United States, with a population approximately the same size as Michigan's. As a country, it is quite similar to the great plains of the United States, and the non-desert areas can easily remind one of eastern Wyoming. Most people in Inner and Outer Mongolia are nomadic herders who move with their animals seeking pastures.

The original inhabitants of Mongolia and the steppes around the Gobi Desert are thought to have been Uigers, a Turkish people, often with red hair and blue eyes. These ancient Uigers made inscriptions in a kind of runic script that has no relation to modern Mongolian. The earliest known inscriptions are runes that are carved on menhirs in western Mongolia.

"Gobi" is the Mongolian word for any broad expanse of semi-barren country, and the area now known as the Gobi Desert is a true desert area thinly covered with gravel and sand. There is a scant covering of grass and scrub brush, but very little water. The Gobi does, however, support quite a few wild animals. The desert is known for its fierce sandstorms, cold nights, and blistering summer days. In winter, even the days are cold. Temperatures range from highs of 122 degrees F in July to lows of minus 40 degrees F in January. What created the sands of the Gobi is something of a mystery. The area was covered by ocean in the Permian Period (280 million years ago), but the exact process of its drying to desert is unknown. Perhaps the area was affected by a great flood/cataclysm, or perhaps most of the Gobi became an inland sea for some time. Both theories are sup-

ported by various sources, although it seems fairly certain that the Gobi, much like the Sahara, was fertile and inhabited at a time in the not-so-distant past.

§§§

The Four Rivers out of Eden

> And a river went out of Eden to water the garden;
> and from thence it was parted,
> and became into four heads.
> The name of the first is Pison:
> that is it which compasseth the whole land of Havilah,
> where there is gold;
> And the gold of that land is good:
> there is bdellium and the onyx stone.
> And the name of the second river is Gihon:
> the same is it that compasseth the whole land of Ethiopia.
> And the name of the third river is Hiddekel:
> that is it which goeth toward the east of Assyria.
> And the fourth river is Euphrates.
> —*Genesis* 2:10-14

The story of Eden, the idyllic home of mankind before the Fall, is well known in the West. But just where Eden was located is a matter of great speculation. As we shall see, other cultures have similar accounts of a paradisiacal past, and it may be that the stories are interrelated.

One of the four rivers mentioned in *Genesis* 2 (above) still exists by name today, the famous Euphrates. This river is said to run out of Eden directly to the Ararat range. In some circles, it is thought that the Biblical account describing the situation after the Great Flood in the Middle East says that the survivors, who ended up at Ararat, proceeded to "go home" by following the river back to "Eden," or ancient Sumeria/Babylon. Along the way, some of them stopped to create events that were to become known as "The Tower of Babel" saga. It is interesting to note that, as the science of linguistics advances, it is being shown increasingly likely that all languages indeed stem from one root source. Another ancient "myth" based in reality? Often, language experts trace the origins of the Indo-European language to Central Asia, the Ararat region, the Caucasus Mountains, or even

to the Gobi Desert/Mongolia region. There are definite links between the Indo-European languages and the Ural-Altai. So where was this Tower of Babel?

Also, where are the other three rivers "out of Eden"? One would appear to be the Nile, encompassing "the whole land of Ethiopia." But how can this be? Since it is difficult to locate the four rivers in the Middle East, it is thought that Eden must have been in another place originally, and was transposed to the Middle East where survivors of the "Eden catastrophe" had settled, possibly renaming the Euphrates after another river somewhere else. But where was this other Eden?

Legend has it that the Gobi region of Asia experienced an ancient Armageddon—a cataclysmic change that created the Gobi Desert and left vestiges of an ancient civilization. The Armageddon of the Gobi is tied into the Taoist myths of the land of the Immortals in the K'un-lun mountains, or possibly the Altai Himalaya.

A popular legend in Central Asia is that the Tarim Basin was a fresh water sea before 3145 BC, going back to 10000 BC or before. Around this inland sea, the last surviving remnants of the golden age of ancient civilization still survived. The eastern Gobi Desert was fertile and on the shores of large body of water. The K'un-lun mountains were along the southern edge of this sea. The Altai Himalaya and the Tien Shan Range would have been to the north.

The Pamir Plateau, on the western side of the lake is said by some Biblical historians to have been the original garden of Eden. Because the Euphrates is mentioned in *Genesis* 2, it has been assumed that Eden was in Mesopotamia. However, researchers E. Raymond Capt and F. Haberman in their various books assert that this is because the Hebrew Eden story is coming from the Sumerian Gilgamesh epic, and the writers would favor their own rivers (the Tigris joins the Euphrates).[40, 41]

The original Euphrates, according to them, is the river Syr Daria, far to the east, whose original name was the Jaxartes River which now flows to the Aral Sea. The Indus River would be the Pison, and the Tarim River is believed to be the Hiddekel. Today, the Oxus river is known as the Amudar'ya River, beginning in eastern Afghanistan, then becoming the border of Turkmenistan and Uzbekistan, and eventually flowing into the Aral Sea.

According to Haberman and Capt, "The Oxus is still called by the natives [of Turkmenistan] the Dgihun or Gihon. The Pamir plateau of today is, of course, a different place from what it was six thousand

years ago. At that time the whole of Asia was lower than it is today. A large inland sea covered the steppes of southern Siberia of which the Caspian and Aral Seas are remnants. Over the now frozen steppes of Northern Siberia roamed the mammoth and sabre-toothed tiger. All the indications are that northern Siberia then had a semi-tropical climate, and ideal conditions prevailed on the Pamir Plateau. The group of Alpine lakes, which now constitute the headwaters of the four rivers, may once have been one lake."[40, 41]

Interestingly, Haberman and Capt believe that the early Hebrews originally migrated from the Pamir Plateau to Ur in Sumeria around 3100 BC. Later the Biblical progenitor Abraham migrated with his wife Sarah and their clan into the Arabian Peninsula. They eventually settled along the Red Sea in what is now Saudi Arabia around 1800 BC. Later they sold themselves into captivity to Egypt because of a drought. Around 1200 BC Moses led his people out of Egypt in the celebrated Exodus to the Jerusalem area.

A few generations later the Hebrews had built a magnificent capital, were extremely wealthy and influential, and King Solomon allegedly flew back into the Pamir region in an airship, according to Central Asian legends related by explorer Nicholas Roerich and others.[9]

The White Island of the Gobi Desert

Central Asia has often been the focus of historians. Many things, including the Caucasian race and most European dialects appear to stem from Central Asia. Esoteric schools like The Lemurian Fellowship and The Stelle Group maintain that a large number of citizens were airlifted out of Atlantis into Central Asia before Atlantis destroyed itself circa 9000 BC. It has been said that Atlantis ultimately destroyed itself with a radio-type weapon that it was using to shoot through the earth; it backfired and the people destroyed themselves.

Should a scenario like this actually be the case, then perhaps the Tarim Basin civilizations continued until 3145 BC when another change in the Earth's crust turned the area into a desert. The Pamir plateau was still habitable, though it did not have the same climate as before. In this theory, civilization did not resume in the Tarim Basin until about the second century BC. Most of the Buddhist caves, pyramids and abandoned cities in the Gobi can be traced to that period.

It was on the edge of the Gobi that the Uigers had their first alleged capital city, Karakota. That the Caucasian Uigers inhabited this

area before the Mongols is quite certain. The Mongols apparently came from farther north in Siberia. How long the Uigers lived there, the level of their culture, and what exactly caused their decline, are still mysteries. There are many stories, some of them substantiated, of lost cities in the deserts of Inner and Outer Mongolia, plus other areas of Central Asia.

According to the Hindu *Kurma Purana,* an island called Sweta-dvepa, or White Island, lay in the northern sea, the paradisiacal home-land of great yogis possessed of supreme wisdom and learning.

According to author Andrew Tomas,[3] the Gobi Desert is the bot-tom of this inland sea that once existed in western China and Mongolia, and the island is now a cluster of high mountains rearing up from the barren desert floor.

Tomas tells the story of the Russian explorer N. M. Prjevalsky, who in the late 1800s recounted an old Mongolian legend concern-ing an ancient island that was a paradise: "Another very, very inter-esting tale concerns Shambhaling—an island lying far away in the northern sea. Gold abounds in it [as it does in the Altai mountains], wheat grows to an enormous height there. Poverty is unknown in that country; in fact Shambhaling flows with milk and honey."

As has been noted, the world of Central Asia and the Gobi Desert was much different in the past than it is today. The great inland sea must have drained to the north and east during some cataclysmic shift of the Earth's tectonic plates. The sea floor became the wind-blown desert that exists today, and the islands that had existed in this great sea have become uninterrupted mountain chains and and isolated groups of peaks. This would seem to be the reverse of pro-cess that produced the Mediterranean of today—there, at least 200 known cities are submerged on the undulating sea floor, which must have in the past been above water.

Of note are the mysterious deep lakes of Lake Baikal just north of Mongolia in Siberia, and its sister lake, Khovsgol Nuur, on the Mon-golian-Russian border just to the south and west of Baikal. Lake Baikal, though thousands of miles from the ocean, has a large seal popula-tion. How these seals got to Lake Baikal is not known by biologists. It is thought that the seals must have migrated to Lake Baikal in some time in the distant past. There must have been some connection to the outer ocean at some time, such as a huge inland sea where the Gobi Desert is now, surrounding the Altai Himalaya and encom-passing areas of central Mongolia.

Author Victoria LePage in her book *Shambhala*[16] argues that the

Altai Himalaya area is the repository of Shambhala and the ancient White Island, or Island of Shambhaling.

LePage identifies Shambhala with the legendary Mount Meru, which she believes is somewhere in the Altai Mountains, possibly the high mountain called Mount Belukha. Says LePage, "Within the magic ring of myth the cosmic mountain is preeminent, both for its universality and its spiritual resonance. As the meeting-place of heaven, earth, and hell and the axle of the revolving firmament, it has figured in the mythology of nearly every race on earth and has been revered even in lands where there are no mountains. It is always pictured as the Axis Mundi and as bearing the habitats of sages, saints or gods upon its sides, as four-sided or six-sided and eighty miles high, with the heavens rotating about its peak and the pole star shining above. It is said by all accounts to be so high that it pierces the firmament, while its roots descend into the abyss beneath the earth where chaos reigns. It has seven levels, believed by some races to be nine, and these correspond to the seven or nine inner worlds and also to the ascending stations of consciousness traversed by the initiate on his purgatorial pilgrimage to heaven."

The ancient land sacred to the Hindus was the White Island says LePage: "To the early Hindus, Mount Meru was the apotheosis of this causal principle. From Central Asia they brought into India the legend of a paradisiacal mountain to the north which, as the *Mahabharata* declares, 'stands carrying the worlds above, below and transversely,' and which Hindus believe to this day is the prototype of all other mythic mountains. This northern mountain was inhabited by seven great Rishis who appeared in the world whenever a new spiritual revelation was required. Eliade catches the inner meaning of the legend when he states that the cosmic mountain symbolizes the highest pinnacle of mystical exaltation, of enlightenment. Hence in antiquity, he says, every religious center partook of the meaning of the sacred mountain: the temple was the highest point of the land, the center of the world, the gateway to revelation, to prophecy, to heavenly gifts and to the human laws received from the gods. Where there was no mountain the people built one; a mound, a pyramid, a ziggurat."[16]

§§§

Atlantis in Mongolia

The French author Robert Charroux is one of the few writers on

mysteries of the past who touches on the enigmas of the Gobi Desert and Mongolia. In *The Mysterious Unknown*[5] he discusses the French Astronomer Royal, Jean Sylvain Bailly, mayor of Paris in 1779, who wrote a book on the history of ancient astronomy which was published in 1781. One-third of the book was devoted to ancient India and surrounding areas and described the scientific discoveries of a Northern people who no longer existed on the earth.

Bailly based his work upon the "Tables of Tirvalour" and documents brought back from the Indies by missionaries, and eventually concluded that there must have been a very highly developed antediluvian civilization which had been "obliterated as a result of natural and political upheavals."

In checking the Indian astronomical tables, Bailly found that they contained mistakes, if one took them to have been worked out in India. On the other hand, if the author had been sited somewhere near the 49th degree latitude north, they appeared to be correct.

Charroux says that Bailly "inferred from this that the Brahmans, in whose possession they had been, must have inherited them from a people living in the Gobi Desert, whom he called Atlantean." Charroux goes on to call this lost civilization "Atlantis in Mongolia," though he admits to the belief that Atlantis was somewhere in the Atlantic Ocean. The Gobi Desert and western Mongolia are more to be associated with, he says, the White Island and Meru/Shambhala.

A Mysterious, Ancient Road in Mongolia

In the book *Unknown Mongolia*,[6] a two-volume set published by Hutchinson & Company in London in 1913, the author describes a mysterious and ancient road that he discovered in the Altai Himalaya. Written by Douglas Carruthers, a "Gold Medalist of the Royal Geographical Society," and subtitled "A Record of Travel and Exploration in North-West Mongolia and Dzungaria," *Unknown Mongolia* is a very rare book, and I was fortunate to obtain a facsimile reprint from my friends at the Pilgrims Book House in Kathmandu.

In Volume One, page 114, Carruthers says, "Between the Cha-Kul Valley and the Kemchik River we found a well-built high-road, six yards in width, raised above the level of the surrounding steppe and having a ditch on either side. The surface was as smooth and well-metalled as an English high-road. Passing caravans, which generally make a row of deep parallel grooves caused by the horses or camels following each other in single file, here had made no impression on the surface. It ran with Roman directness between the two

points here mentioned—a distance of about fifty miles! It appeared incredible to us that any volume of trade could necessitate the building up of so formidable a route. Its object remains inexplicable. The area it crosses needs no road-building to make transport possible. The ground is hard, smooth steppe, suitable to every kind of traffic; therefore road-making seems to be a labour-wasting folly. Were the country soft, wet marsh-land or damp forest, there might have been some reason for the arduous labour this work must have entailed. All we can infer from its presence is that once this region must have been of greater importance, many more caravans must have been in the custom of using the route, and a greater amount of communication must have existed between Mongolia and Siberia."[6]

This curiously "unused" ancient road may be linked to some sort of lost world of western Mongolia that is associated with ancient inland sea of the Gobi and the White Island. According to Carruthers, the caravans of today show no evidence of using this ancient well-made road. Since these caravans have been moving for thousands of years, there is evidence to suggest that this road is many thousands of years old, and was meant for traffic that is different from camel caravan traffic. Today, Russian and Chinese jeeps drive the ancient—now modernized—roads of western Mongolia. This road apparently went to some location that has now disappeared, perhaps an ancient port, or to a mountaintop city on a large island or peninsula in the Gobi Sea.

This road, and other ancient ruins in western Mongolia and China may be related to the mysterious standing stones known as the "Tombs of the Genii." These massive stone menhirs are located in Siberia, and are possibly the largest megaliths ever discovered. Now seemingly lost, these monstrous megaliths (note the horse in the illustration) are located on the Kora River in what was Soviet Turkestan and were depicted in the 1876 book *The Early Dawn of Civilization* (Victoria Institute Journal of Transactions).

They appear to be menhirs, much like giant obelisks, rough-hewn, and placed in the ground by some unknown effort. Either a gigantic waste of time, or leftovers of a technology that predates our own. These standing stones are so huge that they must still be standing today, though modern photos of these megaliths are currently unknown

§§§

Men and Gods in Mongolia

Jennifer and I had dinner in the dining car, and conversed with a couple of guys who had been expats for several years in Southeast Asia, and were now taking a circuitous route back to the West to reestablish residency. We had been given unexpected meal tickets, which we discovered entitled us to the set menu of gristly chicken on rice, and plates full of chopped celery in soy sauce. We all raised our chopsticks and dug in with suitable aplomb. Later, we read books in our berths, with our Chinese and Japanese companions reading their novels or guide books and drinking jasmine tea.

I had brought a curious set of books on Mongolia, *In Secret Mongolia* (originally titled *Tents in Mongolia*) and *Men and Gods in Mongolia*, first published in 1934 and 1935, respectively, by Kegan Paul of London. The books were written by Henning Haslund, a Danish explorer who accompanied Sven Hedin and other explorers into Mongolia and Central Asia in the 1920s and 30s. In these exciting books, Haslund takes us into the barely known world of Mongolia of 1921, a land of god-kings, bandits, vast mountain wilderness and a Russian army running amok. I relaxed in the upper berth reading *In Secret Mongolia*. Haslund amazed me; he was a resourceful, adventurous person, with an cheery attitude that seemed indomitable.

Starting in Peking, Haslund journeys to Mongolia as part of the Krebs Expedition—a mission to establish a Danish butter farm in a remote corner of northern Mongolia. Along the way, he smuggles guns and nitroglycerin, is thrown into a prison by the new Communist regime, battles the Robber Princess and more. Haslund meets the "Mad Baron" Ungern-Sternberg and his renegade Russian army, the many characters of Urga's fledgling foreign community, and the last god-king of Mongolia, Seng Chen Gegen, the fifth reincarnation of the Tiger god and the "ruler of all Torguts."

Aside from the esoteric and mystical material, there is plenty of just plain adventure: Haslund encounters a Mongolian werewolf; is ambushed along the trail; escapes from prison and fights terrifying blizzards—but all in good humor, which makes us wonder at the amazing character of this intrepid adventurer. With Haslund, I witnessed initiation into Shamanic societies, met reincarnated warlords, and experienced the violent birth of "modern" Mongolia. I finished this first book and eagerly dug into the second.

In the 1935 sequel, *Men and Gods in Mongolia*, Haslund continues his adventures by taking us to the lost city of Karakota in the Gobi Desert where we meet Dambin Jansang, the dreaded warlord of the

forbidden expanse of desert known as the Black Gobi. There is even material in this incredible book on the Hi-mori, an "airhorse" that flies through the sky and carries with it the sacred stone of Chintamani (more on that later). The cover of the book features an amazing photo of a famous Mongolian giant, said to have been eight-and-one-half feet tall, standing beside a Russian of normal height. The Mongols are certainly a tall people, perhaps the tallest of the Orientals, though this Mongol was definitely of unusual height.

A Mountaintop Mystery

Haslund includes a very curious story in *Men and Gods In Mongolia* which may be helpful in the search for the phantom power of the Gobi. Toward the end of his book, Haslund discusses his meetings with the Toin Lama of far western Mongolia and Sinkiang. This elderly lama was fascinated by aeroplanes and air travel.

Says Haslund:

It was illustrated papers that were to open the way to the first intimacy between *Toin Lama* and me. He was the most eager of all my auditors, and every evening we went in detail through the pictures in a year-old weekly paper with all the matter for discussion to which each picture gave rise.

The number containing Charles Lindbergh's Atlantic flight lasted three evenings, and I wonder whether the exploit of that blond scion of Scandinavia with the monstrous *nisdeg telleg,* "ether-carriage," anywhere produced more astonishment and delight than among the Torguts of "the Mountains of Heaven."

The marvelous news of man's ability to follow the flight of the bird gave birth to a plan for the future in the primitive but progress-loving mind of *Toin Lama.* Of course it would be only a question of time before the Torguts would have their own "ether carriages" and with their aid one of the country's greatest riddles would be solved.

Deep within the mountains rises a sky-piercing peak with steep sides and topped by an irregular plateau like a gigantic watch-tower. The bare gray precipices of the mountain are clothed at the top with pallid glaciers, and it needs courage to attempt to climb it. Yet the mountain has been climbed by two hunters of a former generation. They reached the top of the alpine tower and came back with an account of what they had seen. Those two hunters are dead long since, but the account

of their wonderful experience survives and has tempted many a hunter of later times to the same climb, but none has been able to accomplish it. For terrifying sounds were heard from the sides of the mountain, and long before they reached the top they were seized with confusion of thought. Many have been entirely lost, but others have been found later at the foot of the mountain with no memory of what had happened after their minds were clouded and no knowledge of how they came down from the heights.

But the sight that the two hunters saw was worth the hardships of the climb, for up there was a paradise for Mongols. High up, the mountain-sides ended in a mighty circular crater the slopes of which were covered wit luxuriant vegetation. Through the green alpine meadows flowed foaming rivers, and on the slopes fat sheep and goats were grazing and multitudes of game. Deep down in the crater valley lay a blue lake on whose fertile banks and surrounding steppes cattle grazed in countless multitudes. White tents were scattered over the steppe and from their smoke-vents the heat of fires trembled in the pure air. But no human beings were to be seen. The tents stood uninhabited, the horses played in unsaddled freedom and nature smiled in secure blessedness.[2]

This strange story of a secret city on top of a mountain may be pure legend, but what legend is not based on something real? What could possibly be real about this story? A mirage on the summit of a mountain? Could there be some lost paradise on top of a mountain in the Altai Himalaya? Haslund did not give this mountain a name, but it is apparently in western China, the Pamirs, or the Altai Himalaya. It sounds remarkably like the Land of the Immortals, sometimes called the Land of Hsi Wang Mu.

Hsi Wang Mu & the Land of the Immortals

The great Chinese philosopher, Lao Tzu, often talked of the "Ancient Ones" in his writings, much as Confucius did. They were wise and knowledgeable human beings that were as gods—powerful, good, loving, and all-knowing. Born around 604 BC, Lao Tzu wrote the book which is still perhaps the most famous Chinese classic of all time, the *Tao Te Ching*. When he finally left China, at the close of his very long life, he journeyed to the west, to the legendary land of Hsi Wang Mu, which may have been the headquarters of the "Ancient

Ones," the Great White Brotherhood. It was as he was leaving, at one of the border posts of China, that a guard persuaded him to write down the *Tao Te Ching*, so that Lao Tzu's wisdom would not be lost. No one ever heard of Lao Tzu again, and it is presumed that he made it to the Land of Hsi Wang Mu.

Hsi Wang Mu is another name for the popular Chinese Goddess Kuan Yin, the "Merciful Guardian." According to *The Shambhala Dictionary of Taoism*,[1] Hsi Wang-mu is defined as: "Royal Mother of the West," a Taoist figure who "rules over the western paradise of the Immortals in the K'un-lun Mountains. As the ruler of the Immortals (hsien) she is portrayed as a young beautiful woman wearing a royal gown, sometimes also riding on a peacock. She lives in a nine-storied palace of jade, which is surrounded by a wall over a thousand miles long and of pure gold. The male Immortals reside in the right wing of this palace, the female Immortals in the left wing.

"In her garden Hsi Wang-mu cultivates the peach of immortality; whoever partakes of this fruit is no longer subject to death. However, her miraculous peach tree forms only one peach every three thousand years, which then takes a further three thousand years to ripen. When it is ripe, the the Royal Mother of the West invites all the Immortals to a feast to celebrate their birthday and to partake of the miraculous peach, which bestows another lease of immortality. The feast has often been described in Chinese literature."[1]

In *Myths and Legends of China*,[34] a collection published in 1922, Hsi Wang Mu is connected to a lost continent: "Hsi Wang Mu was formed of the pure quintessence of the Western Air, in the legendary continent of Shen Chou. …As Mu Kung, formed of the Eastern Air, is the active principle of the male air and sovereign of the Eastern Air, so Hsi Wang Mu, born of the Western Air, is the passive or female principle (yin) and sovereign of the Western Air. These two principles, co-operating, engender Heaven and earth and all the beings of the universe, and thus become the two principles of life and of the subsistence of all that exists. She is the head of the troop of genii dwelling on the K'un-lun Mountains (the Taoist equivalent of the Buddhist Sumeru), and from time to time holds intercourse with favored imperial votaries.

"Hsi Wang Mu's palace is situated in the high mountains of the snowy K'un-lun. It is 100 *li* (about 333 miles) in circuit; a rampart of massive gold surrounds its battlements of precious stones. Its right wing rises on the edge of the Kingfishers' River. It is the usual abode of the *Immortals*, who are divided into seven special categories ac-

cording to the color of their garments—red, blue, black, violet, yellow, green, and 'nature color.' There is a marvelous fountain built of precious stones, where the periodical banquet of the Immortals is held. This feast is called P'an-t'ao Hui, 'the feast of the Peaches.' It takes place on the borders of Yao Ch'ih, Lake of Gems, and is attended by both male and female Immortals."[34]

In *The Shambhala Dictionary of Taoism,* we learn that the K'un-lun is a "mountain range in Western China, glorified as Taoist paradise. ... The K'un-lun—one of the ten continents and three islands in Taoist cosmology—is said to be three (or nine, according to some texts) stories high. Whoever is capable of ascending to its top gains access to the heavens. The K'un-lun furthermore extends three (or nine) stories below the Earth, thereby connecting the subterranean watery realm—the dwelling place of the dead—with the realm of the gods. In the K'un-lun the Royal Mother of the West grows the peaches of immortality, which Taoists have again and again set out to discover in countless expeditions."

The dictionary goes on to say that, "According to tradition the first to visit this paradise was King Mu of Chou, who there discovered a palace of the Yellow Emperor (Huang-ti) and erected a stone memorial. He was then received by the Royal Mother of the West."[1]

In *Shambala: Oasis of Light,* Andrew Tomas relates that, in the Chin Dynasty (265-420 AD), the Emperor Wu-ti ordered the scholar Hsu to edit some bamboo books found in the tomb of an ancient king named Ling-Wang. The books recorded the travels of the Chou Dynasty emperor Mu (1001-946 BC) who journeyed to the K'un-lun mountains to pay a visit the Royal Mother of the West. The emperor met with Hsi Wang Mu on the auspicious day *chia-tzu* on the bank of Jasper Lake in the K'un-lun range. She blessed him and sang for him, and the emperor promised to return in three years after bringing peace and prosperity to his millions of subjects. He then had rocks engraved as a record of his visit and departed eastward across the desert back to his kingdom.[3]

The Shambhala Dictionary of Taoism contains an interesting note on the K'un-lun: "…One may also attain immortality by climbing the first and lowest of the three mountains of K'un-lun—the mountain called Cool Breeze. Whoever reaches the top of the second mountain, called Hanging Garden and twice as high as the first, will become a spirit capable of magic and of commanding wind and rain. Those who climb the third and highest mountain… can step from its peak directly into Heaven and become a spirit of the gods, because

they have reached the palace of the Supreme Celestial Emperor."[1]

It is interesting to wonder if any of the mountains mentioned, Cool Breeze or Hanging Garden (or the third, which is unnamed) could be connected with the mysterious mountain that is mentioned by Henning Haslund in his book *Men and Gods in Mongolia*.[2] There is certainly a strong common theme in these stories of ancient lakes and paradisiacal cities located high in the vicinity of the Altai.

Although apparently unrelated to these tales, it was curiously announced by the *People's Daily* in Beijing in early June 2001 that an underwater archaeological survey was to be carried out on the bottom of Fuxian Lake, in the southwestern Chinese province of Yunnan in search of a legendary sunken city said to be thousands of years old.

Fuxian Lake lies in Chengjiang County of Yuxi City in central Yunnan Province. At an altitude of 1,750 meters, waters with a depth of 153 meters, the article said that Fuxian is the second deepest lake in the province. An old story goes that an unknown old city of the ancient "Yunnan Kingdom" had sunk deep at the bottom of the Fuxian Lake millennia ago. A fact giving people food for thought was that a certain diver some years ago had reported stone slabs and wall ruins found at the bottom of the lake.

The article stated that the underwater archaeological survey is to be the first one of its kind in the history of archaeological research in China. Two sonar expert teams from the Institute of Acoustics of the Chinese Academy of Sciences and Harbin Engineering University, outfitted with underwater robots and other advanced equipment, will take up the task of exploring the lake for the alleged submerged city which is said to be 70 meters (200 feet) under Fuxian Lake.

§§§

Mongolia at Midnight

Suddenly (I having dozed off with a book on my chest and the light on), we came to screeching and grinding halt at the Chinese-Mongolian border town of Erenhot. Chinese officials boarded the train, searched our compartment and asked for our passports. We handed them over and looked out at the dark streets of Erenhot. It was a chilly night, but all passengers had to get off so the train could be taken to the shed where it would be lifted off its Chinese-gauge wheels and placed on a system that fit the Mongolian track. After a short delay (during which, we were later told, police were bundling

off a stowaway), we filed from the train.

We went down the main street with a New Zealand woman from the next compartment. Although it was quite late, midnight in fact, there were still various shops and restaurants open. The train coming to town two or three times a week was a major force in the local economy.

We looked through the door of a restaurant where a group of jovial workers smiled at us, and motioned for us to come in and sit with them. We had a seat, and ordered some Tsing Tao beers. We introduced ourselves and ordered a round of snacks for everyone. Though none of the Chinese-Mongolians spoke English, and none of us spoke Chinese, or Mongolian, we all got along famously and had a good time. Several bottles of beer and many toasts later, we were paying our bill and heading back to our berths to sleep for the rest of the night. The train chugged off, and we were officially in Mongolia.

It was bright autumn sunlight when we awoke the next morning. Soon it was lunch in the dinning car—a new Mongolian car with a different staff. The food was good (the Mongolians have found amazingly palatable ways to serve the national dish, mutton) and people moved up and down the train looking for friends or something to do.

We were still several hours outside of Ulan Bator as the train came to a halt at a dusty concrete town, the remains of Russian military base. The Russians had kept a number of military bases in Mongolia, mainly to watch China, but pulled out of most of the them in 1990 when the Communist regime in Moscow collapsed. Mongolia wasn't actually ready to shed its old Communist government, or for the sudden decolonization that took place almost overnight. As a result, Mongolia lost much of its Russian financial and material aid, but began to reach out to different countries such as South Korea, Japan and the United States. Mongolia, apparently, has become a popular tourist and investment site for South Koreans.

As we pulled out of the station, past a herd of bactrian camels grazing on the edge of town, I looked over the books I had brought along with us. One of the books was *Altai Himalaya*[24] by Nicholas Roerich.

Nicholas Roerich and the Altai Himalaya

The famous Russian-American artist, explorer, archeologist and author Nicholas Roerich was born near Moscow in 1874. Roerich was one of the most famous painters of his time and authored sev-

eral best-selling books including *Shambhala*[19](1930) and *Altai Himalaya*[24] (1929). He studied at the Moscow Art Theater and Diaghilev Ballet for some years and then led a series of well-financed expeditions, lasting for over five years, into Mongolia, western China, and Tibet.

After a number of trips to India and Central Asia, Roerich exhibited his paintings in New York with great success, and the Roerich Museum (N.Y.) was founded in his honor in 1921. Another already existed in Moscow, and still exists to this day, making Roerich one of the few artist-archeologists who has two museums dedicated to him. When in New York or Moscow, I highly recommend visiting either of the Roerich museums; they are both well worthwhile, and easily found in the phone book or any other directory. While the New York Roerich Museum is better funded and well stocked, the Moscow Roerich Museum contains some of Roerich's more unusual paintings and belongings, including several gigantic crystals of translucent quartz, apparently collected somewhere in Central Asia. Roerich died in New York City in 1947.

Roerich's *Altai Himalaya* is a classic 1929 mystical travel book. The explorer's expedition through Sinkiang, Altai-Mongolia and Tibet from 1924 to 1928 is chronicled in 12 chapters, featuring reproductions of his inspiring paintings. Roerich's "travel diary" style encompasses discussions of various mysteries and mystical arts of Central Asia, including such arcane topics as the hidden cities of Shambala, Agartha and others. Roerich is recognized as one of the great artists of this century and the book is richly illustrated with his original drawings.

Roerich was keenly interested in the legends of secret cities in Central Asia, hidden abodes of the Masters and the phantom power of the Gobi. Just south of the Altai mountains, in Sinkiang, the famous explorer and mystic heard of the "Valley of the Immortals" just over the mountains. In his 1930 book *Heart of Asia*[26] he wrote, "Behind that mountain live holy men who are saving humanity through wisdom; many tried to see them but failed—somehow as soon as they go over the ridge, they lose their way." A native guide told him of huge vaults inside the mountains where treasures had been stored from the beginning of history. He also indicated that tall white people had been disappearing into those rock galleries.[26]

On his expeditions, Roerich apparently carried with him a large, very transparent quartz crystal (now in the Moscow museum), and at one time was in the possession of a fragment of "a magical stone

from another world," called in Sanskrit the Chintamani Stone. Alleged to come from the star system of Sirius, ancient Asian chronicles claim that a divine messenger from the heavens gave a fragment of the stone to Emperor Tazlavoo of Atlantis.[27] According to legend, the stone was sent from Tibet to King Solomon in Jerusalem who split the stone and made a ring out of one piece.

The stone is believed by some people to be moldavite, a magnetic stone sold in crystal shops, said to have fallen to earth in a meteor shower 14.8 million years ago. Moldavite is said to be a spiritual accelerator and has achieved a certain popularity in recent years. It is entirely possible that the Chintamani stone is a special piece of moldavite. It is worth noting here, too, that the sacred black stone kept in the Kabbah of Mecca in Saudi Arabia, to which all Muslims pray, is also a piece of meteorite.

Roerich developed an interesting network of friends, and ultimately had a strange connection to the shaping of world events in the first part of the 20th century.

F.D.R.'s Strange Search for a Messiah in Mongolia

One of Roerich's followers, who was strangely fascinated by Mongolia and the occult, was Henry Wallace (1888-1965), the former Vice President of the United States. The Democrat Wallace was second-in-command to Franklin Delano Roosevelt from 1940 to 1944 and was narrowly defeated by Truman for the Vice Presidential nomination in 1944. Wallace was forced to resign from office in 1946 as Secretary of Commerce because of his opposition to U.S. policies regarding Russia and the atomic bomb.

According the book *Henry A. Wallace: His Search for a New World Order*,[21] in 1934, at the height of the Great Depression, President Franklin D. Roosevelt and his friend Wallace, then Secretary of Agriculture, sent agents to Central Asia. They claimed they were seeking drought-resistant grasses. However, as reported in *Newsweek* magazine, in the Roosevelt Administration, it was common knowledge that F.D.R. and Wallace were actually looking for the reincarnated Jesus in Shambhala, the Buddhist paradise.[21]

For Roerich, who had helped create the League of Nations (predecessor of the U.N.) Shambhala was the archetypal paradise the world was on the brink of becoming, in the new golden age. With Wallace's help, and his high-placed connections, Roerich thought he could bring peace to the world.

According to William Henry in his book *One Foot in Atlantis*,[22]

"Their plan was to connect America with a group of spiritual masters whom they believed survived the cataclysm of Atlantis and who lived in Shambhala, secretly influencing world affairs. This race of Atlanteans were the spiritually actualized human beings who would usher in the new Golden Age, the prophesied kingdom of heaven on earth."

Says Henry, "If anyone could bring Jesus to F.D.R. it was Roerich. A renowned mystic and flamboyant peacemaker with a bald head and long, pointed goatee, his influence on world affairs began in World War I when he was associated with the formation of the controversial League of Nations and its purpose of creating a New World Order.

"At that time Roerich made the bold claim that he was in possession of a piece of a mysterious stone from another world. A divine messenger, Roerich claimed, had sent the stone to earth from the star system Sirius. It had previously been given to the emperor of Atlantis and then to King Solomon in Jerusalem (c. 1000 B.C.)."[22, 24]

According to Roerich, the stone had been hidden in a tower in Shambhala, broadcasting rays that influenced the destiny of the world. In 1921, Roerich acquired possession of it to aid in the formation of the League of Nations. A fragment of the stone was supposedly sent to Europe by Roerich. The stone has been described as being the size of a small finger in the shape of a fruit or heart, shiny grey in color with four unknown hieroglyphs inscribed on it. It had certain magical properties, and could be used for divination. With the failure of the League of Nations, Roerich had the stone in his possession. He reportedly returned the stone to Tibet shortly after seeing a shining disk flying through the air in 1927 while in Northern Tibet.[27]

Henry explains that we do not know the outcome of F.D.R.'s and Wallace's bizarre expedition. Why were they seeking Jesus in Mongolia? Henry points out the curious similarity of the root words for Mount Meru, the holy mountain often thought to be in Mongolia, and the dynasty of French Merovingian kings, or Meru-Vingian. This bloodline, affecting much of the royalty of Europe, is said to be connected to the descendants of Jesus, who had survived the crucifixion, and Lady Magdalene, his common-law wife. How this "Meru" dynasty fits into the strange quest of Wallace and Roerich into the Altai Himalaya has yet to seen. Perhaps they were aware of this bloodline of Jesus. Says Henry: "Whether or not Roerich was successful in locating Jesus is uncertain. However, in 1935, Roerich did bring forth two major accomplishments. He persuaded twenty-two countries,

including the U.S., to gather at the White House to sign the Roerich Peace Pact, which created a 'Red Cross of Culture.' The Roerich pact, which is still in effect today, sought to protect cultural treasures from destruction by means of a special flag of three dots in a red circle on a white banner.

"He also, along with Wallace, persuaded F.D.R. to place the Great Seal on the back of the one dollar bill. The Great Seal, which is America's symbolic coat-of-arms, was commissioned on July 4, 1776 and designed under the watchful eye of Benjamin Franklin, John Adams and Thomas Jefferson. Its purpose was to represent the inspiration for the American Revolution and the divine destiny of the American people. It is the logo for the American enterprise."[22]

§§§

The Eye and the Pyramid

The reverse side of the Great Seal features the Great Pyramid of Egypt the first (and only remaining) Wonder of the Ancient World. Unlike the pyramid as seen today, the pyramid has its capstone and within the capstone is a picture of the single All-Seeing Eye of God (sometimes called the Eye of Horus) and a gleaming sunburst behind it. Surrounding the truncated pyramid are the inscriptions, *Annuit Coeptis* and *Novus Ordo Seclorum. Annuit Coeptis* is typically translated as "God smiles on our beginning" while *Novus Ordo Seclorum* is Latin for "New Order of the Ages," or "New Deal of the Ages," a phrase made popular by F.D.R.

Says Henry, "The average American likely does not stay up nights trying to figure out the significance of this exotic symbol. However, its mystical meaning is profound.

"To occultists, the Seal represents the spiritualization of the world. The Great Seal points to America as the leader in the transition from the Piscean Age that began with Jesus to the New Age of Aquarius. …According to Egyptian legend and popular lore, the survivors of a cataclysm built the Great Pyramid of Giza, which is the model for the pyramid on the one dollar bill. No one can say for certain why this profound structure was built or by whom. Among other uses it has been proposed it was constructed as a star clock, a landing beacon, a resurrection machine, and, most interesting to us, as a book in stone.

"Originally, the Pyramid was sheathed in shiny, tura limestone. A few precious pieces of this stone cling to the structure today. Gleam-

ing too brightly to look at in the morning Sun, the immense lime-stone-covered temple would have looked to the ancient observer like a great, silvered mirror.

"The Greek historian, Herodotus, claims hieroglyphics or holy inscriptions of the lost arts and sciences of the advanced civilization that built the pyramid once covered its surface. Pilgrims would stand in front of the pyramid and read it like a book. It also had a capstone, said to have been made of pure crystal, 'the priceless gem of Egypt.' This capstone was believed to have attracted and transmitted cosmic rays."[22]

This highly mystical symbol is seen daily by millions of Americans (and foreigners) who pull a dollar bill out of their wallet and pay for something. But, probably not even one them takes a moment to ponder the meaning or significance, which is truly profound.

On the other hand, there are those in the United States who think that the Great Seal is Satanic, symbolizing the domination of Satan, often as part of some Masonic conspiracy in the American government. Certainly these, and probably others, would rather the Great Seal did not exist at all. After being suppressed since 1776, the Seal was making a comeback in 1935.

As a rebuttal to those who feel that the Great Pyramid and Eye are somehow Satanic, it should be pointed out that the eye is that of Horus, son of Osiris and Isis, and the vanquisher of the evil Set, from which we derive the Judeo-Egyptian concept of "Satan." Furthermore, the Great Pyramid is mentioned in the book of *Jeremiah* (32:18-20) that God himself has set the Great Pyramid in Egypt as a sign and wonder:

> *The great, the mighty God, the Lord of Hosts, is His Name,*
> *Great in counsel, and mighty in work:*
> *… Which has set signs and wonders in the Land of Egypt,*
> *even unto this day.*

The Great Seal of the United States is meant to take us, symbolically, back to an ancient priesthood of builders which thrived in Egypt, but which originated in deepest antiquity. Roerich, Wallace, and apparently F.D.R., believed that this origin went back to Atlantis and the ancient civilization of the Gobi Desert and the Altai Himalaya.

Concludes Henry in *One Foot in Atlantis*, "The Great Seal and its ancient variations symbolize both the prophecy and goal of this ancient priesthood. As Roerich and Wallace intended, its placement on

the back of the one dollar bill symbolically places America in the continuation of a vast evolutionary spiritual enterprise which originated in ancient times—in Atlantis, according to the mystics.

"With F.D.R's stamp of approval, was this project now off and running in twentieth century America?

"If Atlantis was rising again, this would make sense. The harrowing destruction of Atlantis (about 10,000 B.C.) is said to have taken place during the Age of Leo, the sign of the zodiac directly opposite that of our New Age of Aquarius. The Sphinx of Giza, which guards the entrance to the Great Pyramid and its secrets, is half-lion and half-man, indicating to astrologists that the Ages of Leo and Aquarius are connected (coincidentally, F.D.R.'s aides called him *the Sphinx*).

"Mystically speaking, did the placement of the Great Seal on the one dollar bill indicate to those 'in the know' that the long anticipated march to the Golden Age had begun? Did its appearance represent a major paradigm shift in world affairs?"[22]

At one point, F.D.R. named the Presidential hideaway in Maryland "Shangri-la," suggesting that he was captivated by Roerich's mystic concepts. Eisenhower later renamed the retreat Camp David.

Up until 1948 the world was largely unaware of F.D.R.'s, Wallace's and Roerich's supernatural efforts. In that year, during a political battle in his bid for the Presidency, Wallace was discredited for his spiritual beliefs and his association with Roerich.

Suddenly it was publicized that Wallace was a follower of Roerich, whom he sent on special missions to Tibet and Outer Mongolia, in search of evidence of the Second Coming of Jesus Christ. It all sounded pretty fantastic. His letters to Roerich, which began with the salutation "Dear Guru," were sensationalized. Political opponents, especially J. Edgar Hoover—the all powerful head of the FBI who compiled files on all important people—leaked the letters to the press.

Wallace's biographers Graham White and John Maze say that his private papers show he completely severed his ties with Roerich in 1935.[21]

Wallace coined the slogan the 'People's Century.' He wrote in 1934:

It will take a more definite recognition of the Grand Architect of the Universe before the apex stone [the cap stone of the pyramid on the US Great Seal] is finally fitted into place and this nation in the full strength of its power is in position to assume leadership among the nations in inaugurating 'the new

order of the ages.'[21]

According to Lynn Picknett and Clive Prince in their controversial book *The Stargate Conspiracy*,[33] Wallace was a fundamental participant in what these authors call a conspiracy concocted by British Intelligence and the CIA to lead the world into a wacko new age. Picknett and Prince give us some interesting information on Wallace, and claim that he was one of the key figures who lurked behind the scenes of Dr. Andrija Puharich's Round Table Foundation around 1949 or 1950. Much of their fascinating book concerns Puharich's foundation and its promotion of a group of "channeled gods" known as the Council of Nine, apparently related to the nine Egyptian gods known as the *Neter*.[33]

Say the authors, "A devout, fundamentalist Christian, Wallace believed that God had chosen America to be the leader of the world and that his own place in the scheme of things was hardly that of a humble footsoldier for Christ. ... Wallace was also deeply interested in mysticism and spiritualism and was a prominent Freemason."[33]

Here, the authors seem a bit confused. Perhaps it is because they are British, far away from the Bible Belt, that they could make the mistake that a fundamentalist Christian would be deeply interested in mysticism and even endorse the symbolism of the Great Seal. Wallace was clearly no fundamentalist Christian. He, like many Christian mystics, Theosophists, and Rosicrucians before him, believed in reincarnation, ancient civilizations, enlightened Masters, and a cosmic battle between good and evil that spanned time and space like some George Lucas *Star Wars* movie. Or Armageddon.

In and Out of Ulan Bator

After spending a morning at M.I.A.T., the Mongolian national airline, we had finally found a flight out of Ulan Bator. It turned out that all of the upcoming flights to the Altai were booked, but we could get a flight to Dalanzadgad, a "major" town in the south central Gobi, near the Flaming Cliffs where the famous dinosaur finds had been made. Given the paucity of roads and extreme travelling conditions overland, we decided a flight to the Gobi would be fine. We got tickets out to Dalanzadgad, and were set to leave a few days later.

During the next few days we explored Ulan Bator, a city which has no real old quarter, but does harbor some historic sites. The Monastery of Choijin Lama houses incredible papier mache *tsam* masks

used in Buddhist rituals. Other religious works of art, including life-size statues of the Immortals and some bronzes by the famous Mongolian artist Zanazabar, were on display in various temples on the grounds. Many monasteries were destroyed in the Soviet purges of the late 1930s, but this and a few others were spared. The most important monastery in Mongolia, the Gandantegchinlen Khiid, is located on the west side of Ulan Bator, surrounded by neighborhoods of gers (the traditional, round tent-homes which many Mongolians still prefer to the concrete-block high rise apartments built with Russian aid). Religious freedom was reintroduced in 1990, and about 150 monks now reside at Gandan. In the largest temple, a 20-ton, 70-ft. tall gilded and bejeweled Buddha presides over contemporary worshippers.

Ulan Bator is a fairly small city, and we managed to cover most of it on foot, although it was usually cold and windy. We went to the Museum of Natural History to view the dinosaur skeletons from the Gobi, and see replicas of the ancient rune-inscribed menhirs that are scattered over the Mongolian landscape. We visited the Zanazabar Museum of Fine Arts, and the National Museum of History. The most impressive exhibit there was a collection of life-size statues clad in the traditional dress of Mongolia's large number of ethnic groups. Since the people were largely nomadic, their wealth had to be portable, and they displayed it in fantastic headpieces, breastplates and belts.

Ulan Bator also boasted a number of good restaurants. In addition to befriending the local expat community at cafes like Lilly's and Chez Paul, we ventured into quite a few Mongolian-run establishments, where we were handed menus printed in Mongolian, often helpfully translated into Cyrillic. We were never quite sure what we would get, but usually ended up with a pretty good version of mutton and potatoes. We even went for Mongolian Hot Pot, the national dish, where we were served two differently-spiced vats of boiling water and an assortment of sliced meats and vegetables, which we then used to concoct our own stew. With these delicacies and plenty of Chinggis Khan beer, we fortified ourselves for our trip to the desert.

A Flight into the Gobi

We reported to the domestic terminal of the Ulan Bator Airport at 7:30 am on the scheduled day of our departure, only to find out that our flight was delayed by a sandstorm in the Gobi. We read our books, bought pancakes filled with spiced mutton, and waited. At 4:00 pm,

our flight was officially cancelled, which was reported to us by our morning taxi driver who found us in the airport, having apparently waited for this news and the chance for an additional fare. After spending another night in Ulan Bator, we finally flew on a Russian propeller plane to Dalanzadgad. My seat above the wheel allowed me to see right up close the worn tire as we hit the gravel-and-dirt runway of Dalanzadgad. We bounced a few times and then began to level out on the runway. The tires had not burst.

With a broad grin, I looked around the plane and noticed that other people seemed particularly glad that we had landed without any incident. We taxied up to the small airport building to deboard the plane and await our luggage.

Suddenly, a tall Mongol, Druk, stepped up to us. "Are you David and the World Explorers Club?"

He had the keys to his Russian van in his hand and we happily told him that we were the ones he was waiting for. He was our driver, who would take us to our hotel and the other sites we would visit in the next couple of days. He dropped us off at the hotel, where we quickly dumped our luggage in the concrete room, and headed out into the late afternoon.

Dalanzadgad was a dusty, devilish town—full of ghosts and broken dreams. Even the dust was covered in dust. It was starting to get cold already, and we walked from the hotel, on the edge of town, to the town center which was a small open-air market. There were sellers of vegetables, jars of honey, various dried fruits, and other canned goods. Inside the several general stores located around the market there were all kinds of goods, including candy bars, soft drinks and canned beer for the traveller. Restaurants were few and far between out here in Dalanzadgad (in fact, the only currently-operating one was located in our hotel), but the shops had most of what you might want. We bought some drinks and peanuts and headed back to the hotel for dinner.

There, we discovered we had missed traditional "dinner time" and had to venture into the kitchen to discover what they might be able to serve us. Pointing to some eggs we saw in a skillet, and some bread, we went back to the dining room, where the interpreter of the only other tourist in town, a Japanese woman, helped us order some drinks. Since it was not quite winter yet, the heat and electricity at the hotel were not turned on. Wearing our parkas, we ate our cold egg sandwiches by candlelight (apparently the skillet we had seen was not actually hot) while sipping Chingis Khan vodka. The effect

of the vodka gave us an appreciation of why this drink is so popular in the Russian, Scandinavian and Siberian wastelands—it does warm you up! When we finally trundled off to our concrete room, we slept quite well under the heavy covers.

Beyond Dalanzadgad

The next day our driver picked us up and we headed west toward the peaks of the Gurvansaikhan Nuruu range. After a couple of blocks, we were out of town and the packed-dirt street became a faint track running off through the desert. The road was in some places discernible by deep ruts left by preceding traffic; in other places it was extremely difficult to tell if we were at all on course. It was kind of like a free-wheeling, four-wheeling adventure into the vast Gobi, except we weren't in a four-wheel drive vehicle. We were in a Russian-made van that bumped, shivered and shook over the rough terrain. To add to the carnival feel, our seat was missing a couple of bolts, so it moved pretty freely with each jolt.

After a while, the path divided and we veered off to the left. A little further on, the track again divided, and we again turned left. It became very clear to us why tourists are advised absolutely not to hire their own jeep and think they'll make their way around Mongolia. There were no signposts, and Druk was obviously navigating from memory. It was hard to imagine anybody accurately mapping the area.

We were on our way to a section of the Gurvansaikhan National Park known as Yolyn Am. "Gurvansaikhan" means "three beauties," and apparently refers to the ridges that run through the park, although there are four of these. "Yolyn Am" means "vulture's mouth," and the area features a valley that is covered with several meters of ice most of the year. Although Yolyn Am is only 40 kilometers from Dalanzadgad, it took almost two hours to get there. We did stop a couple of times for photo shoots with groups of wandering bactrian camels, and to let a herd of goats cross the road.

When we reached Yolyn Am gate to the National Park, we stopped at the tiny museum. We were warmly greeted by a large man, who was sitting on the steps wearing a traditional *del*, the long, wrapped wool robe still worn by many Mongolian men today, even in the cities. The museum had some interesting dinosaur eggs and nests, and some stuffed animals that were indigenous to the area, including a snow leopard. Druk amiably chatted with the museum employees while we made our way around the three rooms of exhibits.

Then the large man took us to his souvenir shop, housed in a ger next door. We picked through the scant collection and finally settled on some Mongolian postage stamps.

A 13-kilometer drive further into the Park brought us to the car park area where tourists are let off for a hike into the valley. It appeared we were the only ones here. We were learning that if you go to Mongolia anytime other than July (when it is reasonably warm and the week-long Naadam Festival is held), you are often alone. Many people had already questioned us as to why we had chosen to visit in October. We bid Druk adieu and fastened our hoods against the cold wind blowing through the mountains. We were instructed to follow the stream that meandered around a bluff in the distance.

We picked our way through the scrubby landscape toward the valley. The sky was clear, and the late afternoon sun cast long shadows on the rock faces. Large hawks (or were they vultures?) circled above. We forded the stream a couple of times to stay on a navigable path. We passed a couple of *ovoos*, small pyramids of rocks placed along the path in a shamanistic offering to the gods, and performed the traditional act of respect by circling them clockwise three times and placing a new stone in the array. Inside the valley, the sun scarcely penetrated. We started to encounter patches of ice, and when the stream cut a narrow path through the sheer cliffs, we decided to retrace our steps.

As we rounded the bluff into the more open landscape, we encountered two Mongolian herders who were taking a cigarette break near one of the ovoos. Their horses grazed contentedly nearby. We greeted them and asked if we might take a picture, using the international sign language of pointed at our camera and at them. They happily assented. Then they surprised us by producing a pair of high-power binoculars, and pointing out a group of argali sheep picking their way daintily along the opposite cliff face, about 600 feet up.

As we neared the car park, we saw that Druk had found a friend. From the distance, it appeared they were sharing a flask of vodka. When they sighted us, the other man drove off, and Druk started up the van for the wild ride back to Dalanzadgad.

The next day, Druk took us north to the Flaming Cliffs, where archaeologist Roy Chapman Andrews, on his famous expeditions into the Gobi in the 1920s, found relics of what he called the "mysterious dune dwellers." Along the way, we stopped at a homestead where two gers housed an extended family of about 10 people. As they could see us approaching from the distance, the family was gath-

ered outside when the van came to a stop. The apparent patriarchs, an elderly couple, left the initial greetings to the middle-aged father and three teen-aged sons. They bid us enter their ger, and the smiles of the mother and their young daughter, who was holding her infant sister, indicated this would be their pleasure.

In the vast, scantly-inhabited stretches of Mongolia, where weather extremes are brutal, hospitality is key. There are well-laid-out rules of etiquette to be followed, though, when you are someone's guest. Gers are always set up so that the door (usually brightly-painted, as was this family's) faces south. On entering, women go to the right, and men to the left. Guests are seated toward the back, on the left. The back of the ger is where the family altar and valuables are kept, and the elders are seated. True to form, when we entered the ger, we were shown to seats on the west side, and the family took their positions. The mother tended the smoky fire of twigs and dung, and we were offered *cha* (a milky tea) and some lard-based cookies and salty goat cheese. It is considered bad form to refuse anything offered you, so we accepted these snacks, but we did decline an invitation to lunch. Druk's English was very limited, and our Mongolian nil, so we spent around half an hour listening to them chat, and offering a few comments in sign language about how much we liked the food. Before we left, I took a short ride on one of their camels, donning my fur hat bought in Ulan Bator, much to the family's delight.

When we boarded the van, we had two new passengers—the elderly man and young girl accompanied us. We drove to the Flaming Cliffs, where we saw evidence of several digs in process, although no archeologists were currently on site. We hiked around for a while, but didn't discover any old bones. When we returned to the van, we drove yet further into the Gobi, to our puzzlement. We stopped at some scrub-covered hills, and hiked out to find a lot of new bones— of sheep, goats and camels which had died in the recent droughts and been left to the elements. We soon ascertained that it was the mission of our passengers to gather twigs, not readily available throughout the Gobi, to stockpile for the upcoming winter. When they had filled the van, we began our return journey to Dalanzadgad.

Back at the homestead, we were invited into the other ger, where we were served *airag*, the home brew made from mare's milk. Horses are almost sacred to the nomadic Mongolians, and it was their skillful mastery of the beasts that allowed them to conquer China and the great beyond. It is said they survived some campaigns by utilizing their horses to the utmost, such as drinking mare's milk or even eat-

ing their flesh when times demanded—after beef and sheep, horse and dog meat have always been highly prized!

§§§

Finds in the Gobi Desert

The "dune dwellers" found at the Flaming Cliffs by Dr. Andrews, according to him, "inhabited the Gobi Desert in the many millions—more than there ever have been in historical or traditional times." Sven Hedin, another great explorer, traced the culture as far west as Sinkiang, and there is evidence that these people used agriculture, as well-made mortars and pestles were found in the desert.[30]

Dr. Andrews felt these people migrated elsewhere because the Gobi was drying up. Mongolia shows signs of being the oldest known dry-land area in the world, never having been submerged for the last one hundred fifty million years (or so Andrews thought). This allows for a great wealth of fossil evidence; for instance, Dr. Andrews' team uncovered fossils of the largest known land mammal ever to have been found, a shovel-tusked mastodon called a *Baluchitherium*.

While it is possible that Mongolia may have been high and dry for the last 150,000,000 years, it is also possible, and in my opinion, likely, that huge tidal waves have washed over the area during that time period—witness the mammoth-bone graveyards throughout the northern lands. Much of the ivory used in billiard balls and piano keys in the 1800s came from huge mountains of bones and ivory found in Siberia and Alaska, and on Arctic islands. These giant piles of ivory were apparently created when huge mammoth herds were suddenly picked up by tidal waves, pulverized and washed up into various piles throughout the arctic. This may have occurred during a poleshift circa 10000 BC.

While Andrews felt that the past inhabitants were fairly primitive people living in sand dunes beside now dried-up lakes, could it be that these were the remains of the highly sophisticated Uigers, their artifacts washed up onto sand dunes during a cataclysm?

To add to the confusion, a report from the Soviet journal *Smena* (no. 8, 1961) tells about a joint Russian-Chinese paleontological expedition under the direction of Dr. Chow Ming Chen, which discovered in the Gobi Desert a fossilized print of shoe with a ribbed sole. Members of the team who carefully examined the shoe print were quick to recognize that it was not the footmark of any animal, for the ribbing was too straight and regular to be of natural origin. While the

fossilized footprint of a shoe that is around fifteen thousand thousand years old may not seem completely out of the realm of possibility, the team had a completely different date! The fossil was found in a sandstone formation of a type in which Roy Chapman Andrews had found dinosaur fossils pronounced to be fifteen million years old!

This is one of the peculiar anomalies in dinosaur fossil research. The early dinosaur fossils, including eggs, were said to be fifteen million years old. Later, this date, a guess at best, was pushed back by 40 million years to 65 million years. Recently, however, CNN announced that fossils found in the Big Bend National Park of west Texas were only 20 million years old, harking back to the early dates proposed by Andrews, give or take a few million.

On the other hand, there are those who feel that the dinosaurs and their fossils of the Gobi are not 65 million, or even 15 million years old. Some think that the teeming animals of the Gobi, and their fossils, come from a time that is much more recent, when an inland sea stretched into Central Asia and the sand dunes of Dalanzadgad were the northern dunes of a huge sea and coastline swamps.

These vast swamps, filled with large animals such as the triceratops, were suddenly left utterly dry, and the animals and their eggs were covered with volcanic ash, so as to fossilize them.

There are a large number of odd artifacts and fossils similar to the Gobi footprint which defy normal geological dating and time scales. Considering that the fossil is genuine, I would venture to say that it is probably not fifteen million years old, but rather of a much more recent geological period, say hundreds of thousands of years ago. This would mean that geological change happens in a much more rapid and violent way, and that much of our geological dating is wildly off.

A find that does not seem to suffer from the dating problems of the fossils, but which is of considerable interest, is that of a pyramid built around 5,000 years ago found in Inner Mongolia. The Chinese government publication *People's Daily* reported on July 6, 2001 that a three-story pyramid was discovered in north China's Aohan County. The pyramid, which looks like a trapezoidal hill from afar, is located on a hill one kilometer north of Sijiazi Town. It is about 30 meters long and 15 meters wide at its base.

Guo Dasun, an archaeologist in charge of the excavation, said that this is considered the best-preserved pyramid built during the Hongshan Culture period that has been found so far. Seven tombs

and an altar were also found on the top of the pyramid. Archaeologists also discovered a number of pottery pieces with the asterisk character inscribed on the inner wall. The asterisk character is believed to be related to the understanding of ancient people on astrology.

Among the cultural relics excavated from one of the seven tombs are a bone flute and a stone ring; a life-sized stone statue of a goddess was unearthed in another tomb. The thing that most astonished the archeologists was a palm-sized stone genital found on the inner wall of a tomb with a small stone statue of goddess below.

Guo Dasun said that most of these relics were first-time finds which would shed light on the study of the ancient civilization in the area. However, Professor Dasun and many others, are simply unaware of how old the Gobi Desert/Pamirs/Altai Himalaya region really is—a lost world of lost cities covered in sand, pyramids, and megalithic remains.

§§§

The Wild Men of the Gobi Desert

Passing time in Dalanzadgad, read the weekly English newspaper *The Mongol Messenger*. This issue happened to have a story about the "Wild Men" of the Gobi and the Altai.

This Mongolian version of the Yeti (also known in North America as Sasquatch or Big Foot, and in Australia as the Yowie), is called the *Almas*. It is described as a wild, hairy man, short but strong, and covered with fur. According to the article, entitled "Is the Almas of the Gobi More than a Myth?," written by a Mongolian journalist named B. Ooloon:

> Deep in the Gobi Desert, in the undiscovered caves and remote mountains, a mysterious creatures lives a silent existence. This huge hairy, ape-like beast is known in Mongolia as the Almas ...
>
> The Almas is the fabled beast of the Gobi, and while many skeptics doubt its existence, some are convinced of its reality. No one has proved the Almas is real, but many sightings have been made and the Gobi people swap many stories about the Almas.
>
> The first documentation about the Almas was made in the 13th century by Piano Carpini, a representative of Pope Inno-

cent IV. Piano Carpini said he saw an Almas "south of Hami City" (in China). Another European explorer called Shildberger wrote that he captured two Almas and one wild horse from Arbus Mountain in China. In 1906, a Buriat scientist named Bazariin Baradin said he found an Almas during his research work, details of which were reported to Academician B. Rinchin.

Rinchin was very interested in studying the Almas and spent years collecting information about this beast. He documented that Gobi people do not consider the Almas unusual, but a typical wild animal. His findings and interviews were reviewed at a ten-country Yeti conference held in Prague in the 1950s. From the conference, the participants formed the International Association for Scientists studying the Yeti.

In the late 1950s Rinchin received an interesting letter that reported a dead Almas was found in Bulgan Soum, Hovd Aimag. ... The body was found in a place called "Almastai Ulaan," (Red Almas). The herder believed this was an Almas, which had died from old age. It was revealed that the herder had come to the soum chairman with this information, but the news was kept classified for three years.

After receiving the letter, a group of scientists went to Hovd to find the body. A skull was eventually found, described as human-like, but larger. ...

"I have been searching for the Almas for over 16 years. For me there is no doubt that it exists. I have seen the footprints of the Almas thirty-seven times during my search but I have only seen the Almas three times. They are difficult to find because they are nocturnal," Almas researcher Ravjir told P. Tsolmon, a geographer.

Almas sightings have been similar. It is described as being naked, dark yellow with thin hair, and having a large jaw, oval eyes and a low forehead. The Almas does not use fire, has no tools and stoops over when it walks.

The last Almas sighting occurred in autumn 1990. Three men travelling by car through Erdeneburen Soum, Hovd Aimag saw an Almas at a distance of one kilometer. The Almas was afraid of the car and ran away with amazing speed. The men tracked the beast, but only managed to find its footprints 40 cm long and 8 cm wide. Scientists later took notes on what they had found. The Almas had just four toes, the first and

fourth were 10 cm long. The third toe was 11 cm and the second toe was 13 cm.

The driver of the car admitted that he had seen an Almas in 1988 while hunting for wolves in Tsambagarav Mountain, thus furthering the mystery of the Almas.

Still Living, the Neanderthal Enigma

Many respectable researchers, such as the British biologist Dr. Myra Shackley, have considered the Almas very seriously. She even wonders if the Almas might be some sort vestige of Neanderthal Man in her book, *Still Living?*.[13] Ivan Ivlov, a Russian children's doctor, was travelling in the Altai mountains of southern Mongolia in 1963 when he saw a family of man-like creatures consisting of a male, a female and a small child, standing on a mountain slope. lvlov is a man of high reputation whose father, Nicholai, was also a doctor and worked in the Mongolian capital Ulan Bator for many years; indeed, there is actually a monument erected to his memory. So we are not dealing with folktales or local legends, but with an event which was recorded by a trained scientist and transmitted to the proper authorities. There is no reason to doubt Ivlov's word, partly because of his impeccable scientific reputation and partly because, although he had heard local stories about these creatures he had remained skeptical about their existence. Ivlov was able to observe this particular family of Almas through field glasses at a distance of about half a mile for some time, until they moved off and disappeared from view behind a jutting rock. The Mongol driver who accompanied him also saw the creatures, assuring him that they were quite common in the area.

Much surprised by this event, Ivlov had the idea of questioning the children who were his patients, reasoning that their accounts were less likely to be biased than those of adults. He found that many of them had seen Almas, and obtained a number of detailed stories. One child told him of a time when he had seen a male Almas crossing the shallow waters of a creek where he and a whole group of other children had been bathing. The Almas had been accompanied by an Almas child, which it put upon its shoulders to wade across the river, taking no notice of the group of human children who were looking at it with amazement but not, apparently, with any fear. Ivlov's small patient told him that they could all see the back of the male Almas quite clearly, and the little Almas child looking over its shoulder, sticking its tongue out and making faces at them! This seems

a surprising story for any child to invent, especially as it was cor-roborated by other local people, and Ivlov concluded that it was prob-ably true.[13]

If Almas exist, then who, or what, are these creatures who are to be seen strolling so casually across Mongolia?

Dr. Shackley says in *Still Living?*[13] that the word "Almas" is a genderless noun meaning "a strange species between man and ape," but it might come from two Mongolian words, *ala* ("to kill") and *mal* ("animals"). Linguists are very undecided on the precise origin of the term, which may also be translated as "wildman." Mongolia is full of place-names associated with Almas, such as *Almasyn dobo* (the hills of Almas), *Almasyn ulan oula* (the red mountains of Almas), and *Almasyn ulan khada* (the red rocks of Almas), but the names seem to be confined to the southern regions of Mongolia in the Altai and Gobi junction area.

The difference between Almas stories and those describing, say, the Yeti of the Himalayas or Sasquatch/Bigfoot of North America is the general lack of mythological overtones, except in the northwest of the country. There some mythological elements have been tacked on, and there is also a link with the 'wild hunter' legends of Europe. In the shamanist legends of northwest Mongolia the souls of the wildmen help hunters pursue wild beasts in the hope of being re-warded with a portion of the prey. Some local mythologies include an Almas 'god' to whom is offered only the meat of wild animals and edible wild roots, but this seems to be connected with Buddhist beliefs about the demons who live in mountain forests and highland plateaux. Mongol ethnologists see these myths as being founded on fact, representing a folk tradition of human-like hairy bipeds who were explained away as demons by some of the early shamans. The legends include references to the creatures using stone tools and hav-ing an aversion to the food of the nomadic cattle breeders. But Almas are not usually endowed with supernatural powers, and the local people are not afraid of them. They are generally regarded as differ-ent, more primitive, forms of man whose presence in an area is hardly a cause for remark. There is no evidence that Almas have ever inten-tionally harmed modern man, although there are plenty of instances where they have deliberately sought to contact him.

Almas stories go back a very long way, but obviously the further back one goes, the more difficult it becomes to distinguish between genuine literary references to Almas and general 'wild man of the woods' stories. However, certain descriptions date from the 15th cen-

tury and appear to refer to Almas. These descriptions occur in the remarkable memoirs of a Bavarian nobleman, Hans Schiltberger (mentioned in the Ooloon article above as "Shildberger"). Schiltberger was taken prisoner by the Turks and sent to Timur Lang ("Tamerlaine" of legend, then Khan of the Golden Horde), destined for the retinue of a Mongol prince named Egidi. He managed to return home in about 1427, and wrote a journal of his travels which was completed in 1430 and is now lodged in Munich. The following extract is taken from this journal, and the Arbus mountains mentioned are to be identified with the Tien Shan range. Tschekra was a Mongol prince.

> Tschekra joined Egidi on his expedition to Siberia, which it took them two months to reach. In that country there is a range of mountains called Arbus which is thirty-two days' journey long. The inhabitants say that beyond the mountains is the beginning of a wasteland which lies at the edge of the earth. No one can survive there because the desert is populated by so many snakes and tigers. In the mountains themselves live wild people, who have nothing in common with other human beings. A pelt covers the entire body of these creatures. Only the hands and face are free of hair. They run around in the hills like animals and eat foliage and grass and whatever else they can find. The lord of the territory made Egidi a present of a couple of forest people, a man and a woman. They had been caught in the wilderness, together with three untamed horses the size of asses and all sorts of other animals which are not found in German lands and which I cannot therefore put a name to.[13]

The interest of this piece is two-fold. Firstly, Schiltberger reports that he saw the creatures *with his own eyes.* Secondly, he refers to Przewalski horses, a tiny native breed which was only rediscovered by Nicholai Przewalski in 1881. The description of the people is vague, but the geographical location of the find suggests that this may indeed be the earliest reference to Almas. Przewalski himself saw 'wildmen' in Mongolia in 1871.

Several scholars have taken an interest in the Almas. The scientist Baradin (mentioned in the Ooloon article above) is said by Shackley to have been advised not to mention his 1906 sighting in his published expedition report by none other than the Imperial Russian

Geographical Society's president. She says that he did, however, report it to the eminent Mongolian professor Zhamtsarano, who was amassing an archive of all Almas sightings, plotting each on a map with the names of the informants. Most of these were nomadic Mongols, who reported frequent sightings and footprints. Zhamtsarano did extensive fieldwork from the late 1800s until 1928, but his map has apparently been lost, although collections of his papers are held at the Leningrad Institute of Oriental Studies and the Institute of Social Sciences at Ulan Ude (Siberia). Rinchin, who was indisputably one of the Mongolian People's Republic's leading intellectuals at the time of his death in 1977, had studied the Almas question for the better part of 50 years.

In the 1950s, the Czech anthropologist Emmanuel Vlcek began work on two old anthropological and anatomical works. The first book, held in the library of the Gandan monastery in Ulan Bator, included a systematic discussion of the wild fauna of Mongolia; greatly to Vlcek's surprise, it contained an unmistakable reference to a wildman. The book was Tibetan in type, printed from woodcuts on narrow strips of paper, and included an illustration of the creature, which is obviously bipedal, standing upright on a rock and with one arm stretched upwards. It is almost entirely covered with hair, except for the hands and feet, but is not very realistic, being stylized according to the artistic traditions of state lamaism. Trilingual captions say the creature was called *samdja* (Tibetan), *bitchun* (Chinese) and *Kumchin gorugosu* (Mongolian), all of which may be translated as 'man-animal.' Further searches in the central library of the Scientific Committee in Mongolia produced a more recent edition of the same book, reprinted a century later in Urga (modern Ulan Bator) under the same title, which could be translated as 'Anatomical Dictionary for Recognizing Various Diseases.' Here this same bipedal primate appears as part of a systematic discussion about Mongolian natural history, but some explanatory notes are added in Tibetan to the effect that the given names (different here from those in the first book) are to be taken to mean 'wildman.' The illustration is very similar to the one in the earlier edition, but more stylized and perhaps less credible. The head is covered with hair and the face sports a full beard. The rest of the body, except the hands and feet, has short fur which emphasizes the muscles, particularly the exceptionally well-developed chest. The Tibetan text beside the picture says: 'The wild man lives in the mountains, his origins close to that of a bear, his body resembles that of man, and he has enormous strength. His meat

may be eaten to treat mental diseases and his gall cures jaundice.'[13]

It is particularly interesting that this creature, which is clearly an Almas, must have been sufficiently well known to travellers between Tibet and Mongolia to have been included in what is really a standard work on Mongolian natural history, as it may be applied to Buddhist medicine. The book contains thousands of illustrations of various classes of animals (reptiles, mammals and amphibia), but not one single mythological animal such as are known from similar medieval European books. All the creatures are living and observable today. There seems no reason at all to suggest that the Almas did not also exist, and the supporting text and illustration seem to suggest that it was found among rocky habitats, in the mountains.[13]

§§§

The All-Time King of Mongolia

Back in Ulan Bator, I sat back in my chair at the local restaurant and took a sip of Chinggis Khan beer. My change, sitting on the bar counter, had "you know who's" face on it as well. Every other thing in Mongolia is named after Chingis, including the restaurant I was in. The beer spelled his name with two "g's", inexplicably. I unfolded this week's issue of *The Mongol Messenger* and glanced at the headlines. "Experts Doubt China's Chingis Tomb Discovery," was the top headline.

In a country obsessed with Chingis Khan, this story seemed curiously normal: a story was about Chingis' lost tomb, a tomb reputed to contain billions in treasure. Said the article:

Mongolia's community of archaeologists and historians are in denial over China's announcement that it has discovered the last resting place of Chingis Khan.

"The tomb of the great Chingis Khan is on Mongolian territory," said incensed history professor A. Ochir. "Every single Mongolian, Chinese and Arabic historical text says that Chingis Khan was buried in Hentii Aimag at a place called Ikh Horig (Great Prohibited Place). I can't believe that the tomb has been found in China."

Chinese archaeologists claim the have found Chingis in Qinghe County of northern Xinjian Province, just to the west of Bayan Olgii. The tomb has not yet been opened.

Ochir explains that the great Khan died in 1227 in a place called Turemgiin of the Tangut territory in China (present day

Gansu). He reportedly died of wounds from falling off his horse while hunting.

"We have not seen any documents that suggest the dead would be brought to a far off place instead of his homeland. I cannot believe the Chinese claim," he said.

Ochir said that if the site in Xinjiang has any significance, it is simply a shrine for Chingis Khan, which have been found in several regions of Asia. He warned that nothing further can be said about the claim until more news is published or evidence presented.

"I have no information about this find, I don't know what kind of digging or observations have been made."

Resources suggest that tomb lies somewhere in the mountains of northern Hentii, where a Japanese-Mongolian team searched for three years in the early 1990s but found no trace of the warlord. The purpose of the expedition was not to loot its possessions, but to protect and study it. Millions of dollars were put into the effort but the location of the tomb remains a secret, just how Chingis wanted it.

While other great leaders have built monuments and .pyramids to mark their grave, Chingis wanted his resting place to remain a secret—probably according to his Shamanist beliefs.

Historical sources state that the 2,000 people who attended the funeral were killed by 800 soldiers. 40,000 horses were then driven across the tomb and finally the soldiers themselves were killed by another battalion. "The idea of turning Chingis Khan's grave into a tourist attraction appeals to no one. In any case, we don't have the technology to do it. If and when the tomb is found it must be cared for responsibly. We are not ready for this. Some day we will find the tomb on Mongolian territory, and it will be treated with respect," Ochir said.

Chingis was called "Chingis Kha Khan" by his people, meaning "Emperor of All Men." His real name was Temujin, "the finest steel." After melding together the feuding Mongol tribes into an army, he turned this army against the Tartars to the east and conquered them. With the Tartars added to his army, he turned against the collapsing Chin Dynasty, and took Beijing in 1214. Soon, nearly all of China was under his control— except for a small portion in the south—and he turned his armies to the west, to march against peoples who had never even heard about the Mongols.

He swept over Turkestan, Persia, the Middle East, and Eastern Europe. The entire population of Herat, in Afghanistan, over one million people, were slaughtered at his command. When a Chinese historian visited Balk, where Zoroaster had preached his cosmic battle between good and evil, it was immediately after Chingis Khan had leveled the city, and the scribe was astonished to find even one living thing in the smoldering ruins: a cat!

Good ol' Chingis is credited with saying, when asked what would best bring great happiness, "To crush your enemies, to see them fall at your feet, to take their horses and goods, to hear the crying and see the tears of their women: that is best."

The Mongols, after Chingis' death, continued their bloody campaigns, and the one good thing they did do was to destroy the power of the Order of Assassins in Persia. The Mongols ruled over all of Persia, most of Russia, and many countries in Eastern Europe. The Kublai Khan, for whom Marco Polo was court minister, succeeded the other Mongol rulers, but was in turn overthrown by the Chinese, finishing off the Yuan, or Mongol, Dynasty. The Chinese then marched on Karakorum, the capital of the Mongols (which they in turn had taken over from the Uigers), and razed it to the ground.

All that is left now of Karakorum are the ruins of the temple, surrounded by stone tortoises, staring blindly out over the empty grassland. Also left from the exploits of Chingis Khan and his successors is the Chingis Khan Wall (similar to the Great Wall of China, which was originally meant to keep guys like Chingis out) which stretched for several hundred miles across northeast Mongolia.

Mongolia feuded and raided with other nations continuously for three hundred years. One Mongol chieftain almost took Beijing again, but was turned back by the Ming. The Manchus, ancient enemies of the Mongolians, toppled the Ming dynasty, and established the Qing Dynasty in 1644. They eventually invaded Mongolia, bringing it under the control of China. The cruel reign of the Manchus lasted until 1911.

Magicians of the Black Gobi

The Mongol Revolution of 1911 sought to recreate the independent Mongol country. Sun Yat Sen was busy overthrowing the Manchus in China, so it was an excellent time for the Mongolians to have their own revolution. The new capital was Urga, now Ulan Bator, and was just near the ancient, destroyed capital of Karakorum.

The chosen ruler of the new independent monarchy was the

Khutuku or Kut-humi, eighth "Living Buddha" of the Mongols; the Bodgo Gegen. It is interesting to note here that the term Kut-humi is a title, not a person's name, meaning something like "great king." Specifically, it relates to the ruler of Mongolia. It makes one wonder about metaphysical groups, channellers and churches in the West that claim to receive information from "an ascended Master" named Kut-humi. Are they channeling the living Buddha from Ulan Bator? Probably not. This is a vague *nom de plume* at best. Probably one to be used by someone wanting to conceal their true identity.

The Bodgo Gegen, known as the "Master of the World" by his people, was the spiritual ruler of a hundred thousand lamas and a million subjects. He is a living Buddha in the same way as the Dalai Lama of Tibet is a successive incarnation of the same person, according to his followers. Supernatural powers are ascribed to the Bodgo Gegen; he is said to possess a "magic" ring—basically a large ruby set in a ring—which is said to have been worn constantly by Chingis Khan and his successor, Kublai Khan, on the right index finger.[20]

One story about the 1911 revolution illustrates well, I feel, the passions and emotional background of the Mongolians. The story is as follows.

The Tushe Gun (Avenging) Lama, born Dambin Jansang in the Altai mountains of western Mongolia in the 1870s, was said to possess a hypnotic power and gigantic force of will. His early years were spent studying occult sciences in Tibetan lamaseries, as well as studying with fakirs in India and with Chinese mystics in Beijing. As he traveled around Mongolia, the conviction spread that he was the reincarnation of Amursana, hero of the western Mongols who fought against the Manchus in the mid-1700s.

Worshipped as a divine warrior, in a time when Mongolia was looking for heroes, Dambin became the leader of the 1911 revolution against the Chinese. His horde captured and sacked the Chinese garrison at the western Mongolian city of Kobdo. The story says that Dambin was unharmed, but his clothes were in shreds from bullet holes. The new ruler of the newly-independent Mongolia, the Bodgo Gegen himself, appointed Dambin governor of the west, with his provincial capital in Kobdo.

Meanwhile the Russians and Chinese were plotting to put an end to free Mongolia, and in 1914 when some Czarist Russian Cossacks attacked Kobdo by surprise, they found Dambin sitting on a throne covered with the human hides of Chinese that he had flayed alive. He was then imprisoned in Russia until the civil war broke out there,

when he escaped and returned to Mongolia to raise ten thousand men to help the "Mad Baron." (This was Baron Ungern Von Sternberg, the leader of the White Russian army that was taking refuge in Mongolia and helping the Mongols fight the Chinese general "Little Hsu.")

Dambin was once again the "Mongol Messiah." He helped the Mad Baron defeat the Chinese, and then fought against the invading Red Russian Army. The Red Russians, however, won, and Dambin escaped to the dreaded "Black Gobi," a barren area of southwestern Mongolia, where he built a fortress in an oasis called Bayang Bulak. He commanded his own personal army, and was quite a threat to the new Communist power in Urga.

Late in 1922, a force of six hundred Russians and Mongols set out for the Black Gobi with orders to assassinate Dambin at all costs. The leader of the attackers, Baldan Dorje, had his men stop some miles outside the oasis, and then he and another went in alone, disguised as high lamas.

Baldan Dorje told Dambin that he was there on a mission from the Bodgo Gegen in Urga, who requested Dambin's aid in a revolt against the Russians. For several days they discussed how to free Mongolia. Then Baldan Dorje pretended to fall sick. He lay in bed for two days and said he was dying. He wanted a blessing from the Tushe Gun Lama (Dambin) before he died. As Dambin leaned over the man to give him his blessing, Baldan drew a revolver from beneath his lama's robe, put it to Dambin's chest and fired!

Grabbing a knife nearby, he cut off Dambin's head and before the guards could reach the door, flung it out into the courtyard! Baldan then ripped out Dambin's heart, and stepped outside to face Dambin's warriors with the heart high in the air. Then, as the terrified, panic-stricken warriors watched, Baldan Dorje swallowed the bloody heart of Dambin Jansang, the Avenging Lama!

All the men were convinced that by swallowing the heart of Dambin, Baldan was now invincible, as had been their leader, and fled into the desert. Baldan escaped with his life and took Dambin's head back to Urga where it was placed on a lance and paraded all around Mongolia to show the people that the revolution was dead. People rarely go back to the oasis of Bayan Bulak, as it is thought to be haunted by the ghost of Dambin. Those that have gone say that they have seen Dambin, with his head and mounted on his horse, followed by the fierce watchdogs that used to guard his tent. Many Mongolians sincerely believe that one day Dambin Jansang, the Tushe

Gun Lama, will ride out of the Black Gobi once again and old Mongolia will live once more.

As for the Bodgo Gegen, he died in 1924, and immediately afterward, the People's Republic of Mongolia was declared—the second communist government in the world, and the first Soviet satellite. But Bodgo Gegens don't die easily. Like the Dalai Lama of Tibet, he was reborn, and lives to this day in Mongolia. It is this new Bodgo Gegen that helped Molotov escape from Khrushchev. He still wears the ring of Chingis Khan, and now wanders the steppes, followed by an impressive court of lamas and shamans, with enormous trunks guarded by the Shabinari monks in his service. In them are the sacred books: the 226 volumes of the Panjur and the 108 volumes of the Ganjur, plus other ancient religious objects.[13]

This last part is mere hearsay and legend, but what legend is not based somewhat on fact? The Bodgo Gegen seems to be somewhat concerned with the two mysterious occult groups, the Agarthi and Shamballists. In 1947, a man showed up in Paris, claiming to be the Maha Chohan, "Master of the World," and ruler of Agartha. He called himself Kut-humi and he claimed he wore the ring of Chingis Khan— all these are titles and artifacts of the Bodgo Gegen.

§§§

The Living Gods of the Gobi Desert

One of the first books to discuss the bizarre, legendary underground world of Central Asia was *Beasts, Men and Gods*[18] by the Polish scientist Ferdinand Ossendowski (1876-1945). Ossendowski had lived most of his life in Russia and had attended the University of St. Petersburg. In the 1890s he travelled east through Siberia into Mongolia and western China for several years, and was in awe of the rugged wilderness and mystic Buddhism of these areas.

He returned to Europe at the turn of the century and earned a doctorate in Paris in 1903. He led a tumultuous life as an anticommunist at the time when Bolsheviks took control of more and more of Russia. Ossendowski and a small group of White Russians fled Russia and he and his companions voyaged across Siberia and into Mongolia; their adventures along the way became the bulk of his best-selling book.

Ossendowski and his group then crossed into China from whence he made his way back to Europe. There he wrote his book in 1921, and it was wildly successful, with the New York publisher E.P. Dutton

& Company reprinting it 21 times between August 1922 and June 1923. It was what might be considered an "early New Age best seller."

In the last section of the book Ossendowski writes about the "Mystery of Mysteries—The King of the World," and "The Subterranean Kingdom." Says Ossendowski, "On my journey into Central Asia I came to know for the first time about 'the Mystery of Mysteries,' which I can call by no other name. At the outset I did not pay much attention to it and did not attach to it such importance as I afterwards realized belonged to it, when I had analyzed and connoted many sporadic, hazy and often controversial bits of evidence.

"The old people on the shore of the River Amyl related to me an ancient legend to the effect that a certain Mongolian tribe in their escape from the demands of Jenghiz Khan hid themselves in a subterranean country. Afterwards a Soyot from near the Lake of Nogan Kul showed me the smoking gate that serves as the entrance to the 'Kingdom of Agharti.' Through this gate a hunter formerly entered into the Kingdom and, after his return, began to relate what he had seen there. The Lamas cut out his tongue in order to prevent him from telling about the Mystery of Mysteries. ...

"I received more realistic information about this from Hutuktu Jelyb Djamsrap in Narabanchi Kure. He told me the story of the semi-realistic arrival of the powerful King of the World from the subterranean kingdom, of his appearance, of his miracles and of his prophecies; and only then did I begin to understand that in that legend, hypnosis or mass vision, whichever it may be, is hidden not only mystery but a realistic and powerful force capable of influencing the course of the political life of Asia. From that moment I began making some investigations."[18]

One of Ossendowski's informants told him, "More than sixty thousand years ago a Holyman disappeared with a whole tribe of people under the ground and never appeared again on the surface of the earth. ... All the people there are protected against Evil and crimes do not exist within its bournes. Science has there developed calmly and nothing is threatened with destruction. The subterranean people have reached the highest knowledge. Now it is a large kingdom, millions of men with the King of the World as their ruler. He knows all the forces of the world and reads all the souls of humankind and the great book of their destiny. Invisibly he rules eight hundred million men on the surface of the earth and they will accomplish his every order."

One of Ossendowski's informants, Prince Chultun Beyli added,

"This kingdom is Agharti. It extends throughout all the subterranean passages of the whole world. I heard a learned Lama of China relating to Bodgo Khan that all the subterranean caves of America are inhabited by the ancient people who have disappeared underground. Traces of them are still found on the surface of the land. These subterranean peoples and spaces are governed by rulers owing allegiance to the King of the World. In it there is much of the wonderful. You know that in the two greatest oceans of the east and the west there were formerly two continents. They disappeared under the water but their people went into the subterranean kingdom. In underground caves there exists a peculiar light which which affords growth to the grains and vegetables and long life without disease to the people. There are many different peoples and many different tribes."

Agharta would appear a rather fanciful lost city, though many persons attest that it really exists. In the last hundred years, a number of travelers and mystics have claimed to have visited Agharta, or at least to have had some contact with its citizens.

The whole idea of hidden Masters in secret underground abodes had been introduced in the West back in the 1800s with Madame Blavatsky's *The Secret Doctrine* (published in London in 1888) and the French writer Louis Jacolliot's books *Le Spiritualisme dans le Monde*[38] (published in Paris in 1875) and *Occult Science in India* (published by Rider, London, in 1884).

Louis Jacolliot (1837-1890), told the earliest tales in the West of secret libraries, underground cities and ancient technology. Said Jacolliot in 1875 about the legendary subterranean world, "This unknown world, of which no human power, even now when the land above has been crushed under the Mongolian and European invasions, could force a disclosure, is known as the temple of Asgartha[sic]… Those who dwell there are possessed of great powers and have knowledge of all the world's affairs."

Is it possible that some will be saved from the coming Armageddon by retreating into the subterranean depths already used by people escaping the Mongol horde? As we left Mongolia, flying back to Beijing and then to San Francisco, it seemed that we would have to return to Mongolia, to find Henning Haslund's mysterious mountain and the land of Hsi Wang Mu. Maybe after Armageddon the secret Masters, the Phantom Power, would step out of their mountain fortresses and reveal themselves to mankind. That time, it seemed, was getting closer and closer.

Bibliography

1. *The Shambhala Dictionary of Taoism,* Ingrid Fischer-Schreiber, 1996, Shambhala Publications, Boston.
2. *Men and Gods in Mongolia,* Henning Haslund, 1939, Kegan Paul, London. Reprinted by Adventures Unlimited Press, Kempton, IL.
3. *Shambala: Oasis of Light,* Andrew Tomas, 1977, Sphere Books, London..
4. *In Secret Mongolia (Tents In Mongolia),* Henning Haslund, 1938, Kegan Paul, London, Reprinted by Adventures Unlimited Press
5. *The Mysterious Unknown,* Robert Charroux, 1972, Neville Spearman, London.
6. *Unknown Mongolia* (Two Volumes), Douglas Carruthers, 1913, Hutchinson & Co., London.
7. *Legacy of the Gods,* Robert Charroux, 1965, Robert Laffont Inc., New York.
8. *Atlantis: Lost Lands, Ancient Wisdom,* Geoffrey Ashe, 1992, Thames & Hudson, London.
9. *Lost Cities of China, Central Asia & India,* David Hatcher Childress, 1985, Adventures Unlimited Press, Kempton, Illinois.
10. *The Mahabharata,* translated by Protap Chandra Roy, 1889, Calcutta.
11. *Forgotten Worlds,* Robert Charroux, 1971, Popular Library, New York.
12. *Masters of the World,* Robert Charroux, 1967, Berkeley Books, New York.
13. *Still Living?,* Myra Shackley, 1983, Thames & Hudson, London.
14. *The Gods Unknown,* Robert Charroux, 1969, Berkeley Books, New York.
15. *Himalayas: Abode of Light,* Nicholas Roerich, 1930, Roerich Museum, New York.
16. *Shambhala,* Victoria LePage, 1996, Quest Books, Wheaton, IL.
17. *One Hundred Thousand Years of Man's Unknown History,* Robert Charroux, 1965, Robert Laffont Inc., New York.
18. *Beasts, Men and Gods,* Ferdinand Ossendowski, 1922, E.P. Dutton & Co., New York.
19. *Shambala,* Nicholas Roerich, 1930, Roerich Museum, New York.
20. *Legacy of the Gods,* Robert Charroux, 1965, Robert Laffont Inc., New York.
21. *Henry A. Wallace: His Search for a New World Order,* Graham White & John Maze,, 1995, University of North Carolina Press, Chapel Hill.
22. *One Foot in Atlantis,* William Henry, 1998, Earthpulse Press, Anchorage.
23. *Atlantis: Lost Lands,* Ancient Wisdom, Geoffrey Ashe, 1992, Thames & Hudson, London.
24. *Altai-Himalaya: A Travel Diary,* Nicholas Roerich, 1929, Roerich Museum, New York.
25. *UFOs Over Modern China,* P. Dong & W. Stevens, 1983, UFO Photo Archives, Tucson, Arizona.
26. *Heart of Asia*, Nicholas Roerich, 1930, Roerich Museum, New York.
27. *On Eastern Crossroads,* J. Saint-Hilair (H. Roerich), 1930, Roerich Museum, New York.

28. *The Morning of the Magicians,* Louis Pauwels & Jacques Bergier, 1960, Stein & Day, New York.

29. *In Secret Tibet,* T. Illion, 1936, Rider & Co. London. Reprinted by Adventures Unlimited Press, 1991, Kempton, Illinois.

30. *Darkness Over Tibet,* T. Illion, 1937, Kegan Paul, London. Reprinted by Adventures Unlimited Press, 1991, Kempton, Illinois.

31. *Compassion Yoga, The Mystical Cult of Kuan Yin,* John Blofeld, 1977, Allen & Unwin Publishers, London

32. *Die Weisse Pyramide,* Hartwig Hausdorf, 1994, Langen Müller Verlag, Munich.

33. *The Stargate Conspiracy,* Lynn Picknett & Clive Prince, 1999, Little, Brown, & Co.,London.

34. *Myths and Legends of China,* E.T. Werner, 1922, Ryder, London.

35. *Ends of the Earth,* Roy Chapman Andrews, 1928, Curtis Publishing Co., New York.

36. *The Mongols,* David Morgan, 1986, Basil Blackwell, Ltd., Oxford.

37. *The Devil's Horsemen,* James Chambers, 1979, Atheneum, New York.

38. *Le Spiritualisme dans le Monde*, Louis Jacolliot, 1875, Paris.

39. *Histoire des Vierges*, Louis Jacolliot, 1879, Paris.

40. *King Solomon's Temple,* E. Rayond Capt, 1979, Artisan Publishers, Thousand Oaks, CA.

41. *Great Pyramid Decoded,* E. Rayond Capt, 1976, Artisan Publishers, Thousand Oaks, CA.

Reconstruction of the reliefs at Dongting-See in the Chinese Gobi by Chinese archeologists seem to show Immortals on their vimanas (airships).

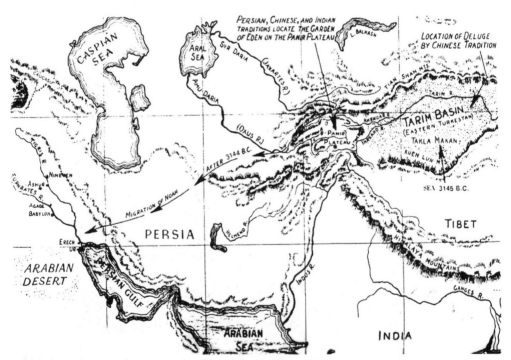

Four rivers out of Eden—E. Raymond Capts' map of the ancient Pamirs, the original Eden, showing the Takla Makan Desert as a sea, with the four rivers of *Genesis*.

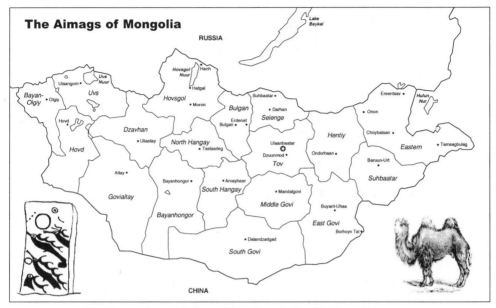

The departments (aimags) and capitals of Mongolia.

The Tombs of the Genii in Siberia, possibly the largest megaliths ever discovered. Now seemingly lost, these monstrous megaliths (note the horse) are located on the Kora River in what was Soviet Turkestan and were depicted in the 1876 book *The Early Dawn of Civilization* (Victoria Institute Journal of Transactions).

The Great Seal of the United States, found on the one dollar bill.

Henry Wallace, former Vice President of the United States under Franklin D. Roosevelt. Wallace was responsible for the Great Seal of the United States and the use of the Great Pyramid and Eye of Horus as a symbol, now commonly seen the one dollar bill.

Russian-American explorer, author and mystic Nicholas Roerich, seen here holding a box containing the sacred "Chintamani Stone."

A drawing of an Almas sleeping by the Soviet zoologist Khakhlov, c. 1900. From Myra Shackley's book, *Still Living*?

An Almas as depicted in the *Mongol Messenger,* October 4, 2000.

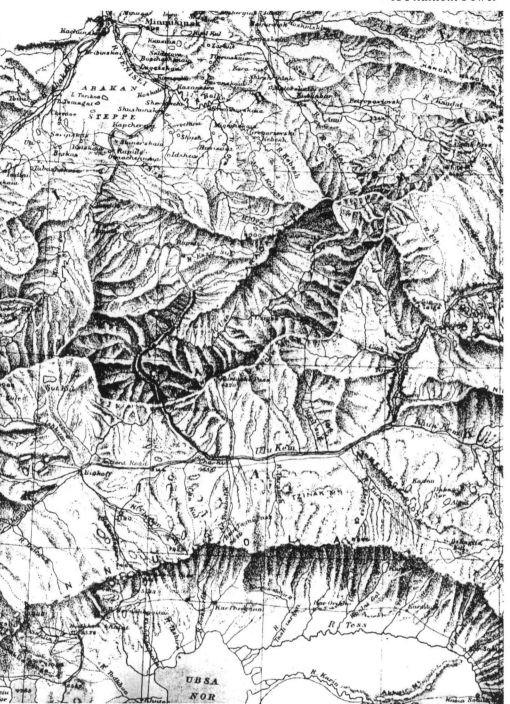

THE BASIN OF
THE UPPER YENISEI
and surrounding regions
By DOUGLAS CARRUTHERS

Nat. Scale 1 : 2,000,000 or 1 Inch = 31·56 Stat. Miles

An ancient road is mentioned in Carruther's 1913 book *Unknown Mongolia.*

251

Russian zoologist Dr. Z. Kofman taking a cast of an Almas footprint in 1981. From Myra Shackley's book, *Still Living*?

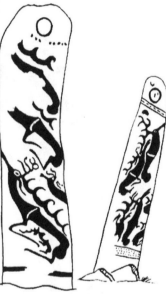

Right: Megalithic stones carved with stags in the Altai, probably from the Uiger period, or before. The stag carvings may have been added many years later.

Megaliths in the western Altai Mountains of Mongolia.

252

8.
From Scotland to Jerusalem— The New Templars

I know a person in Christ who 14 years ago was caught up to the third heaven—whither in the body or out of the body I not know; God knows —was caught up into Paradise and heard things that are not to be told, that no mortal is permitted to repeat.
—2 Corinthians 12:2-14

"Who controls the past controls the future.
Who controls the present controls the past."
—George Orwell (1903-1950)
author of *Animal Farm* and *1984*

The millennium was coming to a close, the year 2000 was ending and the year 2001 was dawning. The world economy had not collapsed, the Y2K bug had not brought the computer world to its knees, but had rather fueled a tech-driven economy that was now on the edge of a serious depression. Areas around the Pacific like California, Seattle, Japan, Taiwan, Korea and Hong Kong had supplied the world with the computers, software and Internet companies that, according to news reports, were keeping the entire world from falling into a depression. Now those tech-stocks were starting to slide, and investors were becoming worried.

Fortunes that had been made overnight were being lost. Formidable companies that had been the darlings of Wall Street were closing their doors and their "genius" directors were driving away in

their BMWs looking for a cabin in Montana or Idaho to hole up in while angry investors demanded to know what had become of their money.

Hey, it wasn't the end of the world or anything. Sure, a few people jumped out of windows, but most just shook their heads and were glad that they hadn't invested any more than they did.

Me? Like one of the Biblical prophet Enoch's "Watchers," I merely caught the news, sipped my coffee and planned my next trip. "Where should I go?," I mused, as I looked over the globe in my office. A trip to Europe and then to Egypt and the Middle East might be good. Though the fighting between the Palestinians and the Israelis had started to heat up in the fall of 2000, Armageddon was still over the horizon, so to speak.

I had begun to look into my own family history as well. Being of Scottish background on my father's side, I had always had a fascination for things Scottish, from the Loch Ness monster to the Stone of Destiny to the Knights Templar and their connection to the "New Scotland."

The Mysterious Origins of the Scots

My family history took me back to the area around Edinburgh, or "Eden Town." Scotland, I learned, was originally inhabited by the mysterious and defunct Picts, who left a number of stone steles and other menhirs to mark their passing. The Scots, according to mainstream historians, had originally arrived on the west coast of Scotland from Ireland. But where had the Scots come from before Ireland? Had they come from the eastern Mediterranean like legends say?

Lawrence Gardner in his book *Bloodline of the Holy Grail*[25] does a good job in tracing the descent of European royalty from the Merovinginans, who descended from the Fisher Kings, who were allegedly descended from a 1st century Phoenician-Hebrew settlement in southern France which is supposed to have included the children of Jesus and Mary Magdalene, who settled in southern France in 44 AD. Jesus himself was descended from the House of David, and was linked to the Egyptian royal family. He has been called "The last of the Pharaohs."[1, 2, 16, 25]

The theories postulating an ancient Egypto-Hebrew origin of the Scots are separate from the *Bloodline* descents, however. They allege that the Scots hail from a group who, led by the Hebrew-Egyptian princess Scota, migrated to Ireland before 500 BC and made their

capital at Tara (more on this below).

Curiously, the Scots may have originated in Scotland and gone to the Eastern Mediterranean as part of the "Sea Peoples"—which included other northern European maritime cultures such as the Dutch, Frisians and Danish. In fact, one of the twelve tribes of Israel was the Tribe of Dan. These people apparently settled in Denmark, or "Dan-Mark" as well as other areas of the North Sea.

The farthest north of these islands in the North Sea were known to the ancients as the Lands of Set, and are known today as the Shetlands or "Set-Lands," named after the Egyptian god Set, a fallen god who had cunningly murdered his brother Osiris.

Recently scientists have even suggested that the pyramids of Egypt may have been inspired by a group of builders on the Scottish island of Orkney. Academic Dr. Robert Lomas, of the University of Bradford, believes complex construction techniques were developed on Orkney more than 1,000 years before the Egyptians used similar ideas. He said skills used on the island from 3800 BC were extremely sophisticated. According to him, the Egyptians heard of the ideas and copied their techniques after they spread across Europe.

Said Dr. Lomas: "These people seem to have been led by a group of astronomer priests who passed on their knowledge to pilgrims all over Britain.

"Unfortunately, although they were intelligent, they had not developed any type of writing that we are able to read so their discoveries have been forgotten. We can see what they did but have to experiment to find out how they did it."

At Maes Howe on the Orkney islands, a chambered tomb constructed around 3000 BC, the builders devised a standard unit of length by taking detailed readings from the movement of sun and stars. Dr. Lomas believes this measurement—the megalithic yard—proves the islanders knew the earth was round. They also understood that it moved around the sun centuries before it was generally accepted by the rest of the world.

The measurement was used to build state-of-the-art monuments, Lomas said. In the book *Uriel's Machine: The Ancient Origins of Science*,[17] Dr. Lomas and co-author Christopher Knight argue that the megalithic yard—which measures 82.966 cm—could easily have been taken by seafarers to Brittany and beyond. The megalithic yard was first discovered in 1967 by Professor Alexander Thom, of Oxford University, who analyzed more than 400 sites around the British Isles and Northern France and found this common unit of measure.

The problem with all these theories on prehistory is which way these megalith builders were going. Were they going from northern Scotland and the "Set Lands" to Egypt, or were they going from Egypt up to northern Scotland—or both? I think the answer here is: both. Evidence suggests that man has been voyaging in boats for over 30,000 years! That there was once a connection between northern Scotland, the British Isles, and ancient Egypt is not so far-fetched at all. In fact, despite what your history teacher may have told you, oceans are highways, not barriers.

§§§

A Brief History of Ireland

A mythological history of Ireland relating to its Hebrew-Egyptian colonization has been preserved in an ancient manuscript called *The Book of Invasions*. It chronicles the various races that have invaded and settled in Ireland. The history begins just after the legendary Flood that drowned the world when the tribe of Partholon arrived in Erin, fleeing the flood.

Partholon and his tribe are said to have come from the west, across the Atlantic, to an Ireland that was quite different from today. They cleared away some of the forests and fought against a people called the Fomorians, who were invaders from continental Europe. Partholon and his group are eventually wiped out by a terrible plague.

A tribe called the Nemed, or Nemedians, then arrive in Ireland. *The Book of Invasions* says that they came from Greece, via Scythia and the Northern Sea. They followed what was the ancient amber trade route; amber came from Denmark, Germany and Scandinavia and was sold in the eastern Mediterranean.[4]

The Nemedians settled in Ireland, according to the book, and fought three battles against the Fomorians and successfully held them off until their leader, Nemed, died of the plague. The Fomorians returned and their chief, Conann, built a great tower on Tory Island, off the northwest coast of Donegal, where he ruled over Ireland.

In an ensuing battle protesting the oppressive rule of Conann, the Nemedians defeated the Fomorians and killed every one, including Conann himself. But no sooner had they defeated the Fomorians, than a further host of Fomorians came to reinforce Conann. The Nemedians then began to fight the new Fomorian fleet, when sud-

256

denly a giant tidal wave swept into the harbor and killed nearly everyone.

Ireland was virtually deserted for 200 years, says *The Book of Invasions,* until the Nemedians returned from Greece, calling themselves the Firbolgs or "Men of Bags." The Firbolgs were conquered by the legendary Tuatha de Danann, with their magical weapons, the magic cauldron and the Stone of Destiny.

Historian N.L. Thomas says this about the Tuatha de Danann in *Irish Symbols of 3500 B.C.*[5]: "The followers of the Bolg were some time later subjected to an invasion from the north by the Tuatha de Danann... The Tuatha were a people possesed of magic wonders, the supreme artists of wizardry, who came to Ireland, not by ship, but descended from the northern sky. They dwelt in a timeless land of everlasting festivities, a supernatural realm, the domain of the gods. Their mythological sites of the Otherworld, the 'Brú', were magic places not inhabited by humans. The Brú na Boinne (Newgrange by the river Boyne) was the most important of these places."

It is fascinating to think that the Tuatha de Danann arrived via airships—this may be merely a legend, or perhaps it actually chronicles the landing of ancient airships in Ireland. It is more probable to think that the Tuatha de Danann were descendants of the Hebrew seafaring Tribe of Dan, who travelled by boat and landed first in northern Ireland, which would be the explanation for their arriving from the north, rather than the south, which is the direction of Mediterranean.

The Hill of Tara and the Ark of the Covenant

A great deal of tradition and associated evidence shows that the Tuatha de Danann probably migrated from the eastern Mediterranean at the time of Nebuchadnezzar's attack on Jerusalem. According to this theory, the prophet Jeremiah, who had been imprisoned by his own people for his dire prophecies, was released by Nebuchadnezzar (whose takeover of Jerusalem was, ironically, the realization of the dire prophecies). Jeremiah was able to escape with many of the treasures of the Temple of Solomon, and also rescued the princess Tea (also called Scota). They, together with a small band of others, went to Egypt, and thereafter to a Phoenician port near present-day Barcelona and finally to Ireland.

The Tuatha de Danann were said to have come to Ireland via Spain, from Egypt and Israel with the many treasures, including the Stone of Destiny. The Irish version of this story can be found in the old Irish book, *Chronicles of Eri,* which says that at some time around 580 BC a ship landed at Ulster and on board were the prophet Ollamh Fodhla, the Princess Tara and a scribe named Simon Brech. These three were apparently the prophet Jeremiah, Princess Tea and Jeremiah's scribe Baruch.[21]

After her arrival in Ireland, it appears that Princess Tea, or Scota, married the local Irish King Eochaid the Heremon, forming the Kingdom of the Tuatha de Danann. It didn't last long, for although the Tuatha de Danann defeated the Firbolgs, Nuada, the first Tuatha de Danann king, lost a hand in the battle. Since kings had to be perfectly whole, in a magnificent gesture of reconciliation, he abdicated in favor of Bress, son of the Fomorian king.[21]

The site known as Tara was, two and a half thousand years ago, a huge palace with a great wooden tower and a Druidic college. James Bonwick, in his 1894 book *Irish Druids and Old Irish Religions*[4] says: "The palace of Teamair, or Tara, was held by the Tuatha. The chief college of the Druids was at Tara. At Tara was held the national convention of the Teamorian Fes. It was associated with the marriage sports of the Tailtean. The foundation is attributed to the wise Ollam Fodhla."[4]

The tenth-century Irish poet O'Hartigan spoke of Tara in the *Book of Ballymote*:

> *Fair was its many-sided tower,*
> *Where assembled heroes famed in story;*
> *Many were the tribes to which it was inheritance,*
> *Though decay lent a green grassy hand.*

In a chapter devoted to Tara in *Irish Druids and Old Irish Religions* Bonwick says, "*Heber* of *Heber of the Bards* is to them Hebrew. Tara is named for Terah (Torah). Jeremiah fled thither after the siege of Jerusalem, carrying away the treasures of the temple; as, the ark, the scepter of David, the Urim and Thummin, and others. Some persons at this day affect to believe that in the hill of Tara might yet be found these memorials of Judaism, and hope to recover thence David's harp,

carried to Ireland by Jeremiah and the Princess Scota, daughter of Pharaoh."[4]

Bonwick also mentions the Reverend F. R. A. Glover, M.A., who says the Stone of Destiny, or Liag Phail, was taken from its sanctuary in 588 BC and "brought thither by Hebrew men in a ship of Dan, circa 584."

Reverend Glover goes on to say that Jacob's pillar was taken to Tara. "In Ireland, in the royal precincts of Tara, circa B.C. 582-3, there was a Hebrew system and a transplanted Jerusalem ..." Bonwick comments, "Some pious friends of the Anglo-Israel movement have desired a digging search over Tara, now a wilderness region, to discover the missing treasures from Solomon's temple."[4]

So, it seems the sacred and magical items possessed by the Tuatha de Danann were probably various treasures of the great repository of the past, Solomon's Temple. Items of machinery and electrics were known to still exist in those days. Such a simple but effective device as a crossbow would seem like a "magic spear" to people who had never seen one, and similarly an electrical device, as the Ark of the Covenant was said to be, would seem magical to any primitive observer.

Another simple invention that was in existence at the time, and could be described as a "magic spear," would be small field rockets. The Chinese and Hindus used small rockets, similar to modern fireworks, in warfare. A barrage of exploding rockets into a fort or onto a battlefield could cause havoc and even death.

The Tuatha de Danann, followers of the Princess Scota, may be the tribe that arrived in Scotland from Ireland. Their "magical" artifacts, including the Stone of Destiny, were moved to Scotland, according to tradition, by the Scottish-Irish king Fergus the Great. Today, the Stone of Destiny is in Westminster Abbey, England.[28]

§§§

The Knight's Templar & the Ark of the Covenant

The search for the Knights Templar is as fascinating a story as history provides us. The Knights Templar have been associated with all sorts of amazing activities including having the Ark of the Covenant, the Holy Grail, a secret fleet that sailed the oceans, and an

awe-inspiring self-confidence and courage that made their enemies fear them.

Despite their fearsome, battle-hardened reputation, the Knights Templar were learned men, dedicated to protecting travellers and pilgrims of all religions, not just Christians. They were great states-men, politically adept economic traders, and they were apparently allied with the great sailor-fraternity that had created a world-wide trading empire in Phoenician times.

Despite a great deal of negative publicity against the Templars at the time of their suppression, they are still known today as the pre-servers of knowledge and sacred objects. While the origins of the Knights Templar are said to go back to the building of King Solomon's Temple by Phoenician masons from Tyre, or even the Great Pyra-mid and Atlantis, we trace their modern history to the period of the Crusades in the Middle Ages.

In his book *The Mysteries of Chartres Cathedral*[8] the French architect Louis Charpentier claims that the Knights Templar built Chartres as a repository for ancient wisdom, a repository that is equal to Stonehenge, the Temple of Solomon or the Great Pyramid of Egypt. He further claims that special knowledge about the Temple in Jerusa-lem was gained by the founding group of nine knights during their residence at Solomon's Temple starting in 1118 AD. In that year it is historically recorded that nine "French" knights presented themselves to King Baldwin II of Jerusalem, a Christian king, and explained that they planned to form themselves into a company with a plan for protecting pilgrims from robbers and murderers along the public highways leading into Jerusalem. King Baldwin II had been a pris-oner of the Saracens and knew of their disunity. Factions such as the Assassins were also active in Moslem politics.

The knights asked to be housed within a certain wing of the pal-ace, a wing which happened to be adjacent to the Dome of the Rock mosque which had been built on the site of Solomon's Temple. The king granted their request and the order of the Poor Fellow-Soldiers of Christ and the Temple of Solomon (or Knights Templar) was born. Ten years later the knights presented themselves to the Pope, who gave his official approval to the Knights Templar.

Although there had been only nine mysterious knights, a tenth joined them, who was the Count of Champagne, an important French

noble. In fact, none of the "poor" knights was apparently poor, nor were they all French. Several came from important French and Flemish families. Of the ten original knights, four have not been fully identified, although their names are known.

The ranks of the Knights Templar grew rapidly. When a nobleman joined their ranks, he surrendered his castle and property to the Knights, who would use revenues generated from the property to purchase weapons, war-horses, armor and other military supplies. Other noblemen and Kings who were not members often gave them gifts of money and land. King Steven of England contributed his valuable English manor of Cressing in Essex. He also made arrangements for high-ranking members of the Knights to visit nobles of England and Scotland. By 1133, King Alfonso of Aragon and Navarre (northern Spain) who had fought the invading Moors in 29 battles, willed his kingdom to the Templars. However, the Templars were prevented from claiming the kingdom because of the Moorish victory over Spain.

Pope Eugenius decreed that the Knights Templar and only the Knights Templar would wear a special red cross with blunt, wedge-shaped arms (called the cross patee) on the left breasts of their white robes, so that they could be quickly recognized at any time by Christians and by other Templars on the field of battle. The white robes with red crosses became their required dress. The warrior-knights fought bravely in the Middle East, and were highly respected by their Moslem counterparts for their strategy and bravery. Many Templars were, in fact, of Palestinian birth, spoke perfect Arabic, and were familiar with every religious sect, cult and magical doctrine. For instance, the Grand Master Philip of Nablus (1167 AD) was a Syrian.[7]

So the Templars proved a very successful group, distinguishing themselves on the battlefield and amassing great fortune. But what were they really all about? Charpentier likens the mission of the original band of Knights Templar to a commando raid on the ancient Temple of Solomon with the purpose of uncovering its engineering secrets, and possibly recovering lost treasure such as the Ark of the Covenant, which may have been hidden deep in a strange cavern system beneath the temple.

With the help of the brilliant French abbot Bernard de Clairvaux, the knights, directed by the Count of Champagne, had become well

established. With money that they accumulated, they built the fabulous and mysterious cathedral at Chartres. Later, other cathedrals were built around Europe and the legends of the "Master Stonemasons" became common.[8]

Incorporated into Chartres cathedral are beautiful stained-glass windows, many of the colors difficult or impossible to duplicate today. Hidden within the cathedral are various ancient "cubits" of measure, plus such esoteric devices as the famous Chartres Maze and other visual tools such as sacred geometry, for personal transformation—a sort of personal alchemy of the soul. Included in the imagery was the quest for the Holy Grail. Were the Templars themselves on such a quest? It seems somewhat unlikely that the Knights of the Temple of Solomon were formed to protect pilgrims on the path to Jerusalem, because such an order of Knights already existed. They were the Knights Hospitalers of St. John, later to become the Knights of Malta.

§§§

The Knights Hospitalers of St. John

The Knights Hospitalers of Saint John of Jerusalem (generally known as the Knights of St. John), were founded at Amalfi, Italy, in the 11th century. They went to Jerusalem to protect and minister to the Christian pilgrims, but soon extended their mission to tending to the sick and poor all over the Holy Land.

As the years went by the Knights of St. John became increasingly militant and, generally speaking, fought alongside the more mystical Knights Templar and the Germanic order of the Teutonic Knights of St. Mary.

With the fall of Jerusalem in 1187, the Knights of St. John retreated Acre. After the fall of Acre, the Knights moved in 1309 first to Cyprus and then to Rhodes. As the main base for the crusaders in their struggle against the Ottoman Empire, Rhodes was a fortress, a prison, and a supply base for the ships and armies on their way to Palestine and Asia Minor.

In 1481 when the Ottoman Sultan Mehmet Fatih failed to clarify the succession question of the newly powerful Ottoman Empire, a battle between his two heirs at Bursa resulted and Çem was defeated

by his brother Beyazit. Çem fled to Egypt but was denied asylum by the Mamelukes who controlled that country for the Ottomans.

Çem took the irreversible step of fleeing to Rhodes where he availed himself to the archenemies of the Ottomans, the Knights of St. John. With his brother now in the hands of the crusader army, Beyazit knew he was in trouble and the Ottoman Empire had to respond quickly.

Beyazit shrewdly contacted the Knights of St. John and negotiated a contract to pay 45,000 ducats of gold annually—a huge sum at the time—in return for the imprisonment of his brother on Rhodes and later in the English Tower at the castle in Bodrum, on the Turkish mainland.

The Knights eventually handed their valuable prisoner over to the Vatican, where Çem was made an interesting offer: to lead a crusader army to recapture Istanbul (Constantinople).

To stop this final threat from his wayward brother Beyazit spared no expense, paying to the Vatican 120,000 gold ducats and a number of sacred relics from Jerusalem including the famous "Spear of Destiny." The Spear of Destiny was reportedly the spearhead of the Roman centurion Longinus that was used to pierce the side of Jesus while He was on the cross. Another artifact offered was the "sponge of the last refreshment." This was the sponge used to wet Jesus' lips.

Legend has it that the possessor of the Spear of Destiny has the power to rule the world. Adolf Hitler believed in this and removed the spear from the Vienna museum when the Nazis took over Austria.

With this hefty payment, the Pope abandoned Çem and the plans for him to lead an army against Istanbul. Çem died alone at the Terracina prison in 1495. Rumor had it that he was eventually poisoned. Today Çem is but a footnote in history, a victim of the diplomatic maneuvers that brought the Spear of Destiny to the West.

The Knights stayed on Rhodes for 213 years, transforming the city into a mighty fortress with 12-meter thick walls. They withstood two Muslim offenses in 1444 and 1480, but in 1522 the sultan Suleiman the Magnificent staged a massive attack with 200,000 troops.

A mere 600 Knights with 1,000 mercenaries and 6,000 Rhodians eventually surrendered after a long siege, being guaranteed safe passage out of the citadel. For a brief period the Knights of St. John were

without a major base until 1529 when Charles V, grandson of Ferdinand and Isabella of Spain, offered Malta to the them as their permanent base. In that year the soon-to-be-called Knights of Malta began to build fortifications around the Grand Harbor of Valetta, Malta's largest port. In 1565 the Ottoman fleet arrived at Malta and immediately attacked the fortifications.

With 181 ships carrying a complement of over 30,000 men, the fleet bombarded the fortress with over 7,000 rounds of ammunition every day for over a month, and finally took St. Elmo. But the Turkish marines had suffered many casualties and could not take the other heavily-defended forts that were around the bay and the interior of the island. News of reinforcements coming from Sicily caused the Turks to retreat from the island and the Great Siege was over.

The Knights of St. John changed their name to the Knights of Malta and were said to be fanatically loyal to the Vatican, and the Pope apparently used them as his personal crusaders and soldiers. Other orders such as the Knights Templar and the Teutonic Knights were far more independent. The Knights of Malta are sometimes even said to be a secret society for the Vatican.

It was Napoleon who finally ended the rule of the Knights of St. John over Malta. The French knights had sent money to Louis XVI and when the French King was executed, the Knights of St. John on Malta were denied any French revenues by Napoleon.

The Knights of Malta then turned to the Russian Tsar Paul I who offered to found an Orthodox League of the Knights of St. James. This deal with the Russian Tsar particularly enraged Napoleon.

Napoleon sailed to Malta and made anchor just outside the Grand Harbor in June of 1798. When he was refused entry by the knights, he began to bombard the fortress. After two days of shelling, the French landed and gave the knights four days to leave, thus ending their 268-year presence on the island.

The Pope restored the office of the Grand Master in 1879 and the Knights of Malta, although they never returned to Malta. Instead they have offices in Rome and various other cities in Europe (Prague and Vienna, for example). Even though they have no actual territory, they are still recognized as a separate state by 40 or more countries around the world, similar to the recognition of the Vatican.

§§§

The Persecution of the Knights Templar

It is important not to confuse the Knights Templar with the Knights of Malta, as many readers, and some historians, do. The Knights Templar are quite different from the other crusaders, and were sometimes even said to fight in combat against the others, even in the "Holy Land."

Charles Addison, a London lawyer, who wrote about the Templars in his 1842 book *The History of the Knights Templars*[6] mentions in the first few pages how it was commonly believed that Templars were at odds with the Vatican and their military arm, the Knights of St. John. Addisson denies the allegations, but demonstrates that such rumors did exist.

It is not so far-fetched to believe that the Knights Templar secretly opposed the Church since their inception. As we queried earlier, what was their actual mission? If they truly wanted to protect the pilgrims in the Holy land, why didn't they simply join the order of St. John, which was already in existence?

As mentioned above, some people believe that the Knights Templar were the Middle Ages version of a society that had its inception far earlier. It was the purpose of this society to secrete and preserve truly valuable items, documents and knowledge from the swing and sway of changing temporal powers. If this were the case, it would be logical to assume that the knights were following their own agenda—one that would vary greatly from that of the Roman Catholic Church in that era, which would seem to have been to establish hegemony, collect as much money as possible and put fear into people's hearts.

Whatever one believes about the true mission of the Knights Templar, the historical fact of their persecution remains the same, and can be explained as stemming from simple greed.

During the 180 years of Crusades, the Templar wealth grew into a huge fortune. They owned over nine thousand manors and castles across Europe, all of which were tax free. Each property was farmed and produced revenues that were used to support the largest banking system in Europe. The Templar wealth and power caused suspicion and jealously among some members of the European nobility.

Slanderous rumors were spread of secret rituals and devil worship.

After the defeat of the crusaders in the Eastern Mediterranean, the Templars moved from Jerusalem to the Pyranees with their headquarters in Paris. Their main naval base was La Rochelle, a French port near the Pyranees. The Knights Templars operated in many European countries and Mediterranean islands with strong links to Portugal, France, Holland, England and Scotland.

Meanwhile, King Philip IV of France was growing envious of the Templar popularity and wealth, and was responsible for many of the slanderous rumors. Philip IV had once taken refuge from an angry mob in Paris at the Templar Headquarters there. The Templars gave Philip IV refuge from the mob, but it is said that the King saw the magnificence of the Templar treasure and wanted it for himself. His nation was bankrupt, he was a weak king who was unpopular with the people, and he knew that the Templars were more powerful and wealthy than he was.

King Philip IV went to Rome in 1307 to convince Pope Clement V that the Knights Templar were not holy defenders of the Catholic faith, but were seeking to destroy it. Templars throughout Europe began to be arrested and tortured to extract confessions of heresy. The Pope finally issued a papal bull suppressing the Order in 1312. By now, when the King's men went to the Templar castles they found many of them abandoned. Those who were arrested were tried and found guilty of sins against God. Jacques de Molay, the last Grand Master of the Knights Templar, was burned at the stake in Paris in 1314 after rescinding his "confession."

A contemporary English poem asked the question that many ask today:

> Where did all the Templars and their great wealth go?
> The brethren, the Masters of the Temple,
> Who were well-stocked and ample
> With gold and silver and riches,
> Where are they?
> How have they done?
> They had such power once that none
> Dared take from them, none was so bold;
> Forever they bought and never sold ...

This question has plagued historians and treasure hunters for centuries. For hundreds of years there have been rumors that the Knights Templar were not only the defenders of the true faith, but were also the guardians of the Holy Grail. The Holy Grail is said to be the most holy of religious artifacts. Different versions of the legend exist, with the two most prominent stating that the Holy Grail is the chalice used by Christ at the Last Supper or, alternatively, the genetic blood-lineage of Jesus. The chalice version of the Holy Grail says that Saint Joseph of Arimathea brought the cup, which had been used to collect the blood that flowed from Christ's wounds, to England. A Welsh version of the Grail story says he left the holy relic at Glastonbury, from whence it reached King Arthur and the Knights of the Round Table.

The mysterious Knights Templar had an extensive sea network and may even have inherited some of the maps and other secrets of the Phoenicians. When the Templars were outlawed and arrested beginning in 1307, the huge Templar fleet at La Rochelle, France, vanished and many Knights Templar sought refuge in lands outside of France. Portugal was one of the few places where they could find some asylum. Portugal was a country which, unlike Spain, was largely sympathetic to the Knights Templar.

North of Lisbon, near the town of Abrantes, is an interesting tourist attraction called Almourol castle. Almourol is a fortress with a tower and walls located on a small rocky island covered in greenery in the center of the river Tagus. It was constructed by Gualdim Pais, Master of the Order of the Knights Templar, in 1171. The castle is built on the site of an earlier Roman fortress. The Roman fortress in turn may well be built on the foundations of an earlier structure. It is likely that the Templar fleet made a stop at Almourol castle before continuing to their final destination.

As far as Portugal is concerned, it should be noted that many Portuguese explorers and royalty were Knights Templar and later Masons. It is said that Portuguese Knights Templar were instrumental in Portugal gaining its transatlantic colony, Brazil.

Curiously, Brazil has many Masonic Lodges and was originally set up as an independent state by a wealthy group of Masons who desired to be independent of Portugal in much the same way that

Masons and Rosicrucians were instrumental in the creation of the United States. Brazil, like the United States, seemingly has deep connections to the Knights Templar. Perhaps this is why Brazil is one of the most stable South American country as well as the most dynamic, economically and culturally. Such a racially and culturally mixed nation was apparently the sort of nation that the Knights Templar, and later Masons, were trying to create.

While Portugal was an important haven for the Knights Templar, their main base of operations, until they were outlawed, was southern France and Catalunya, the area of the Cathars and the Merovingian Kings. Barcelona, the capitol of Catalunya, was originally a Phoenician port and this area along the border of Spain and France has long thought of itself as a state, people and culture separate from the rest of Spain. The populace speaks its own language, Catalunian, a language that may have originated with ancient Phoenician.

Outside of Barcelona is the mountain named Montserrat, a site of religious pilgrimage for a long time, probably going back even before the Christian era. It rises 4,054 feet above the coastal plain, and eventually became the site of a celebrated Benedictine monastery. It was at Montserrat that Saint Ignatius of Loyola vowed to dedicate himself to a religious life.

According to the *Grolier Multimedia Encyclopedia* (1997), Montserrat was thought in the Middle Ages to have been the site of the the Holy Grail. Says the encyclopedia, "the monastery contains the Shrine of Our Lady of Montserrat (La Moreneta), a wooden statue said to have been carved by Saint Luke. During the Middle Ages, the monastery was the legendary home of the Holy Grail."[29]

Indeed, there is a certain mystery surrounding Montserrat. The monastery makes an almond liqueur called Aromes del Montserrat which uses for its logo a steep mountain peak with a box and cross at the summit.

When visiting the monastery with a group of tourists, I wondered if the box on top of the mountain was the legendary Ark of the Covenant, a wooden and metal box which held the sacred relics of the Temple in Jerusalem. Was the Ark of the Covenant and, later, the Holy Grail, taken to a secret cavern complex in the mountains of Montserrat? Legend says that a secret Brotherhood of Essenes moved

to Catalunya and Montserrat in the early centuries before Christ. This secret brotherhood built a network of subterranean caverns, castles and monasteries in the Pyrenees Mountains along the border of southern France and Spain. Did the Templars move to this area in order to safeguard these relics?

§§§

The Final Stand of the Knights Templar

The lost Templar fleet is discussed in Michael Baigent and Richard Leigh's book *The Temple and the Lodge*.[3] They point out that the Templars had a huge fleet at their disposal, a fleet that was stationed out of ports in Mediterranean France and Italy as well as ports in northern France, Flanders and Portugal.

"On the whole, the Templar fleet was geared towards operation in the Mediterranean—keeping the Holy Land supplied with men and equipment, and importing commodities from the Middle East into Europe. At the same time, however, the fleet did operate in the Atlantic. Extensive trade was conducted with the British Isles and, very probably, with the Baltic Hanseatic League. Thus Templar preceptories in Europe, especially in England and Ireland, were generally located on the coast or on navigable rivers. The primary Atlantic port for the Templars was La Rochelle, which had good communication with Mediterranean ports. Cloth, for example, could be brought from Britain on Templar ships to La Rochelle, transported overland to a Mediterranean port such as Collioure, then loaded aboard Templar ships again and carried to the Holy Land. By this means, it was possible to avoid the always risky passage through the Straits of Gibraltar, usually controlled by the Saracens."[3]

With the issuance of the papal bull in 1312, the Knights Templar became an outlawed organization. The question is, what happened to the Templar fleet after they were outlawed? Traditional history has no answer to this question.

Baigent and Leigh in *The Temple and the Lodge*[3] claim that the Templar fleet escaped en masse from the various ports in the Mediterranean and northern Europe and left for a mysterious destination where they could find political asylum and safety. This destination was Scotland.

The Mediterranean fleet had to sail through the dangerous Straits of Gibraltar and then probably stopped at various Portuguese ports that were sympathetic to the Templars such as Almourol castle, as mentioned above.

Baigent and Leigh go on to say that the Templar Fleet sailed up the west coast of Ireland to the safe ports in Donegal and Ulster, where Templar properties were located and arms smuggling to Argyll was common.

The Templar fleet then landed in Argyll by sailing to the south of the islands of Islay and Jura into the Sound of Jura where the Templars unloaded men and cargo at the Scottish Templar strongholds of Kilmory, Castle Sweet and Kilmartin.

Robert the Bruce controlled portions of Scotland, but not all of it. Significant portions of the northern and southern Highlands were controlled by clans that were allied with England. Robert the Bruce had been excommunicated by the Pope in 1306, one year before the persecution of the Templars began. Essentially, the papal decree that outlawed the Knights Templar was not applicable in Scotland, or at least in the parts that Robert the Bruce controlled.

The turning of the tide for Robert the Bruce, Scotland and (maybe) the Knights Templar was the famous Battle of Bannockburn. Although the actual site of the battle is not known, it is known to have taken place within two and a half miles of Stirling Castle, which is just south of Edinburgh.

On June 24 of 1314, Robert the Bruce of Scotland with 6,000 Scots miraculously defeated 20,000 English soldiers. But exactly what took place has never really been recorded. It is believed by some that he did it with the help of a special force of Knights Templar.

Say Baigent and Leigh in their book: "Most historians concur that the Scottish army was actually made up almost entirely of foot soldiers armed with pikes, spears and axes. They also concur that only mounted men in the Scottish ranks carried swords, and that Bruce had few such men …"[3]

Suddenly in the midst of combat, with the English forces engaged in a three-to-one battle against the Scottish soldiers, there was a charge from the rear of the Scottish camp.

A fresh force with banners flying rode forth to do battle with the English. The English ranks took one look at the new force and in

sheer terror of the new combatants, they literally fled the field. Say Baigent and Leigh, "... after a day of combat which had left both English and Scottish armies exhausted ... Panic swept the English ranks. King Edward, together with 500 of his knights, abruptly fled the field. Demoralized, the English foot-soldiers promptly followed suit, and the withdrawal deteriorated quickly into a full-scale rout, the entire English army abandoning their supplies, their baggage, their money, their gold and silver plate, their arms, armour and equipment. But while the chronicles speak of dreadful slaughter, the recorded English losses do not in fact appear to have been very great. Only one earl is reported killed, only 38 barons and knights. The English collapse appears to have been caused not by the ferocity of the Scottish assault, which they were managing to withstand, but simply by fear."[3, 13]

In fact, what appears to have happened was a charge in full regalia by the remaining forces of Knights Templar against the English host. These crusade veterans were like the Green Berets or Special Forces of the Middle Ages. All combatants suddenly stopped to witness the charging army of Knights Templar, white banners with red cross insignias flying high above these mounted Grail Knights. This sight evidently frightened the English forces so much that even though they still had a superior force, they fled, rather than fight.

The probable strategy behind the Templars' charge into battle would have been to ride through the thick of the battle and attempt to reach King Edward and his personal guards. Once engaged with the commanding officers of the English foe, these seasoned war veterans would have easily defeated King Edward's knights and possibly killed the king himself. As noted, King Edward and his special knights immediately fled upon witnessing the Templar charge.

And thus Scotland stayed an independent kingdom, free from the domination of Rome and the Pope. It was thus a safe haven for the missing Templar fleet and for the knights themselves.

§§§

Those who do not remember the past
are condemned to repeat it.
—George Santayana (1863-1952)

The Orkney Islands and the Holy Grail

One of the most interesting and mysterious of Scottish characters was Prince Henry Sinclair, the last king of the Orkney Islands. Sinclair, like many other nobles of the Middle Ages, held many titles and he was many things. He was king of the Orkney Islands, although they were officially an earldom granted to Prince Henry by the King of Norway. At the same time Prince Henry held other territories as a vassal of the Scottish king. Prince Henry Sinclair was also a Grand Master of the Knights Templar, a veteran of the crusades and, according to some sources, the possessor of the Holy Grail.

In the year 1391, Prince Henry Sinclair met with the famous explorer and mapmaker Nicolo Zeno at Fer Island, a lonely spot between the Orkneys and the Shetlands. Zeno and his brother were well known for their maps of Iceland and the Arctic. Prince Henry contracted with them to send an exploratory fleet to the New World.[12]

With the aid of funding from the Knights Templar, who had now been banished by the Pope, Prince Henry gathered a fleet of twelve ships for a voyage to establish a safe haven for the order of Knights and their treasure. The party was led by Prince Henry under the guidance of Antonio Zeno, Nicolo's brother from Venice.

The fleet left the Orkneys in 1398 and landed in Nova Scotia, wintered there and later explored the eastern seaboard of the United States. It is said that the effigy of one of Henry's close companions, Sir James Gunn, who died on the expedition, is to be found carved upon a rock face at Westford, Massachusetts.

The party is said to have built a castle and left a portion of their navy in Nova Scotia. As we shall see, the famous Oak Island just off the mainland of Nova Scotia is to become part of the mystery surrounding Prince Henry Sinclair.[9, 11, 12]

Prince Henry and his fleet returned to the Orkneys but shortly afterward Prince Henry was assassinated in Scotland. The year was 1400 and it was 92 years before Cristobal Colón, known to us as Columbus, was to use his knowledge of Iceland and the Zeno Brothers' maps to make his famous voyage across the Atlantic.

In his book *Holy Grail Across the Atlantic*,[9] Michael Bradley attempts to show that a vast treasure was transported to the new world by Henry. He claims that the treasure was kept at Montségur in the

French Pyrenees. This mountain fortress was besieged by the forces of Simon de Montfort and the Inquisition on March 16, 1244, but Bradley believes that the secret treasure escaped harm, having been spirited off by the Knights Templar.

The treasure probably included both ancient treasure from the Middle East, and gold, silver and jewelry of more modern manufacture. The Knights Templar were well funded in secret by various royalty, after all, even the Merovingian kings who were claimed to be of the Holy Blood of Jesus.

While some claim that the German S.S. retrieved sacred relics from Montségur (such as the Holy Grail) during World War II, it does seem more likely that the most important parts of the treasure like the Holy Grail and the Ark of the Covenant had already been rescued by the Merovingian kings during or after the 1244 siege. Other treasure left by the Cathars in the vicinity of Montségur may well have been discovered by the Nazis.

Bradley asserts that Prince Henry took over as many as 300 colonists to the New World and a literal "Grail Castle" was built in Nova Scotia—or "New Scotland." So strong is the evidence for Prince Henry Sinclair's voyage across the Atlantic with the Knights Templar that his distant relative Andrew Sinclair wrote a book entitled *The Sword and the Grail*[12] in which he claimed much the same as Bradley in *Holy Grail Across the Atlantic*.

Bradley and Sinclair claim that a special Grail Castle was built in an area of central Nova Scotia called "The Cross." This spot could be reached via river from either side of the Nova Scotia peninsula and at the mouths of both rivers was an island called "Oak Island." Curiously, one of these Oak Islands has the famous "Money Pit" which is a man-made shaft hundreds of feet deep with side tunnels. It is believed that there is a treasure in this pit and millions of dollars have been spent in attempts to reach the submerged bottom of the pit.[12]

It has been traditionally believed that the Oak Island Money Pit was built by pirates to hide a treasure, but Bradley and Sinclair claim that it was built by Sinclair and the Knights Templar. Furthermore, they claim, Canada was settled as a direct result of the Holy Grail being taken there. Sinclair and the Templars were attempting to create the prophesied "New Jerusalem" in the New World.

The French explorer and founder of the Quebec colony Samuel

de Champlain (1567-1635) was a secret agent for the Grail Dynasty, says Bradley, and the Grail was moved to Montreal just before Nova Scotia was attacked by the British Admiral Sedgewick in 1654. A mysterious secret society called the Compagnie du Saint-Sacrement carried the Grail to Montreal. Its whereabouts today are unknown, Bradley says.[9]

The fascinating concept of the Knights Templar taking the Holy Grail to the New World in order to found the New Jerusalem takes us directly into Atlantis studies. It is possible that the exploits and desires of Prince Henry influenced Sir Francis Bacon who, around the year 1600, published his unfinished utopian romance entitled *The New Atlantis.*

Bacon's *The New Atlantis* tells how, on a voyage from Peru to China, the narrator's ship was blown off course to an undiscovered South Sea land where a turbaned population have a perfect society, that is, a democratic state with an enlightened king, much as that to which Britain aspired.

The people had come to their country which they called "Bensalem" from Plato's Atlantis, which was actually in America. Bacon's Atlantis-from-America utopia is a very scientific land with submarines, airplanes, microphones, air-conditioning and a great research foundation. The folk of Bensalem are Christians, of course, having received the gospel from Saint Bartholomew.

Bacon's *The New Atlantis* was published 200 years after Prince Henry's tragic murder in the Orkneys in 1400 AD. Was he drawing on rumors of a new utopia having been established in America by Henry? Apparently, Prince Henry Sinclair's voyage from Orkney explains what happened to at least part of the lost fleet of the Knights Templar.

§§§

The Jolly Roger and the Lost Templar Fleet

One possible connection to the original Knights Templar and the missing Templar fleet is that of the "Jolly Roger," the black skull and crossbones flag of popular pirate lore. The theory goes that, since the missing fleet could not fly their Templar flag of a red cross, they became the early pirates and sailed under the Jolly Roger.

The Jolly Roger is named after Roger II of Sicily (1095-1154). Roger had reputedly been associated with the Templars during the crusades, and conquered Qpulia and Salerno in 1127 AD, despite opposition from Pope Innocent II. He was crowned king of Sicily by Antipope Anacletus II in 1130 AD. Innocent eventually yielded and invested Roger with the lands he already possessed. Roger established a stong central adminstration, largely free of Rome, and his brilliant court at Palermo was a center of arts, letters, and sciences. His court was full of dancers, music and entertainers, and he was known as "Jolly Roger." His fight with the Pope was well known, especially to seafarers and traders.

After the persecution of the Templars and the disappearance of their fleet, pirates were plying the Atlantic and the Mediterranean under their trademark: the Jolly Roger. They only attacked Spanish, French, and Italian ships, or others allied to Rome. Portuguese ships were largely safe—because it was known that Portugal was a safe haven for Templars?

According to Michael Bradley, author of *Holy Grail Across the Atlantic*[9] and *The Columbus Conspiracy*,[10] the "skull and crossbones" is carved on many Templar and Freemason gravestones and is nothing more or less than the old Templar "cross pattee" rendered in human skeletal material, with the knobs of the leg-bones being the pattees of the Templar cross. The message of the skull and crossbones is abundantly clear says Bradley: a "neo-Templar" vow to oppose the Roman Church to the death, and thus the symbolism of human bones on both the flag and the Templar and Freemason gravestones.

Experts might quibble with this interpretation were it not for the fact that the Roger of Sicily, a Templar, first flew the skull and crossbones on his vessels. He also established a navigational school on Sicily, one isolated from the Vatican by both the sea and his fleet, which invited Jewish and Islamic geographers as consultants. The Arabic geographer, Ibn Idrisi, was attracted to Roger's court and produced a "celestial disc" and a "terrestrial disc," both in silver, which represented respectively all the astronomical and geographic knowledge of the day. Idrisi and Roger also produced the important navigational treatise called the Al Rojari.

In some places, however, the Templars were welcomed and did not have to cloak themselves with too much secrecy. Portugal was

such a place. The Knights Templar there retained something of a cohesive organization, and merely changed their name to "The Order of the Knights of Christ," and they found royal support to which the Church could only turn a blind eye. First, King Alfonso IV of Portugal became the Grand master of the "new" Knights of Christ. Later, Prince Henry the Navigator was also Grand Master of the Order.[10]

The Black Flag and the Red Flag

As an interesting aside, according to David Cordingly in his book *Under the Black Flag*,[24] pirates weren't such bad guys really, and were often very gentlemanlike in their behavior.

The pirates always had the advantage when approaching a victim. They could follow a ship for hours or days at a safe distance while they worked out her potential strength in terms of guns and crew. If she proved to be a powerful Indiaman or a man-of-war, the pirates would veer away and seek a weaker victim. If the vessel appeared vulnerable, the pirates had a choice: they could take her by surprise, or they could make a frontal attack.

The simplest method of catching a victim off guard was to use false flags, a *ruse deguerre* which naval ships frequently adopted in time of war. Before the advent of radio or Morse code signaling, the only way that a sailing ship out at sea could identify the nationality of another vessel was by her flags. By 1700 the design of national flags was well established, and an experienced seaman was able to identify the ships of all the seafaring nations by the colors flying at their mastheads or ensign staffs.

A black flag with a white skull and crossbones emblazoned on it has been the symbol for pirates throughout the Western world. However, the Jolly Roger was only one of many symbols associated with piracy. In the great age of piracy in the early 18th century a variety of images appeared on pirate flags, including bleeding hearts, blazing balls, hourglasses, spears, cutlasses, and whole skeletons. Red or "bloody" flags are mentioned as often as black flags until the middle of the 18th century. The Jolly Roger, at least in the early days, meant an association with the lost Templar Fleet.

A French flag book of 1721 includes hand-colored engravings of pirate flags, including a black flag with various insignia, and a plain

red flag alongside a red pennant. Under the red flags is written "Pavilion nomme Sansquartier" ("Flag called No Quarter"). The idea that a red flag could mean no quarter is confirmed by Captain Richard Hawkins, who was captured by pirates in 1724. He later described how "they all came on deck and hoisted Jolly Roger (for so they call their black ensign, in the middle of which is a large white skeleton with a dart in one hand, striking a bleeding heart, and in the other an hourglass). When they fight under Jolly Roger, they give quarter, which they do not when they fight under the red or bloody flag."[24]

Cordingly says that in the great majority of cases merchant ships surrendered without a fight when attacked by pirates. If a merchant ship surrendered without a fight, the pirates usually refrained from inflicting violence on the crew.

§§§

The Templar Legacy

The Legacy left by the Knights Templar on the modern world should not be underestimated. Their pirate fleet roamed the North Seas for centuries, preying on ships that were loyal to the Vatican. As the new lands of Nova Scotia and America began to be settled, the Knights Templar and their fleet were there as well. In their new guise as the Scottish Rite of Masons, they were instrumental in creating the United States of America, if nothing else.

The Templars began their modern transformation at Rosslyn castle according to Tim Wallace-Murphy in his book, *The Templar Legacy & the Masonic Inheritance within Rosslyn Chapel*.[13] According to Wallace-Murphy, the builder of Rosslyn Chapel, William St. Clair, was the last Sinclair 'Jarl' [Earl] of Orkney, who lived in the middle of the fifteenth century. After Earl William, the 'Jarldom of Orkney' passed from the family to the Scottish crown as part of the dowry of Margaret of Denmark on her marriage to King James III of Scotland. William was not only the grandson of Prince Henry and the last Jarl of the Orkneys, he also had the somewhat peculiar title of Knight of the Cockle and the Golden Fleece. According to Wallace-Murphy, Sir William St. Clair was a member of a secret group that preserved important knowledge concerning the Holy Grail, the Holy Blood of the Merovingian kings, and the destiny of the new continent across the

Atlantic.

In *The Temple and the Lodge*,[3] Baigent and Leigh say that, "... by the Middle Ages, the architect or builder of Solomon's Temple had already become significant to the guilds of 'operative' stonemasons. In 1410, a manuscript connected with one such guild mentions the 'king's son of Tyre' [Hiram], and associates him with an ancient science said to have survived the Flood and been transmitted by Pythagoras and Hermes. A second, admittedly later, manuscript, dating from 1583, cites Hiram and describes him as both the son of the King of Tyre and a 'Master.' These written records bear testimony to what must surely have been a widespread and much older tradition."[3]

Clearly, the Knights Templar saw themselves as the inheritors of ancient knowledge that went back to Atlantis. They struggled for hundreds of years against the Vatican and the reign of terror known as the Inquisition. To the Templars, the true church, one that taught mysticism, reincarnation and good works, was being suppressed by a dark power that called itself the one true faith. Oppression of these other faiths was accomplished through the familiar devices of torture, terror and extermination.

Henry Sinclair of Orkney had risked all to make his voyages across the North Atlantic. Had he taken the Holy Grail and possibly even the Ark of the Covenant to America? Had these sacred relics helped spur on the creation of the United States, a land which Masonic founding fathers like George Washington, Thomas Jefferson and Benjamin Franklin were to create partially on the Templar ideals of religious freedom and a free-trade banking system?

According to Templar historians like Michael Baigent, Richard Leigh, Andrew Sinclair and Tim Wallace-Murphy, the Knights Templar had helped create an independent Scotland, then a "New Scotland" and finally an independent United States.

> *God made all men,*
> *but Sam Colt made them all equal.*
> —sign in a bar in Amsterdam

The Knights Templar and the American Revolution

It is estimated that over 80% of the founding fathers of America, the signers of the Declaration of Indepencence, were Scottish Free Rite Masons, and therefore descendants of the Knights Templar and

the societies that preceded them. The American Revolution was not so much a battle against the King of England and Scotland—King George—but a battle to create a Templar/Masonic estate of the "Builders" who would be free of any hereditary monarchy or other corruptible system of government.

Even servants of the King, initiates of the Masonic Order, were working against him and the royalty, because they had been instructed to do so. Though it was not well known, an inner core of the Scottish Order was coordinating, as best they could, the creation of the United States and the defeat of the British Royal Crown. The Knights Templar/Masons were behind the scenes in the creation of the United States, seeing to it that certain bridges were left unguarded and that Washington and his troops could escape when they were surrounded.[2]

Though King George back in Britain wasn't let in on these plans to create an independant United States, separate from his royal power, the ancient societies nonetheless allowed him to wage war on the colonies, knowing he would be defeated. In modern Masonic mythology, two brothers, both Masons, were commanders in the British Red Coat forces against the revolutionaries, but because they were Masons, allowed Washington to escape from time to time to regroup his forces and continue the battle.[2]

Among the efforts of General Washington to elude the British forces, apparently with the help of the Masons, was the use of the "Culver Spy Ring." In June of 1778, British General Sir Henry Clinton's forces occupied the majority of New York City, while General George Washington's troops were scattered throughout the area. The war was only in its second year, but things were going badly for the colonies and Washington desperately needed intelligence regarding the movements of Clinton's forces. Long Island, like New York City, was occupied by the British when Washington's people recruited Long Island resident (and Mason) Abraham Woodhull to do intelligence work for the rebelling colonies. His code name, and alias, became Samuel Culper.

Woodhull's first move was to recruit a New York City businessman named Robert Townsend, also a Mason. In turn, Townsend recruited agents of his own, his wife and his brother-in-law. Together they formed the Culver Spy Ring, which would provide important information regarding Clinton's troop movements for Washington's forces. Washington instructed them to write the information on the pages of common pocket books of the time. Then these books would

be delivered to Washington.

Washington didn't know the identities of the spies, but knew they were Masons. He wanted them to mix with the British and Tories, to visit their coffeehouses and all their public places—and they did. Townsend, for one, wrote a gossip column for a Tory newspaper which gave him increased access to the enemy. One contact he cultivated was Major John Andre who would later turn Benedict Arnold over to the British side. Townsend would take his reports to a tavern keeper named Austin Roe. Roe, in turn, would forward them on to Woodhull's farm. The information then was sent through one of Woodhull's couriers to Washington.

The messages gave Washington the day-by-day movements of Clinton's troops. This way Washington could stay one step ahead of the British forces since a direct confrontation with Clinton's forces could wipe out the revolutions' ragged army. The information turned out to be priceless. Washington knew exactly what the British were doing and what they were planning. An example of how this type information could be used can be illustrated by the arrival of French troops in 1780. By that time, the long efforts to get help by Benjamin Franklin to the American cause had come to fruition. When French troops arrived in Newport, Rhode Island, Clinton's troops prepared to attack the French before they could join up with Washington's army.

The Culver Spy Ring went into action. They saw the British preparing for an invasion of Newport and reported this to Washington. Washington, in turn, decided to divert the attention of the British by preparing an invasion of Manhattan. This news got back to the British, because they too had their spies, and Clinton decided to call off the attack. This flurry of disinformation was a major turning point in the war. The British had been fooled and the forces of France and Washington's army did meet. The American forces and the French were able to defeat the British and the colonies won their independence. Throughout the revolution the colonies were able to gather information that was crucial to an American victory.

With the creation of United States of America, a new age had begun in politics, taxation, science, religious freedom, and multi-cultural acceptance. America became the melting-pot of the world, where the best from all societies, races, creeds, and philosophies came in search of the golden age that their ancient texts had always predicted. The United States would become strong because it welcomed all people, all ideas, all religions (except the intolerant and violent), and

most importantly, all people with the burning desire for a better life and an idealist and spiritual lifestyle. With such innocence and naiveté, the United States of America entered into the history of the world.

§§§

The Templars, Masons, Rome and Armageddon

Recent conspiracy literature has painted a dark portrait of modern day Masons, often putting the blame of an Orwellian nightmare New World Order squarely on the shoulders of a Masonic conspiracy. Murderous renegade Masonic groups like the infamous P-2 organization in Italy has caught world headlines. The fact that many influential businessmen are also Masons is also seen as part of the exclusive club of the puppet-masters.

My own opinion is that, while the Masons were a powerful political group 200 years ago, their significance in modern power struggles is probably overrated. The early founding fathers of the United States were visionaries and rebels who belonged to many such groups who were popular at the time. Today, such groups as the Masons, the Shriners, or the Knights of Columbus (a Catholic version of the Masons) are little more than business clubs where local businessmen get together for luncheon meetings.

Masonic, and thereby Templar, doctrines are highly misunderstood and misinterpreted by many conspiracy writers, especially those who link the Masons and Knights Templar with the devil, much in the same way as the original persecution by the Vatican.

The Masons and Templars, it is said, worship the Angel Lucifer, whom Jehovah banished from Heaven. This may be true, but there is an important distinction to be made between Lucifer and Satan, two separate characters who are often confused today. The Devil, or Satan, comes from the Egyptian god Set. On the other hand, Lucifer is the same god as the Greek Prometheus, the bringer of God's Fire to mankind. For this act, giving man fire, Prometheus was banished from heaven, as was Lucifer.

According to the ancient stories, Lucifer had destroyed Eden, where man had lived off the fruits of the Garden, by giving man fire. With Eden's destruction, mankind had to struggle to survive. He had to better himself through work. Of mankind's children, there

were two general types: "Man the Builder," those who created the cities, bridges and roads of the ancient world, and "Man the Destroyer," those who conquered and destroyed whole nations in their quest for power and domination.

Lucifer, like Prometheus, was the patron of those who were the Builders, advocates of hard work. The name Lucifer means "the light bringer," and the Masons make an important distinction between Lucifer and Satan, just as the Greeks did. The word Satan comes from the ancient Egyptian god Set, as has been mentioned before.

It was the Knights Templar's and Mason's belief that salvation came not through the belonging to any certain church, but rather through one's own good works. Salvation was a matter of being a good person, working hard and being *a builder, not a destroyer.*

The Knights Templars of their day, and the Revolutionary War Masons of their day, were free thinkers who rebelled against any artificial thought controls or economic controls forced upon them by the controllers. The Knights Templar lost their battle against the Vatican, and escaped as enemies to Scotland and possibly the New World. The Revolutionary War Masons of British/Scottish descent and the Rosicrucians of German and Dutch descent succeeded in defeating the British Crown and fending off encroachment from the Vatican (in the form of Royal Spain) at the same time.

Power struggles between religious, racial and political factions have occurred since the beginning of history. History records that the Knights Templar, and later the Masons, stood for philosophical and political freedom. It is difficult to believe that the founding fathers of America, virtually all members of secret societies linked to the Knights Templar, were trying to set up a nation that was meant to be led into a New World Order police state. Rather, they were attempting to set up a nation with special safeguards against such a possibility. The checks and balances, guarantees of freedoms and inalienable rights, are part of the plan for a true "Nation Under God"— a utopian society where all citizens live in peace and freedom.

Yet, let us not be fooled. There is Christ and there is the Anti-Christ. There is the Buddha and there is the Anti-Buddha, and there is the *Novus Ordo Seclorum,* and there is the *Anti-Novus Ordo Seclorum.* This anti-Utopia is now the focus of many conspiracy theories, many of them valid, and has earned the name "The New World Order" (of

slavery). While some groups struggle for a "new order" of freedom and equality, others struggle for a "new order" of totalitarian control and consolidation of money and power into the hands of a select few—a confusing selection of choices, especially given the powerful media manipulation of the masses that moves the majority of people towards the "obvious" politically correct choices.

Nevertheless, a nation of idealistic principles was envisioned—and created—by our founding fathers along the Templar belief in "A New Atlantis." All prophecies remind us that a golden age once existed in the past, and a new golden age is soon to come in the future. What shall we call this new era of Light?

According to arcane lore, possibly preserved by the Templars, earth changes will destroy many lands, including Europe, while new lands will rise in the Atlantic and Pacific. New countries, created by new pioneers, will settle these new lands. These same people will be escaping the devastation happening in their own countries. Perhaps the new golden age is still to come, occurring on a land that has not yet formed.

The Knights Today

As I travel the world, from Scotland to Jerusalem to Kempton and beyond, I often run into a great deal of confusion between the Knights of Malta and the Knights Templar. Usually, it is thought that they are are the same organization. I was surprised to see myself even criticized in a national magazine to this regard, where it was clear that the writer did not have a clear knowledge of the various crusader groups and their successors.

Originally known as the Knights of the Hospital of St John of Jerusalem during the Crusades, the Knights of Malta were given that island in 1530. They now occupy a small building in Rome, admit Dames as well as Knights and are correctly called the Sovereign Military Order of Malta—but almost everybody still calls them the Knights of Malta.

Critics of the Knights of St. John/Malta claim that they are a right-wing Catholic organization that worked in Eastern Europe to suppress non-Catholic ethnic groups. The Nazi S.S. chief Rheinhard Gellen received the highest honor given by the Knights of Malta shortly after World War II for "services rendered." Gellen has been

credited with helping to mastermind the notorious Project Paperclip in which many members of the German S.S. were absorbed by the American Office of Strategic Services (O.S.S.) to create the Central Intelligence Agency.

As far as the Knights Templar during World War II, we know very little of their activities. Apparently, the Knights of Malta worked closely with the Germans during the war, while the Knights Templar would likely have taken an opposition stance to the Nazis and Fascists. The Knights Templar had always stood for religious and political tolerance along the lines of the United States and not one of book-burnings and pogroms.

According to English journalist Gordon Thomas, the Knights of Malta currently act as couriers between the Vatican and the C.I.A. Thomas says that recent members of the Knights of Malta have included: Franz von Papen, who persuaded von Hinderburg to resign and make Hitler the Chancellor of Germany; General Rheinhard Gehlen, Hitler's chief of Intelligence; General Alexander Haig, major architect of foreign policy in both the Nixon and Reagan regimes; Alexander de Marenches, former chief of French Intelligence; William Casey, head of the CIA during the Iran-Contra conspiracy; Otto von Hapsburg, also a member of the Bilderbergers and part of the Merovingian bloodline according to Baigent, Lincoln and Leigh, and Licio Gelli, Roberto Calvi and Michele Sindona, leaders of the P2 Conspiracy in Italy in the 1970s-80s.

According to researcher David Bernard, the 32nd degree in freemasonry reveals to the initiate that freemasonry is descended from the Knights Templar and devoted to fighting "tyranny and superstition" of which the main examplar is the Knights of Malta.

We see from this curious list that the power struggle between the Knights Templar and the Vatican (with the Knights of Malta) can encompass people of all kinds of backgrounds. We see how the Hapsburgs, who are descended, among others, from the Merovingian bloodline. The Merovingians, it would seem, would more likely be aligned with the Knights Templar and anti-Vatican forces. Some historians note the Austrian Hapsburgs were the real power behind the Vatican for many years and Templar orientated Merovingians would see the Hapsburgs as an evil family who still were related to Jesus and Mary Magdallen.

Indeed, at least in the western world, the struggle for domination in the West was between the secret forces behind the Knights of Malta and the Knights Templar. This translates in modern times as the waning power of the Vatican and the Catholic Church with the Hapsburg dynasty heirs, and modern British Empire coupled with the tremendous power of the United States as a Masonic republic.

Britain still retains close political and economic relations with most of its former colonies, and prospers greatly because of it. The United States has the most powerful military in the world, with the ability to strike from space if need be. It is this high-tech army, navy, and airforce of the United States, combined with Britain and her allies, that will be the ultimate strike force in the battle of Armageddon. A battle that will decide the fate of Planet Earth. A battle planned and prepared for thousands of years ago...

Now Who Rules the World?

With the steadily waning influence of the Vatican, and the steadily gaining influence of the Neo-Britiish Empire and the U.S. The Knights Templar have literally turned the tables on their oppressors—survived to create a new political order, one that was free of the tyrany of Popes, Kings, and Dictators. A strong and free country, where religion and fanatical religious beliefs were kept well separated from politics and the legislature.

Western Europe, including Italy these days, is firmly allied with Canada and the United States in setting the trend for standards of how a government should operate and people should prosper. Ironically, support for such religious dictatorships as Saudi Arabia is the antithesis of what the Knights Templar and United States stood for. As the United States wakes up to its destiny, public support for countries like Saudi Arabia will wane, and the stage is now set in Middle East for Armageddon: The final battle between the Masters of War and, depending on whose side you're on, the final battle between so-called "good" and so-called "evil." This final battle is not the end of the world, but a serious restructuring of the order of politics and religion.

Bibliography and Footnotes

1. *Holy Blood, Holy Grail*, Michael Baigent, Richard Leigh & Henry Lincoln,

1982, Jonathan Cape, London (published in the U.K. as *The Holy Blood and the Holy Grail).*

2. *The Messianic Legacy,* Michael Baigent, Richard Leigh & Henry Lincoln, 1985, Jonathan Cape, London.

3. *The Temple and the Lodge,* Michael Baigent & Richard Leigh, 1989, Jonathan Cape, London.

4. *Irish Druids and Old Irish Religions, James Bonwick, 1894. Dorset reprint 1986*

5. *Irish Symbols of 3500 B.C.,* N.L. Thomas, 1988, Mericer Press, Dublin.

6. *The History of the Knights Templars,* Charles G. Addison, 1842, London.

7. *A History of Secret Societies,* Arkon Daraul, 1962, Citadel Press, NY.

8. *The Mysteries of Chartres Cathedral,* Louis Charpentier, 1975, Avon Books, New York. 1966, Robert Lafont, Paris.

9. *Holy Grail Across the Atlantic,* Michael Bradley, 1988, Hounslow Press, Willowdale, Ontario.

10. *The Columbus Conspiracy,* Michael Bradley, 1992,, A & B Publishers, Brooklyn.

11. *Prince Henry Sinclair,* Frederick Pohl, 1974, Clarkson Potter Publisher, New York.

12. *The Sword and the Grail,* Andrew Sinclair, 1992, Crown, New York.

13. *The Templar Legacy & the Masonic Inheritance Within Rosslyn Chapel,* Tim Wallace-Murphy, 1993, Friends of Rosslyn, Rosslyn, Scotland.

14. *The Glastonbury Legends,* R. F. Treharne, 1967, Sphere Books, London.

15. *St. Joseph of Arimathea At Glastonbury,* Lionel Smithett Lewis, 1922, James Clark & Co., Cambridge.

16. *Jesus, Last of the Pharoahs,* Ralph Ellis, 1998, Edfu Books, Dorset, UK.

17. *Uriel's Machine: The Ancient Origins Of Science,* Dr Robert Lomas and Christopher Knight, 1999, Arrow Books, London.

18. *The Templars, Knights of God,* Edward Burman,1986, Destiny Books, Rochester, Vermont.

19. *Lost Cities of North & Central America,* David Hatcher Childress, 1992, Adventures Unlimited Press, Kempton, IL.

20. *Atlantis To the Latter Days,* H.C. Randall-Stevens, 1957, The Knights Templars of Aquarius, London.

21. *The Search For the Stone of Destiny,* Pat Gerber, 1992, Canongate Press, Edinburgh.

22. *The Knights Templar and Their Myth,* Peter Partner, 1987, Destiny Books, Rochester, Vermont.

23. *The Knights Templar,* Stephen Howarth, 1982, MacMillan Publishing, New York.

24. *Under the Black Flag,* David Cordingly, 1995, Harcourt Brace & Co., New York.

25. *Bloodline of the Holy Grail,* Laurence Gardner, 1996, Element Books, London.

26. *Genesis of the Grail Kings,* Laurence Gardner, 1998, Element Books, London.

27. *Realm of the Ring Lords,* Laurence Gardner, 2000, Media Quest, London.

28. *King Solomon's Temple,* E. Raymond Capt, 1979, Artisan Sales, Thousand Oaks, CA.

Jacques de Molay is tortured by the Inquisition.

The Inquisition enquires into the Templar wealth.

Left: The "Jolly Roger." Right: The U.S. Marine Raiders and their flag.

Pirates fought under a flag called the "Jolly Roger."

Above: English Masonic Knights Templar apron, c. 1800. Right: Seventeenth century Scottish Templar-Masonic grave near Edinburgh. Both illustrations from *The Temple and the Lodge*.

Above: George Washington in Masonic pose, including apron.

Mary Magdalene holds up an egg as a cosmic symbol of fertility and new birth in this painting from the Russian Church of Saint Mary Magdalene in Jerusalem. Mary's alleged marriage to Jesus of Nazareth is said to have spawned the "Sangrael" or Holy Grail bloodline that includes the Merovingians and the Knights Templar.

A Templar grave in Scotland.

The Sphinx.

9.
Egypt & the Hall of Records— The Armageddon Script

And the third angel sounded,
and there fell a great star from Heaven,
burning as it were a lamp,
and it fell upon the third part of the rivers,
and upon the fountains of waters.
And the name of the star is called Wormwood:
and the third part of the waters became wormwood;
and many men died of the waters,
because they were made bitter.
—Revelation 8:10-11

For this they (scoffers) willingly are ignorant of,
that by the word of God the heavens were of old,
and the earth standing out of the water
and in the water: Whereby the world that then was,
being overflowed with water, perished.
—II Peter 3:5, 6

It is curious that physical courage should be so common in the world
and moral courage so rare.
—Mark Twain

In March and April of the year 2001, I found myself back in Egypt. One evening we were sitting at a cafe in Cairo, looking out at the great Giza pyramids in the distance. We were on a rooftop terrace

near our hotel, Mena House, and were being served hors d'oerves and drinks. At our table was the famous Egyptologist John Anthony West and the publisher of *Nexus* magazine, Duncan Roads.

With the pyramids in the fading twilight, we talked about the association between the Great Pyramid and the so-called Armageddon Script.

According to one Armageddon Script, the combatants in the final war will essentially immolate themselves in their fanatical beliefs—religious, political and racial—each equally sure that he is right, and unable to make a compromise. Therefore, neighbor fights neighbor in the streets and on the borders, while other parts of the world watch it all play out on CNN.

When we suddenly hear the announcer say, "We interrupt Armageddon for a word from our sponsors…" then we will know for sure that we are in the midst of that legendary war. Fortunately, the remote batteries won't have run out yet, and we can switch over to reruns of *Get Smart* or *The Prisoner*, all while watching from the comfortable, familiar space of our favorite chair. The active sponsors for this live program of "reality TV" will probably be the oil companies, who are working for a better life for everyone, including finding "alternative" energy resources such as giant clouds of methane on the moons of Saturn.

Sure, the economy is in a downturn, energy prices are going up, and a war is raging across television screens—the two-horned beast of *Revelation*. The beast that was made to speak. The beast that deceives the world. And no one without the mark of the beast may buy or sell.

As we move further into the Big Brother world of the Internet, television and credit cards, we may wonder if startling things have already come into place, but we didn't know it—until now. Probably in the end, we'll all realize what is happening in the middle of it all, while we wonder how something that lasts for years can be summed up in a prediction of a few sentences.

It's the world on a string. A world on a collision course with itself, gathering speed and crashing together like two derailed locomotives. No one will laugh, but many will look at it in wonder.

Outside on the terrace of the hotel next to the Giza pyramids, I leaned back in my chair and sipped my *Stella* lager beer. It was smooth, cold and satisfying. "A good beer to drink while watching Armageddon," I thought out loud.

With the pyramids as a backdrop to the ultimate sound and light

show, I wondered how the rest of the world would fare when the lights suddenly went out. They would come back on, slowly, here and there. Those peaceful and prosperous areas of the world, the central United States, central Canada, Australia and other areas, would largely continue their way of life and the high technology of the Western coalition would be kept intact. The giant underground or intra-mountain fortress of the NORAD command structure would survive with most systems running.

Meanwhile, military craft would be flying out of the largest airforce base in the world—the U.S. manned underground base in Saudi Arabia. A highly sophisticated airforce command center in the center of the Saudi Arabian desert—an airforce base that will launch many of the destructive sorties that will be part of the battle of Armageddon.

§§§

The Mysterious Origins of the Pyramids and Sphinx

Regarding just exactly where the Egyptian civilization came from, archeologists have different opinions. Some archeologist think that nomadic hunters along the Nile in prehistoric times gradually became settled and began building simple mud brick houses and eventually giant temples and pyramids, not to mention obelisks that weigh up to 1,200 tons. Today, no known crane can lift these massive obelisks. Yet the Egyptians didn't seem to worry about lifting and moving such massive single blocks of granite.

Other archeologists, such as our host, John Anthony West, conclude that Egyptian culture is a legacy from another civilization, a civilization that had ended in an ancient Armageddon, one that occurred about 10,000 years ago. West and others think that the Great Sphinx, and certain other monuments in Egypt, are pre-Egyptian. The Sphinx, they think, has also been recarved and repaired several times. The current head of the statue is thought to be too small for the body, and was recarved from the original, larger head, possibly by the Pharaoh Kephren.

Even mainstream archeologists admit that Egypt has gone through dramatic climatic changes as recently as only 5,000 years ago, and the North African desert was a fertile savanna back then. Boston University Professor Farouk El-Baz, suggests that the pyramids and Sphinx— symbols of the emergence of Egyptian civilization—were inspired by natural landforms that abound in the Western Desert of

Egypt.

Knowledge of these landforms came with people of the desert who moved to the Nile Valley in response to a dramatic climate change some 5,000 years ago. In the March-April 2001 issue of *Archaeology* magazine, Dr. El-Baz contends that it was the merger of these two peoples—Nile farmers and desert nomads—that served as a catalyst that led to the flowering of Egyptian civilization and made possible the construction of great monuments that endure today.

Although the land west of the Nile River is now one of the driest places on Earth, it had much kinder climates in the past. Cycles of wet and dry climates alternated during the past 300,000 years. The last wet cycle persisted from 11,000 to 5,000 years ago.

Radar images from space can penetrate today's sand cover to unveil ancient topography. Analysis of satellite images by Dr. El-Baz and his team at the Boston University Center for Remote Sensing reveals numerous channels of rivers and streams in the desert which are now covered by sand.

Archaeologists have found ostrich eggshell fragments in the desert—evidence that the land was once a savanna—along with the remains of plants at the boundaries of dry lakes and hand-axes fashioned by prehistoric people.

In his article in *Archaeology*, El-Baz points out that the beginning of the current drought in the eastern Sahara coincides with the emergence of Egyptian civilization 5,000 years ago. He presents a number of indicators that the migration of nomadic people from the drought-stricken land to the Nile Valley ignited the spark of civilization.

Dr. El-Baz thinks that during the 2,000 years before the drying of North Africa, agrarian people tilled the banks of the Nile and developed an advanced "river technology," living in harmony with the seasonal ebb and flow of the river and learning how to lift water to channels in their fields. The nomads who joined them 5,000 years ago brought with them "desert wisdom." Having roamed the drying land during night to escape the day's heat, they became especially adept in astronomy.

As we sat the restaurant with our drinks and snacks, I asked our host, author of *Serpent in the Sky*,[3] John Anthony West, what he thought of Dr. El-Baz's theories.

Said West, "Well, evidence shows that the Sphinx is probably over 10,000 years old. I think it may be as old as 30,000 years old. Its been

recarved at least once. Furthermore, Egyptian science, medicine, mathematics and astronomy were all of an exponentially higher order of refinement and sophistication than modern scholars usually acknowledge. The whole of Egyptian civilization was based upon a complete and precise understanding of universal laws."

"Moreover, every aspect of Egyptian knowledge seems to have been complete at the very beginning. The sciences, artistic and architectural techniques and the hieroglyphic system show virtually no signs of a period of 'development'; indeed, many of the achievements of the earliest dynasties were never surpassed, or even equaled later on. This astonishing fact is readily admitted by orthodox Egyptologists, but the magnitude of the mystery it poses is skillfully understated, while its many implications go unmentioned.

"The answer to the mystery is of course obvious, but because it is repellent to the prevailing cast of modern thinking, it is seldom seriously considered. Like I say in my book, *Egyptian civilization was not a 'development,' but a legacy.*"

I smiled and took a deep gulp of nice cold beer. I could agree with all those things. That the Sphinx was possibly 30,000 years old was very intriguing. "So what about the secret chambers in the Great Pyramid?" I asked him. "Do you believe in this so-called Hall of Records?"

With that West gave a hearty laugh. "Well, I don't know about the Hall of Records," he smiled, "but it might be there. I don't believe that they have found it yet—or at least they aren't telling us about it."

With that we all laughed and looked at the massive bulk of the Great Pyramid in front of us in the darkening sky. Floodlights lit up the base and sides. The top was like a distant mountain peak. In the vastness of the Giza Plateau, there might be several hidden chambers.

§§§

Claims of Secret Rooms inside the Great Pyramid

I had brought with me a copy of the book *Secret Chamber*[4] by the Egyptologist Robert Bauval. A Belgian who grew up in Alexandria, Egypt, Bauval was famous for pointing out that the three pyramids at Giza were lined up in a manner similar to the constellation Orion. Was there a connection?

In *Secret Chamber,* Bauval goes on a quest for the Hall of Records, though no hidden chamber has so far come to light. However, as I picked up a newspaper, the *International Herald Tribune,* I was surprised to see an article on how a French group had supposedly located these hidden chambers.

On April 19, 2001, at a press conference in Paris, French researchers announced that they may have located entrances to hidden portions of Egypt's Great Pyramid, shedding light on a question that has intrigued archaeologists for centuries.

Said the article:

> Two archaeologists from the Paris-based Association of Archaeological Study and Research told a news conference that evidence gathered over 12 years indicated that secret passageways might exist behind blocks of stone inside the pyramid.
>
> Jacques Bardot and Francine Darmon said the Great Pyramid boasts an ingenious system, designed to hide entrances. Their research unearthed a series of clues, leading them to believe in the existence of secret rooms.
>
> But Zahi Hawass, the chief Egyptian archaeologist for the region near Cairo that includes the pyramid, said today that he knew nothing of the French research and had "no idea at all" about any internal passageways inside the pyramid.
>
> "All these are lies," Hawass, whose permission is required for any research on the pyramids plateau, said in Cairo. "I don't have any information about that."
>
> Bardot and Darmon said they plan to present their findings to local authorities.
>
> They told reporters their research showed that many of the joints in the walls of the grand gallery in the pyramid are false.
>
> By analyzing photographs, they also found a special marking on a stone inside the pyramid and said the marking was historically used to indicate a point of access. They believe it could be a sign that undiscovered chambers or rooms exist nearby.
>
> The mysterious Great Pyramid, which was built some 4,500 years ago as a tomb for King Cheops, has long fascinated archaeologists and speculation has been rife about the existence of hidden chambers.
>
> The French team said they decided to study the pyramid as something created during an evolution of architectural con-

cepts, rather than as a single monument.

They analyzed maps of royal funeral sites from six dynasties, and also studied texts and documents relating to religious symbolism to gain insights into its structure and possible hidden chambers.

As other evidence that possible hidden areas may exist, the researchers noted that their photographic analysis has revealed parts inside the pyramid that appear to be caulked, perhaps to ensure isolation.

They said they believed that the Great Pyramid also contains a funeral chamber as well as two other chambers, not yet discovered.

The Hall of Records and the Armageddon Prophecy

There are also said to be secret passages beneath the Giza Plateau. These passages go to the pyramids, allegedly starting from the Sphinx, and are part of the ancient Mystery Schools of Egypt. A strange shaft in the Giza Plateau between the Pyramid of Chephren and the Sphinx is known as Campbell's Tomb or Campbell's Well. This shaft is now blocked by a grate, but one can still look down it. The shaft is about 15 feet square and about 100 feet deep. On each side of the walls, one can see numerous tunnels, passages and doors cut into the solid rock. These passageways are thought to be part of the tunnel system that goes beneath the Giza Plateau. It is purposely dangerous to attempt to reach the pyramids, or the secret underground rooms that can be found in the tunnels. Their existence, and what lies in them, is a matter of legend and prophecy.

The idea that there is a secret library kept somewhere beneath Sphinx, Great Pyramid or the Giza Plateau is a fascinating one. Do these ancient records indicate that Armageddon is close at hand?

According to Peter Lemesurier in *The Great Pyramid Decoded* (as well as other authors), a Divine Plan and timetable for man's spiritual upliftment is spelled out in the geometry and inner passages of the Great Pyramid. This prophetic timetable has a different specific emphasis from most other prophecies.[1]

Lemesurier, in his book *The Armageddon Script*,[4] says that ancient prophecies, apparently based on the Great Pyramid in some cases, are all pointing to a turning point in time where the earth experiences a great battle as well as cataclysmic earth changes, just prior to a golden age. Prophecies usually state that an event is going to occur, but details are typically vague. The Great Pyramid, in contrast, is

solid and virtually indestructible, symbolically an icon for a future to be—and a past that once was.

The Great Pyramid's chronological prophecy has now been largely based on the pyramid inch scale where 1 inch = 1 year. The evidence indicates, say the proponents, a six thousand year system of prophetic dates, beginning in 3999 BC (the Age of Taurus the Bull) through the Age of Pisces (the familiar Christian fish symbol) and ending in 2001 AD.

Max Toth in his book *Pyramid Prophecies*[5] projected that the end of the Pyramid's recorded time falls between July 1993 and September 2001. According to Robert Menzies of Edinburgh, Scotland, the passageways and chambers in the Great Pyramid hold the secrets of God's Divine Plan and its progression through the ages. In 1865 Menzies first proposed the theory that the proportions and measurements of the passage system in the Great Pyramid were a chronological representation of Scripture prophecy. Included in this prophecy was the birth and ministry of Jesus, 11,000 years before the fact.[6] Aparently Menzies believed that the pyramid was built an astonishing 13,000 years ago.

The sides of the Great Pyramid were once covered with a fine surface of shiny, white limestone. Its four sloping sides originally merged at a point 481.4 feet above the pyramid. Apparently, there was originally a capstone at the summit, perhaps one of gold or even crystal?

Incredibly, the Egyptian government announced in the summer of 1999 that they planned to put a capstone made of gold on the summit of the Great Pyramid at the New Year's Eve Millennium celebration that year. A gigantic helicopter was to lower the golden capstone onto the top of the pyramid at midnight of December 31, 1999. As the day neared, however, the Egyptian government backed down from their ambitious plans and the event never took place.

According to William Henry in his book *The Peacemaker*,[6] "Before Menzies' time, Scripture scholars had already noticed that the Bible revealed the purpose of the Great Pyramid. To support their idea that the Pyramid was a Bible in stone or even the House of the Messiah, they referenced many verses in the Bible containing allegorical references to the Pyramid.

"The focus of the Pyramid chronology is the return of the Earth Teacher. The key Scriptural reference, which incontrovertibly upholds the divinity of the Great Pyramid, is found in *Ephesians* 2:20: 'And are built upon the foundation of the apostles and prophets,

Jesus Christ himself being the chief cornerstone.'

"This is but one of many scriptural text references to Jesus Christ as the living cornerstone, foundation stone, top stone or capstone and the Pyramid itself.

"It is recorded in *Matthew* 21:42 that Jesus uttered these extraordinary words: 'The stone which the builders have rejected [the one that isn't there] has become the chief corner-stone,' and is yet to become the 'head of the corner' (*I Cor.* 3:11, *Eph.* 2:20-22, *1 Pet.* 2:4-5). The author of *Matthew* must have been directly referring to the Great Pyramid: it's the only type of structure that has a chief cornerstone. Furthermore, the most famous building in the world with a Divine purpose is the Great Pyramid. The missing cornerstone they are referring to is the capstone of the Pyramid."[6]

According to Peter Lemesurier, the Messianic significance of the final placement of the capstone on the previously incomplete Pyramid is referred to in the book of *Zechariah*:

> How does a mountain, the greatest mountain, compare with Zerubabel? It is no higher than a plain. He shall bring out the stone called Possession while men acclaim its beauty...

§§§

The Conflict in Palestine and Israel

While stories in the newspaper about hidden chambers in the Great Pyramid caught my interest, the local papers were mainly full of stories of the intensifying conflict on the edge of Egypt's borders. The ongoing confrontations between Israelis and Palestinians—the daily skirmishes —captured much of the attention of the Egyptian populace and the media.

For the Egyptians, the Palestinians were their brothers who had lost their lands to invaders. It puzzled Egyptians why the Americans, whom they so admired, were helping the Israelis. It was a question best avoided.

But I decided that I would try to learn as much as I could about the history of Jerusalem, Palestine and Israel. Much o the following information is from the *Groliers Encyclopedia*[13] I consulted and can corroborated by numerous sources. It is a history of conflict that, according to prophecy, would end in Armageddon.

As we saw in Chapter 1, the borders of Palestine have fluctuated

throughout history but have generally included the territory lying between the southeastern Mediterranean coast on the west, the Jordan/Dead Sea Valley on the east, the Negev Desert on the south, and the Litani River on the north—an area only about 280 km (175 miles) long by 128 km (80 miles) wide. This land has been coveted throughout history because, by local standards, it is relatively well watered and strategically located on major land routes linking western Asia and northern Africa.

Although the Maccabees had prolonged the influence of the Jewish community in the area, the last vestige of ancient Hebrew statehood was shattered in AD 70, when the Romans responded to a revolt by occupying the capital city of Jerusalem, destroying the Temple, placing Palestine under Roman governors, and scattering rebellious segments of the Jewish population. During the succeeding 500 years of Roman and Byzantine rule, Palestine became overwhelmingly Christian.

The Arab conquest of 641 brought Palestine under the sway of the Islamic caliphate. Although Islam tolerated other faiths, it also encouraged conversion and facilitated immigration of Muslim Arab tribes into the country. Thus, by the 10th century most Palestinians had embraced Islam. After the decline of the central caliphate, the region endured another period of political instability. In 1099 the Crusaders took Jerusalem and established a feudal kingdom which was itself destroyed in 1291 when the Europeans were expelled by the Mamelukes of Egypt. Expelling the Mamelukes in 1516, the Turkish Ottoman Empire ruled until their defeat at Meggido in 1918.

The Creation of Israel after the 1918 Battle of Meggido

In 1918, the British, under General E. H. Allenby, defeated the Turkish forces at Megiddo and Palestine became a British Protectorate. In that year Palestine's population numbered about 500,000 Muslim Arabs, 100,000 Christian Arabs, and 60,000 Jews. All but a few thousand of the Jews had arrived since the 1880s, when immigrants from Europe started establishing agricultural settlements. Arabs, like Sephardic Jews, are Semites that inhabit the Middle East, Arabia and North Africa. Turks, Kurds and Iranians are not Arabs, however. Lebanese, Syrians, Iraqis and Palestinians are, along with Egyptians and Libyans (and other North Africans, except Berbers).

The Jewish immigrants were inspired by Zionism, an ideology born in Central and Eastern Europe's Jewish communities. Zionism combined a program to revive ancient Hebrew culture with an as-

sertion of the self-identity of Jews who felt threatened by various European nationalist movements. Zionism's program, as outlined by the World Zionist Congress (1897), called for a Jewish "national home" in Palestine supported financially and politically by a world-wide organization.

Britain's occupation of Palestine ended four centuries of Ottoman sovereignty. In 1922 the League of Nations approved a British mandate over Palestine and neighboring Transjordan. The mandate was supposed to encourage the development of self-governing institutions and, eventually, independence. The Arab state of Transjordan (later Jordan) became autonomous in 1923 and was recognized as independent in 1928.

In Palestine, however, independence was delayed while conflicting Arab and Jewish claims were weighed and Britain searched for a solution to the Palestine question. In 1916 an ambiguous political accord between Husayn ibn Ali, sharif of Mecca, and Henry McMahon, British high commissioner in Cairo, had led the Arabs to believe that the British would support the creation of an independent Arab state that would include Palestine. On Nov. 2, 1917, however, the British government issued the Balfour Declaration, which promised support for Zionist aims.

According to the *Grolier Encyclopedia,* not long after World War I ended, Arab Palestinians began to evidence fears that enactment of the Zionist program would submerge them under waves of Jewish immigrants. In July 1919, the General Syrian Congress in Damascus demanded independence for a Syrian state that would include Palestine, categorically rejecting the concept of a Jewish national home. In 1920, Emir Faisal (later Faisal I, King of Iraq), military commander of an Arab revolt (1916-18) against Ottoman rule, was declared king of this Syrian neo-Babylonian state.

In April of 1920 the Allied supreme council assigned France the mandate over Syria (approved in 1922 by the League of Nations) and, in July, French troops took Damascus, deposing Faisal, who fled the country. Anti-Zionist riots broke out among Arab Palestinians in April 1920 and were followed by even more serious violence in May 1921, after Britain announced that 16,500 Jewish immigrants would be admitted. Another serious clash erupted at the Wailing Wall in Jerusalem in 1929 when the Jewish Zionists formed the Jewish Agency to help develop quasi-governmental institutions among the area's Jews.

The Palestine crisis deepened in the 1930s when, in reaction to

303

Nazi persecution of Jews in Europe, Jewish settlement jumped dramatically; the Jewish population totaled more than 400,000 by 1939, comprising nearly a third of Palestine's inhabitants. Between 1935 and 1939, Britain advanced proposals to stabilize the population with an Arab majority. Between 1936 and 1939 the Arab Higher Committee, formed to unite Arab opposition to Jewish claims and led by the grand mufti (chief Islamic judge) of Jerusalem, Hajj Amin al-Husayni, carried on a virtual civil war. Thousands were killed, and many of the Arab Palestinian leaders were deported or forced to flee.

The conflicts of these years exposed serious Arab social fragmentation, as well as military deficiencies, that contrasted with the solidarity and organizational efficiency displayed by the Jews, who formed a paramilitary organization, the Haganah, during the period of unrest.

Britain's last serious attempts to reach a compromise were the inconclusive London Round Table Conference (1939) and the *White Paper* of that year, which promised the establishment within ten years of an independent Palestine retaining an Arab majority. The *White Paper* also limited Jewish immigration to 1,500 per month until 1944, when Jews would no longer be admitted to Palestine. This limit was a devastating blow to the Jews of Hitler's Europe, and, after the outbreak of World War II, Zionists transferred their major efforts to attract support from Britain to the United States. In May 1942 the Biltmore Conference in New York demanded the formation of an independent Jewish commonwealth, a stance that attracted wide endorsement from U.S. political leaders.

During World War II the potential economic and military strength of Palestine's Jewish population increased considerably. After the war's end, when large numbers of European concentration-camp survivors sought homes in Palestine, Britain's resistance to reviving large-scale Jewish immigration prompted a revival of widespread disorder.

§§§

And it shall come to pass,
in that day, that I will seek to destroy
all the nations that come against Jerusalem.
—The Prophet Zechariah, quoting *YHWH*

Jerusalem and the Birth of Modern Israel

The British had first occupied Jerusalem in 1917, and it became the capital of mandated Palestine from 1923 until 1948. During this period the city saw Arab rioting against the Jews. The 1948 United Nations partition plan for Palestine called for internationalization of the city. The Arabs rejected this resolution, and, from 1949, Jerusalem was divided into an Israeli and a Jordanian sector. The city remained divided until 1967, when Israel took the entire city following the Six Day War. The city is reunited today under Israeli government, which guarantees religious freedom and protection of all holy places. The question of who will ultimately control Jerusalem, however, remains a major obstacle to any lasting peace settlement in the Middle East. Both sides are unyielding on this aspect of any peace negotiations.

By 1947 the exhausted British declared that they could do no more and referred the problem to the United Nations, which voted in November to split Palestine into Arab and Jewish states. Despite violent Arab protests, Palestine's Jews proclaimed the creation of the independent state of Israel, comprising more than half of Palestine's territory, on May 14, 1948, the eve of Britain's evacuation. Armies of the adjacent Arab states quickly entered Palestine.

This war, the first in a series of Arab-Israeli Wars, ended in 1949 with a hard-fought Israeli victory that included possession of territories won on the battlefield; the migration of more than 700,000 Arab Palestinian refugees out of Israeli territory into adjacent areas controlled by various Arab states; the confiscation of the property left by the Arab refugees and its redistribution to Israelis; and the eclipse of Palestine as a political entity. Most of the territory west of the Jordan River that the United Nations had designated as Arab came under the control of Transjordan, renamed Jordan, which formally annexed it in 1950. After the 1967 Arab-Israeli War, however, this West Bank territory was occupied by Israel.

Since the United Nations partition of Palestine in 1947 and the establishment of the modern state of Israel in 1948, there have been five major Arab-Israeli wars (1947-49, 1956, 1967, 1973, and 1982) and numerous intermitent battles. Although Egypt and Israel signed a peace treaty in 1979, hostility between Israel and the rest of its Arab neighbors was complicated by the demands of Palestinian Arabs for an independent state in Israeli-occupied territory.

§§§

The First Palestinian War (1947-49) and the Suez-Sinai War (1956)
The first war began as a civil conflict between Palestinian Jews and Arabs following the United Nations recommendation of Nov. 29, 1947, to partition Palestine, then still under British mandate, into an Arab state and a Jewish state. Fighting quickly spread as Arab guerrillas attacked Jewish settlements to prevent implementation of the UN plan.

Jewish forces prevented the seizure of most settlements, but Arab guerrillas, supported by the Transjordanian Arab Legion under the command of British officers, besieged Jerusalem. By April, Haganah, the principal Jewish military group, seized the offensive, scoring victories against the Arab Liberation Army in northern Palestine, Jaffa, and Jerusalem. British military forces withdrew to Haifa; although officially neutral, some commanders assisted one side or the other.

After the British had departed and the state of Israel had been established on May 15, 1948, under the premiership of David Ben-Gurion, the Palestine Arab forces and foreign volunteers were joined by regular armies of Transjordan (now the kingdom of Jordan), Iraq, Lebanon, and Syria, with token support from Saudi Arabia. Efforts by the UN to halt the fighting were unsuccessful until June 11, when a four-week truce was declared. When the Arab states refused to renew the truce, ten more days of fighting erupted. In that time Israel greatly extended the area under its control and broke the siege of Jerusalem. Fighting on a smaller scale continued during the second UN truce beginning in mid-July, and Israel acquired more territory, especially in Galilee and the Negev. By January 1949, when the last battles ended, Israel had extended its frontiers by about 1,930 sq. miles beyond the 4,983 sq. miles allocated to the Jewish state in the UN partition resolution. It had also secured its independence. During 1949, armistice agreements were signed under UN auspices between Israel and Egypt, Jordan, Syria, and Lebanon. The armistice frontiers were unofficial boundaries until 1967.

Border conflicts between Israel and the Arabs continued as hundreds of thousands of Palestinian Arabs who had left Israeli-held territory during the first war concentrated in refugee camps along Israel's frontiers and infiltrated back to their homes or attacked Israeli border settlements. A major tension point was the Egyptian-controlled Gaza Strip, from which Arab guerrillas raided southern Israel. Egypt's blockade of Israeli shipping in the Suez Canal and Gulf of Aqaba intensified the hostilities.

These escalating tensions converged with the Suez Crisis caused by the nationalization of the Suez Canal by Egyptian president Gamal Nasser. Great Britain and France strenuously objected to Nasser's policies, and a joint military campaign was planned against Egypt with the understanding that Israel would take the initiative by seizing the Sinai Peninsula.

The war began on Oct. 29, 1956, after an announcement that the armies of Egypt, Syria, and Jordan were to be integrated under the Egyptian commander in chief. Israel's Operation Kadesh, commanded by Moshe Dayan, lasted less than a week; its forces reached the eastern bank of the Suez Canal in about 100 hours, seizing the Gaza Strip and nearly all the Sinai Peninsula. The Sinai operations were supplemented by an Anglo-French invasion of Egypt on November 5, giving the allies control of the northern sector of the Suez Canal.

The war was halted by a UN General Assembly resolution calling for an immediate cease-fire and withdrawal of all occupying forces from Egyptian territory. The General Assembly also established a United Nations Emergency Force (UNEF) to replace the allied troops on the Egyptian side of the borders in Suez, Sinai, and Gaza. By December 22 the last British and French troops had left Egypt. Israel's forces were not withdrawn from Gaza until March 1957.

The Six-Day War (1967) and the October War (1973)

In the following decade the Suez Canal remained closed to Israeli shipping, the Arab boycott of Israel was maintained, and periodic border clashes occurred between Israel, Syria, and Jordan. However, UNEF prevented direct military encounters between Egypt and Israel.

By 1967 the Arab confrontation states—Egypt, Syria, and Jordan—became impatient with the status quo, and border incidents increased. Tensions culminated in May when Egyptian forces massed in Sinai, and Cairo ordered the UNEF to leave Sinai and Gaza. President Nasser also announced that the Gulf of Aqaba would be closed again to Israeli shipping. At the end of May, Egypt and Jordan signed a new defense pact placing Jordan's armed forces under Egyptian command.

Believing that war was inevitable, Israeli Premier Levi Eshkol, Minister of Defense Moshe Dayan, and Army Chief of Staff Yitzhak Rabin approved preemptive Israeli strikes at Egyptian, Syrian, Jordanian, and Iraqi airfields on June 5, 1967. By the evening of June 6,

Israel had destroyed the combat effectiveness of the major Arab air forces. Israel also swept into Sinai, reaching the Suez Canal and occupying most of the peninsula in less than four days. Arab armies are still feeling the sting of this highly effective preemptive strike and the loss of their airforces.

King Hussein of Jordon rejected an offer of neutrality and opened fire on Israeli forces in Jerusalem on June 5. But a lightning Israeli campaign placed all of Arab Jerusalem and the Jordanian West Bank in Israeli hands by June 8. As the war ended on the Jordanian and Egyptian fronts, Israel opened an attack on Syria in the north. In a little more than two days of fierce fighting, Syrian forces were driven from the Golan Heights, from which they had shelled Jewish settlements across the border. The Six-Day War ended on June 10 when the UN negotiated cease-fire agreements on all fronts.

The Six-Day War increased severalfold the area under Israel's control. Through the occupation of Sinai, Gaza, Arab Jerusalem, the West Bank, and Golan Heights, Israel shortened its land frontiers with Egypt and Jordan and temporarily increased its strategic advantages vis-a-vis the neighboring Arab states. But the addition of more than 1,500,000 Palestinian Arabs to areas under Israeli control threatened internal security.

Israel was the dominant military power in the region for the next six years. Led by Golda Meir from 1969, it was generally satisfied with the status quo, but Arab leaders repeatedly warned that they would not accept continued Israeli occupation of the lands lost in 1967. After Anwar al-Sadat succeeded Nasser as president of Egypt in 1970, threats were more frequent, as was periodic massing of troops along the Suez Canal. Egyptian and Syrian forces underwent massive rearmament with sophisticated Soviet equipment. Sadat consolidated war preparations in secret agreements with President Hafez al-Assad of Syria for a joint attack and with King Faisal of Saudi Arabia to finance the operations.

Egypt and Syria attacked on Oct. 6, 1973, pushing Israeli forces several miles behind the 1967 cease-fire lines. Israel was thrown off guard, partly because the attack came on Yom Kippur (the Day of Atonement), the most sacred Jewish religious day. Although Israel recovered from the initial setback, it failed to regain all the territory lost in the first days of fighting. In counterattacks on the Egyptian front, Israel seized a major bridgehead behind the Egyptian lines on the west bank of the canal. In the north, Israel drove a wedge into the Syrian lines.

After 18 days of fighting in the longest Arab-Israeli war since 1948, hostilities were again halted by the UN. The costs were the greatest in any battles fought since World War II. The three-week war cost Egypt and Israel about $7 billion each, in materiel and losses from declining production or damage.

The political phase of the 1973 war ended with disengagement agreements accepted by Israel, Egypt, and Syria after negotiations in 1974 and 1975 by U.S. secretary of state Henry A. Kissinger. The agreements provided for Egyptian reoccupation of a strip of land in Sinai along the east bank of the Suez Canal and for Syrian control of a small area around the Golan Heights town of Kuneitra. UN forces were stationed on both fronts to oversee observance of the agreements.

Under an Egyptian-Israeli peace treaty signed on Mar. 26, 1979, Israel returned the Sinai peninsula to Egypt. Hopes for an expansion of the peace process to include other Arab nations waned, however, when Egypt and Israel were subsequently unable to agree on a formula for Palestinian self-rule in the West Bank and Gaza Strip. In the 1980s tensions were increased by conflicts between Israeli authorities and Palestinians in the occupied territories, by Palestine Liberation Organization (PLO) guerrilla attacks on Israeli settlements in Galilee, and by Israeli retaliatory raids into Lebanon.

Israeli Occupation and Palestinian Self-Rule

Israeli occupation of the West Bank and Gaza Strip resulted in increased, albeit divided, Palestinian nationalist activity, most of which took place outside the occupied territories. Alternative ideologies, personal animosities, and the meddling of neighboring Arab governments resulted in an alphabet soup of rival Palestinian nationalist organizations. Most of these diverse groups cooperated under the umbrella of the Palestine Liberation Organization (PLO), chaired by Yasir Arafat from 1969. Arab and international support for Palestinian national aspirations under the leadership of the PLO began to coalesce in 1974. At the October Arab summit meeting in Rabat, Morocco, the Arab League ended all Jordanian claims to Palestinian territory by designating the PLO as the "sole legitimate representative of the Palestinian people" and recognizing the right of the Palestinians to establish an independent "national authority" in any territories relinquished by Israel. In November, the UN General Assembly reaffirmed the right of the Palestinians to self-determination and national sovereignty and granted the PLO observer status.

Conditions in the West Bank and Gaza Strip under Israeli military occupation remained relatively peaceful. Although generally supporting the PLO, the Palestinian population accommodated itself to Israeli rule. The West Bank, in particular, experienced general economic improvement through the late 1970s, due in large part to remittances from Palestinians working in the Persian Gulf states, agricultural exports, and low-paying employment opportunities in Israel. Despite pressure from the right, successive Israeli Labor governments permitted few Israeli settlers (fewer than 8,000 in 1967-77) and limited settlement to isolated locations.

The election of a Likud government in 1977 greatly altered the situation. The Likud party considered the West Bank to be an integral part of Israel. It initiated an aggressive policy of settlement (nearly 60,000 settlers in 1978-88), land expropriation, and the construction of new settlements close to Palestinian population centers. More than 40 percent of the land in the already-overcrowded Gaza Strip was also expropriated. The vague agreements concerning Palestinian self-determination and autonomy contained in the 1978 Camp David Accords in no way altered the Israeli government's claim to the West Bank. In 1981 the Israeli military administration was replaced by a civilian administration made up of "village leagues" composed of Palestinians acceptable to the Israeli authorities.

Civilian administration was accompanied by an "iron fist" policy on the part of the Israeli government designed to deal with opposition to both the village leagues and Israeli settlement. The result of this policy was increased violence. Younger Palestinians, rejecting what they viewed as accommodation by their parents and the PLO, resorted to demonstrations and rock throwing. Israeli settlers began to retaliate. A parallel development was the growth of Islamic influence, particularly in the Gaza Strip. The Muslim Brotherhood had long dominated Islamic politics in the occupied territories, but more radical groups began to emerge in the mid-1980s.

On June 6, 1982, Israel launched a full-scale invasion of Lebanon to destroy PLO bases there and to end the attacks across its borders in an operation called "Peace For Galilee." Meeting little resistance, Israeli commanders pushed northward, reaching the outskirts of Beirut within a week. Fighting with Syrian forces also erupted; nearly 80 Syrian MiGs and 19 missile batteries in the Bekaa Valley were destroyed without loss of a single Israeli plane. By the end of June, Israel had captured most of southern Lebanon and besieged PLO and Syrian forces in West Beirut. The siege ended through U.S. me-

diation in August, when Israel agreed to leave Beirut provided Syrian and PLO forces also withdrew. A multinational force from the United States and Western Europe supervised the Syrian and PLO evacuation. On September 15, after the assassination of Lebanese president-elect Bashir Gemayel, Israel reoccupied Beirut and authorized Gemayel's Phalangist militia to "cleanse" Palestinian refugee camps of any remaining PLO fighters. The Phalange massacred hundreds of Palestinians, sparking Israeli antiwar protests.

Israel signed an agreement with Lebanon ending the state of war in May 1983, but Lebanon renounced the pact under Syrian pressure in March 1984. Public pressures in Israel led to the withdrawal of Israeli troops by June 1994, leaving 1,000 "security personnel" to assist its Lebanese allies. While Israel's borders remained secure, its internal stability was threatened by continued demands for Palestinian self-determination and by an intifada (uprising) in the occupied territories launched in December 1987.

In December 1987, Palestinian frustration with Israeli policies erupted in the intifada. Although the intifada was initially organized by indigenous Palestinians, its direction was quickly assumed by the PLO under a 14-point program advocating an independent Palestinian state in the West Bank and Gaza Strip that would coexist with Israel. The PLO unilaterally declared this state in November 1988. The intifada, which at first used demonstrations, strikes, and tax boycotts to oppose the Israeli occupation, began to assume a more violent tone by 1990 as radical groups such as Hamas rejected PLO moderation in favor of armed resistance.

In the midst of U.S.-sponsored postwar regional peace talks, the Israelis and the PLO held a series of secret meetings in Norway culminating in the signing of a Declaration of Principles on Sept. 13, 1993. This accord, which was opposed by several radical Palestinian groups and by hard-line Israeli settlers, provided for a transfer of power in the Gaza Strip and Jericho to an elected Palestinian administration. On May 4, 1994, Israel and the PLO signed a more detailed five-year interim agreement. Palestinian police forces quickly moved to replace Israeli security forces in the Gaza Strip and Jericho. In July, 1994, Arafat completed the appointment of a Palestinian administrative council and took up residence in Gaza. In August, Israel and the PLO signed another agreement granting the PLO control over education, health, taxation, tourism, and social welfare in the West Bank, excluding East Jerusalem and the Jewish settlements.

Another accord signed on Sept. 28, 1995, expanded Palestinian

self-rule in the West Bank and provided for elections for a Palestinian Council in the West Bank and Gaza, which were held in January 1996. Arafat won the presidency in this election, and members of his Fatah wing of the PLO captured about 75% of the seats on the newly-elected Palestinian legislative council. The peace process continued following the November 1995 assassination of Israeli prime minister Yitzhak Rabin by a right-wing Israeli, although a number of issues remained unresolved, including the final borders and nature of the Palestinian self-rule entity, the fate of Jewish settlements in the West Bank and Palestinian refugees abroad, and the future status of East Jerusalem.

§§§

Jerusalem: The City of Peace or of War?

Jerusalem the capital of Israel, is a holy city of Judaism, Christianity, and Islam. For Jews, Jerusalem is the focus of their religious longing, the site of their ancient temple, and their historical capital. For Christians, it is the site of many of the events in the life of Jesus Christ. For Muslims, the city is their third holiest as the site from which Muhammad is said to have risen to heaven and the site of important mosques. Jerusalem's religious status has made control of the city a very volatile issue. In 1949, at the end of the First Arab-Israeli War, Jerusalem was partitioned between Israel and Jordan. Israel took control of the entire city in 1967 and officially proclaimed all of Jerusalem the capital of Israel in 1980. These actions were bitterly resented by the Arabs. The status of the city remained unresolved when Israel and the Palestine Liberation Organization signed accords on Palestinian self-rule in the West Bank and the Gaza Strip in 1993 and 1994.

Jews have constituted a majority of Jerusalem's population since about 1876. Today they make up about 72% and Arabs about 26%; there is a dwindling Christian minority. Both Hebrew and Arabic are spoken.

The city is divided into three sections: the Old City, New City (West Jerusalem), and East Jerusalem. The walled Old City, in the center, contains Muslim, Jewish, Christian, and Armenian quarters. The Old City was under Jordanian control from 1949 to 1967. During this period the Jewish quarter was destroyed, but it has since been rebuilt. Most of the narrow streets of the Old City are lined with shops where merchants sell foodstuffs and traditional handicrafts;

homes are clustered around courtyards surrounded by high walls.

Many of Jerusalem's religious landmarks are located in the Old City. The Western Wall (or Wailing Wall), is a remnant of the supporting wall of the Second Temple. After the Jews were banished from the Temple Mount, the Western Wall became the most sacred place of Judaism. Atop the Temple Mount are the gold-domed Dome of the Rock (begun AD 661) and the silver-domed al-Aqsa (begun AD 710) mosques.

The New City, built mostly by Jews, has expanded since the 19th century. This section was under Israeli control during the partition and is the site of many government buildings. To the south is the Israel Museum, which includes the Shrine of the Book, where the Dead Sea Scrolls are located. Farther to the west are modern high-rise apartment buildings and the Hadassah-Hebrew University Medical Center.

East Jerusalem, located just north of the Old City, is the primarily residential modern Arab section, although Jews have outnumbered Arabs there since 1993. It is also the site of the Rockefeller Museum, with a fine archaeological collection.

Since 1967 a ring of Israeli settlements has been built around the entire city. Hebrew University (1925), Israel's leading institution of higher learning, has campuses in the New City and on Mount Scopus.

Tourism is the city's major economic activity, along with the government-related functions and industries include diamond cutting and polishing, home appliances, furniture, pharmaceuticals, chemicals, shoes, plastics, textiles and clothing, printing and publishing, and jewelry. It is expected that the battle of Armageddon will curtail economic growth in the city, at least for awhile.

While Jerusalem is an ancient city, probably as old as Jericho, it is a city that brings us into the modern millennium at a whirlwind pace. From the ancient depths of time, and its many battles, victories and tragic losses, the city now involves the entire world in its conflicts. Conflicts which will change the world and force man to confront fellow man. A fundamental battle between the forces of good and evil—of freedom and servitude.

§§§

*The Apocalypse will now preempt
our previously scheduled live telecast of Armageddon...*
—predicted BBC broadcast, Friday, Oct. 13, 2001

Prelude to Armageddon

On November 28, 2000, the United Nations Security Council was briefed on possible international force for Palestinian territories. CNN news report on that day said that Secretary-General Kofi Annan met with the President of the Security Council, Ambassador Peter van Walsum of the Netherlands, to brief him on the status of his ongoing efforts to get the Israelis and Palestinians to agree to a possible international presence on the ground.

The issue of an international presence was a major topic during the Council's private meeting with a delegation of the Organization for the Islamic Conference. According to a UN spokesman, during that meeting, the foreign ministers of Qatar, Senegal, Morocco and Iran appealed to the Council for an international force to move in quickly to protect the Palestinians. Immediately following that session, the Council held another private meeting to hear from the Permanent Representative of Israel to the UN, Ambassador Yehuda Lancry.

Meanwhile, in a report reviewing his recent efforts of the fall of the year 2000 in the Middle East, including his work during the Sharm el-Sheikh Summit, the Secretary-General warned that "the present crisis holds the potential for further escalation, with dangerous consequences for the entire region."

On Monday, April 15, 2001, Israeli warplanes launched air strikes on targets in Lebanon's central mountains, the news media reported world-wide. I was watching this live on CNN from a hotel room in Cairo, getting ready to leave the country on a flight to Europe. The attacks took place in an area where Syrian troops maintain radar bases, and there was no immediate word on the targets, casualties or damage.

The attacks came the day after a special UN envoy said that a rocket attack that killed an Israeli soldier in a disputed border zone violated the UN-drawn boundary between Lebanon and Israel. An Israeli tank had been hit with a Sagger missile that day in the Chebaa Farms area, where the borders of Lebanon, Syria and Israel meet. Israeli warplanes and artillery retaliated by blasting suspected guerrilla hideouts on the edge of the Chebaa Farms. As I headed for airport from my hotel in Cairo, I thought that this might be the beginning of the end.

Israel launched both Monday's strike against the Syrian position and Tuesday's raids in Gaza after mortar shells fell near the Israeli

town of Sderot about 5 kilometers (3 miles) inside Israel—the deepest mortar attack into Israel in the seven-month Palestinian-Israeli confrontation.

Later that same day, Israeli troops used a series of air, land and sea raids to occupy an L-shaped section of northern Gaza on late Monday night and early Tuesday, sparking loud protests from Palestinians and their Arab allies.

Israeli generals said the raids were in response to mortar attacks on Israeli towns and warned they could occupy the area "for months."

Palestinian leader Yasser Arafat condemned the raids, saying that "They are dirty. They are intended to bring our people to their knees. Everyone should understand that our people are steadfast and will not kneel before these gangs attacking our people, villages and refugee camps."

Normally soft-spoken Egyptian President Hosni Mubarak also blasted the Israelis, calling the raids and occupation "beyond the limit of what is acceptable."

"These strikes will have no effect, will lead to nothing other than more violence and bring an end to stability and the Israeli people will suffer more," he said.

The Israelis have also sealed Gaza's borders, preventing movement into and out of the area. Then, less than two days later, on Tuesday, April 17, the Israeli Army announced that it had begun withdrawing from the small northeastern corner of Gaza that it had reoccupied.

Eyeless in Gaza—Israel Unveils Virtual Temple

Then, on Wednesday, April 18, 2001, CNN reported that Israeli forces carried out another "pinpoint operation" that destroyed a Palestinian police post in southern Gaza, saying the target was a source of gunfire on Israelis.

Israeli Foreign Minister Shimon Peres said the temporary incursion into Gaza a few days earlier had been a "warning" against Palestinian attacks, like the one launched against Sderot.

"This was an increase in the degree of violence and terror and we have had to warn the Palestinians that it will carry a price," Peres told the press.

But CNN reported that Palestinian Council member Hanan Ashrawi said that Israel's assertions that it must defend itself from Palestinian provocations were false.

"Israel constantly provokes Palestinians—demolishes homes, kills,

and still behaves as though it has a God-given right to determine Palestine rights, lives and dictate to the rest of the world," Ashrawi told CNN. "We don't want violence but it is their policies ...that Palestinian lives and homes are fair game for the Israeli military."

Hours before the strike against the police post, the Israel Defense Forces, commonly known as the IDF, said that mortars were fired at Israeli targets in Gaza after Israel withdrew its troops from Palestinian-controlled territory in the north of Gaza.

"We faced a new situation when the Palestinians introduced mortars," Peres said. "To start with, a mortar is an illegal weapon in the hands of the Palestinians in accordance with the Oslo agreement."

But the move drew heavy criticism from both Arab nations and the United States. U.S. Secretary of State Colin Powell, while acknowledging that Palestinian mortar attacks on Israel were "provocative," labeled the Israeli incursion an"excessive and disproportionate" response.

On the same day, April 18, 2001, Israel unveiled the "Virtual Temple," a computer replica of the ancient temple and what it was like to visit the holy sanctuary.

According to newspaper accounts, deep in the cool recesses of the remains of an ancient Muslim palace, tourists gaze at a computer screen and find themselves transformed into pilgrims as they are led to the Jewish Temple destroyed 2,000 years ago.

Say the press releases published by CNN, Reuters, AP and other sources, "The computer simulation is part of a new interactive museum that opened Wednesday just outside the Al Aqsa Mosque, which sits on land where Jews believe the remains of their two Temples—one built by King Solomon and the second by King Herod—are buried...

"The computer simulation is housed in what used to be the basement of a palace from which Muslim Caliphs ruled the area in the 7th century. In the high-tech computer simulation, developed with the University of California at Los Angeles, visitors are guided by computer images under a high gateway, known today as Robinson's Arch, and up a grand staircase to the majestic Second Temple, as it stood before the Romans destroyed it in 70 A.D.

"The computer program, like a flight simulator, takes the audience into the wide plaza surrounding the Temple. The royal portico adorns one side of the courtyard with four rows of columns. The square sanctuary, decorated with a gold frieze, rises high above the covered heads of virtual Jewish pilgrims on the other side.

"Not every detail was clear when they reconstructed the Temple in the computer model. Though he led excavations near the Temple Mount, archaeologist Ronny Reich said he had conflicting information, or not enough, and had to use educated guesswork to complete the model, answering questions posed by Lisa Snyder, a computer expert with the UCLA Urban Simulation Team. ...Emerging from the dark chambers, visitors face 21st century reality, including some of the structures pictured in the simulation."

This virtual temple may, incredibly, be the fulfillment of the ancient prophecy that when the temple at Jerusalem is rebuilt a third time, the battle of Armageddon will begin (again).

A few days later, on Saturday, April 21, Israel continued its attacks on Palestinian police stations by attacking a Palestinian police post in Gaza as security officials from both sides prepared to meet that same night. What should have been a day of rest was rather a day of activity.

CNN reported that Palestinian officials claimed that Israeli forces used three tanks and two bulldozers to flatten the one-story police post, which Israel said was being used as a base to attack its troops.

"It was a pinpoint operation to stop gunfire that was directed towards our forces from the post as they passed along the fence on the Israeli side," an army spokeswoman said. "After they identified the source of the gunfire, the soldiers went in and destroyed the post."

Reports to Israel's Cabinet count a total of 78 mortar shells fired at Israeli positions in April alone, and Israel holds that Arafat's governing group known as the Palestinian Authority was responsible for the attacks.

CNN said that Palestinian Authority officials deny being responsible for the attacks and say they have arrested several people for firing mortars from populated areas. However, the radical Palestinian group Hamas said on the same day that it would continue the mortar strikes.

"We have to convince the Israelis that their existence in our occupied territories is going to cost a lot," Hamas spokesman Mahmoud al-Zahar said. "Without reaching this conclusion, they will not withdraw from Palestinian areas."

§§§

The Return of the Mahdi

On December 10 of 2000, it was reported by the official Iranian

news agency that an Iranian Islamic revolutionary court has begun the trial of a group of messianic Shi'ite Muslim rebels charged with attempting to assassinate a senior judge.

Iranian Press reports quoted by CNN said that 30 members of the Mahdaviat group were to stand trial for the 1999 attempted assassination of the Tehran judiciary chief and cleric Ali Razini who was badly wounded when attackers on motorcycles attached a bomb to his official car.

The group has also been linked to plots against President Mohammad Khatami and his predecessor, Akbar Hashemi Rafsanjani, as well as stealing arms from state depots.

The trial, like many in Iran, was held behind closed doors and the outcome of the first hearing was not immediately clear.

The press report from the official Iranian news agency said that, "Mahdaviat, led by the grandson of a prominent scholar and cleric who died before the 1979 Islamic Revolution, takes its name from the 12th Imam, the Mahdi, whom Shi'ites believe will return one day to usher in an era of perfect justice." This confrontation of violence, looking for an era of "perfect justice," sounds a lot like Armageddon.

Security officials in Iran have said Mahdaviat, numbering between 30 to 34 members, sought to eliminate anyone they saw as an obstacle to the return of the Mahdi, who "went into hiding in the year 874."

The group, observers say, is on the violent, extremist fringe of traditionalist Shi'ite opposition to clerical rule in the Islamic Republic which argues that religion has been polluted by direct involvement in politics. Many Shi'ite Muslims are awaiting the return of the Mahdi in such countries as Pakistan, Iran, Afghanistan, Iraq, Syria and the former Muslim republics of the Soviet Union.

In contrast, countries such as Kuwait, Qatar, Saudi Arabia, Jordon, Egypt and rest of North Africa are comprised mostly of Sunni Muslims, who view the Shi'ites as a corruption of Islam, worshipping false prophets, while only Mohammed is the Prophet. Curiously, while most of Iraq, especially in the south, is Shi'ite Muslim, like Iran, Saddam Hussein and his elite military class are Sunni Muslim. This curious twist in Iraqi politics is sort of like a Protestant dictator ruling Catholic Ireland. Saddam Hussein is a puzzle, wrapped in an enigma. Some modern authors have called Hussein and his elite military hierarchy the "Mystery Babylon." As we shall see shortly, Saddam Hussein ("one who confronts" in Arabic) is just one aspect of the "Mystery Babylon" and its attendent apocalypse.

Iran Declares "War" on Israel

Several months later Iran and its "allies" declared "war" on the state of Israel. According to an Associated Press report, some of Israel's worst enemies gathered on the first of May in Tehran.

Angered by what they call aggression against Palestinians, the leader of Lebanon's Hezbollah guerrillas said "the fully armed Zionist military should wait for surprise attacks by Palestinian resistance groups."

Similarly, Iran's supreme leader, Ayatollah Ali Khamenei, called on the rest of the Muslim world to support the Palestinians, even if that meant defying the United States and the West.

"Supporting the Palestinian people is one of our important Islamic duties," he said.

He said that Zionists had exaggerated the Holocaust to justify crimes against the Palestinians. "There are documents at hand that show... that the numbers of the Jewish Holocaust were exaggerated to solicit international sympathy and lay the grounds for the occupation of Palestine and justify the atrocities of the Zionists," Khamenei said.

The attendees at the two-day conference organized by anti-Israeli resistance groups also included Khaled Mashaal, a leader of the radical Islamic Hamas movement and Ramezan Abdullah, head of the Palestinian Islamic Jihad.

Until now, most Muslim countries had distanced themselves from Iran, which considers Israel its archenemy, in its all-out support for a Palestinian uprising. But parliamentary leaders from over 30 Islamic countries, including Yemen, Lebanon, Bahrain, Qatar and Saudi Arabia attended the conference.

Iran's President Mohammad Khatami, a soft-spoken moderate on most issues, also did not hold back in his condemnation of Israel and its founding ideology saying, "The oppressed people of Palestine, whether those who dwell in that bloodstained holy land or those who continue to bear the brunt of hardship and displacement worldwide, are all-in-all the victims of Zionist discrimination and aggression."

In an April 27, 2001 interview, U.S. Vice President Dick Cheney said the Bush administration was actively involved in the Mideast peace process, talking and visiting with leaders in the region. But he said that Palestinian leader Yasser Arafat had not been invited to the White House yet because "that hasn't been something that we felt

would definitely move the process forward."

Cheney refused to leak any information about the president's expected speech on the U.S. missile defense system. But he said the main threat to the United States and its allies no longer comes from a superpower such as the former Soviet Union. He said the threat now comes from countries such as Iraq, Iran and Libya that he says are trying to obtain ballistic missiles and arm them with weapons of mass destruction.

§§§

Thy Kali Yuga Come—India's Border Clashes Escalate

Historically, India has had repeated clashes along its borders with Pakistan and China, and on April 20, 2001 had an unusual clash with another of its neighbors—the Muslim nation of Bangladesh.

On that day, India says at least eight of the 16 Border Guards killed during clashes on its frontier with Bangladesh had been tortured and then shot from close range.

"It was a brutal act of murder," Home Secretary Kamal Pandey told reporters after a meeting with Prime Minister Atal Bihari Vajpayee and members of his Cabinet. Indian doctors who had examined the bodies say the eight had bullet wounds that indicated the victims were shot at point blank range.

"They have also been mutilated, and one case of strangulation is also there," Pandey said. "It is very evident that these injuries and these bullet wounds could not have been obtained in fighting, but they were done as a brutal act of murder at close range."

Border disputes have occurred often over the years, but a high death toll is rare. Sections of the border have been in dispute since the British carved up the subcontinent in 1947, creating India and Pakistan. The eastern portion of Pakistan later became Bangladesh.

Tensions between the usually friendly India and Bangladesh erupted on Sunday, April 15, when Bangladeshi troops marched into a border village which it says India illegally occupied decades ago.

Then, on May 23, 2001, India ended a six-month military cease-fire against Islamic guerrillas in Kashmir and at the same time invited Pakistani military ruler Pervez Musharraf to peace talks aimed at ending five decades of hostility there.

India's defense minister, Jaswant Singh, told reporters the cease-fire "is now over. These terrorist groups have hindered the restoration of peace in Jammu and Kashmir and have inflicted misery upon

people of that state. Hereafter, security forces shall take such action against terrorists as they judge best."

Any talks would be the first by government officials from India and Pakistan since they came close to war while fighting on the Kashmir border in the summer of 1999. In November 2000, India began the unilateral cease-fire in Kashmir during the holy Islamic month of Ramadan in an attempt to get Islamic separatists to talk peace after a decade-old rebellion against India had left more than 30,000 people dead.

But widespread fighting continued between Indian forces and the guerrillas in Jammu-Kashmir, a state claimed by both countries but controlled by India. India and Pakistan have fought two wars over Kashmir, a territory that was divided between them. Although the state has always been mostly Muslim, and would have normally gone to Pakistan in the partition of 1947, the rajah of Kashmir was a Hindu, and decided that the state should be part of Hindu India. India has never backed down on its claim that Kashmir is part of its territory. Furthermore, Kashmir also administers sparcely populated Buddhist Lahdak, a key military area for India which is also claimed by the Chinese.

Meanwhile, just days before, India conducted its largest military exercises in the history of the country in the western Thar Desert near the Pakistani border. It was described in the press as an emergency drill of the armed forces in case of earthquake, flood, war or other disaster. Others preferred to call it a preparation for Armageddon.

§§§

The People's Armageddon

While all this was happening, on April 1, 2001, a mid-air collision between a Chinese jet and a U.S. surveillance plane occurred, triggering an 11-day standoff between the U.S. and China. The collision—over international waters in the South China Sea—destroyed the Chinese jet and forced the crippled U.S. aircraft to make an emergency landing at the nearest landing strip—China's Langshui military base on the Chinese island of Hainan.

China held the 24 U.S. crew members for 11 days while diplomats forged an agreement for their release. The deal included an American apology for the loss of the Chinese pilot and for landing the damaged plane without "verbal permission" from Chinese offi-

cials.

On April 12, 2001, a chartered jet with 24 crew members of a U.S. Navy plane took off from Hainan Island, China bringing to an end a tense 12 day negotiation between U.S. and Chinese diplomats. The release of the U.S. Navy crew occurred after the U.S. expressed regret for the collision between the Chinese fighter jet and U.S. spy plane and the subsequent emergency landing in China.

Although the crew was now released, the damaged U.S. plane remained on Hainan island as the negotiations continued. It was eventually returned, but not without a great deal of rhetoric from both sides.

Officials from the U.S. and China began meeting April 18 to discuss the collision, the return of the aircraft and China's concerns about U.S. surveillance flights, and in Washington a Bush administration official said the Chinese had agreed that the issue of "rules of the road"—how the two countries treated each other in international air space—would be examined by a bilateral joint maritime commission.

Meanwhile, Pentagon sources say it might be necessary for the United States to show it is willing to protect its flights, particularly if China takes a hard line. One compromise that the U.S. suggested would be to have U.S. F-15s from the air base in Okinawa, Japan flying at the same time as the surveillance flights, but some distance away, to keep an eye on things.

Publicly, administration officials would only say that they have a right to conduct those surveillance flights in international air space. However, the U.S. admits that such fighter-escorted flights could lead to further confrontations with the Chinese—confrontations which the U.S. may be subtly encouraging.

In most war scenarios, one country "dares" the other to take a certain step, with threatened retaliation. In order to save face, the one country takes the dare, and the fighting starts, as planned. Sometimes, in order to beat someone up, you have to make them throw the first punch.

Then, CNN reported on April 27, 2001, that Vice President Dick Cheney said a buildup in missiles deployed along China's coast prompted President Bush to warn Beijing that the United States would do whatever it took to protect Taiwan.

"Peace and the stability in the western Pacific and that part of Asia depends very much upon a continued U.S. presence and upon everybody in the area being comfortable that none of the nations out

there has hostile intent toward any others," Cheney said.

But the vice president strongly emphasized that the United States was committed to a "one-China" policy—as long as mainland China and Taiwan were united peacefully.

One element of the Armegeddon scenario is the constant buildup of advanced weapons and their delivery systems. The U.S. and Britain are decades ahead of the Third World combatants in Asia and the Middle East, but these countries are catching up fast. Rocket technology and various sorts of missiles are key to many of the Asian countries.

The Chinese government has been promoting their ambitious space program in its official press, announcing in the fall of 2000 that it would soon send its first astronaut into space—on a giant Chinese rocket. Incredibly, when the test of this rocket occurred, a silver disk was captured on film at the launching—a UFO hovering near the launch site.

On January 3, 2001, the Associated Press reported that poor farmers in Beijing's barren hills saw an object swathed in colored light arcing heavenward that some say must have been a UFO. Furthermore, people in 12 other Chinese cities reported possible UFO sightings during the spring of 2001. UFO researchers, meanwhile, were busy looking into claims of an alien abduction in Beijing.

At the beginning of the new millennium, China is astir with sightings of otherworldly visitors. Such sightings are treated with unexpected seriousness in this country usually straight-jacketed by its communist rulers.

China has a bimonthly magazine—circulation 400,000—devoted to UFO research. The conservative state-run media report UFO sightings. UFO buffs claim support from eminent scientists and liaisons with the secretive military, giving their work a scientific sheen of respectability.

"Some of these sightings are real, some are fake and with others it's unclear," said Shen Shituan, a real rocket scientist, president of Beijing Aerospace University and honorary director of the China UFO Research Association. "All these phenomena are worth researching."

Research into UFOs will help spur new forms of high-speed travel, unlimited sources of energy and faster-growing crops, claims Sun Shili, president of the government-approved UFO Research Association (membership 50,000).

A foreign trade expert and a Spanish translator for Mao Tse-tung, Sun saw a UFO nearly 30 years ago while at a labor camp for ideo-

logically suspect officials.

"It was extremely bright and not very big," said Sun. "At that time, I had no knowledge of UFOs. I thought it was a probe sent by the Soviet revisionists."

For thousands of years, Chinese have looked to the skies for portents of change on Earth. While China is passing through its first millennium using the West's Gregorian calendar, the traditional lunar calendar is ushering in the Year of the Dragon (2000-2001), regarded as a time of tumultuous change.

"All of that sort of millennial fear and trepidation fits in so nicely with Chinese cosmology—and also the Hollywood propaganda that everybody's been lapping up," said Geremie Barme, a Chinese culture watcher at Australia National University, in the press reports.

Even the Chinese are looking up at the sky, and seeing strange signs. The Chinese space race has begun. Will they really want to see lots of UFOs over their cities after all, considering some are probably made by their adversaries? While China has the largest army in the world, most of the fighting won't be done by men on the ground, but by space-based weapons and maybe even real UFOs will intervene. No matter how Armageddon unfolds in China, we can be assured it will be promoted vigorously in the official press.

§§§

Babylon or Bust

Meanwhile, on April 30, 2001, heavily armed jet fighters flown by British and American pilots were flying out of Incirlik Air Base in southern Turkey. These "coalition" aircraft dropped ordnance on elements of the Iraqi air defense system after Iraqi forces fired anti-aircraft rounds at them, the U.S. European Command said.

The incident occurred in the northern no-fly zone of Iraq near Mosul, U.S. officials said. The coalition aircraft were unharmed, the report said. There was no immediate response from Iraq, which remained silent.

The U.S. and British have been enforcing no-fly zones over northern and southern Iraq since the end of the Gulf War in 1991. The northern no-fly zone was ostensibly created by the United Nations to protect Kurds and other citizens in northern Iraq and the southern no-fly zone to protect Shi'ite Muslims in the south.

Saddam Hussein's army was relatively quiet and contained. If he could unite the Arab world around himself and against Israel, the

Arab kings, and the West, he might be able to achieve the glory of Nebuchadnezzar, the powerful Babylonian king who sacked Jerusalem in 587 BC, destroying the temple built by Solomon. Curiously, Saddam Hussein has been quoted as saying that he believes himself to be the reincarnation of Nebuchadnezzar, destined to conquer Israel and unite the Arab world. Does the "rebuilding" of the Temple the creation of the "Virtual Temple" mean his time has come?

The Continuing Crisis—Love and Rockets in Gaza

While British and U.S. jets patrolled over Iraq, violence continued in Gaza, when on May 10, a missile, fired by the Israeli Defense Forces, struck a police station and a compound containing a prison and Palestinian intelligence offices. Missiles also struck the offices of the Fatah party of Palestinian Authority President Yasser Arafat.

The strikes came after two Romanian workers were killed and one was wounded during a roadside bomb explosion on the border fence between Israel and Gaza.

After the blast near the Kissufim frontier crossing, Israeli tanks fired at a nearby Palestinian village, wounding three security officers and a civilian, Palestinian police sources said.

The blast came hours after seven people were injured after Israeli soldiers and Palestinians fought a gunbattle in the southern Gaza Strip in a fresh spasm of violence. Just prior to this latest exchange of fire the bodies of two Jewish teenagers—one an immigrant from Maryland, U.S.—were found beaten to death with rocks in a West Bank cave.

Six Palestinians and an Israeli soldier were wounded after Israeli bulldozers and tanks entered a Palestinian refugee camp. The Israeli security sources said the tanks and bulldozers went into the region to destroy buildings where they claimed Palestinians had launched attacks on Israelis.

Then, on May 12, a member of Palestinian President Yasser Arafat's Fatah movement was killed in an Israeli attack. CNN quoted Palestinian sources who said the man was one of two Palestinians killed in an attack by Israeli helicopter gunships in the West Bank town of Jenin, just a few miles from Israel's border with the West Bank.

Senior Palestinian official Tawfiq al-Tirawi said the attack was an assassination attempt by Israel against an intelligence officer.

Israeli helicopters were seen hovering near the Palestinian security headquarters when the car of Abdel-Karim Oweis was hit with a missile, he said. Oweis is reported to have escaped serious injury

and was treated at a nearby hospital but his passenger was killed.

The other man killed was a Palestinian police officer standing near the car when the missiles hit. Eyewitnesses said one missile struck the ground near the car and at least two more missiles were fired. One struck the car and another hit a nearby building.

It was on May 18 that the real fighting in the battle of Armageddon began in earnest. On this day, the Israeli Air Force for the first time used sophisticated weapons, two American-built F-16 fighter jets, to carry out retaliatory strikes on Gaza and the West Bank for a suicide bomber.

It was the first time since the 1967 Six-Day War that Israel used fighter jets to attack targets in Palestinian-controlled areas of the West Bank and Gaza, strikes that killed at least 11 people and injured about 60.

Early that day, a busy Friday before the Saturday Sabbath, six people died in a suicide bombing at a shopping mall in the Israeli coastal city of Netanya. Police said the suicide bomber drew the attention of security guards outside the shopping center by wearing a heavy coat on a warm day. The guards prevented him from entering the crowded mall, so the bomber detonated his explosives outside. Police reported that, in addition to the 6 dead, over 100 people were injured in the blast.

The Palestinian militant group Hamas claimed responsibility for the attack, identifying the bomber as a 20-year-old carpenter from the West Bank. Hamas spokesman Mahmoud al-Zahaar said that as Israel continues what he called the occupation of Palestinian lands, "no one in Israel, no one in Palestine will be safe."

Israeli reaction was swift and the country's U.S.-built F-16 fighters fired missiles at a Palestinian Authority police station in Nablus and offices of Palestinian Authority leader Yasser Arafat's elite Force 17 in Ramallah. At least eight were killed in Nablus, and a Force 17 member was reported killed in Ramallah.

In Gaza, Israeli jets hit the offices of Force 17 and the Palestinian Authority's coastal patrol force. Another raid hit the West Bank town of Tulkarem, the hometown of the Palestinian militant who carried out the bombing in Netanya.

The raids marked the first time that Israel has used fighter aircraft against Palestinian targets in the 7-month-old conflict, though previous raids had employed helicopter gunships.

At a meeting of the Arab League in Cairo, Egypt, on Saturday, May 19, foreign ministers urged in a non-binding resolution that the

22 members of the body suspend political contacts with Israel—a more moderate step than breaking off diplomatic relations, which also was under discussion.

The foreign ministers of Egypt and Jordan—the two Arab countries that have peace treaties with Israel and have been trying to broker a cease-fire—were among those who voted for the move.

Although Egyptian President Hosni Mubarak said the two countries will not give up on peace efforts, he was critical of the attacks. "Sharon is making the peace process difficult," Mubarak said. "The use of excessive force will never lead to peace.

Weeks of daily fighting continued and then CBS news reported on July 13th, (Friday the 13th, infact, a day that lives in infamy because the Knights Templars were arrested in Paris on Friday the 13th, October 1307) that "Israeli generals are planning for a possible massive invasion of Palestinian territories if the current Mideast cease-fire fails. A report published by the Jane's Information Group in London says the goal would be to destroy Palestinian armed forces and the Palestinian Authority, forcing Chairman Yasser Arafat back into exile, where he spent 12 years after the 1982 Israeli invasion of Lebanon."

According to the report, the invasion plan would be launched after another suicide bomb attack resulting in a large number of deaths, like the one at a Tel Aviv disco last month. The plan calls for air strikes by F-15 and F-16 fighter-bombers, a heavy artillery bombardment, and then an attack by a combined force of 30,000 men, including paratroopers, tank brigades and infantry. Israel's Arab neighbors, Syria, Jordan and Egypt are expected to stay out of the fight. The report considers the possibility that Iraq might try to intervene with troops, which would then be destroyed by the Israeli airforce. It also states that Egypt could invade the Sinai peninsula, forcing Israel to call up its reserves.

With this report from London, the Armageddon scenario was in full swing. Only the hour and day need be pin-pointed.

§§§

The Armageddon Scenario

With the world drawing sides for the big battle, the Armageddon scenario is starting to take form. On one side are hostile Arab and

Muslim forces, which include the former Soviet Muslim Republics in Central Asia, Afghanistan and its adopted revolutionaries such as Osama Bin Laden, Iran, Pakistan and eventually such Muslim-populated countries as Malayasia and Indonesia. Also on this side will be China and North Korea, and other states that oppose the dominance of the West and their "New World Order."

On the other side, the side of the Western powers, will be most of Europe, including Russia and Israel, plus the U.S., Canada, Japan, Australia, India, and the pro-Western governments of Southeast Asia, the Far East and Latin America. Many countries in Africa and Asia will simply be caught up in the fighting and will struggle to retain some sort of neutrality.

Of particular concern will be the direction of important, normally pro-Western countries that could go either way—mainly because the governments are typically pro-Western, while the populace at large is anti-Western, anti-Israeli, and anti-Arab monarchy. These countries include such pivotal nations as Egypt, Turkey, Saudi Arabia, Morocco, and Pakistan.

China has constructed a railway line that stretches from the factories of central China, through the Gobi Desert into western China and then over the Karakoram mountain range into Pakistan. This railway is a literal life-line of war ordnance and war materiel to Pakistan, Iran and the radical Islamic fundamentalists who are determined to destroy Israel and the west.

Other weapons, such as planes, submarines and ships are simply delivered to their destination by their motive power. Meanwhile, countries like Iraq, Iran, Pakistan and India make a considerable amount of their own weapons, and need little help, ultimately, from outside sources.

In each historical era, lasting approximately two generations, or 40 to 50 years, there is a proliferation of arms in various regions of the world, mainly in industrial countries and emerging industrial countries. In the early decades of this century and then in the early 1940s, the industrial nations of Europe, North America and the Far East reached a threshhold of technology- and arm-proliferation that made it essential that fighting—somewhere—had to occur, just to see if these submarines, torpedoes, bombers, and rocket bombs could really work like everyone said.

Now, this same sort of proliferation in the emerging industrial nations is reaching its peak. These countries have long sought to have their own powerful army and "defense" machines (hey, why not?)

and now they have achieved their goals. They need now only to use some of these deadly toys that they have acquired. This is called World War III. This is called Armageddon.

§§§

Mystery Babylon and the Four Horsemen of the Apocalypse

And upon her forehead was a name written
Mystery, Babylon the Great,
the mother of harlots and
Abomination of the Earth.
—Revelation 17:5

The strange term "Mystery Babylon" has come to be used as part of the enigma of Armageddon. With the collapse of the Tower of Babel, according to the Bible, the many mentions of Babylon (over 286) is begun. Babylon is important in the Bible as one of the many enemies of Israel, and Zion, that the ancient Hebrews had. Others included Egypt, Rome, Phoenicia, and the Hittite states.

Mystery Babylon is another name associated with "the beast"— the two-horned beast that was made to speak. This two-horned beast speaks to the entire world and deceives it. No one can buy or sell without a special "mark" or stamp of the beast. The code for this "mark of the beast" is the letter 6 repeated three times as 666.

This beast with two horns that speaks sounds remarkably like a modern television set. The modern television, especially in Asia and Europe, where cable TV is less common, has two antennae on the top of it, like two horns. Likewise, the modern television speaks to the entire world, and in some cases it deceives the world by promoting propaganda or certain world events from a highly biased point of view. This two-horned beast that was made to speak might also be a computer, as many television sets and computers are now merged into into one super technology that is used in the home. And with the increased use of credit cards, especially over the Internet and in response to TV ads, no one may truly buy or sell, without this "mark of the beast." This mark is essentially a computerized credit identifi-

cation and credit cards that come with it.

The Bible mentions Babylon hundreds of times, and most of the times Babylon is referenced as some sort of enemy of good people in general and Jerusalem in particular. The Hebrews were taken into captivity in 597 BC by Nebuchadnezzar and the Babylonians. It was here that they "wept" when they remembered Zion—the "city (and land) of Peace"—Jerusalem—that had lasted for 500 years.

The "Whore of Babylon" was predicted to rule for a thousand years. This is often seen as the thousand-year reign of the Catholic Church, or Church of Rome, a period known as the Dark Ages. Starting from about the 4th century AD with the destruction of the Library of Alexandria and the Councils of Nicea and Ephesus, and going to the discovery of the New World by Columbus and others circa 1500 AD, we have the thousand-year rule of the Whore of Babylon. This is seen, by Protestants at least, as the time of the false church, the evil priesthood who would seek to control the world by keeping them ignorant and suppressing the truth.

With the rise of the neo-Templars and the British-American domination of the world (including the world's oil reserves and oil-based technology) the Church of Rome is all but defeated. Though still strong in poor villages in Latin America and the Philippines, the Church of Rome's days are numbered. And it knows it.

Talk is in Rome that it is not desirable for the next Pope to be in power for such an extended period of time—nearly 20 years—as the present Pope. The next Pope should be especially elderly and feeble...

According to to the prophecies of the strange Irish monk known as Saint Malachy, there will be only three more popes and then the Catholic Church will be finished. Saint Malachy visited Rome in 1139 AD and left a list of 113 popes to reign from that day forward. He has been remarkably accurate. He calls the last pope Peter the Roman, and says that Rome will be destroyed at the end of his reign and the papacy will be no more.

So, according to these prophecies, there are only a few more Popes to go, and the entire Papacy will have come to a halt. Not through torture or execution, but out of sheer lack of interest.

But Armageddon probably won't be canceled for lack of interest. Interest is great indeed, and for some, the waiting is getting a bit tiresome. For others, the trap is set, and Mystery Babylon is either about to take over the world, or get its ass whipped. Or both. While the Catholic church may have been the Whore of Babylon that would rule for a thousand years, its time is now past, and the Mystery

Babylon of Armageddon appears to be something different, a kind of control system on one hand, and a Middle Eastern leader and military power on the other.

The whole quest for Mystery Babylon takes us to obvious candidates such as Saddam Hussein, the dictator of Iraq, the former power once known as "Babylon." It also takes us in completely different directions as well—to the power structure of the international bankers, royal families, oil companies and the churches and governments they control.

Indeed, what had started out as letters of credit amongst the Knights Templar has today become a banking system where no money ever has to change hands—a cashless economy. Yet this cashless economy does not come without a price—the mark of the beast: a credit card and an established tax-paying identity behind the card. Otherwise, no one might buy or sell.

Yet, while there is nothing wrong with a cashless economy, or credit cards and computer tracking systems in general, what is a serious problem is the level of deception and manipulation that the "Mystery Babylon" money system and its brokers have brought upon a world that is looking forward to this like a street riot waiting to take place.

And Mystery Babylon, the new system, is ready for the riots to start. They want them to start. They just want the riot to be manageable, without flashing too fast—more of a slow burn with occasional bangs.

§§§

The Death Star and Armageddon

Meanwhile, a space-based weapons system has been installed around the planet and special super-sonic bombers and fighters are ready to make air strikes anywhere in the world. While a lot of this new equipment has not really been tested in battle, it needs to be tested—soon!

With a rush of hot wind, the four horsemen of the apocalypse will swoop down from their hidden fortresses and decimate their foes. And their foes will strike back, and there will be more misery. And the Masters of War will fight, and kill, and die. And in the end the meek shall inherit the Earth. The man of war will inherit the wind.

Once again, peace will reign on the planet. A thousand years of peace, a period during which "evil shall be bound." After this, pros-

perity and peace remain, but those who have been withheld from reincarnation will be allowed to return to the Earth to complete their karma.

Thus, this Armageddon is not the end of the world. It is only the end of the Old Order. George H. Bush's New World Order was just the Old Order with a new face—a kinder, gentler, machine-gun hand, as Neil Young once said—and other aspects of the old order went back to the gladiators of ancient Rome—evidenced by today's Super Bowl, modern gladiators in full armor.

It is the end of the many obsolete modes of thinking, religions, customs, and unwillingness to treat our neighbors as ourselves. It will be the end of monarchies and family-owned countries. It will be the age of information—for those that have power—and of awesome technology. Some of this technology will be brought out during Armageddon, including beam weapons and whole new generations of formerly-secret aircraft.

While the emerging industrial combatants want to wage a conventional war with the weapons they have accumulated over the decades, the U.S. and Britain will fight back with weapons that are only rumors to other countries, weapons that will not start the war, but weapons that will finish it.

After the general fighting in the Middle East begins, the U.S. and Britain will hold back from the fighting, and daily warn the many different parties that it is unwise to fight, and things might get worse. Meanwhile, these countries will carry on daily skirmishes, from Gaza to Israel, to Lebanon, to Syria, to Iraq, to Iran, to Pakistan, to India, to China…

Eventually, the U.S. and Britain, and probably all of NATO will be dragged into the war. Russia is already immersed in this war, particularly in Chechnya. Other Islamic-Christian hot spots continue to be Bosnia, Kosovo, Macedonia, Egypt, and Indonesia. Pakistan and India have been fighting continuously for years, but the fighting intensifies.

China will flex its muscles, and, because it is the biggest bully on the block, the U.S. will purposely confront it. Not being able to back down, China will commit an unwise, but justifiable, act of aggression on a U.S. property, such as a reconnaissance plane. This will give the U.S. the much-wanted opportunity to match its military with the Chinese, and see who wins. With allies in Russia, Japan and Taiwan, the U.S. would wage war in the Far East, and not in North America.

With the declaration of war by the U.S. and NATO against the Muslim League and China, the U.S. system would begin to systematically take out all of the radar installations, control centers and military bases of the enemy countries. Cyber viruses would paralyze all the governments' computers, and communication across the countries would be on a virtual war-footing. Much of the destruction would be from space-based weapons or smart missiles, and so little engagement of actual soldiers would take place. That would be happening on the ground with some neighboring country.

Countries always fight with their neighbors it seems. Why have a fight with the guy way across town? His barking dogs aren't keeping you up all night. For 40 years during the Cold War America's enemy was thousands of miles away, in Russia. Most countries don't have to look that far away. Their enemy, traditional or otherwise, is right next door.

So, you let them fight. Meanwhile, you make sure both sides get a good whooping. Supply them with all the cans of extra-strength whoop-ass that you can. Then, because you're more powerful than either of them, you get them to make peace and allow free trade. Meanwhile, you're looking out for mom and her apple pie by making sure all the war mongers around the world are using up their arms stockpiles. And if they're not, you use it up for them—blowing the stockpiles up before they can be used!

§§§

Apocalypse Hollywood Style

While all the tension was building in the Middle East, on May 10, 2001, a group of about 20 former government workers, many of them military and security officials, stepped forward to say they had witnessed evidence of aliens and unidentified flying objects and called for congressional hearings about such sightings.

"These testimonies establish once and for all that we are not alone," said Steven Greer, director of the Disclosure Project, a nonprofit research organization dedicated to disclosing alleged alien sightings. Greer, who organized the program at the National Press Club in Washington, argued that the United States and other governments have known about UFOs for at least 50 years and have been keeping the information secret.

The group's extensive website, which can be viewed at www.disclosureproject.org, quoted Greer as saying that there were

333

some 400 witnesses who claim to have firsthand experience with UFO sightings or alien evidence, and are willing to testify before Congress. Although some of Greer's sources are apparently unreliable, one is Daniel Sheehan, a well-known and respected Washington lawyer who is acting as counsel for members of Greer's group.

Sheehan told reporters that during the Carter administration he found out about government-held UFO information that then-CIA Director George Bush, father of the current president, would not release.

Sheehan said he was then led into the National Archives, where he was shown photographs of captured UFOs, complete with what appeared to be alien writing symbols, but he was only allowed to take notes on a yellow legal pad. He traced the photos onto the cardboard back of his pad, he said.

As information from the group reached the press on May 10th, James Oberg, an ABC News space consultant and retired NASA engineer, told the media that Greer has long argued "there's this bizarre theory that there is a world-wide real X-file cabal that is using UFO technology."

But Oberg noted not every witness attending the conference necessarily subscribed to Greer's theory, and says those attending the press conference shouldn't be mocked. "People see strange things they can't understand, and that can't be explained either then or in hindsight, and it's good to keep documenting these, because often the mysterious sightings are things of interest, to military intelligence or even to science."

Oberg said people sometimes can be too quick to conclude that the explanation is little green men, when the answer might be something else, including secret military technology.

The U.S. government repeatedly has denied having any evidence of extraterrestrial visitors, their craft, or that it has advanced craft or underground manufacturing facilities. The government does admit, though, that it investigated UFOs for decades, and has an intense interest in the phenomena—which is essentialy the science of unidentified aircraft—aircraft that seems to incorporate an advanced technology.

In another statement at the conference on May 10, Donna Hare, a former NASA contract employee, said that Apollo astronauts saw an alien craft when they landed on the moon, but were told not to reveal it. Hare's source was a man who had been quarantined with the astronauts.

In a statement to the press, Greer said extraterrestrials could provide a new, plentiful source of energy that would supply the world's energy needs. Furthermore, Greer went on to say that information from alien encounters could also have significant impact on the global environment and the quest for world peace. Like preventing Armageddon?

Will the the end of the world as we know it be an apocalypse Hollywood style? With lasers and light shows, sirens and screaming, flying saucers and triangular UFOs wreaking havoc on the concrete bunkers of Iraq, Iran, Syria and Gaza? Will millions watch the "apocalypse now" scenario played out on big-screen TV with terse commentary and snappy commercials? Lots of Holocaust movies will suddenly appear on television, forcing us to remember why all this is happening in the first place.

From the underground bases at Area 51 a new generation of aircraft will go into combat for the the first time—and the world will be amazed! Yet, can we believe what we see on television? Though it may look real, can we really trust the two-horned beast that was made to speak and would deceive the world? The ability to wage a Star Wars-type battle on Earth, including space-based weapons in a similar manner to George Lucas' Death Star technology, would tip the scales in the final battle for earth in one direction or another. The question is, as Bob Dylan would say, which way are we heading? To Lincoln Country Road, or Armageddon?

Bibliography and Footnotes

1. *The Great Pyramid Decoded*, Peter Lemesurier, 1978, Element Books, London.
2. *Armageddon, Oil and the Middle East*, John F. Walvoord, 1970, (revised 1990), Zondervan Publishing, Grand Rapids, MI.
3. *The Serpent in the Sky*, John Anthony West, 1979, Quest Books, Wheaton, IL.
4. *The Armageddon Script*, Peter Lemesurier, 1981, Element Books, London.
5. *Pyramid Prophecies*, Max Thoth, 1974, Dell Books, New York.
6. *The Peacemaker*, William Henry, 1997, Earthpulse Press, Anchorage, AK.
7. *Saddam's Mystery Babylon*, Arno Froese, 1998, Olive Press, Columbia, SC.
8. *Rolling Thunder*, Joseph Jochmans, 1980, Sun Books, Sante Fe, NM.
9. *Secret Chamber*, Robert Bauval, 1999, Random House UK, London.
10. *Warriors of the Old Testament*, Mark Healy, 1989, Firebird Books, Dorset, UK.
11. *Secrets of the Great Pyramid*, Peter Tompkins, 1971, Harper & Row, New York.
12. *Egypt Before the Pharaohs*, Michael A. Hoffman, 1979, Alfred Knopf, New York.

13. *Groliers Encyclopedia*, 1997, Grolier Interactive, Danbury, CT..
14. *The Great Pyramid: Man's Monument to Man*, Tom Valentine, 1975, Pinnacle, New York.
15. *Solomon's New Men*, E.W. Heaton, 1974, Pica Press, New York.
16. *Pyramidology, Books I & II*, Adam Rutherford, 1957,1962, Institute of Pyramidology, Hertfordshire, Great Britain.
17. *Book of Enoch,* translated by Richard Laurence, 1883, 1999, Adventures Unlimited Press, Kempton, IL.
18. *Groliers Encyclopedia,* 1997, Grolier Multimedia, Danbury, CT.

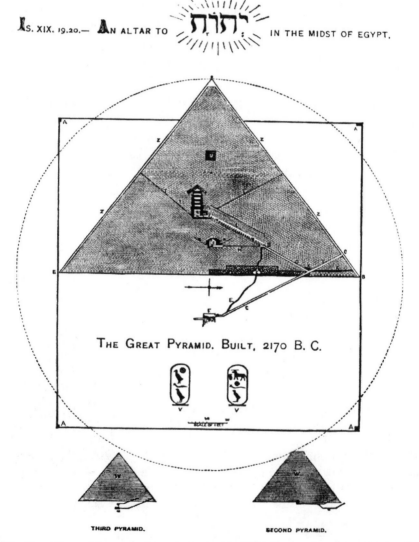

The Great Pyramid as a prophecy device in this 1877 diagram from one of the earliest books on the subject, *The Great Pyramid: A Miracle in Stone* by Joseph A. Seiss.

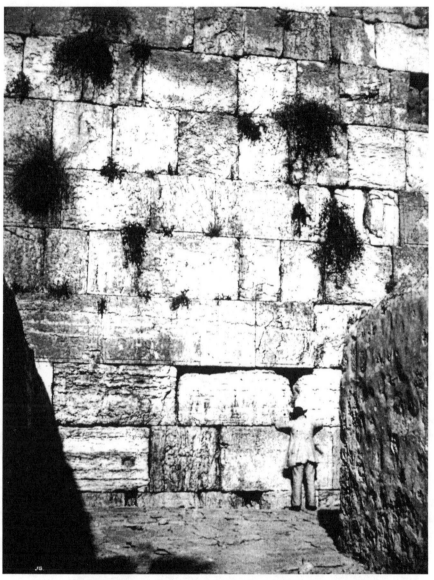

The Wailing Wall in Jerusalem, part of the First Temple.

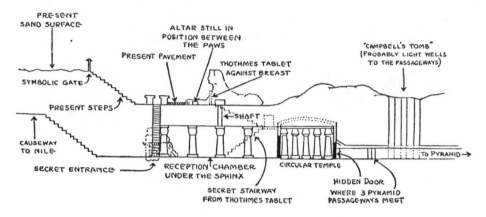

Secret tunnels beneath the Sphinx, leading to the Great Pyramid, are conjectured in this 1936 drawing from *The Symbolic Prophecy of the Great Pyramid* by H. Spencer Lewis.

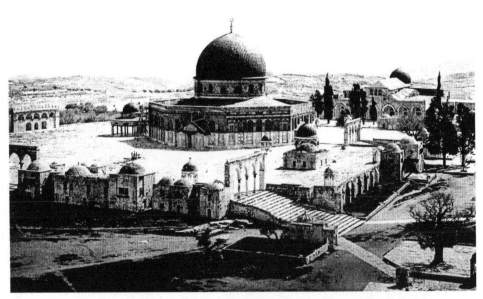

The Dome of the Rock mosque in Jerusalem, built on top of the ancient Temple, in a photo taken in 1895 by the Swiss photographer Bonfils.

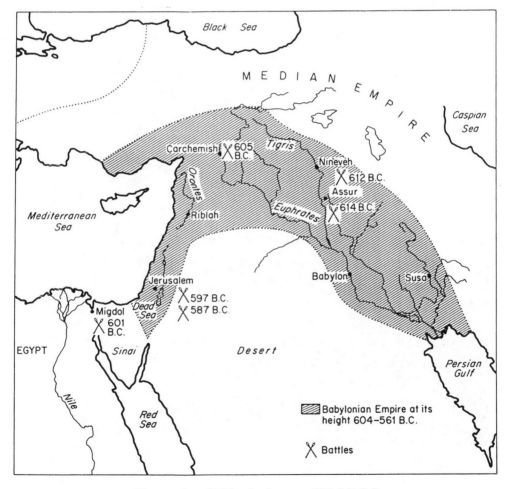

The empire of Nebuchadnezzar, 604-561 BC.

Nebuchadnezzar grasps the hand of a statue of his lord, Marduk, during the Babylonian festival of the New Year.

10.
Tomorrow
Never Knows—
Brave New World

The world of reality has its limits;
the world of imagination is boundless.
—Jean-Jacques Rousseau

Violence does, in truth, recoil upon the violent, and the
schemer falls into the pit which he digs for another.
—Sherlock Holmes

Seven blunders of the world that lead to violence:
wealth without work, pleasure without conscience,
knowledge without character, commerce without morality,
science without humanity, worship without sacrifice,
politics without principle.
—Mahatma Gandhi *(1869-1948)*

Preeminent New York journalist John Swinton, the guest of honor at a media banquet, responded to a request to drink a toast to the independent press saying:

"There is no such thing, at this date of the world's history, in America, as an independent press... The business of the journalists is to destroy the truth, to lie outright, to pervert, to vilify, to fawn at the feet of mammon, and to sell his country and his race for his daily bread. You know it and I know it, and what folly is this toasting an independent press? We are the tools and vassals of rich men behind the scenes. We are the jumping jacks, they pull the strings and we dance. Our talents, our possibilities and our

lives are all the property of other men. We are intellectual prosti-tutes."

He said this around 1880.

Unfortunately, things have not changed that much in 120 years. The "independent press" is still controlled by rich men behind the scenes. Whether the press is telling us that there is an energy crisis and we must drill for more oil in our backyard nature pre-serves, or the Holocaust in 1944 is excuse enough for anything that the modern state of Israel does in 2001, or that we need to give up more and more of our so-called "freedoms" to make a safer society for our children, the controllers behind the scenes are behind it all.

Back in the 1800s it was the railroad barons, mining barons and European bankers such as the Rothschilds, that were in con-trol of the governments and the "independent press." Today, the power brokers are big business, oil companies and their partners in the military-industrial complex. Rockets, missiles, bombers, jet fighters, and a whole new generation of aerospace and military products with their high-tech computer operating systems are driving the world and its economy into a headlong rush to a ca-tastrophe of unequaled proportions. When all these military con-sumer products are eventually used as they are intended, it will be an event of such great magnitude that the name given to it by the independent press will be none other than Armageddon.

> *Karmageddon:* It's like, when everybody is sending off all these really bad vibes, right? And then, like, the Earth explodes and it's like, a serious bummer.

§§§

The Strange Vision of General George Washington

The destiny of the United States in relation to the rest of the world has been the subject of many books, prophecies, and specu-lation. While in every nation the people are taught to love their country, their government, their royalty, and to trust their lead-ers, in the United States there is a strong tradition that our nation is destined to lead the world into a new golden age, a new order based on divine law, a kingdom of God that will be "on Earth as it is in heaven."

While many nations promote the belief "my country, right or wrong," as a population becomes better educated, more compassionate, informed, and spiritually-minded, people can more clearly see through the haze of special interests, media manipulation, and regional selfishness. The dream of America, like the New Jerusalem and the elusive "Kingdom of God," encompasses all people who desire a better world—for everybody. This dream is not for some select chosen people of some regional ethnic group, religious group, or ancestry, but for like-minded people of every background and race.

The strange vision of George Washington has a bearing on all this. The popular leader of the American armed forces during the Revolutionary War (yes, at one time America supported revolutions against dictators and monarchs—today, we support the same dictatorships and monarchies that we had fought so bravely against years ago) allegedly had a vision of the future conflicts of the United States. While the vision wasn't published until 1880 and it cannot be verified, it is an interesting story nonetheless, and is at least 120 years old.

George Washington's vision was originally published by a man named Wesley Bradshaw who apparently began circulating the story around 1859, when it first began appearing in newspapers and magazines. The following version is copied from a reprint in the *National Tribune*, Vol. 4, No. 12, December, 1880. This is the story of Washington's vision:

> The last time I ever saw Anthony Sherman was on the Fourth of July, 1859, in Independence Square. He was then ninety-nine years old, his dimming eyes rekindled as he gazed upon Independence Hall, which he came to visit once more. "I want to tell you an incident of Washington's life— one which no one alive knows of except myself—and, if you live, you will before long, see it verified.
>
> He said, "From the opening of the Revolution, we experienced all phases of fortune, good and ill. The darkest period we ever had, I think, was when Washington, after several reverses, retreated to Valley Forge where he resolved to pass the winter of 1777. Ah! I have often seen the tears coursing down our dear commander's careworn cheeks, as he would be conversing with a confidential officer about the condition of his soldiers. You have doubtless heard the

story of Washington's going to the thicket to pray. Well, he also used to pray to God in secret for aid and comfort.

"One day, I remember well, the chilly winds whistled through the leafless trees; though the sky was cloudless and the sun shone brightly, he remained in his quarters nearly all the afternoon, alone. When he came out I noticed that his face was a shade paler than usual, and there seemed to be something on his mind of more than ordinary importance. Returning just after dusk, he dispatched an orderly to the quarters of the officer I mentioned who was presently in attendance. After a preliminary conversation of about half an hour, Washington, gazing upon his companion with that strange look of dignity which he alone could command, said to the latter:

"I do not know whether it is owing to the anxiety of my mind, or what, but this afternoon, preparing a dispatch, something seemed to disturb me. Looking up, I beheld, standing opposite me, a singularly beautiful being. So astonished was I, for I had given strict orders not to be disturbed, that it was some moments before I found language to inquire the cause of the visit. A second, a third, and even a fourth time did I repeat my question, but received no answer from my mysterious visitor, except a slight raising of the eyes. By this time I felt strange sensations spreading through me, and I would have risen, but the riveted gaze at the being before me rendered volition impossible. I assayed once more to speak, but my tongue had become useless, as though it had become paralyzed. A new influence, mysterious, potent, irresistible, took possession.

"All I could do was to gaze steadily, vacantly at my unknown visitor. Gradually the surrounding atmosphere seemed as though becoming filled with sensations, and grew luminous. Everything about me seemed to rarefy, including the mysterious visitor.

"I began to feel as one dying, or rather to experience the sensations which I have sometimes imagined accompany dissolution. I did not think, I did not reason, I did not move; all were alike impossible. I was only conscious of gazing fixedly vacantly at my companion.

"Presently I heard a voice saying, 'Son of the Republic, look and learn,' while at the same time my visitor extended

an arm eastwardly. I now beheld a heavy vapor at some distance rising fold upon fold. This gradually dissipated, and I looked out upon a strange scene. Before me lay spread out in one vast plain all the countries of the world: Europe, Asia, Africa and America. I saw rolling and tossing between Europe and America the billows of the Atlantic, and between Asia and America lay the Pacific.

"'Son of the Republic,' said the same mysterious voice as before, 'look and learn.' At that moment I beheld a dark shadowy being as an angel standing, or rather floating in mid-air, between Europe and America. Dipping water out of the ocean in the hollow of his hand, he cast some on Europe. Immediately a cloud raised from these countries, and joined in mid-ocean. For a while it remained stationary, and then moved slowly westward until it enveloped America in its murky folds. Sharp flashes of lightning gleamed through it at intervals, and I heard smothered groans and cries of the American people. A second time the angel dipped water from the ocean and sprinkled it out as before. The dark cloud was then drawn back to the ocean, in whose billows it sank from view.

"A third time I heard the mysterious voice saying, 'Son of the Republic, look and learn,' and I cast my eyes upon America and beheld villages and towns and cities spring up one after another until the whole land from the Atlantic to the Pacific was dotted with them. Again I heard the mysterious voice say, 'Son of the Republic, the end of the century cometh, look and learn.'

"And this time the dark shadowy angel turned his face southward, and from Africa I saw an ill omened spectre approach our land. It flitted slowly over every town and city of the latter. The inhabitants presently set themselves in battle against each other. As I continued looking, I saw a bright angel on whose brow rested a crown of light, on which was traced the word, 'Union,' bearing the American flag which he placed between the divided nation, and said, 'Remember, ye are brethren.' Instantly the inhabitants, casting down their weapons, became friends once more, and united around the National Standard.

"Again I heard the mysterious voice saying 'Son of the Republic, look and learn.' At this the dark, shadowy angel

placed a trumpet to his lips and blew three distinct blasts; and taking water from the ocean, he sprinkled it on Europe, Asia and Africa. Then my eyes beheld a fearful scene; from each of these countries arose thick black clouds that were soon joined into one. And throughout this mass there gleamed a dark red light by which I was seeing hordes of armed men who, moving with the cloud, marched by land and sailed by sea to America which country was enveloped in the volume of cloud. And I dimly saw these vast armies devastate the whole country and burn the villages, towns and cities that I beheld springing up.

"As my ears listened to the thundering of the cannon, slashing of swords, and the shouts and cries of millions in mortal combat, I again heard the mysterious voice saying, 'Son of the Republic, look and learn.' When the voice had ceased, the dark angel placed his trumpet once more to his mouth and blew a long and fearful blast.

"Instantly light as of a thousand suns shown down from above me, and pierced and broke into fragments the dark cloud which enveloped America. At the same moment, the angel upon whose head still shown the word 'Union' and who bore our national flag in one hand and a sword in the other, descended from the heavens attended by legions of white spirits. These immediately joined the inhabitants of America, whom I perceived were well-nigh overcome, but who, immediately taking courage again, closed up their broken ranks and renewed the battle. Again amid the fearful noise of the conflict I heard the mysterious voice saying, 'Son of the Republic look and learn.' As the voice ceased, the shadowy angel for the last time dipped water from the ocean and sprinkled it upon America. Instantly the dark cloud rolled back, together with the armies it had brought, leaving the inhabitants of the land victorious.

"Then once more, I beheld the villages, towns and cities springing up where I'd seen them before while the bright angel, planting the azure standard he had brought in the midst of them, cried with a loud voice: 'While the stars remain and the heavens send down dew upon the earth, so long shall the Union last.' And taking from his brow the crown on which blazoned the word 'Union' he placed it upon the standard while the people, kneeling down, said

'Amen.'

'"The scene instantly began to fade and dissolve, and I, at last, saw nothing but the rising, curling vapor I at first beheld. This also disappeared, and I found myself once more gazing upon the mysterious visitor who, in the same voice I had heard before said, 'Son of the Republic, what you have seen is thus interpreted. Three great perils will come upon the Republic. The most fearful is the third passing which the whole world united shall not prevail against her. Let every child of the Republic learn to live for his God, his land and Union.' With these words the vision vanished, and I started from my seat and felt that I had seen a vision wherein had been shown me the birth, the progress and the destiny of the United States."

"Such, my friends," said the venerable narrator, were the words I heard from Washington's own lips, and America will do well to profit by them."

And so was Washington's alleged vision, given to him by a mysterious stranger. Washington is reported to have told only a few chosen officers of his encounter, one of these being Anthony Sherman. He related the story to the newspaperman Wesley Bradshaw, who, as we have noted, began popularizing the story in 1859—two years before the Civil War.

The first part of Washington's vision apears to describe the Revolutionary War and the subsequent settlement of the nation. In the second vision, Washington sees the Civil War, while in the third vision, he is possibly witnessing Armageddon. The vision starts in Europe, Africa, and Asia, regions issuing out thick black clouds, then joining as one and moving toward America. Throughout this mass the general saw explosions of gleaming red light, outlining in each flash great numbers of armed men, moving with the cloud. America, however, is victorious over this invading force, and a period of reconstruction begins.

In the battle of Armageddon, it is possible that victorious armies of the Middle East and North Africa will turn to Europe, and eventually to the hated United States, sometimes called "The Great Satan" by radical leaders of the Middle East. On the other side of the world, Sunday preachers are calling Saddam Hussein and his allies the "Mystery Babylon" and the Anti-Christ. Meanwhile right-wing Jews in Israel plot to blow up the mosque on Solomon's

Temple mount. Fanatical Hindus march through Muslim villages in India as well.

§§§

The Prophecies of Mother Shipton

Another curious body of work that is worth examining is the so-called Prophecies of Mother Shipton. Mother Shipton reputedly was born Ursula Sontheil in 1488 in Norfolk, England, and died in 1561, burned at the stake for being a witch. She exhibited prophetic and psychic abilities from an early age. At 24, married to Toby Shipton, she eventually became known as Mother Shipton. Many of her visions came true within her own lifetime and in subsequent centuries.

These rare verses from Mother Shipton, published as you see them, have appeared in a number of magazines, particularly in Britain. This version was published in *Nexus* magazine (Vol. 2, No. 3, 1992). The verses are in rhyme and seem to have prophetic indications for our times, but of course are open to interpretation:

> And now a word, in uncouth rhyme
> Of what whall be in future time
>
> Then upside down the world shall be
> And gold found at the root of tree
> All England's sons that plough the land
> Shall oft be seen with Book in hand
> The poor shall now great wisdom know
> Great houses stand in far flung vale
> All covered o'er with snow and hail
>
> A carriage without horse will go
> Disaster fill the world with woe.
> In London, Primrose Hill shall be
> In centre hold a Bishop's See
>
> Around the world men's thoughts will fly
> Quick as the twinkling of an eye.
> And water shall great wonders do
> How strange. And yet it shall come true.

Through towering hills proud men shall ride
No horse or ass move by his side.
Beneath the water, men shall walk
Shall ride, shall sleep, shall even talk.
And in the air men shall be seen
In white and black and even green

A great man then, shall come and go
For prophecy declares it so.
In water, iron, then shall float
As easy as a wooden boat
Gold shall be seen in stream and stone
In land that is yet unknown.

And England shall admit a Jew
You think this strange, but it is true
The Jew that once was held in scorn
Shall of a Christian then be born.

A house of glass shall come to pass
In England. But Alas, alas
A war will follow with the work
Where dwells the Pagan and the Turk

These states will lock in fiercest strife
And seek to take each others life.
When North shall thus divide the south
And Eagle build in Lions mouth
Then tax and blood and cruel war
Shall come to every humble door.

Three times shall lovely sunny France
Be led to play a bloody dance
Before the people shall be free
Three tyrant rulers shall she see.

Three rulers in succession be
Each springs from different dynasty.
Then when the fiercest strife is done
England and France shall be as one.

The British olive shall next then twine
In marriage with a German vine.
Men walk beneath and over streams
Fulfilled shall be their wondrous dreams.

For in those wondrous far off days
The women shall adopt a craze
To dress like men, and trousers wear
And to cut off their locks of hair
They'll ride astride with brazen brow
As witches do on broomstick now.

And roaring monsters with man atop
Does seem to eat the verdant crop
And men shall fly as birds do now
And give away the horse and plough.

There'll be a sign for all to see
Be sure that it will certain be.
Then love shall die and marriage cease
And nations wane as babes decrease

And wives shall fondle cats and dogs
And men live much the same as hogs.

In nineteen hundred and twenty six
Build houses light of straw and sticks.
For then shall mighty wars be planned
And fire and sword shall sweep the land.

When pictures seem alive with movements free
When boats like fishes swim beneath the sea,
When men like birds shall scour the sky
Then half the world, deep drenched in blood shall die.

For those who live the century through
In fear and trembling this shall do.
Flee to the mountains and the dens
To bog and forest and wild fens.

For storms will rage and oceans roar
When Gabriel stands on sea and shore
And as he blows his wondrous horn
Old worlds die and new be born.

A fiery dragon will cross the sky
Six times before this earth shall die
Mankind will tremble and frightened be
for the sixth heralds in this prophecy.

For seven days and seven nights
Man will watch this awesome sight.
The tides will rise beyond their ken
To bite away the shores and then
The mountains will begin to roar
And earthquakes split the plain to shore.

And flooding waters, rushing in
Will flood the lands with such a din
That mankind cowers in muddy fen
And snarls about his fellow men.

He bares his teeth and fights and kills
And secretes food in secret hills
And ugly in his fear, he lies
To kill marauders, thieves and spies.

Man flees in terror from the floods
And kills, and rapes and lies in blood
And spilling blood by mankind's hands
Will stain and bitter many lands

And when the dragon's tail is gone,
Man forgets, and smiles, and carries on
To apply himself—too late, too late
For mankind has earned deserved fate.

His masked smile—his false grandeur,
Will serve the Gods their anger stir.
And they will send the Dragon back
To light the sky—his tail will crack

Upon the earth and rend the earth

And man shall flee, King, Lord, and serf.
But slowly they are routed out
To seek diminishing water spout
And men will die of thirst before
The oceans rise to mount the shore.

And lands will crack and rend anew
You think it strange. It will come true.

And in some far off distant land
Some men—oh such a tiny band
Will have to leave their solid mount
And span the earth, those few to count,
Who survives this (unreadable) and then
Begin the human race again.
But not on land already there
But on ocean beds, stark, dry and bare
Not every soul on Earth will die
As the Dragons tail goes sweeping by.

Not every land on earth will sink
But these will wallow in stench and stink
Of rotting bodies of beast and man
Of vegetation crisped on land.

But the land that rises from the sea
Will be dry and clean and soft and free
Of mankind's dirt and therefore be
The source of man's new dynasty.

And those that live will ever fear
The dragons tail for many year
But time erases memory
You think it strange. But it will be.

And before the race is built anew
A silver serpent comes to view
And spew out men of like unknown
To mingle with the earth now grown

Cold from its heat and these men can
Enlighten the minds of future man.

To intermingle and show them how
To live and love and thus endow
The children with the second sight.
A natural thing so that they might

Grow graceful, humble and when they do
The Golden Age will start anew.
The dragons tail is but a sign
For mankind's fall and man's decline.

And before this prophecy is done
I shall be burned at the stake, at one
My body singed and my soul set free
You think I utter blasphemy
You're wrong. These things have come to me
This prophecy will come to be.

These verses were on the outer wrapping of the scrolls:

I know I go—I know I'm free
I know that this will come to be.
Secreted this—for this will be
Found by later dynasty
A dairy maid, a bonny lass
Shall kick this stone as she does pass
And five generations she shall breed
Before one male child does learn to read.
This is then held year by year
Till an iron monster trembling fear
Eats parchment, words and quill and ink
And mankind is given time to think.

And only when this comes to be
Will mankind read this prophecy
But one mans sweet's another's bane
So I shall not have burned in vain.
—Mother Shipton

This section was kept apart from the other and it appears to have been written together yet was in a separate jar:

The signs will be there for all to read
When man shall do most heinous deed
Man will ruin kinder lives
By taking them as to their wives.

And murder foul and brutal deed
When man will only think of greed.
And man shall walk as if asleep
He does not look—he many not peep
And iron men the tail shall do
And iron cart and carriage too.

The kings shall false promise make
And talk just for talking's sake
And nations plan horrific war
The like as never seen before
And taxes rise and lively down
And nations wear perpetual frown.

Yet greater sign there be to see
As man nears latter century
Three sleeping mountains gather breath
And spew out mud, and ice and death.
And earthquakes swallow town and town,
In lands as yet to me unknown.

And Christian one fights Christian two
And nations sigh, yet nothing do
And yellow men great power gain
From mighty bear with whom they've lain.

These mighty tyrants will fail to do
They fail to split the world in two.
But from their acts a danger bred
An ague—leaving many dead.
And physics find no remedy
For this is worse than leprosy.

Oh many signs for all to see
The truth of this true prophecy.

Mother Shipton speaks of many amazing things in her prophecy. Some of these amazing things have already come true, such as a horseless carriage that fills the world with woe (cars and their attending auto accidents) or a house made of glass (Kew Gardens in London). Others are yet to happen. She speaks of wars, of earth changes, of a comet or something else that could be described as a dragon's tail in the sky, airships and new race of children. Are we about to enter those times?

§§§

The World of Tesla Technology

A brave new world would soon be beginning at Cheyenne Mountain outside of Colorado Springs, with it's electric cars and deep tunnel network. The science fiction of tomorrow is now, secretly beneath our feet and in the skies above our heads. The technology used inside this "city in a mountain" is apparently a different type of technology than is currently used in the outside world. There are no fossil fuel burning cars, diesel generators, or pollution. The entire city is based on highly efficient electric motors and mag-lev trains that run underground to other high-tech installations beneath military bases and other areas.

More and more the modern press is using terms like "Tesla Technology," anti-gravity, free energy, and electrogravity. The world of rocket propulsion and oil wars seems firmly entrenched in the last century.

Ironically, the main proponent of many of these concepts, Nikola Tesla, did most of his work at the turn of the last century. Many of his inventions and concepts were so advanced that they are thought of as science fiction yet today. Tesla himself became something of a suppressed person. Even though he is probably the greatest inventor who ever lived, even having invented the alternating current electrical system that is used to light the world today, most people have never heard of him!

While oil-producing countries like Iraq, Iran, and Saudi Arabia are lured into a false sense of energy importance—that is, how desperately important their oil is to the world economy—the West, with Japan, is secretly developing technologies that will make oil

obsolete as an energy source. At some time in the future, fossil fuels will only be used for plastics and other forms of chemical engineering. Meanwhile, as the West advances into technologically unknown territory, countries like Iraq are buying up toys and other gadgets that have sophisticated computer components for possible use in weapon systems.

In December 2000, NBC News, citing Pentagon and intelligence sources, reported that thousands of Sony PlayStation 2s may have been purchased by Iraqi sources recently, to capitalize on the device's powerful computer processor and video cards, possibly to use in connection with weapons systems. One expert told the World Net Daily news service that an integrated bundle of 12 to 15 PlayStation 2s could provide enough power to control a chemical-weapons-delivering Iraqi aircraft. (A Sony spokesperson said it was unlikely anyone could buy thousands of units.) Other similarly alarming, everyday products sought by enemy countries described in an October *New York Times Magazine* report were the 2001 Cadillac Deville (whose sophisticated night-vision system is potentially useful for tanks) and automobile airbags (whose compact explosive charge might be useful to terrorists).

It is an amusing thought, I suppose, that Armageddon may be being fueled by large purchases of Sony PlayStation 2s and Cadillac Devilles. Is this what it takes for Saddam Hussein and his allies to equip their motley armies of mujaheedin and soldiers of the Holy War— the Jihad—against the West?

Along these lines of advanced new technologies, the Associated Press announced a new invention on January 9, 2001. They said that Amazon.com CEO Jeff Bezos says it's a "product so revolutionary, you'll have no problem selling it." Apple Computer CEO Steve Jobs says it will change the way cities are designed. Venture capitalist John Doerr has invested millions in it.

Harvard Business School Press has paid $250,000 for a book about a mysterious invention with the code name "Ginger." Neither the agent nor the publisher know what "Ginger" is, but they apparently believe it's well worth finding out.

The Harvard press declined to say when the book is coming out, but the invention's identity is expected to be revealed in 2002. The book will be written by Steve Kemper, a journalist whose articles have appeared in *National Geographic, Smithsonian* and elsewhere.

According to the inventor of "Ginger," Dean Kamen, his de-

vice will be an alternative to products that "are dirty, expensive, sometimes dangerous and often frustrating, especially for people in the cities."

The submitted proposal for the book states that Doerr expects "Ginger" to be as significant as the development of the "world wide web." Another investor, Credit Suisse First Boston, thinks "Ginger" will be the most lucrative start-up in history and will make Kamen richer than Bill Gates. Bezos and Jobs were reportedly dazzled by a demonstration.

The 49-year-old Kamen lives in an hexagonally-shaped mansion on a hilltop outside Manchester, New Hampshire, where visitors have included President George W. Bush. His previous inventions include the first portable insulin pump and a wheelchair that can climb stairs.

Kamen recently received the National Medal of Technology, the country's highest award for technology. The web site of his corporation, DEKA, describes him as an "inventor, physicist & snappy dresser."

The device has been described on various websites as a type of mag-lev scooter for local travel, an electric scooter with a hydrogen-cell battery that is perfectly balanced on two wheels and can climb stairs by use of another set of parallel wheels. It is for one person only, and is a handy super-scooter for travel in the city or other congested areas.

People-Zappers, Stun-Guns, and EM Weapons

The higher-end arms manufacturers are now looking at high-tech non-lethal and lethal weapons like people-zappers, beam weapons and other electronic methods for temporarily immobilizing the enemy or confusing them. Because of these new generations of weapons, riot shields and water cannons may soon be made obsolete by a revolutionary weapon that can stun a hostile crowd with invisible microwaves.

The Observer, published in London, noted in its March 18, 2001 issue that the U.S. Vehicle Mounted Active Denial System (VMADS), a radar dish mounted on the back of a tank or jeep, is being considered for use by British police forces.

The VMADS, known as the 'people zapper,' uses a 'directed energy beam,' according to a Pentagon spokesperson, says the report. "When it comes into contact with skin it causes a sensation of heat to an uncomfortable level." The Pentagon insists the

beam causes no permanent damage—no one gets hurt, but the crowd or enemy soldiers retreat hastily.

The weapon harnesses the beams found in kitchen microwaves. Traveling at the speed of light, the energy of the beam penetrates less than a millimeter under the skin, quickly heating the skin's surface. This triggers the body's defense reaction: pain. When the subject moves out of the beam, the pain stops. The report says that scientists will start testing the weapons on goats and humans soon.

The report mentioned that *Jane's Defense Weekly* said recently the "non-lethal" nature of some weapons "might... encourage military forces to use them directly against civilians and civilian targets."

"It's part of this new political correctness on the battlefield," said a spokesperson. "The problem today in situations like Palestine is that you have adversaries mixing with innocent civilians. Forces now need a suite of weapons for different situations."

Scientists have spent $40 million developing the weapon at the Air Force Research Laboratory in New Mexico. Demand for non-lethal weapons grew after the disastrous U.S. military mission to Somalia in 1993, when marines died because they could not shoot back without hitting civilians.

The report went on to say that the VMADS is the most sophisticated development in the search for the ultimate non-lethal weapon, and that the British SAS recently began training with "glue guns" that fire a web of resin from a gun-mounted aerosol. The resin hardens around opponents, paralyzing them.

Allah on the Holodeck—Operation Blue Beam

In an article that appeared in the *Washington Post* on Feb. 1, 1999, it was mentioned that a special research department at Los Alamos Labs in New Mexico was creating a digital morphing technology that could virtually duplicate any human voice, and project a holographic image that would be difficult to distinguish from the real thing.

According to the article, by taking just a 10-minute digital recording of anyone's voice, scientist George Papcun is able, in near real time, to clone speech patterns and develop an accurate facsimile. To refine their method, Papcun's team took various high quality recordings of U.S. generals and experimented with creating fake statements. One of the most memorable is Colin Powell

stating "I am being treated well by my captors."

"They chose to have him say something he would never otherwise have said," chuckled one of Papcun's colleagues.

The article mentions how most Americans were introduced to the tricks of the digital age in the movie *Forrest Gump*, when the character played by Tom Hanks appeared to shake hands with President Kennedy. For Hollywood, it is special effects. For covert operators in the U.S. military and intelligence agencies, it is a weapon of the future.

"Once you can take any kind of information and reduce it into ones and zeros, you can do some pretty interesting things," says Daniel T. Kuehl, chairman of the Information Operations department of the National Defense University in Washington, the military's school for information warfare. Digital morphing—voice, video, and photo—has come of age, available for use in psychological operations.

PSYOPS, as the military calls them, seek to exploit human vulnerabilities in enemy governments, militaries and populations to pursue national and battlefield objectives.

Says the article, "To some, PSYOPS is a backwater military discipline of leaflet dropping and radio propaganda. To a growing group of information war technologists, it is the nexus of fantasy and reality. Being able to manufacture convincing audio or video, they say, might be the difference in a successful military operation or coup."

The *Washington Post* article claims that Pentagon planners started to discuss digital morphing after Iraq's invasion of Kuwait in 1990. Covert operators kicked around the idea of creating a computer-faked videotape of Saddam Hussein crying or showing other such manly weaknesses, or in some sexually compromising situation. The nascent plan was for the tapes to be flooded into Iraq and the Arab world.

Says the article, "The tape war never proceeded, killed, participants say, by bureaucratic fights over jurisdiction, skepticism over the technology, and concerns raised by Arab coalition partners."

But the "strategic" PSYOPS scheming didn't die. Says the *Post*, "What if the U.S. projected a holographic image of Allah floating over Baghdad urging the Iraqi people and Army to rise up against Saddam, a senior Air Force officer asked in 1990?"

According to a military physicist given the task of looking into

the hologram idea, the feasibility had been established of project-ing large, three-dimensional objects that appeared to float in the air.

But doing so over the skies of Iraq? To project such a hologram over Baghdad on the order of several hundred feet, they calcu-lated, would take a mirror more than a mile square in space, as well as huge projectors and power sources.

On top of that, investigators came back, what does Allah look like?

The Gulf War hologram story might be dismissed were it not the case that the *Washington Post* reported that they learned that a super secret program was established in 1994 to pursue this very technology for PSYOPS application. The "Holographic Projector" is described in a classified Air Force document as a system to "project information power from space ... for special operations deception missions."

Voice-morphing? Fake video? Holographic projection? They sound more like *Mission Impossible* and *Star Trek* gimmicks than weapons. Yet for each, there are corresponding and growing re-search efforts as the technologies improve and offensive informa-tion warfare expands.

Early voice morphing required cutting and pasting speech to put letters or words together to make a composite, while Papcun's digital software developed at Los Alamos can far more accurately replicate the way one actually speaks, by eliminating the robotic intonations. Now with holographic projections and voice morphing at such a sophisticated phase, we might expect almost any kind of diabolical deception.

The former wife of October Surprise pilot Gunther Russbacker, Rayelan Russbacker Allen, writes in her book *Diana: Queen of Heaven*[1] with an insider's knowledge on the mysterious death of Princess Diana and the bizarre plan to create a cult around the popular figure Diana by using a similar holographic technique. Allan claims that Diana's "murder" was intentionally committed at the Pont de L'Alma tunnel in Paris, an ancient underground tunnel dedicated to the venerated goddess Diana. Using several CIA documents and other references, she reconstructs the sinister events leading up to the Princess' death and the plan to create a religion based on her memory 80 years from now.

Bizarrely, she includes information on a top secret project known as Project Blue Beam. This high-tech project, proposed to

President Kennedy by James Bond/007 author Ian Fleming, was to be first used against Castro and Cuba. Fleming proposed that the CIA use a laser to project holographic images of Jesus over Cuba to make the deeply religious Catholics on the island believe that the second coming of Christ was happening—right then during the Bay of Pigs invasion! Needless to say, JFK rejected the idea, but offered Fleming another martini, shaken, not stirred.

Today, this technology has allegedly been developed by none other than NASA, offering a gigantic space show with tri-dimensional optical holograms and sounds. In principle, "Blue Beam" will make use of the sky as a movie screen as spaced-based laser generating satellites project simultaneous images to the four corners of the planet, in various different languages, depending on the region targeted. Computers will coordinate the satellites and special software will the run the show. With computer animation and sound effects appearing to come from the depths of space, astonished followers of various creeds will witness their own returned Messiah in spectacular life-like realness.

It seems bizarre, but Project Blue Beam, or something like it, must be a reality. This secret holographic technology could be used to create holographic images of Jesus, Mohammed, Buddha, Krishna, Mother Mary, and (according to Russbacker), even Princess Diana for the simple purpose of just plain screwing with peoples' heads. Hey, it's war out there, and part of war is screwing with peoples' heads—but it is the warfare of the future: bombing minds instead of villages.

So, will the final battles of Armageddon—over the oil fields of Iraq and Iran, the hills of Israel and Lebanon, and other areas—be replete with holographic visions in the sky of Jesus, Mohammed, Moses, Satan, Mother Mary, and a host of holographic flying saucers? Whether it is "Plan 9 from Outer Space" or "Plan 9 from the CIA," cities all over the world may find themselves witnessing en masse a cinemascope projection of Armageddon in the sky. Tickets will be free.

A bizarre incident happened in the American military in July of 1990 that may have something to do with Project Blue Beam. A story was reported widely in the news during 1990, 1991 and 1992 about a group of U.S. Army Intelligence Specialists from the 701st and 713th Military Intelligence brigades in Augsburg, Germany, who deserted their posts and returned to the United States in anticipation of Armageddon.

The group of six, lead by Vance A. Davis, who later wrote a book about it entitled *Unbroken Promises*,[2] headed for Gulf Breeze, Florida, where there is a large military base, and they were promptly arrested. The six Army Intelligence Specialists were then interrogated for three weeks under suspicion of desertion and espionage. However, they were subsequently released without further action and given Honorable Discharges from the Army.

The thing that prompted these six soldiers to embark on this strange journey from one Army base in Germany to another in Florida, where they were "captured," was supposedly their playing with a Ouija board. This Ouija board gave them various predictions of the future, including scenes of various natural disasters and, of course, Armageddon.

What views of Armageddon were released to these soldiers? How accurate would they have to be for the Army to abandon the course of courtmartialing the men and instead offer honorable discharges? One wonders, is it all part of some elaborate operation meant to deceive and prepare the people of the world for a holographic onslaught of lies?

§§§

Will the Real Armageddon Please Stand Up?

My quest for knowledge on Armageddon, starting from my early days hitchhiking across the Middle East in the late 1970s, has ranged from interest in ancient armies battling at Meggido to the happening-today reality of the current Middle East conflict. Armaggedon was an ancient conflict, yet, it seems to be happening today.

How ancient is Armaggedon? In my recent book *Technology of the Gods*, I include an entire chapter on the distinct possibility of ancient atomic warfare. Incredibly, there is evidence, both physical and textual, of an ancient war that included atomic weapons, or something like them.

Here are some quotes from the *Mahabharata*, an ancient Indian text that describes the horrific wars of the past, written approximately 400 BC, using older texts:

"Various omens appeared among the gods—winds blew, meteors fell in thousands, thunder rolled through a cloudless sky."

"There he saw a wheel with a rim as sharp as a razor whirling around the soma... Then taking the soma, he broke the whirling

machine..."

"Drona called Arjuna and said: ... 'Accept from me this irresistible weapon called Brahmasira. But you must promise never to use it against a human foe, for if you did it might destroy the world. If any foe who is not a human attacks you, you may use it against him in battle... None but you deserves the celestial weapon that I gave you." (This is a curious statement, as what other kind of foe, different from a human might there have been? Are we talking about an interplanetary war?)

"I shall fight you with a celestial weapon given to me by Drona. He then hurled the blazing weapon..."

"At last they came to blows, and seizing their maces struck each other... they fell like falling suns."

"These huge animals [elephants] like mountains, struck by Bhima's mace fell with their heads broken, fell upon the ground like cliffs loosened by thunder."

"Bhima took him by the arm and dragged him away to an open place where they began to fight like two elephants mad with rage. The dust they raised resembled the smoke of a forest fire; it covered their bodies so that they looked like swaying cliffs wreathed in mist."

"Arjuna and Krishna rode to and fro in their chariots on either side of the forest and drove back the creatures which tried to escape. Thousands of animals were burnt, pools and lakes began to boil... The flames even reached Heaven... Indra without loss of time set out for Khandava and covered the sky with masses of clouds; the rain poured down but it was dried in mid-air by the heat."

These are also verses from the ancient *Mahabharata*:

> ...(it was) a single projectile
> Charged with all the power of the Universe.
> An incandescent column of smoke and flame
> As bright as the thousand suns
> Rose in all its splendor...
> ...it was an unknown weapon,
> An iron thunderbolt,
> A gigantic messenger of death,
> Which reduced to ashes
> The entire race of the
> Vrishnis and the Andhakas.

...The corpses were so burned
As to be unrecognizable.
The hair and nails fell out;
Pottery broke without apparent cause,
And the birds turned white...
...After a few hours
All foodstuffs were infected...
...to escape from this fire
The soldiers threw themselves in streams
To wash themselves and their equipment.

In the way we traditionally view ancient history, it seems absolutely incredible that there was an atomic war approximately ten thousand years ago. And yet, of what else could the *Mahabharata* be speaking? Perhaps this is just a poetic way to describe cavemen clubbing each other to death; after all, that is what we are told the ancient past was like. Until the bombing of Hiroshima and Nagasaki, modern mankind could not imagine any weapon as horrible and devastating as those described in the ancient Indian texts. Yet they very accurately described the effects of an atomic explosion. Radioactive poisoning will make hair and nails fall out. Immersing one's self in water is the only respite, though not a cure.

Incredible as it may seem, archaeologists have found evidence in India indicating that some cities were destroyed in atomic explosions. When excavations of Mohenjo-Daro and Harappa reached the street level, they discovered scattered skeletons about the cities, many holding hands and sprawling in the streets, as if some instant, horrible doom had taken place. I mean, people are just lying, unburied, in the streets of the city. And these skeletons are thousands of years old, even by traditional archaeological standards! What could cause such a thing? Why did the bodies not decay or get eaten by wild animals? Furthermore, there is no apparent cause of a violent death (heads hacked off, bashed in, etc.).

It was reported as recently as Dec. 15, 2000 in the leading New Delhi newspaper *The Hindu,* (and posted on the web) that India once had a treasure trove of high-tech warfare technology including spacecraft technology. Says the article:

The "Brahmastra" and "Vimana" used in the pre-*Mahabharata* period are nothing but the earlier versions of

today's nuclear weapons and spacecraft.

It is this feeling that one would get after listening to a lecture on "High Technology in Ancient Sanskrit Literature" by Mr. C. S. R. Prabhu, senior scientist, NIC, Hyderabad ... Mr. Prabhu, quoting extensively from ancient texts, stressed that the pre-*Mahabharata* period was an age of high technology, which was ignored in the Medieval period due to reasons not known.

He quoted from the texts of a great scholar, Subbaraya Sastry, who, in a state of yogic trance, is said to have orally dictated the spacecraft technology in a period somewhere between 1875 and 1919, which was recorded by his disciples. The text, a copy of which is still in Nepal's Royal Library, contained technical details on assembling, fabricating and erecting a spacecraft, the metals, semi-conductors, advanced alloys used and other minute aeronautical information. Though quite difficult to be believed on the face of it, the fact that this technology did not exist anywhere in the world—not even in America and Europe—in the mentioned period, makes it hard for one to disbelieve.

... To further strengthen his claim, he said there were wall paintings in some forts in Rajasthan depicting the use of rockets in Mughal warfare and even by Tipu Sultan of Mysore. Another interesting fact he gave was that the spacecraft could become invisible on its own. The lead alloy "Thamogarbha Loha" used in making the body of the spacecraft would absorb light around it in a photochemical reaction that would make it disappear.

On testing the "Krishna Seesa" metal mentioned in the formula in the laboratory of Birla Institute of Science, Hyderabad, Mr. Prabhu found the metal absorbing 78 per cent of laser light, which means, any other light could be easily absorbed, giving ample proof that there existed a technology to make things invisible. Also the use of an alloy of copper, zinc and lead made the spacecraft's body resist corrosion by 1,000 times over that of the current levels. Using Ararakamra material for the axle and wheels had made it possible to take 'U' turns and serpentine movements.

An astonishing fact is that the "Ararakamra" metal was an alloy of copper, zinc, lead and iron, the combination of which is impossible, according to modern metallurgy. Tech-

nically, the "Young's modulus" of this metal is said to be higher than that of steel, making it stronger. As the space-craft had to be capable of resisting high temperature, on re-entering our atmosphere from the outer space, its body was made with a metal called "Raja Loha." Its special feature was that apart from resisting heat, it converted light from lightning into energy. To crosscheck all these details, there were no furnaces available in Hyderabad to melt metals at a high temperature of 2500 degrees celcius, Mr. Prabhu lamented.

… Mr. Prabhu said he had submitted the model and some more information on the "super metal" to the Indian Metal Society Conference and further claimed that the advisor to the government on scientific affairs Dr. A. P. J. Abdul Kalam too had asked him to bring the design of the plane.

A committee which was appointed by Indian Institute of Science to investigate into it, declared Sastry's texts as 'fraud', but Mr. Prabhu reasons that the descriptions mentioned in the ancient texts were perhaps too advanced to believe, making the committee to hastily come to the conclusion. He wanted a national level effort to prove that the so called 'myths' were in fact, scientific formulae on advanced technology. He said he had proposed a project called 'Bharadwaja Institute of Vedic Science and Technology', the objective of which was to derive, decipher and reproduce advanced methodologies and processes from Vedic and post-Vedic Sanskrit texts, for which he sought government's support.

While journalists in New Delhi wondered about their forefathers' technical achievements, others were searching for the lost cities of the ancient epics, and were finding them under water! On May 20, 2001, the *Times of India* announced under the heading, "Scientists find submerged archaeological sites" that scientists from the National Institute of Ocean Technology had discovered archaeological sites submerged in the Gulf of Cambay off Gujerat, similar to on-land structures of the Harappan and pre-Harappan era.

The article said:

Releasing underwater acoustic images of the sites, hu-

man resource development minister Dr Murli Manohar Joshi said that it was the first time that such sites had been reported in the Gulf of Cambay. "It is important that the structures have a similarity with the structures found on-land on archaeological sites of Harappan and pre-Harappan times," Joshi said.

Structures very similar to the great bath, Acropolis, temples and granaries had been located in the National Institute of Ocean Technology discovery, made a few weeks ago. Multi-disciplinary underwater surveys carried out by the National Institute of Ocean Technology, picked up images of several geometrical object which were normally man-made in the 9-km long stretch west of Hazira in Gujarat.

The area has been seen lined with house-basement-like-features partially covered by sand waves and sand ripples at a depth of 30-40 metres. The acoustic images point to the existence of some Harappan-like ruins below the sea bed.

Joshi said findings revealed that a few major rivers had been flowing approximately in the east-west direction coinciding with the course of the present day Tapti and Narmada rivers. Due to the geological processes and tectonic events, the entire Cambay area might have sunk along with river sections and the settlement.

The scientists, Joshi said, were working on the assumption that frequent major earthquakes in the region caused upheavals, which eventually led to submergence. The Bhuj earthquake in January has caused an upheaval of up to one metre.

It has been concluded that around 6000 years ago, the sea level was about six metres higher than at present, and it stabilised at the present leve about 4000 years ago, with minor fluctuations. The new findings are thus believed to be between 4000 and 6000 years old.

Scientists, concluded the article, have inferred a Gujarat coastline during the Indus Valley civilisation showing that places like Lothal were port cities. Similarly, it is thought the ancient city of Krishna, known as Dwarka, is also underwater in the coast off Gujerat.

The astonishing portrait of ancient India that is emerging is one of a sophisticated land with cities that have been destroyed

by horrific wars and earthquakes. Some of the cities are now underwater. An "Atlantis in the Indian Ocean"?

So, while India looks back wistfully at the technology of its ancient times, it prepares for war with Pakistan, and ignores its own past. We all ignore the past, and are condemned to repeat it. Part of repeating the past is recreating Armageddon over and over. The combatants are often the same people, in a different time, but still the same place—the legendary fortress of Meggido.

War is mankind's favorite sport, and the man of war will continue to want to solve his problems with violence. But, despite the cyclical nature of these conflicts, mankind spirals slowly upward, and the age of information is managing to make a difference, at least for some people.

In the future, the individual will be supreme. Individual freedom will triumph over special interests, media manipulators, and "experts" whose real expertise is in continuing falsehood. And, as the smoke clears over those stricken places where Armageddon has taken its worst toll, survivors will look at the sun, and the moon, and the stars with a new wonder, and a new sense of life and purpose. And people will finally learn to treat neighbors as they would have themselves be treated.

> *The best thing about the future*
> *is that it comes only one day at a time.*
> —Abraham Lincoln (1809-1865)

Bibliography and Footnotes

1. *Diana, Queen of Heaven*, Rayelan Russbaker Allen, 1999, Pigeon Point Publishing, Aptos, CA.
2. *Unbroken Promises,* Vance Davis and Brian Blashaw, 1995, White Mesa Publishers, Kent, WA.
3. *Technology of the Gods*, David Hatcher Childress, 2000, Adventures Unlimited Press, Kempton, IL.
4. *Vimana Aircraft of Ancient India and Atlantis,* David Hatcher Childress, 1989, Adventures Unlimited Press, Kempton, IL.
5. *The Tesla Papers*, Nikola Tesla, 2000, Adventures Unlimited Press, Kempton, IL.

(12) INTERNATIONAL APPLICATION PUBLISHED UNDER THE PATENT COOPERATION TREATY (PCT)

(19) World Intellectual Property Organization
International Bureau

(43) International Publication Date
14 December 2000 (14.12.2000)

PCT

(10) International Publication Number
WO 00/75001 A1

(51) International Patent Classification⁷: B62K 1/00, A61G 5/04, A63C 17/00, B62D 51/02, 51/00, 37/00, B62K 3/00, B62D 61/00

(21) International Application Number: PCT/US00/15144

(22) International Filing Date: 1 June 2000 (01.06.2000)

(25) Filing Language: English

(26) Publication Language: English

(30) Priority Data:
09/325,978 4 June 1999 (04.06.1999) US

(71) Applicant: DEKA PRODUCTS LIMITED PARTNER-SHIP [US/US]; 340 Commercial Street, Manchester, NH 03101 (US).

(72) Inventors: KAMEN, Dean, L.; 15 Westwind Drive, Bedford, NH 03110 (US). AMBROGI, Robert, R.; 141 Arah

Street, Manchester, NH 03104 (US). DUGGAN, Robert, .L; Box 69D RD#2, Old Turnpike Road, Northwood, NH 03261 (US). FIELD, Douglas, J.; 19 Mountain Road, Bedford, NH 03110 (US). HEINZMANN, Richard, Kurt; P.O. Box 272, Francestown, NH 03043 (US). AMSBURY, Burl; 164 Brookline Street, Cambridge, MA 02139 (US). LANGENFELD, Christopher, C.; 4 Dunloggin Road, Nashua, NH 03063 (US).

(74) Agents: SUNSTEIN, Bruce, D. et al.; Bromberg & Sunstein LLP, 125 Summer Street, Boston, MA 02110-1618 (US).

(81) Designated States (national): AE, AL, AM, AT, AU, AZ, BA, BB, BG, BR, BY, CA, CH, CN, CR, CU, CZ, DE, DK, DM, EE, ES, FI, GB, GD, GE, GH, GM, HR, HU, ID, IL, IN, IS, JP, KE, KG, KP, KR, KZ, LC, LK, LR, LS, LT, LU, LV, MA, MD, MG, MK, MN, MW, MX, NO, NZ, PL, PT, RO, RU, SD, SE, SG, SI, SK, SL, TJ, TM, TR, TT, TZ, UA, UG, UZ, VN, YU, ZA, ZW.

[Continued on next page]

(54) Title: PERSONAL MOBILITY VEHICLES AND METHODS

(57) Abstract: A class of transportation vehicles for carrying an individual (10) over ground having a surface that may be irregular. Various embodiments have a motorized drive, mounted to the ground-contacting module (6) that causes operation of the vehicle in an operating position that is unstable with respect to tipping when the motorized drive arrangement is not powered. Related methods are provided.

WO 00/75001 A1

The "Ginger" patent. This revolutionary device, powered by a hydrogen fuel cell, is predicted to change the way cities will be built in the future.

LOST CITIES

LOST CITIES OF ATLANTIS, ANCIENT EUROPE & THE MEDITERRANEAN
by David Hatcher Childress

Atlantis! The legendary lost continent comes under the close scrutiny of maverick archaeologist David Hatcher Childress in this sixth book in the internationally popular *Lost Cities* series. Childress takes the reader in search of sunken cities in the Mediterranean; across the Atlas Mountains in search of Atlantean ruins; to remote islands in search of megalithic ruins; to meet living legends and secret societies. From Ireland to Turkey, Morocco to Eastern Europe, and around the remote islands of the Mediterranean and Atlantic, Childress takes the reader on an astonishing quest for mankind's past. Ancient technology, cataclysms, megalithic construction, lost civilizations and devastating wars of the past are all explored in this book. Childress challenges the skeptics and proves that great civilizations not only existed in the past, but the modern world and its problems are reflections of the ancient world of Atlantis.
524 PAGES. 6X9 PAPERBACK. ILLUSTRATED WITH 100S OF MAPS, PHOTOS AND DIAGRAMS. BIBLIOGRAPHY & INDEX. $16.95. CODE: MED

LOST CITIES OF CHINA, CENTRAL INDIA & ASIA
by David Hatcher Childress

Like a real life "Indiana Jones," maverick archaeologist David Childress takes the reader on an incredible adventure across some of the world's oldest and most remote countries in search of lost cities and ancient mysteries. Discover ancient cities in the Gobi Desert; hear fantastic tales of lost continents, vanished civilizations and secret societies bent on ruling the world; visit forgotten monasteries in forbidding snow-capped mountains with strange tunnels to mysterious subterranean cities! A unique combination of far-out exploration and practical travel advice, it will astound and delight the experienced traveler or the armchair voyager.
429 PAGES. 6X9 PAPERBACK. ILLUSTRATED. FOOTNOTES & BIBLIOGRAPHY. $14.95. CODE: CHI

LOST CITIES OF ANCIENT LEMURIA & THE PACIFIC
by David Hatcher Childress

Was there once a continent in the Pacific? Called Lemuria or Pacifica by geologists, Mu or Pan by the mystics, there is now ample mythological, geological and archaeological evidence to "prove" that an advanced and ancient civilization once lived in the central Pacific. Maverick archaeologist and explorer David Hatcher Childress combs the Indian Ocean, Australia and the Pacific in search of the surprising truth about mankind's past. Contains photos of the underwater city on Pohnpei; explanations on how the statues were levitated around Easter Island in a clockwise vortex movement; tales of disappearing islands; Egyptians in Australia; and more.
379 PAGES. 6X9 PAPERBACK. ILLUSTRATED. FOOTNOTES & BIBLIOGRAPHY. $14.95. CODE: LEM

ANCIENT TONGA
& the Lost City of Mu'a
by David Hatcher Childress

Lost Cities series author Childress takes us to the south sea islands of Tonga, Rarotonga, Samoa and Fiji to investigate the megalithic ruins on these beautiful islands. The great empire of the Polynesians, centered on Tonga and the ancient city of Mu'a, is revealed with old photos, drawings and maps. Chapters in this book are on the Lost City of Mu'a and its many megalithic pyramids, the Ha'amonga Trilithon and ancient Polynesian astronomy, Samoa and the search for the lost land of Havai'iki, Fiji and its wars with Tonga, Rarotonga's megalithic road, and Polynesian cosmology. Material on Egyptians in the Pacific, earth changes, the fortified moat around Mu'a, lost roads, more.
218 PAGES. 6X9 PAPERBACK. ILLUSTRATED. COLOR PHOTOS. BIBLIOGRAPHY. $15.95. CODE: TONG

ANCIENT MICRONESIA
& the Lost City of Nan Madol
by David Hatcher Childress

Micronesia, a vast archipelago of islands west of Hawaii and south of Japan, contains some of the most amazing megalithic ruins in the world. Part of our *Lost Cities* series, this volume explores the incredible conformations on various Micronesian islands, especially the fantastic and little-known ruins of Nan Madol on Pohnpei Island. The huge canal city of Nan Madol contains over 250 million tons of basalt columns over an 11 square-mile area of artificial islands. Much of the huge city is submerged, and underwater structures can be found to an estimated 80 feet. Islanders' legends claim that the basalt rocks, weighing up to 50 tons, were magically levitated into place by the powerful forefathers. Other ruins in Micronesia that are profiled include the Latte Stones of the Marianas, the menhirs of Palau, the megalithic canal city on Kosrae Island, megaliths on Guam, and more.
256 PAGES. 6X9 PAPERBACK. ILLUSTRATED. COLOR PHOTOS. BIBLIOGRAPHY. $16.95. CODE: AMIC

LOST CITIES

TECHNOLOGY OF THE GODS
The Incredible Sciences of the Ancients
by David Hatcher Childress

Popular *Lost Cities* author David Hatcher Childress takes us into the amazing world of ancient technology, from computers in antiquity to the "flying machines of the gods." Childress looks at the technology that was allegedly used in Atlantis and the theory that the Great Pyramid of Egypt was originally a gigantic power station. He examines tales of ancient flight and the technology that it involved; how the ancients used electricity; megalithic building techniques; the use of crystal lenses and the fire from the gods; evidence of various high tech weapons in the past, including atomic weapons; ancient metallurgy and heavy machinery; the role of modern inventors such as Nikola Tesla in bringing ancient technology back into modern use; impossible artifacts; and more.

356 PAGES. 6X9 PAPERBACK. ILLUSTRATED. BIBLIOGRAPHY. $16.95. CODE: TGOD

VIMANA AIRCRAFT OF ANCIENT INDIA & ATLANTIS
by David Hatcher Childress, introduction by Ivan T. Sanderson

Did the ancients have the technology of flight? In this incredible volume on ancient India, authentic Indian texts such as the *Ramayana* and the *Mahabharata* are used to prove that ancient aircraft were in use more than four thousand years ago. Included in this book is the entire Fourth Century BC manuscript *Vimaanika Shastra* by the ancient author Maharishi Bharadwaaja, translated into English by the Mysore Sanskrit professor G.R. Josyer. Also included are chapters on Atlantean technology, the incredible Rama Empire of India and the devastating wars that destroyed it. Also an entire chapter on mercury vortex propulsion and mercury gyros, the power source described in the ancient Indian texts. Not to be missed by those interested in ancient civilizations or the UFO enigma.

334 PAGES. 6X9 PAPERBACK. ILLUSTRATED. $15.95. CODE: VAA

LOST CONTINENTS & THE HOLLOW EARTH
I Remember Lemuria and the Shaver Mystery
by David Hatcher Childress & Richard Shaver

Lost Continents & the Hollow Earth is Childress' thorough examination of the early hollow earth stories of Richard Shaver and the fascination that fringe fantasy subjects such as lost continents and the hollow earth have had for the American public. Shaver's rare 1948 book *I Remember Lemuria* is reprinted in its entirety, and the book is packed with illustrations from Ray Palmer's *Amazing Stories* magazine of the 1940s. Palmer and Shaver told of tunnels running through the earth—tunnels inhabited by the Deros and Teros, humanoids from an ancient spacefaring race that had inhabited the earth, eventually going underground, hundreds of thousands of years ago. Childress discusses the famous hollow earth books and delves deep into whatever reality may be behind the stories of tunnels in the earth. Operation High Jump to Antarctica in 1947 and Admiral Byrd's bizarre statements, tunnel systems in South America and Tibet, the underground world of Agartha, the belief of UFOs coming from the South Pole, more.

344 PAGES. 6X9 PAPERBACK. ILLUSTRATED. $16.95. CODE: LCHE

LOST CITIES OF NORTH & CENTRAL AMERICA
by David Hatcher Childress

Down the back roads from coast to coast, maverick archaeologist and adventurer David Hatcher Childress goes deep into unknown America. With this incredible book, you will search for lost Mayan cities and books of gold, discover an ancient canal system in Arizona, climb gigantic pyramids in the Midwest, explore megalithic monuments in New England, and join the astonishing quest for lost cities throughout North America. From the war-torn jungles of Guatemala, Nicaragua and Honduras to the deserts, mountains and fields of Mexico, Canada, and the U.S.A., Childress takes the reader in search of sunken ruins, Viking forts, strange tunnel systems, living dinosaurs, early Chinese explorers, and fantastic lost treasure. Packed with both early and current maps, photos and illustrations.

590 PAGES. 6X9 PAPERBACK. ILLUSTRATED. FOOTNOTES & BIBLIOGRAPHY. $14.95. CODE: NCA

LOST CITIES & ANCIENT MYSTERIES OF SOUTH AMERICA
by David Hatcher Childress

Rogue adventurer and maverick archaeologist David Hatcher Childress takes the reader on unforgettable journeys deep into deadly jungles, high up on windswept mountains and across scorching deserts in search of lost civilizations and ancient mysteries. Travel with David and explore stone cities high in mountain forests and hear fantastic tales of Inca treasure, living dinosaurs, and a mysterious tunnel system. Whether he is hopping freight trains, searching for secret cities, or just dealing with the daily problems of food, money, and romance, the author keeps the reader spellbound. Includes both early and current maps, photos, and illustrations, and plenty of advice for the explorer planning his or her own journey of discovery.

381 PAGES. 6X9 PAPERBACK. ILLUSTRATED. FOOTNOTES. BIBLIOGRAPHY. $14.95. CODE: SAM

LOST CITIES & ANCIENT MYSTERIES OF AFRICA & ARABIA
by David Hatcher Childress

Across ancient deserts, dusty plains and steaming jungles, maverick archaeologist David Childress continues his world-wide quest for lost cities and ancient mysteries. Join him as he discovers forbidden cities in the Empty Quarter of Arabia; "Atlantean" ruins in Egypt and the Kalahari desert; a mysterious, ancient empire in the Sahara; and more. This is the tale of an extraordinary life on the road: across war-torn countries, Childress searches for King Solomon's Mines, living dinosaurs, the Ark of the Covenant and the solutions to some of the fantastic mysteries of the past.

423 PAGES. 6X9 PAPERBACK. ILLUSTRATED. FOOTNOTES & BIBLIOGRAPHY. $14.95. CODE: AFA

FREE ENERGY SYSTEMS

LOST SCIENCE
by Gerry Vassilatos
Rediscover the legendary names of suppressed scientific revolution—remarkable lives, astounding discoveries, and incredible inventions which would have produced a world of wonder. How did the aura research of Baron Karl von Reichenbach prove the vitalistic theory and frighten the greatest minds of Germany? How did the physiophone and wireless of Antonio Meucci predate both Bell and Marconi by decades? How does the earth battery technology of Nathan Stubblefield portend an unsuspected energy revolution? How did the geoaethetic engines of Nikola Tesla threaten the establishment of a fuel-dependent America? The microscopes and virus-destroying ray machines of Dr. Royal Rife provided the solution for every world-threatening disease. Why did the FDA and AMA together condemn this great man to Federal Prison? The static crashes on telephone lines enabled Dr. T. Henry Moray to discover the reality of radiant space energy. Was the mysterious "Swedish stone," the powerful mineral which Dr. Moray discovered, the very first historical instance in which stellar power was recognized and secured on earth? Why did the Air Force initially fund the gravitational warp research and warp-cloaking devices of T. Townsend Brown and then reject it? When the controlled fusion devices of Philo Farnsworth achieved the "break-even" point in 1967 the FUSOR project was abruptly cancelled by ITT.
304 PAGES. 6x9 PAPERBACK. ILLUSTRATED. BIBLIOGRAPHY. $16.95. CODE: LOS

SECRETS OF COLD WAR TECHNOLOGY
Project HAARP and Beyond
by Gerry Vassilatos
Vassilatos reveals that "Death Ray" technology has been secretly researched and developed since the turn of the century. Included are chapters on such inventors and their devices as H.C. Vion, the developer of auroral energy receivers; Dr. Selim Lemstrom's pre-Tesla experiments; the early beam weapons of Grindell-Mathews, Ulivi, Turpain and others; John Hettenger and his early beam power systems. Learn about Project Argus, Project Teak and Project Orange; EMP experiments in the 60s; why the Air Force directed the construction of a huge Ionospheric "backscatter" telemetry system across the Pacific just after WWII; why Raytheon has collected every patent relevant to HAARP over the past few years; more.
250 PAGES. 6x9 PAPERBACK. ILLUSTRATED. $15.95. CODE: SCWT

THE TIME TRAVEL HANDBOOK
A Manual of Practical Teleportation & Time Travel
edited by David Hatcher Childress
In the tradition of *The Anti-Gravity Handbook* and *The Free-Energy Device Handbook*, science and UFO author David Hatcher Childress takes us into the weird world of time travel and teleportation. Not just a whacked-out look at science fiction, this book is an authoritative chronicling of real-life time travel experiments, teleportation devices and more. *The Time Travel Handbook* takes the reader beyond the government experiments and deep into the uncharted territory of early time travellers such as Nikola Tesla and Guglielmo Marconi and their alleged time travel experiments, as well as the Wilson Brothers of EMI and their connection to the Philadelphia Experiment—the U.S. Navy's forays into invisibility, time travel, and teleportation. Childress looks into the claims of time travelling individuals, and investigates the unusual claim that the pyramids on Mars were built in the future and sent back in time. A highly visual, large format book, with patents, photos and schematics. Be the first on your block to build your own time travel device!
316 PAGES. 7x10 PAPERBACK. ILLUSTRATED. $16.95. CODE: TTH

THE TESLA PAPERS
Nikola Tesla on Free Energy & Wireless Transmission of Power
by Nikola Tesla, edited by David Hatcher Childress
David Hatcher Childress takes us into the incredible world of Nikola Tesla and his amazing inventions. Tesla's rare article "The Problem of Increasing Human Energy with Special Reference to the Harnessing of the Sun's Energy" is included. This lengthy article was originally published in the June 1900 issue of *The Century Illustrated Monthly Magazine* and it was the outline for Tesla's master blueprint for the world. Tesla's fantastic vision of the future, including wireless power, anti-gravity, free energy and highly advanced solar power. Also included are some of the papers, patents and material collected on Tesla at the Colorado Springs Tesla Symposiums, including papers on: •The Secret History of Wireless Transmission •Tesla and the Magnifying Transmitter •Design and Construction of a Half-Wave Tesla Coil •Electrostatics: A Key to Free Energy •Progress in Zero-Point Energy Research •Electromagnetic Energy from Antennas to Atoms •Tesla's Particle Beam Technology •Fundamental Excitatory Modes of the Earth-Ionosphere Cavity
325 PAGES. 8x10 PAPERBACK. ILLUSTRATED. $16.95. CODE: TTP

THE FANTASTIC INVENTIONS OF NIKOLA TESLA
by Nikola Tesla with additional material by David Hatcher Childress
This book is a readable compendium of patents, diagrams, photos and explanations of the many incredible inventions of the originator of the modern era of electrification. In Tesla's own words are such topics as wireless transmission of power, death rays, and radio-controlled airships. In addition, rare material on German bases in Antarctica and South America, and a secret city built at a remote jungle site in South America by one of Tesla's students, Guglielmo Marconi. Marconi's secret group claims to have built flying saucers in the 1940s and to have gone to Mars in the early 1950s! Incredible photos of these Tesla craft are included. The Ancient Atlantean system of broadcasting energy through a grid system of obelisks and pyramids is discussed, and a fascinating concept comes out of one chapter: that Egyptian engineers had to wear protective metal head-shields while in these power plants, hence the Egyptian Pharoah's head covering as well as the Face on Mars! •His plan to transmit free electricity into the atmosphere. •How electrical devices would work using only small antennas. •Why unlimited power could be utilized anywhere on earth. •How radio and radar technology can be used as death-ray weapons in Star Wars.
342 PAGES. 6x9 PAPERBACK. ILLUSTRATED. $16.95. CODE: FINT

24 hour credit card orders—call: 815-253-6390 fax: 815-253-6300
email: auphq@frontiernet.net www.adventuresunlimitedpress.com www.wexclub.com

ANTI-GRAVITY

THE FREE-ENERGY DEVICE HANDBOOK
A Compilation of Patents and Reports
by David Hatcher Childress

A large-format compilation of various patents, papers, descriptions and diagrams concerning free-energy devices and systems. *The Free-Energy Device Handbook* is a visual tool for experimenters and researchers into magnetic motors and other "over-unity" devices. With chapters on the Adams Motor, the Hans Coler Generator, cold fusion, superconductors, "N" machines, space-energy generators, Nikola Tesla, T. Townsend Brown, and the latest in free-energy devices. Packed with photos, technical diagrams, patents and fascinating information, this book belongs on every science shelf. With energy and profit being a major political reason for fighting various wars, free-energy devices, if ever allowed to be mass distributed to consumers, could change the world! Get your copy now before the Department of Energy bans this book!
292 PAGES. 8X10 PAPERBACK. ILLUSTRATED. BIBLIOGRAPHY. $16.95. CODE: FEH

THE ANTI-GRAVITY HANDBOOK
edited by David Hatcher Childress, with Nikola Tesla, T.B. Paulicki,
Bruce Cathie, Albert Einstein and others

The new expanded compilation of material on Anti-Gravity, Free Energy, Flying Saucer Propulsion, UFOs, Suppressed Technology, NASA Cover-ups and more. Highly illustrated with patents, technical illustrations and photos. This revised and expanded edition has more material, including photos of Area 51, Nevada, the government's secret testing facility. This classic on weird science is back in a 90s format!
• **How to build a flying saucer.**
• **Arthur C. Clarke on Anti-Gravity.**
• **Crystals and their role in levitation.**
• **Secret government research and development.**
• **Nikola Tesla on how anti-gravity airships could
 draw power from the atmosphere.**
• **Bruce Cathie's Anti-Gravity Equation.**
• **NASA, the Moon and Anti-Gravity.**
**230 PAGES. 7X10 PAPERBACK. BIBLIOGRAPHY/INDEX/APPENDIX. HIGHLY ILLUSTRATED.
$14.95. CODE: AGH**

ANTI-GRAVITY & THE WORLD GRID

Is the earth surrounded by an intricate electromagnetic grid network offering free energy? This compilation of material on ley lines and world power points contains chapters on the geography, mathematics, and light harmonics of the earth grid. Learn the purpose of ley lines and ancient megalithic structures located on the grid. Discover how the grid made the Philadelphia Experiment possible. Explore the Coral Castle and many other mysteries, including acoustic levitation, Tesla Shields and scalar wave weaponry. Browse through the section on anti-gravity patents, and research resources.
274 PAGES. 7X10 PAPERBACK. ILLUSTRATED. $14.95. CODE: AGW

ANTI-GRAVITY & THE UNIFIED FIELD
edited by David Hatcher Childress

Is Einstein's Unified Field Theory the answer to all of our energy problems? Explored in this compilation of material is how gravity, electricity and magnetism manifest from a unified field around us. Why artificial gravity is possible; secrets of UFO propulsion; free energy; Nikola Tesla and anti-gravity airships of the 20s and 30s; flying saucers as superconducting whirls of plasma; anti-mass generators; vortex propulsion; suppressed technology; government cover-ups; gravitational pulse drive; spacecraft & more.
240 PAGES. 7X10 PAPERBACK. ILLUSTRATED. $14.95. CODE: AGU

ETHER TECHNOLOGY
A Rational Approach to Gravity Control
by Rho Sigma

This classic book on anti-gravity and free energy is back in print and back in stock. Written by a well-known American scientist under the pseudonym of "Rho Sigma," this book delves into international efforts at gravity control and discoid craft propulsion. Before the Quantum Field, there was "Ether." This small, but informative book has chapters on John Searle and "Searle discs;" T. Townsend Brown and his work on anti-gravity and ether-vortex turbines. Includes a forward by former NASA astronaut Edgar Mitchell.
108 PAGES. 6X9 PAPERBACK. ILLUSTRATED. $12.95. CODE: ETT

TAPPING THE ZERO POINT ENERGY
Free Energy & Anti-Gravity in Today's Physics
by Moray B. King

King explains how free energy and anti-gravity are possible. The theories of the zero point energy maintain there are tremendous fluctuations of electrical field energy imbedded within the fabric of space. This book tells how, in the 1930s, inventor T. Henry Moray could produce a fifty kilowatt "free energy" machine; how an electrified plasma vortex creates anti-gravity; how the Pons/Fleischmann "cold fusion" experiment could produce tremendous heat without fusion; and how certain experiments might produce a gravitational anomaly.
170 PAGES. 5x8 PAPERBACK. ILLUSTRATED. $9.95. CODE: TAP

24 hour credit card orders—call: 815-253-6390 fax: 815-253-6300
email: auphq@frontiernet.net www.adventuresunlimitedpress.com www.wexclub.com

ATLANTIS REPRINT SERIES

ATLANTIS: MOTHER OF EMPIRES
Atlantis Reprint Series
by Robert Stacy-Judd

Robert Stacy-Judd's classic 1939 book on Atlantis is back in print in this large-format paperback edition. Stacy-Judd was a California architect and an expert on the Mayas and their relationship to Atlantis. He was an excellent artist and his work is lavishly illustrated. The eighteen comprehensive chapters in the book are: The Mayas and the Lost Atlantis; Conjectures and Opinions; The Atlantean Theory; Cro-Magnon Man; East is West; And West is East; The Mormons and the Mayas; Astrology in Two Hemispheres; The Language of Architecture; The American Indian; Pre-Panamanians and Pre-Incas; Columns and City Planning; Comparisons and Mayan Art; The Iberian Link; The Maya Tongue; Quetzalcoatl; Summing Up the Evidence; The Mayas in Yucatan.

340 PAGES. 8x11 PAPERBACK. ILLUSTRATED. INDEX. $19.95. CODE: AMOE

MYSTERIES OF ANCIENT SOUTH AMERICA
Atlantis Reprint Series
by Harold T. Wilkins

The reprint of Wilkins' classic book on the megaliths and mysteries of South America. This book predates Wilkins's book *Secret Cities of Old South America* published in 1952. *Mysteries of Ancient South America* was first published in 1947 and is considered a classic book of its kind. With diagrams, photos and maps, Wilkins digs into old manuscripts and books to bring us some truly amazing stories of South America: a bizarre subterranean tunnel system; lost cities in the remote border jungles of Brazil; legends of Atlantis in South America; cataclysmic changes that shaped South America; and other strange stories from one of the world's great researchers. Chapters include: Our Earth's Greatest Disaster, Dead Cities of Ancient Brazil, The Jungle Light that Shines by Itself, The Missionary Men in Black: Forerunners of the Great Catastrophe, The Sign of the Sun: The World's Oldest Alphabet, Sign-Posts to the Shadow of Atlantis, The Atlanean "Subterraneans" of the Incas, Tiahuanacu and the Giants, more.

236 PAGES. 6x9 PAPERBACK. ILLUSTRATED. INDEX. $14.95. CODE: MASA

SECRET CITIES OF OLD SOUTH AMERICA
Atlantis Reprint Series
by Harold T. Wilkins

The reprint of Wilkins' classic book, first published in 1952, claiming that South America was Atlantis. Chapters include Mysteries of a Lost World; Atlantis Unveiled; Red Riddles on the Rocks; South America's Amazons Existed!; The Mystery of El Dorado and Gran Payatiti—the Final Refuge of the Incas; Monstrous Beasts of the Unexplored Swamps & Wilds; Weird Denizens of Antediluvian Forests; New Light on Atlantis from the World's Oldest Book; The Mystery of Old Man Noah and the Arks; and more.

438 PAGES. 6x9 PAPERBACK. ILLUSTRATED. BIBLIOGRAPHY & INDEX. $16.95. CODE: SCOS

THE SHADOW OF ATLANTIS
The Echoes of Atlantean Civilization Tracked through Space & Time
by Colonel Alexander Braghine

First published in 1940, *The Shadow of Atlantis* is one of the great classics of Atlantis research. The book amasses a great deal of archaeological, anthropological, historical and scientific evidence in support of a lost continent in the Atlantic Ocean. Braghine covers such diverse topics as Egyptians in Central America, the myth of Quetzalcoatl, the Basque language and its connection with Atlantis, the connections with the ancient pyramids of Mexico, Egypt and Atlantis, the sudden demise of mammoths, legends of giants and much more. Braghine was a linguist and spends part of the book tracing ancient languages to Atlantis and studying little-known inscriptions in Brazil, deluge myths and the connections between ancient languages. Braghine takes us on a fascinating journey through space and time in search of the lost continent.

288 PAGES. 6x9 PAPERBACK. ILLUSTRATED. $16.95. CODE: SOA

THE HISTORY OF ATLANTIS
by Lewis Spence

Lewis Spence's classic book on Atlantis is now back in print! Spence was a Scottish historian (1874-1955) who is best known for his volumes on world mythology and his five Atlantis books. *The History of Atlantis* (1926) is considered his finest. Spence does his scholarly best in chapters on the Sources of Atlantean History, the Geography of Atlantis, the Races of Atlantis, the Kings of Atlantis, the Religion of Atlantis, the Colonies of Atlantis, more. Sixteen chapters in all.

240 PAGES. 6x9 PAPERBACK. ILLUSTRATED WITH MAPS, PHOTOS & DIAGRAMS. $16.95. CODE: HOA

ATLANTIS IN SPAIN
A Study of the Ancient Sun Kingdoms of Spain
by E.M. Whishaw

First published by Rider & Co. of London in 1928, this classic book is a study of the megaliths of Spain, ancient writing, cyclopean walls, sun worshipping empires, hydraulic engineering, and sunken cities. An extremely rare book, it was out of print for 60 years. Learn about the Biblical Tartessus; an Atlantean city at Niebla; the Temple of Hercules and the Sun Temple of Seville; Libyans and the Copper Age; more. Profusely illustrated with photos, maps and drawings.

284 PAGES. 6x9 PAPERBACK. ILLUSTRATED. $15.95. CODE: AIS

24 hour credit card orders—call: 815-253-6390 fax: 815-253-6300

email: auphq@frontiernet.net www.adventuresunlimitedpress.com www.wexclub.com